Digital Wildlife Photography

Digital Wildlife Photography

John and Barbara Gerlach

Focal Press
Taylor & Francis Group
NEW YORK AND LONDON

First published 2013
by Focal Press
70 Blanchard Road, Suite 402, Burlington, MA 01803

Simultaneously published in the UK
by Focal Press
2 Park Square, Milton Park, Abingdon, Oxon OX14 4RN

Focal Press is an imprint of the Taylor & Francis Group, an informa business

Library of Congress Cataloging in Publication Data
Gerlach, John.
 Digital wildlife photography / by John and Barbara Gerlach.
 p. cm.
 Includes index.
 1. Wildlife photography. 2. Photography—Digital techniques.
 I. Gerlach, Barbara. II. Title.
 TR729.W54G47 2012
 778.9'32—dc23 2012022219

ISBN: 978-0-240-81883-2 (hbk)
ISBN: 978-0-240-81904-4 (ebk)

Typeset in Slimbach and Helvetica
By Keystroke, Station Road, Codsall, Wolverhampton

Cover image: John and Barbara Gerlach

Printed and bound by 1010 Printing International Ltd,China

Contents

JOHN GERLACH

John has been a full-time professional nature photographer for more decades (four) than he cares to admit. He was lucky to discover his nature photography passion shortly after graduating from Central Michigan University in the mid-1970s with a wildlife biology degree. After all of these years, his intense interest in nature photography burns hotter than ever. His extensive nature photography experience over many years and in-depth science studies that include physics, biology, and math from college enable him to rapidly figure out ways to use new photo tools to capture pleasing images. He especially loves to teach others how to shoot excellent photos easily and consistently through writing, in-the-field instruction, and seminars. He has written a regular column for *Nature Photographer* magazine (www.naturephotographer mag.com) for many years. Always eager to teach, he and Barbara post many instructional articles about nature photography on their web site at: www.gerlachnaturephoto.com.

BARBARA GERLACH

Barbara is a tremendously talented creative nature photographer who loves to teach. She is well known as a superb photo tour leader who instantly knows everyone's name and quickly solves any problem that arises. Of the two, she is the computer nerd who is able to figure out everything without even opening the manual. Barbara processed all of the RAW images you see in this book with PhotoShop CS5. She is gifted at figuring out new camera features and applying them to the field.

Currently, John and Barbara have three dogs—two Pomeranians and a wire-haired pointing griffon. The poms are trouble (Barbara says "adorable") and the affectionate griffon is John's first bird hunting dog.

As a one-year-old, she has already proven to be an excellent pointer of, well, okay—butterflies and mice. They love riding their three Tennessee walking horses along the highest ridges in the mountains surrounding their Idaho home near Yellowstone National Park. They also enjoy kayaking, fishing, birdwatching, snowshoeing, camping, and hummingbirds.

Acknowledgments

We wish to thank hunters and fishermen who have contributed untold millions of dollars through license fees, donations, and special taxes on sporting equipment to preserve and restore wetlands in the United States and Canada. Without this massive influx of money, much of our wildlife heritage would have been lost forever. Today we enjoy a huge network of national wildlife refuges and waterfowl production areas that have been successfully preserved for wildlife, us, and future generations. Everyone, and especially nature photographers, owe a huge debt of gratitude to these conservationists.

The shallow pond that attracts this graceful American avocet was purchased with money from hunting and fishing license sales. Although this marshland was originally protected for the benefit of waterfowl and fish, all water-loving non-game species benefit tremendously. Nikon D300, Nikon 200-400mm f/4 lens at 340mm, f/9 at 1/400 second, ISO 200, and manual exposure.

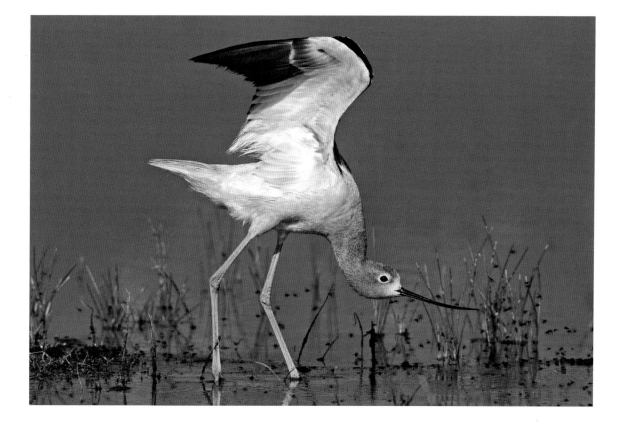

Hundreds of helpful folks have aided us in our pursuit of wildlife images over many decades. Early in my career, David Blanton, the founder of Voyagers International, asked me to guide a photo tour to Kenya when I was 33. This fantastic opportunity lit a fuse that became a life-long burning interest in traveling to the world's finest wildlife hot spots. Little did I realize in the beginning that I would co-lead, along with my wife Barbara, more than three dozen photo tours to Kenya, along with numerous trips to the Galapagos Islands, the Falkland Islands, Antarctica, Midway Atoll, Alaska, Canada, and other fascinating destinations. (For the record, Barbara is the main tour leader now because she is simply brilliant in that role. I mainly offer photo instruction and set the schedule. I let her assume most of the leadership duties because there is no point in messing with perfection.)

Eventually, International Expeditions bought Voyagers and we have worked with this fine company for many years. To the splendid folks at International Expeditions, thanks so much for your advice and help in making our photo tours incredibly successful for our clients. On our popular Kenya wildlife safaris, we work with Steve Turner of Origins Safaris and his incredible native driver-guides. Thanks so much to all of you, especially David and his son, Stanley, who have skillfully guided us to the best photo spots for 20 years.

The incredible folks who join our photo tours deserve a huge round of applause. All have been outstanding individuals to travel with. Your patience and good humor as we solve small travel problems (lost luggage and flat tires) and make the photo tour the finest it can be are heartwarming.

We feel truly blessed to have the best clients in the world. Many have traveled with us to every destination we offer. Together, we have toured the world and you have been a big part of our success in offering the finest photo tours possible.

Thanks to Alan Charnley who participated in the first photo workshop I ever taught in Lapeer, Michigan, where I was born. Alan became my dentist, but he frequently joined me in the field to photograph. He is a terrific companion and an excellent sounding board. We threw ideas at each other and together developed new techniques for shooting better nature images. Alan always kept me humble. He excels at everything. Not only is he an outstanding dentist, but he is a superb nature photographer. His nature images and knowledge of the camera are far better than most pros. Therefore, I never thought too highly of myself, just because I earned a living at nature photography. Thanks to Alan, I always knew there were plenty of fantastic amateur nature photographers who are every bit as skillful as the pros. Alan continually develops new tools and strategies. A few years ago, he helped Barbara and me build our own floating blind that lets us stalk wildlife in the water. It's one of our favorite ways of shooting images and we look forward to using our fourth-generation "Charnley" blind every year.

Bill Forbes came to the rescue when Barbara decided she had to photograph Gambel's quail. He invited us to his home to photograph the numerous quail that drink from the pond in his desert yard. Thanks a lot, Bill. It was tons of fun and encouraged us to develop water lures at our Idaho mountain home.

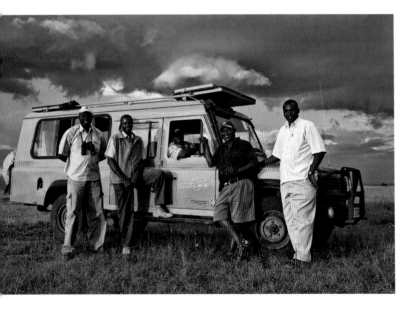

These superb Kenyan guides help us enormously while leading photo safaris to Kenya's best game parks. Pictured left to right: Henry, Joseph, Patrick, David, and Peter. Other wonderful guides we like include Stanley, Edwin, Zachary, Joshua, Felix, and Bernie. Special thanks goes to David who is our lead guide and a tremendous game driver, spotter, and dear friend. Canon EOS-5D Mark II, 24-105 f/4 lens at 40mm, f/8 at 1/200 second, ISO 320, and manual exposure.

Hummingbirds are fascinating to us. Great appreciation is extended to Cindy and Hans Koch for letting us turn their spectacular Bull River Guest Ranch into the world's most productive hummingbird photo workshop.

We've enjoyed our ten years there more than we can ever tell you and have such wonderful memories. And many thanks to Gina and Greg Koch, the ranch managers, for putting up with us for all of these years. They are wonderful friends and terrific hosts.

Thanks to the staff at Focal Press who continue to tolerate this writer/photographer who disappears for months at a time to all corners of the world. They put a lot of trust in me to actually get everything done without hearing from me for long periods of time.

Finally, Al Hart and Woodice Fuller deserve praise for editing the manuscript. They found most of my typos and helped me write tighter and more accurately. The feedback they provided helped make the book easier to read and more instructional than it would have been without them.

Introduction

This book will help you select excellent camera equipment and teach you how to use it efficiently to capture superb wildlife images easily and consistently. We emphasize photographic techniques that are simple, precise, fast, and produce high-quality images.

Thirty-five years of active full-immersion nature photography teaching have allowed us to help improve the photography of more than 60,000 clients in person. They've attended our one-day seminars, week-long workshops, overseas wildlife photo tours, and they've read our books and watched our videos. Many have repeated workshops and seminars. We've been able to helpfully pinpoint areas of weak technique in many students, and we've enlightened many more who were still encumbered by outdated film shooting methods. Moreover, far too many digital camera users come to us unaware of the still largely unknown, but digitally helpful techniques of back-button focusing, manual metering, Shutter-priority with Auto ISO, main flash, fill-flash, multiple flash, the all-important RGB histogram, and precision focusing techniques.

We always ask workshop and seminar audiences whether we should be politically correct and gentle with our opinions on equipment, techniques, and images, or whether they want hard-hitting honesty. Honesty, though, often results in our stating facts or opinions contrary to the thinking of the student. Honesty may conflict the student who thought otherwise on a matter, or in some cases even offend that student. As but a few examples, we rarely use carrying straps on cameras

and lenses. They're always in the way, hang up on things, and slow us down. We don't use filters solely for the protection of lenses, as filters reduce important image sharpness and in many lighting conditions, cause or worsen objectionable flare. We use filters only to obtain a specific photographic effect. Yet our lenses continue to survive years of professional use without damage. We primarily use manual metering for arriving at the optimum exposure, though sometimes use Shutter-priority and employ Auto ISO when the light dims. We know the vast majority of amateur and pro photographers favor Aperture-priority, though we don't understand why when you consider all of the problems its use creates. We can't survey all readers before writing a book though, so we'll assume that readers prefer just what workshop and seminar students prefer, that is, the most honest approach we can bring to a subject. We'll explain why we do what we do, and we'll guide you toward successful photographic techniques that will serve you well in your goal of capturing fine images.

We're highly experienced photographic educators, but we're also full-time working nature photographers. From both perspectives, we're very passionate about landscape images, macro work, wildlife photography, and yes, outdoor photography in general. Wildlife photography is always our favorite though, and that's easily explained by Barbara having grown up surrounded by wild and domestic animals on an Ohio farm, and John being a professional wildlife biologist before becoming widely known as a nature photographer and teacher.

Like many, we learned wildlife photography with film cameras, but we've substantially modified our techniques after switching to digital photography in 2003. We've come to appreciate the high ISO choices, the crop factors of some cameras, the efficiency of back-button focusing, using the RGB histogram to guarantee excellent exposure, the fast shooting speeds available for fast-moving mammals and birds, the convenience of high capacity memory cards, the very sophisticated integrated flash systems, and the usefulness of live-view operations. We've included all of these tactics, and many more, in this book.

Every image in this book is a digital capture. There are no digitized film images. This decision causes a small problem. We've led more than 60 wildlife photo tours around this world, including trips to Antarctica, the Falkland Islands, and the Galapagos. The problem is that we haven't visited some of these locations since switching to digital photography, so there are no images from some countries included in the book. Luckily, we have extensive image files from several trips to Rwanda and our many trips to the wildlife-rich game parks of Kenya. We've also included wildlife images from a wintery northern Japan, hummingbird images from Ecuador and British Columbia, and a 2011 trip to the Galapagos.

Regardless of the source of illustrative images, the focus of this book (pun intended) is to show you to systematically optimize your camera equipment and technique for capturing excellent wildlife images. There's plenty to cover. You'll learn how to exploit your camera's many menu choices and custom functions as we ourselves do in capturing exciting wildlife images. We also use a "shooting workflow" that has worked wonderfully for us and for thousands of our students. That workflow is meticulously covered in the book.

We'll be as specific as we can in how to employ our methods. Again we encounter a problem. A lens or camera that we discuss with specificity might be obsolete by the time you read about it. So we must be general.

Hopefully you can apply the ideas to its successor. Some techniques, such as the back-button focusing (some call it thumb focusing) we so heartily endorse, must be set on the specific camera, but cameras differ from model to model. Trying to describe exactly how to do it on every camera in the marketplace would be practically impossible, and would surely put the most eager reader into deep slumber. In such cases we'll explain what we do, why we do it, how we do it, and suggest that you study your own camera manual to learn the details.

The modern "digital darkroom" that lets computer technology replace hot, wet, and smelly chemical darkrooms, is critically important to digital photographs generally and certainly to wildlife photography. As but one example, all images generated by a digital sensor must be sharpened. Sharpening

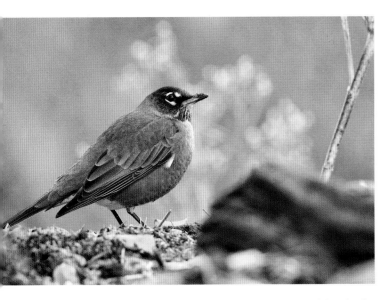

American robins are abundant at our home. I lay on the ground to obtain this low shooting viewpoint and used back-button focusing to sharply focus its face. Canon EOS-7D, 500mm f/4 lens , f/5 at 1/250 second, ISO 500, Shutter-priority with +1/3-stop exposure compensation.

can be done in the camera in some cases, but generally, all images should be subjected to post-capture sharpening. Many images can or should be adjusted in exposure, contrast, color, and even composition.

Digital file management and digital post-capture editing though, are thoroughly covered in many excellent and widely available books, so we've decided to leave them out of this book. Space is severely limited, even in a book, and we want to devote all available space here to the carefully pinpointed subject of wildlife photography. This means I must reluctantly leave some topics out, and not develop others as much as I would like. This forces me to pick and choose which topics will be helpful to most photographers. Some chapters such as the ones on exposure, focusing, composition, and flash could easily be an entire book in themselves. Indeed, the art of hummingbird photography (a specialty of ours) could be its own book, but I fear the market for it is too small to make it financially feasible.

Nothing will aid your wildlife photography more than your own knowledge of the wildlife. Its appearance, its anatomy,

its eating and sleeping habits, its mating habits, and in general, anything you can learn can be important. Consider attending appropriate classes at a local college, nature center, or a national park. Read books, magazines, and field guides about wildlife.

Explore the internet. Spend as much time as you can observing wildlife. All knowledge you gain is invaluable in finding the wildlife, in learning weather conditions that foster good availability of the wildlife, in finding optimum shooting locations, in foreseeing proper camera gear setup, and in learning to anticipate the animal's movements so you can very gently push your shutter button at the optimum "peak of the action."

It's critical that you never harass, or stress, wildlife! Critical! What is harassment? Simply, you're too close if your presence causes an animal to change what it's doing. Always watch an animal's reaction to you, and never disrupt its natural behavior. Not only critical to the wildlife's well-being, wildlife harassment is critical to the public, critical to the community of wildlife photographers, and can even be critical to you. We've all read of the perils of photographing Mama Moose and Mrs. Grizzly, and I even know a careless wildlife photographer who had to hastily abandon camera and tripod to escape an irritated 8-foot alligator!

To continue on that important topic, you should learn any special wildlife viewing rules at your location and stay aware of other wildlife viewers. Flushing a rare harlequin duck for a better shot, while a bunch of bird watchers is viewing it, can result in a rapid outburst of very harsh language. Don't disturb an animal by trying to attract its attention. Be patient and you'll have ample opportunity to photograph its natural behavior. We heard of one unthinking photographer ticketed by a park ranger for throwing a stone into a river to force a feeding moose to raise its head. The moose raised its head anyway long before the ranger finished writing the ticket, and caused Mr. Impatient Shooter to miss his shot!

Feeding can be quite effective in attracting wildlife within easy camera range. However, the feeding of wildlife is illegal in many parks and preserves. Also, some larger predators like bears, mountain lions, and coyotes, should never be fed.

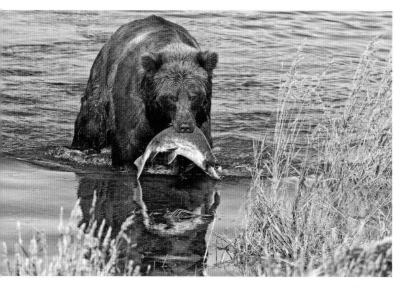

Alaskan brown bears are superb at catching salmon in their natural environment. Large predators must never be fed because they quickly learn to associate humans with food, creating a dangerous situation for both. Nikon D300, Nikon 200-400mm f/4 lens at 390mm, f/9 at 1/1000 second, ISO 800 and aperturepriority with a minus 1/3-stop exposure compensation.

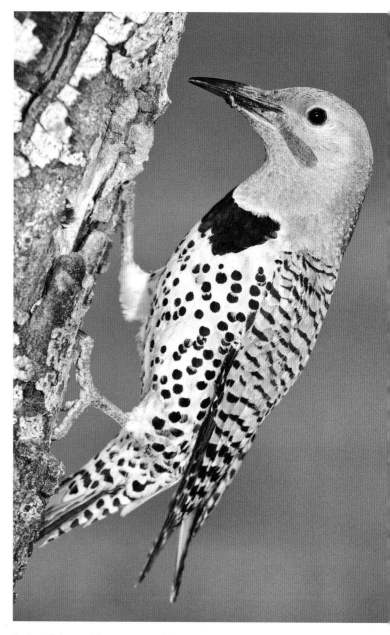

Northern flickers nest in aspen tree cavities next to our Idaho home. This handsome male flicker was accustomed to seeing us in the yard and easily accepted our presence when we photographed it. Nikon D3, Nikon 200-400mm f/4 lens at 280mm, f/9.0 at 1/200 second, ISO 2000, and manual exposure.

Feeding teaches those unfortunate animals to associate food with humans. The animals invariably become dangerous to people and must be killed. We live in bear country and know well that a fed bear becomes a dead bear. Such warnings notwithstanding, many fine images of small birds and small mammals like chipmunks and squirrels are made at seed feeders. However, feeders placed too close to windows pose a hazard because birds sometimes fly headlong into the glass, thus injuring or killing the bird. And, it's not too hard to foresee that a larger bird could break the glass and cause unforeseeable mayhem. Also note that feeders must be kept scrupulously clean to help prevent bird-to-bird transmission of disease.

Photography of birds at the nest has been very popular, but raising young is stressful for all wildlife. Fortunately, the advent of higher ISO speeds and very long lenses have made the photography of nesting birds far less hazardous than it once was. Contrary to those who uphold that no birds should be photographed at the nest, there are times and conditions where it's easily done without endangering the birds. Birds

that nest in the open are often habituated to humans, unafraid, and not harmed by human presence or photography.

Here too, as always, it's important for the successful photographer to know his subject intimately. If birds are habituated to human presence or otherwise tolerant of your presence, shoot! Recently, a family of dusky flycatchers and another family of northern flickers nesting in our yard offered excellent photo opportunities with no protest to our presence near the nests. Several pairs of mountain bluebirds raise families in our yard and one pair eats meal worms out of Barbara's outstretched hand. We photograph them.

Wildlife photography is a life-long journey. Your skills will improve throughout the trip, as ours still do, while you enjoy the time you spend with wildlife. Your images will be failures all too often, but will occasionally be prideful achievements. As the trip through this life-long venture progresses, your images will gradually change from the occasional decent image to the frequent publishable or prize-winning image. Do enjoy the journey into the wonderful world of wildlife photography and do be considerate of your subjects and the other people you meet along the way. Be sure to share your images and stories with all of us!

Finally, a few words about the evolution of this book. Like our previous books on nature photography, this one too is a joint effort. My main job is to determine content, although Barbara always makes key suggestions. I do the original writing because I type faster, and Barb carefully selects and processes the illustration images. That's why most of the images were made by her! Just kidding—sort of! Actually, the image split is about even, we think, as we don't keep track since neither one of us cares. Barbara carefully proofreads the book to keep me on track, to find my innumerable typos, and she corrects my spelling, grammatical, and technical blunders. Barbara is years and years ahead of me in computer skills. I can barely launch Photoshop, but she can make it do her every bidding with embarrassing ease. She deftly manages the storage and safekeeping of image files, converts our RAW files to other formats, skillfully edits them using Photoshop and ancillary software, thus producing the splendid JPEGs that appear in the book. Actually, the book only exists because of Barbara's mastery of Photoshop and her never-ending industry, patience, tolerance, and complete dedication to the photography skills of our students and readers.

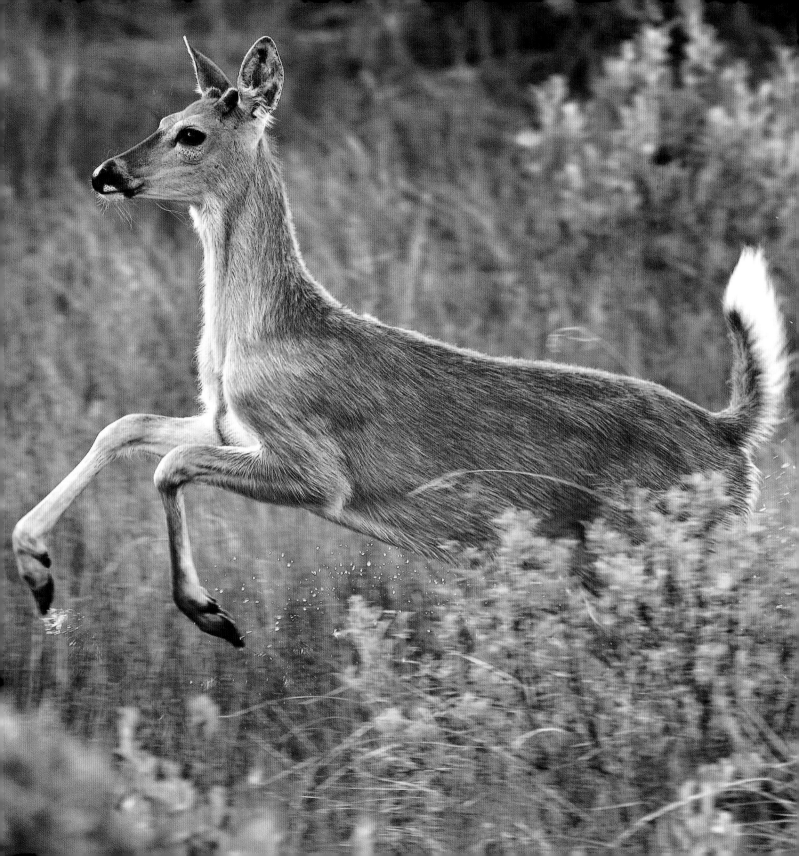

Cameras and Accessories

The Best Wildlife Camera Systems

CANON AND NIKON

You may already own the DSLR you'll use for wildlife photography. But if you're going to buy one, either your first or a replacement, you should know that some cameras offer features especially helpful in wildlife photography. It's true that Nikon, Canon, Sony, Sigma, Pentax, Olympus, and others, are all capable of splendid high-quality images, but wildlife photography is quite specialized. You'll certainly want a camera system that offers appropriately helpful features and accessory equipment.

A survey of the world's nature photographers in general, and wildlife photographers particularly, would loudly shout that an enormous majority use either Canon or Nikon camera systems. Barbara and I use both.

Barbara photographs with Nikon gear and I use Canon. This way we can be "up to speed" on both systems. We are better able to formulate effective techniques for each system and better able to respond to our students' equipment questions. The two systems have been the most popular for decades, and many film aficionados have followed their Canon and Nikon brand loyalties into the digital age. Why? Surely because of the splendid images each can produce, but also because of the depth and breadth of the systems. Both Nikon and Canon offer enormous selections of "ordinary" lenses, but also offer wide selections of special-purpose lenses. They both offer wide arrays of accessories tailored for specialized photographic pursuits. Canon and Nikon

LEFT: This white-tailed deer splashed about a roadside pond in Jasper National Park. Barb used a bean bag to photograph him from the car window. Nikon D3, Nikon 200-400mm f/4 lens at 400mm, f/5.6 at 1/500 second, ISO 1000, and Aperture-priority with no compensation.

certainly attract the majority of nature photographers, but there are other worthy brands offering acceptable equipment at lower cost and lighter systems that are easier to carry.

I've already mentioned that both Canon and Nikon offer huge selections of lenses. Their long telephoto lenses, for bringing wildlife optically closer to the camera, are incredibly important to wildlife photographers. Nikon and Canon have 500mm f/4 lenses and 600mm f/4 lenses, and Canon even has an 800mm f/5.6 offering. Many versions of these lenses feature electronic optical stabilization systems, which Canon calls "IS" for image-stabilization and Nikon refers to its version as "VR" for vibration-reduction. Other manufacturers offer limited or no choices in these focal lengths.

While photographing birds at Bill Forbes' "The Pond" in southern Arizona, a desert cottontail approached the pond. The 500/4 lens I used let me reach across the pond to make the rabbit large in the image. Canon EOS-1D Mark III, 500mm f/4.0 lens, f/11 at 1/500 second, ISO 250, and manual exposure.

TILT/SHIFT LENSES

Canon and Nikon both offer versions of "tilt/shift" lenses. These clever lens designs allow the user to change the physical position of the front elements of the lens with respect to the rear elements of the lens, allowing enormous depths of field even at the largest apertures. Wildlife shooters and their landscape shooting friends regularly find the unlimited depths of field to be invaluable. Wildlife aficionados revel in those large depths of field when shooting herds of animals or a dense colony of nesting penguins.

FLASH

The very word "photograph" derives partially from the word for light, correctly implying that you just can't do it in the dark—at least not well. The wildlife subject though, is annoyingly indifferent to our photographic pursuits and is often uncooperatively more active in the dim light of early day and

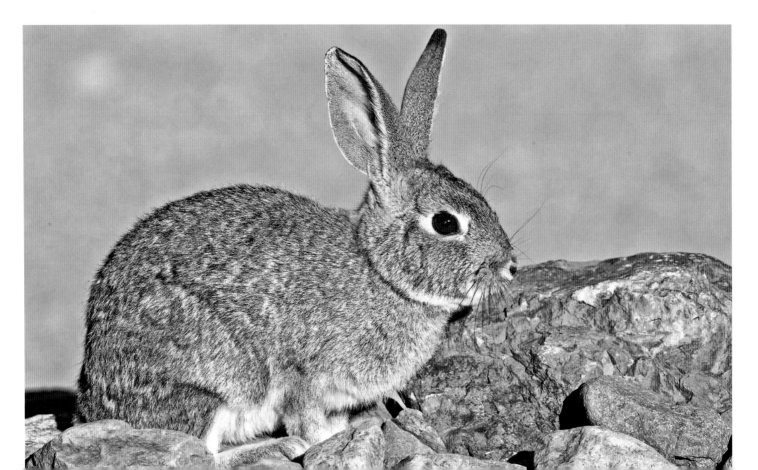

in the equally dim and fast-fading light of eve. The use of flash, anywhere from a simple single on-camera unit to a remotely triggered multiple flash array, can often provide the much needed light. Flash can provide the majority of the needed light or only a portion. Even when there's no shortage of light, such as in the blinding light of the high noon sun, flash can make a wildlife image far more pleasant. The flash can fill in annoying harsh shadows and it can otherwise reduce excessive subject contrast. Both Canon and Nikon offer a wide array of flash equipment with wireless control that fills different needs and suits all budgets. You'll find a great deal more about flash in Chapter 8.

THIRD-PARTY ACCESSORIES

Accessories marketed by third parties are crucial to wildlife photographers. Nearly all serious practitioners use L-brackets for mounting their cameras on the tripod head, flash brackets of various types for moving the flash off of the lens axis, camera mounting plates, lens mounting plates, tripods, tripod heads, camera bags, wires and cables, and a truly vast assortment of gizmos and gadgets to meet every photographic need. Where an accessory's configuration is dedicated to a particular camera model, as with L-brackets, manufacturers will assess market potential before incurring the costs of producing and marketing those dedicated accessories. Since Canon and Nikon are the two most popular camera systems, more third party accessories are made for them. Some non-dedicated "universal" models of accessories are marketed for the less-popular cameras, but more often than not they're like the oft-invented flying car . . . a lousy airplane and a worse car.

MORE HELP FOR NIKON AND CANON USERS

Digital cameras are truly marvelous, but can be complicated. Learning to use your new Canon or Nikon can be easier than learning other brands for several reasons:

- The majority of professional and serious amateur photographers doing outdoor shooting use Nikon or Canon. Consequently, there's a large community of teachers, helpers, and mentors, able to offer experience and guidance in those particular brands.

- Like Barb and me, other workshop instructors are more likely to be using Nikons or Canons, so they become more familiar with the two brands and better able to answer the students' camera-specific questions. (And let me tell you, students can present some very esoteric questions indeed!)

- At least 85 percent of our students shoot Canon or Nikon, so there's no shortage of friendly help from that quarter, either. And, yes, it's not unusual for us to learn a thing here and there from our students. We are blessed to have many gifted students attend our workshops who have helped us immensely.

- Instructional books and DVDs are readily available for these cameras, but sometimes much harder to find for other brands because of their limited market.

OTHER CAMERA SYSTEMS

If wildlife photography is an interest, and if you already have or intend to buy a camera system other than Nikon or Canon, then ignore our misgivings and press on regardless. The image quality of Sony, Sigma, Pentax, Olympus, and other cameras, can be excellent if you do your own part. Do remember, though, the limited availability of lens types, of other system components, and the relative shortage of learning materials, that some brands suffer.

SELECTING A CAMERA FOR WILDLIFE

Even within the product line of a given camera maker, some models can be more suited for wildlife photography than others. In our own photographic work, Barb uses a couple of different Nikon models and I use more than one Canon model. We'll next explore the camera features that are especially desirable for wildlife work.

SHOOTING SPEED (BURST RATE)

This term describes how fast a camera can shoot a sequential series of images. It's generally called "burst rate" and is described in "frames-per-second." Suppose you're photographing a flying bald eagle, and you want an image of the eagle at exactly the instant it snatches a fish from the lake.

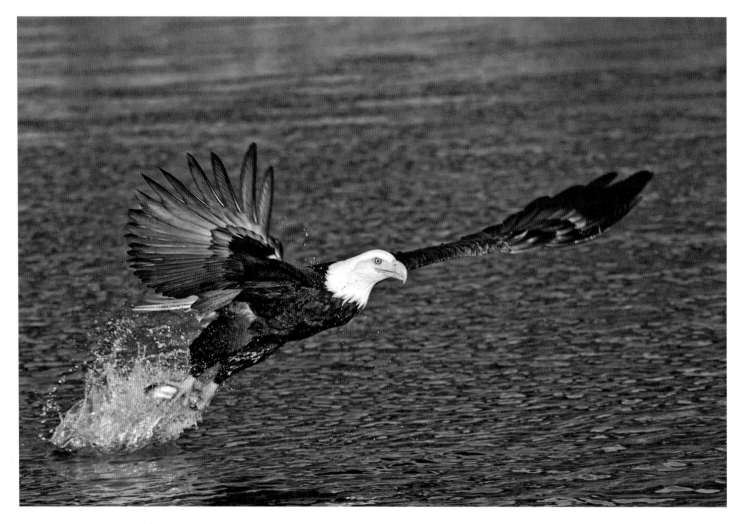

We boarded a fishing boat and the captain threw small fish to the dozens of bald eagles that frequent the waterways around Homer, Alaska. I used the fastest shooting speed possible of 10 images per second to capture the peak of the action. Canon 1D Mark III, 70-200mm lens at 200mm, f/5.6 at 1/1000 second, ISO 500, and manual exposure.

Even Blistering Bob, fastest photographer west of the Pecos, isn't fast enough to push his shutter button at that precise moment. Besides, he has to contend with the time delay between his finger push and the shutter actuation. It's only a small fraction of a second, but it is a factor. You though, being a wise and wily wildlife shooter, set your camera into its continuous shooting mode, gently press the shutter release and hold it down, and let the camera's machine-gun like clickety-clickety-clickety-click hopefully capture that eagle's successful fish grab at the decisive moment. Many throwaways generally result, but the higher the camera's burst rate, the higher the likelihood of at least one success in the burst.

My Canon 5D Mark II has an underwhelming burst rate of four frames-per second. It makes a new exposure every quarter of a second. That certainly seems fast, but by wildlife shooting standards, is dreadfully slow. Much more suited to shooting speedy wildlife is my Canon 7D with its much higher burst rate of 8 frames-per-second. Barb's Nikon D3 model, properly configured, offers a burst rate approaching a speedy 10–11

frames-per second. Future DSLR generations surely will be even faster.

BURST DEPTH

When firing a burst, the camera can make only a certain number of exposures (called "burst depth") before there is a data

Seeing a massive herd of wildebeest cross the Mara River in Kenya's famous Masai Mara is a world-class wildlife experience. In this crossing, the water level was low and the crocodiles were full from eating unlucky animals at earlier crossings, so all of these animals crossed safely. Nikon D200, Nikon 200-400mm f/4 lens at 350mm, f/4 at 1/800 second, ISO 200, and manual exposure.

jam, the electronic equivalent of a traffic jam. A data jam causes the camera to stop shooting.

An image captured by the camera's sensor must be transferred ("written") to the camera's memory card. Writing to memory cards is a relatively slow process, so to improve burst rates, cameras are designed to include a waiting area, called a "buffer." Now the image moves from the camera sensor to the buffer, thus freeing up the sensor to take the next image while previous images wait in the buffer for their turn to be written to the memory card. Cameras can shoot faster than the buffer can be emptied by writing, so after some number of shots the waiting area fills up. Data can no longer be transferred from sensor to buffer, so the temporarily overloaded camera just

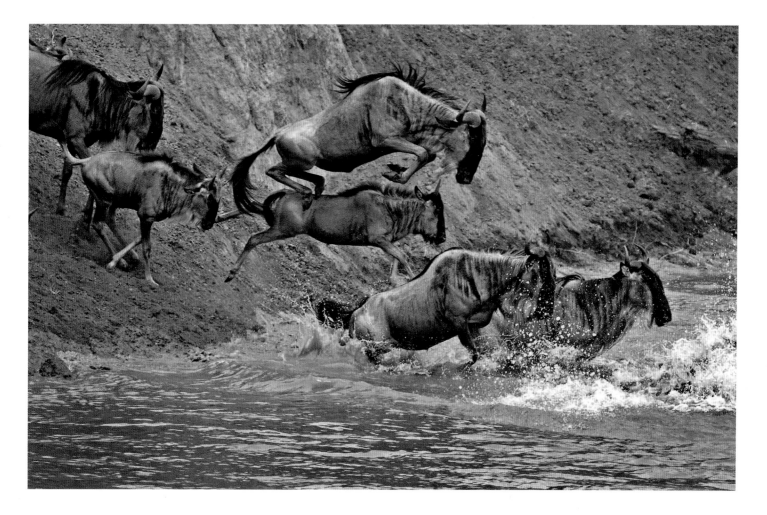

stops. The number of shots made before the camera stops is called the burst depth. A few seconds later, sufficient image data has been written to the memory card to clear some space in the buffer, and the camera will resume shooting.

Barb and I learned early on about the importance of adequate burst depth. We were photographing the African Mara River crossing of wildebeests and zebras so often seen on television. The predatory crocodiles provided spectacular action, but as I shot, shot, and shot, my camera just stopped whenever its buffer filled. I had to grit my teeth and wait until the shots waiting in the buffer had been at least partially written to the memory card.

That made some buffer space available and I could resume shooting, but it left me plenty irritated at having missed some great shots. Several factors determine burst depth. Larger capacity buffers can provide the increased burst depths welcomed by wildlife shooters. File size is also very important to burst depth. RAW files are generally larger than JPEGs. The

Tiny storm petrels are incredibly difficult to sharply photograph because they move erratically and rapidly as they search for food on the surface of the ocean. I shot hundreds of images to get a few good ones. Normally, it's best to have the animal looking into the image, but the splash from its feet behind it completes the composition nicely. Canon EOS-7D, Canon 300mm f/4.0L lens, f/7.1 at 1/2000 second, ISO 400, and manual exposure.

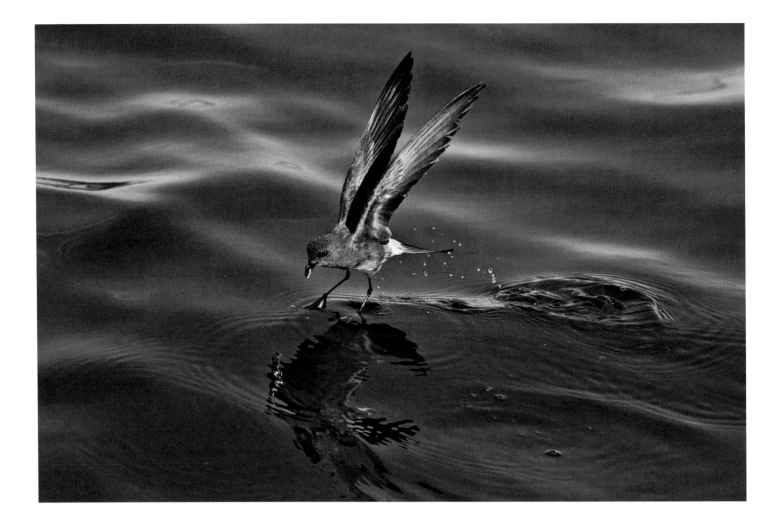

Canon EOS 7D offers a burst depth of 6 images when using a high burst rate on RAW + Large JPEG combination files. That 6-frame limit is increased to a significantly greater 15 frames if only RAW files are shot. The big difference suggests that when we're shooting fast action, we set the camera to produce RAW files only. We'll make the JPEGs in our editing, later.

Finally, the wildlife photographer should consider the writing speed of the camera's memory card. It may be tempting to buy some off-brand card at the local drugstore, but a memory card's in-camera writing speed is a crucial factor in the overall determination of burst depth. Note the term "in camera." Memory card makers sometimes tout card speed when the card is being read during downloading to the computer, but we're generally far more interested in the speed of the card as it's being "written-to" in the camera.

HOW MANY MEGAPIXELS?

Now, let's talk about the megapixels that so many (often unwisely) think are crucial to picture quality. The word means a million pixels, but what is a pixel anyway? The term derives from "picture element" and a pixel is one of the little squares that make up an image on a computer screen. If you magnify the image enough, it will break down into small squares of color. Those are picture-elements or "pixels." No camera engineer has ever laid hands on a pixel or designed one into his latest creation. However, the word "pixel" is used in digital camera jargon to describe a "photosite," the smallest component of the digital sensor in our cameras, of which there are millions, and which convert light into electrical signals. It is also used to describe the smallest part of a digital image. So even though a camera has no such physical entity as a pixel, we all live with the convention holding that the term pixel can refer to a camera photosite and also refer to one of those tiny squares that form a digital image.

Camera advertising invariably touts "megapixels" as a big selling point, with current DSLRs ranging from 10 megapixels to about 24 megapixels. Some buyers unfamiliar with the meaning of the term just think that more must be better. There's an unrelenting pressure from camera marketers

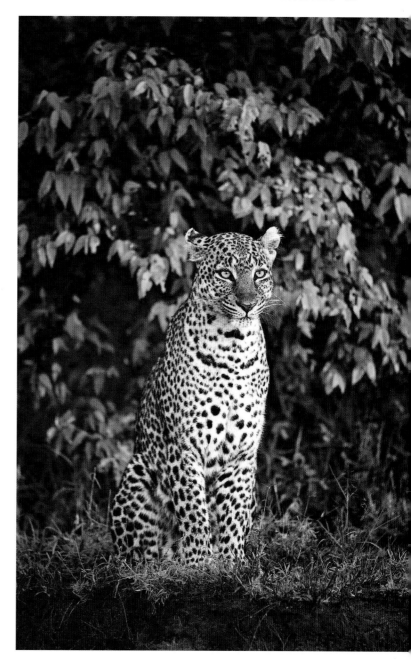

Many leopards are unafraid of safari vehicles in the Masai Mara. This female is searching for prey before sunrise. The combination of Shutter-priority and Auto ISO let me maintain the shutter speed I needed to capture a sharp image of her in the dim light. It's amazing that ISO 2500 does such a fine job. Canon 5D Mark II, 500mm f/4 lens, f/4 at 1/320 second, Auto ISO that selected ISO 2500, and Shutter-priority with a +1/3-stop exposure compensation.

for more and more megapixels because competing cameras have more. There can be too many megapixels, though. The upward spiral in pixel count comes at a literally and figuratively unwelcome price for some, including we wildlife photographers.

High pixel counts have both pros and cons. The main pro is making large prints requires high pixel count. An image data file must contain enough pixels to supply about 180 pixels per inch (ppi) for acceptable quality prints, up to about 300 ppi for super quality prints. If the original file were cropped, the crop is necessarily smaller and has fewer pixels, but the printing ppi requirements still apply. To summarize, with more initial pixels we can make bigger prints, and we can make better prints from smaller crops.

I use a Canon 5D Mark II for my landscape and macro work because it offers a pixel count high enough for the large prints that Barbara sometimes makes. Yet the bulk of our own photography is to illustrate our books, sell to calendar publishers, use on our web site, and project during our seminars and workshops. We don't need a high pixel count for any of these applications and cameras of 10 megapixels are more than adequate. Most modern cameras have at least 10 megapixels and generally more. A 10-megapixel camera can produce a high-quality 8" × 12" print and software enhancement can produce a fully satisfactory 16" × 24" print. A data file from a 20-megapixel camera can produce a beautiful 30" × 40" print. So if large prints are an important goal, then by all means, buy a high-megapixel camera. If fast shooting is a more important goal, make sure the higher pixel count doesn't make the camera too slow.

Looking at the "cons" of high pixel counts brings us to the purview of the wildlife shooter. High pixel counts generate large files that are slower for the camera's electronics to process. Larger files lower the speeds of extracting image data from the sensor, moving it into the buffer, and most of all, writing it to the memory card. We get lower burst rates that action shooters dislike. Important burst depth also suffers because the larger data files fill the buffer more quickly and stop the shooting until the buffer is partially cleared. All other things being equal, high pixel count cameras are more expensive, too. So, the astute wildlife photographer carefully balances the never-ending inherent pressures for higher megapixel counts, with their understanding of when and where fewer megapixels are actually better. One accomplished amateur shooter I know has, not for the first time in his four decades of shooting, bought the latest and greatest model of his favorite brand, solely because its higher megapixel count causes lower burst rates and depths than his present camera has. Lastly, aside from camera considerations, don't forget the effect of the larger file size of high pixel cameras as it affects the size, cost, and speed, of the memory, storage, and backup requirements of your computer.

ELECTRICAL NOISE IN IMAGES

The fundamental physics of many electrical components and devices causes unwanted electrical noise to be mixed with their desired signals. Remember the hiss of an old-time record player during soft musical passages? When the music was louder, the hiss wasn't as annoying, but was still there corrupting the music. A digital camera's sensor is no exception, and the hiss it creates, although electrical and not acoustical, contributes to the degradation of our digital images. Other camera components, including the buffer and processing electronics, also contribute to the total noise of an image. The total electrical noise is made evident by unwanted specks of color or brightness that can be visible in the darker areas of the image and which tend to soften the image. Clearly, the less noise the better. We quantify corruptive noise by the relationship of the desired image data (signal) to the undesired image data (noise), and call it "signal-to-noise ratio." Thus, the higher our image's signal-to-noise ratio, the better.

The ISO being used is a factor in noise. Cameras have a "native" ISO, typically 100 or 200, and all higher or lower ISOs require that the sensor data be processed by electronic amplifiers that add noise to the data. Thus, in a given camera, the native ISO produces the lowest noise and cleanest images. However, different camera brands and models have different noise levels at any given ISO and some better camera models

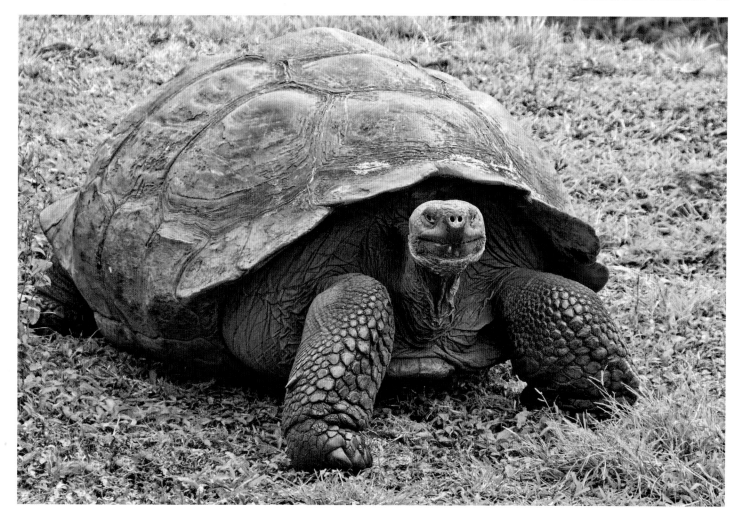

Galapagos tortoises are easy to photograph when they converge on ponds in the highlands during the dry season in November. Barbara used a Nikon 70-200mm zoom lens at 112mm to record this wrinkled individual. Nikon D300, Nikon 200-400mm lens, f/8 at 1/160 second, ISO 400, and Aperture-priority with no compensation.

offer astonishingly low noise levels even at very high ISOs. When wildlife is active, we need faster shutter speeds to stop the action. Wildlife is most active, though, in the dim light of dawn and dusk. Burdened by dim light and the need for high shutter speeds, at any given aperture, we must use higher ISOs, like 400 and above, to properly expose. Those higher ISOs cause more noise.

There's a definite relationship between a camera's pixel count and its noise. Everything else being equal, the more pixels, the more noise. A camera's design establishes its sensor as a certain fixed size. That size sensor can hold only a certain number of pixels (photosites)—unless of course, we make the pixels smaller. However, if we make them smaller to shoehorn more of them into our sensor, we're once again sabotaged by the laws of physics, which insist that smaller pixels are noisier pixels. What is the bottom line here? Remember that high ISO shooting is frequently necessary in wildlife photography so, before succumbing to the seductive siren song of misleading multi-megapixel marketing men, check the camera's ability to

make clean low noise images at higher ISOs while still giving satisfactory burst rates and burst depths!

The sensors of some modern full-frame DSLRs are the same size as a 35mm film slide, that is 36mm × 24mm. Many DSLRs are not full-frame and use a smaller sensor because of far more favorable economics. Some users wonder why a small change in sensor area makes such a large change in camera cost, and the answer is that the smaller sensors mean smaller and lighter cameras, less expensive camera electronics, smaller batteries, smaller and less expensive lenses, and on and on. Small sensor cameras are far more affordable than the full-frame varieties.

Assume an image of an alert deer on a full-frame sensor, where the subject distance and the lens focal length cause the height of the deer to be 50 percent of the height of the sensor. Now, if I slide the sensor out of the camera (without disturbing the deer, of course) and slide in a smaller sensor, the height of the deer image does not change, but that same size image occupies a greater percentage of the smaller sensor's height. (Think of projecting a movie onto a large screen, making no change to the projector, and then changing to a smaller screen.) And, because the image of a given sized subject occupies a larger percentage of the smaller sensor size, it appears just as if we had shot with a longer lens! That effect, and its numerical definitions, are called the "crop factor" or "multiplication factor," and some users call it a "magnification factor." We'll use the term "crop factor" because it's shorter.

The crop factor of a camera is determined solely by the size of its sensor, and today's DSLR models vary from about 1.3 to about 2.0. The more common Nikons and Canons typically have crop factors of 1.5 and 1.6, respectively. Assume a Nikon with a crop factor of 1.5. Further assume the image of a Galapagos tortoise, made by a 100mm lens, occupies n percent of the sensor height. This means that for that same tortoise image to take up n percent of a full-frame sensor's height, we would have had to have used a lens of 150mm. Let's say it another way. Assume my 1.5 crop factor camera using a 200mm lens produces a giraffe image occupying 80 percent of the sensor height. To get that giraffe image to be 80 percent

of the height of my full-frame sensor, at the same camera to subject distance, would require a lens of 300mm. Thus, my smaller sensor seems to make my 200mm lens do the same thing as a 300mm lens would do on a full-frame camera. Put another way, my smaller-sensor camera apparently multiplies lens focal length by 1.5.

Well, the focal length didn't change, but the increased percentage of image size on the sensor certainly makes it seem as if the focal length were longer. One downside to a smaller sensor with a crop factor is that the cameras have a smaller viewfinder that makes it a little more difficult to see everything in the viewfinder. The upsides include not only the several beneficial camera characteristics already mentioned above, but increased safety in that the lens crop factor allows us to stay farther from dangerous shooting locations or potentially dangerous animals, and always, the savings of size, weight, and cost.

CROPPING THE IMAGE

Since the image produced by a small sensor camera is nothing more than a crop of the image produced by a full-frame sensor camera, why not use a full-frame sensor to start with? Cameras with full size sensors tend to be far more expensive than cameras with smaller sensors. Many photographers simply can't afford them. We do have full-frame sensor cameras, but normally use our small sensor cameras for wildlife photography. The smaller image files produced by the small sensor cameras offer us a higher burst rate and depth, both of which are crucial for wildlife.

However, there are occasions when using our large sensor cameras is highly advantageous. It helps to compose a looser composition when a white-backed vulture drops out of a clear blue Masai Mara sky to feed on the remains of a lion kill or when photographing flying hummingbirds. A loose composition reduces the chance of cutting off a wayward wing or tail. Then, using Adobe Lightroom or other software, we crop the image a bit. It is far easier to crop unwanted picture space than resurrect a missing wing or tail.

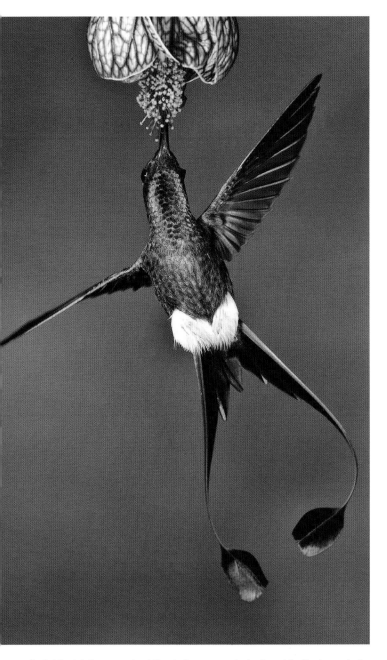

Booted Racketails are regular visitors to the sugar water feeders at the Tandayapa Lodge in Ecuador. Barbara simultaneously used four Nikon SB-800 flashes that were set to manual and 1/16 power. She composed the bird loosely with a camera that has a full-frame sensor to avoid cutting part of the hummingbird off. Then she cropped the image slightly. Nikon D3, 200-400mm f/4 lens, f/20 at 1/250 second, ISO 200, and manual exposure.

LCD MONITOR

The liquid-crystal display (LCD) on the rear of a DSLR is used for displaying setup menu information, for displaying operating information, for displaying the analytical histogram data, for displaying live-view images in some cameras, and reviewing your final images for composition and lighting. Some photographers use the LCD to check sharpness, but we use and prefer the computer for that job. At the risk of nagging, don't even think of using the LCD image as an indicator of exposure! Insist on judging by using only your histogram, and if it's available, the more informative RGB histogram. Here too, size matters. Recent camera models feature a 3" diagonal monitor and we find them far more pleasant to use than smaller LCDs. Perhaps future camera designs will feature even larger LCDs, but in the meantime, all else being equal, favor the camera with the larger LCD.

HISTOGRAMS

Luminance (Brightness)

Probably all of today's DSLR cameras provide a display of the image histogram, a graph depicting the exposure of the image. The simplest form of histogram, generally called the "luminous" or "brightness" histogram, is based on data derived from the three color channels of the sensor: the red, green, and blue channels. The luminous histogram shows the relative quantities of an image's pixels that are exposed at various brightness.

The luminous histogram works reasonably well when no one color predominates the subject amid its surroundings. The unwary shooter can be tricked, though, if the subject has a dominant color. Consider a shot of a tan-colored deer taken against a background of red foliage during autumn. The color red dominates this image, and at some exposure level, the sensor's red channel becomes saturated (overexposed) well before the green or blue channels. The luminous histogram is based on all three channels, but is weighted toward the green channel. In our example, the green favoring luminous histogram might show a satisfactory exposure even though the red channel is overexposed and degrades the image.

The luminous histogram is widely used, even with its shortcomings, and for most images, gives us a reasonable means of determining good exposures. And, regardless of shortcomings, that histogram is a vastly more accurate and reliable indicator of your exposure than the exposure-ignorant LCD image.

RGB Histogram

Many cameras offer a second and superior form of histogram. It's called an "RGB" histogram and it separately displays the histograms of each of the three color channels superimposed onto one image. The separate color data eliminates the subtle errors of the green favoring luminous histogram. Barbara and I use RGB histograms exclusively, and every year we teach hundreds of our students to do the same to achieve fabulous exposures. If you're buying a new camera, be sure to look for this very important feature. The RGB histogram is always the camera's most accurate means of evaluating your exposures. We will say more about histograms in Chapter 3.

HIGHLIGHT ALERTS

Perhaps all DSLR cameras offer a feature called "highlight alerts" or "blinkies." When the feature is activated, generally through the setup or custom function sections of the camera menu, the overexposed areas of an image will prominently blink white and black on the LCD monitor. These attention-getting blinkies enable the photographer to quickly and precisely see what portions of the image are overexposed. You can then decide whether the overexposure is or is not important to that particular image. It's a very useful feature indeed and should be a definite feature in the specs for your new camera.

CAMERA SETTINGS

FORMAT

The images formed by digital cameras are electrical data files presented to the user in formats commonly used by computers. The most commonly used formats are called RAW files

and JPEG files, and most cameras will produce images in both formats simultaneously if you program it for this outcome. The best format for you to use is wholly determined by your own needs and you might change back and forth from time to time as your needs change.

A RAW file approximates the actual data captured by the camera's digital sensor, changed into the manufacturer's often proprietary RAW format, and sent to the memory card with very little additional in-camera editing. No image data is actually discarded during the formatting, and several image parameters including color, sharpness, saturation, and contrast, can all be easily edited later by a "RAW converter" computer program with no loss or degradation of the image. Some camera manufacturers themselves offer RAW conversion programs, and third-party RAW conversion programs abound, such as Adobe Camera Raw, Adobe Lightroom, and Aperture.

JPEG, sometimes written as JPG, and either way pronounced "jay-peg," is a commonly used file format. When a camera is set up to produce JPEG images, the raw data from the digital sensor undergoes considerable in-camera editing. Image parameters of file size, sharpness, tonal contrast, and color rendition, among others, can all be camera programmed to send an image to the memory card consistent with the shooter's taste and it can be changed tomorrow if need be. One disadvantage of JPEGs is that the photographer's flexibility in post-capture (computer) editing of the programmed parameters is more limited than it is with RAW files.

ADVANTAGES OF JPEG FILES

Images in JPEG format have smaller file sizes than RAW images, and smaller files offer several advantages, some of which are:

- Smaller files take up less space on the memory card, so one's shooting plan needs fewer memory cards to purchase and manage.
- Smaller files occupy less space in the buffer, so more files can be held by a given sized buffer, providing the greater burst depth always coveted by action shooting wildlife photographers.
- Smaller files take less electrical energy for in-camera processing of each shot, so we get more shots from each battery charge.

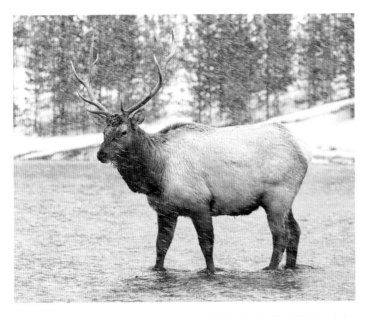

Elk winter along the Madison River in Yellowstone National Park. Since this river drains thermal basins, the water never freezes, providing opportunities for herbivores to find food along the river banks. Using ETTR exposure techniques sometimes reduces the blacks in the image too much. This unprocessed RAW image shows a severe lack of contrast. Canon EOS-20D, Canon 100-400mm lens at 180mm, f/5.6 at 1/90 second, ISO 400, and aperture-priority with a +1-stop exposure compensation.

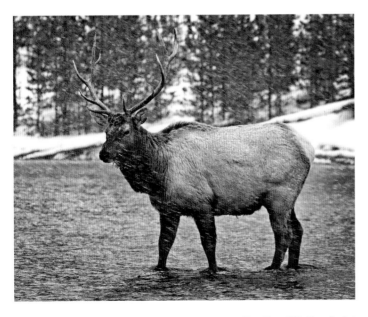

Barbara processed this version of the previous image with PhotoShop CS5. She adjusted the black point to increase the contrast, improved the color, and sharpened the image.

- The already edited JPEG files may often benefit from, but generally do not require, post-capture editing. Unlike RAW files, JPEGs are available for immediate use and sharing with others after being downloaded to a computer.
- Computers can display JPEGs with simple software, often built right into the operating system, and the JPEGs do not need more sophisticated RAW conversion software.

ADVANTAGES OF RAW FILES

All else being equal, RAW files are considerably larger than JPEGs. The larger files sizes have several advantages of varying interest to different shooters:

- Larger RAW files contain more image data and allow the making of higher quality larger prints.
- The photographer can make better crops from a larger initial image because the greater pre-crop data gives proportionally more post-crop data.
- Moreover, and this is a "biggie" for many shooters, RAW files allow much greater latitude in post-capture editing. As a couple of examples, white-balance correction or modification is completely unlimited, and within reasonable limits, even exposure blunders can be nicely corrected.
- The absence of data loss caused by in-camera image editing, and the absence of data loss caused by usage, as with JPEGs, let us download all of the camera's originally captured image data into our computers for archival storage. Your RAW files can be reused as often as desired over years and years to come, and will forever maintain the very same image quality that your camera originally captured. It's a benefit that'll be especially welcome when the never-ending evolution of software gives us better and better RAW conversion programs.

WHAT WE SHOOT!

Barbara usually shoots both RAW files and high-quality JPEGs at the same time. Usually I shoot only RAW files, but sometimes shoot both when I need instructional JPEGs right away to show to my students. Her Nikons and my Canons both allow the combination. We get the best of both worlds, and while the two versions of each image carry identical file

numbers, their different filename extensions permit well-organized storage and retrieval. The combination offers several post-capture benefits, but does occupy more storage space. Sometimes our subjects require us to shoot at the greatest burst depths possible, and in those cases we'll shoot RAW only, without the JPEG file. We can generate a JPEG later in our computer. Also, suppose we are running out of card space and don't have another card to use; to conserve memory space, here too we'll switch over to RAW files only.

MEMORY CARD CONSIDERATIONS

Today's digital cameras store their captured images on solid-state memory cards. Memory cards are available in several configurations, the most common being known as Compact Flash (CF) cards and Secure Digital (SD) cards. Some cameras even accommodate two cards simultaneously, either of the same or different types. Memory cards for digital cameras are made by several well-known manufacturers, including Delkin, Kingston, Lexar, and Sandisk. Each of those firms sells memory cards of several types, capacities, and speeds. The cost of a memory card of a particular configuration varies with capacity and speed, the two major parameters to consider when choosing cards.

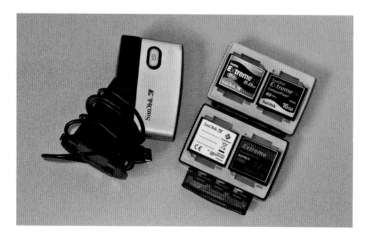

We prefer large capacity memory cards from 8GB to 32GBs. These cards are protected in a plastic cardholder. We use a Sandisk downloader to copy the image files to external hard drives.

Memory card capacity is measured these days in "gigabytes" where each gigabyte (GB) is a billion bytes or a thousand megabytes. What does it all mean?, you ask. Well, first of all, what on earth is a byte? It's the smallest piece of information that can be recognized by our digital doodads, whether that doodad is an IBM supercomputer that beats chess masters or a lowly cell phone camera. Expanding the thought, we call one thousand bytes, a kilobyte (1 KB), a million bytes, a megabyte (1 MB), and a billion bytes, a gigabyte (1 GB). Assuming your camera generates a data file of 10 megabytes, your 1 GB memory card will hold 1 billion bytes divided by 10 million bytes per image, which equals 100 images. At 100 images per gigabyte, a modestly sized 8 GB card will hold 800 images, enough for a day's shooting by most photographers. The CF cards commonly used in DSLRs are available in capacities from 1 GB to 128 GB with proportionate prices. A 128 GB card, although extremely expensive at this writing, can hold an astonishing 12,800 of your 10 MB images. The ever-decreasing cost of memory cards will soon make that 128 GB card more affordable, and the inexorable advance of technology will someday offer cards of even greater capacity and eventually, memory cards will probably become obsolete by some yet unknown memory scheme.

MEMORY CARD SPEED

The speed of a memory card is of minor importance in landscape and macro photography, but the exact opposite is often true in wildlife work. Capturing fast action pictures at the proverbial peak of that action generally requires shooting a rapid burst of images in the hope that somewhere within the burst is the exact image you want. Barb and I configure our cameras to the highest available burst rate (frames-per-second). Barbara has a choice of shooting 12-bit or 14-bit RAW files with her Nikons. Shooting 14-bit files slows down her shooting speed, so she opts for 12-bit image files for wildlife.

Here, it's vital that the memory card's writing speed be as high as possible to obtain the high burst depths demanded by the fast action. Higher speed memory cards are more costly than their lower speed versions, so the wildlife shooter must not

only consider capacity, but must balance speed, cost, and application. If you're going to shoot wildlife, and you probably are, given that you're reading this, don't forget the harsh language you'll be directing at yourself when you miss "The World's Best Wildlife Picture" just because your camera stopped when its buffer couldn't write fast enough to your low cost memory card!

One bit of good news is that the price of memory drops rapidly after introduction. One photographer I know, bought several 4GB Compact Flash cards upon their introduction several years ago, and paid well over $400 each. Faster 4GB cards are available today for around 20 bucks each!

Our international photo tour clients, seminar attendees, and workshop students, often ask what kind of gear we use. We've no secrets and we're more than happy to talk about it. Here's one very important point, though. Having this or that brand of camera does not guarantee excellent results. *Only knowledge and lots and lots of practice will do that.* The skilled and practiced photographer can make fine images with practically any equipment. Barbara and I use Sandisk memory cards and years of use of many cards have never produced a failure. They're reliable cards. Yet, we know another photographer who has used nothing but Lexar cards for a lot of years, and he too has never had a failure. Come to think of it, we know of no major brand of memory card that we consider inferior, but no brand of memory card will make your images better.

What capacity cards should you use? Our preference for wildlife work is high-speed 16GB and 32GB cards. At this time of writing, the fastest Sandisk 32GB card costs about $270, but that price will probably drop significantly by the time this gets into print. A slightly slower 32GB card can be had for about $170, showing that at a slight sacrifice in speed, appreciable money can be saved.

MEMORY CARDS: LOTS OF GIGABYTES OR LOTS OF CARDS?

A photographer's worst nightmare may be the loss or failure of memory cards filled with irreplaceable shots. Folks have agonized for years about the best way to protect their valuable images. Some maintain that several smaller cards, each containing relatively few images, is safer. The theory is that if you lose a card or a card fails, you lose only a few images. Others uphold with equal vigor that it's safer to have fewer cards, each containing a relatively large number of images. Here the theory is that fewer cards have a lower probability of being damaged or lost.

Barb and I agree on many things photographic and likewise agree on this. Based on how we shoot, where we travel, how we travel, how we store and transport gear, our needs are better served by fewer cards of greater capacity. The idea is valid only if we take reasonable anti-loss precautions, so we've evolved a rigid protocol for managing memory cards. We store all cards in card wallets designed for the purpose. Like other brands, our Sandisk wallets allow visibility of stored cards and we store formatted ready-to-shoot cards label-side up. Filled cards are inserted label-side down. This systematic approach ensures that our valuable cards (and even more valuable images) are managed in an organized manner, reducing loss probability. And it prevents us from becoming confused in the chaos of a fast-shooting event. All of our cards are either in cameras or in card wallets. Don't keep your cards loose in pockets or purses. If you must, do it only in the little plastic boxes suitable for your card type. Lint or other dirt entering tiny connector holes in certain cards, like CF cards, can cause expensive camera damage. Also, a cycle or two through the washing machine may bring unhappy results.

Memory cards rarely fail in mid-life, so if your card survives its newness and infancy, and if you use them with reasonable care, they should last a lifetime of ordinary use. We observe the following card rules, and we've never yet suffered a card failure.

- Keep the card protected in the safety of your camera or card wallet.
- Don't turn the camera off until all writing has stopped, to avoid corrupting image files. Some cameras are designed to temporarily maintain power if turned off while writing to the card to prevent problems.

- Format your cards only in your camera. Never format a card in the computer.
- After downloading images from your card, re-format the card and put it in your card wallet label-side up.

Running out of memory space at the wrong time can spoil your whole day. Trust me on this one. I was co-leading a photo safari in Kenya a few years ago, using a camera equipped with a 2GB memory card. We spotted a rosy-patched shrike, a species uncommonly seen, and I had never photographed one. The bright overcast light was splendid, the soft yellow-green background was pleasing, and the bird was stunning. Just as I pushed the shutter and squeezed off a short burst of shots, the darn bird turned its head away and I had nothing except the back of its head. I waited and waited some more. The instant it turned its head back, I excitedly pushed the shutter button again, only to "hear" a terrible silence.

That camera did nothing but smile at me. My memory card was filled. I frantically jammed a new card into the camera only to have that silly shrike fly away the instant before I pushed the shutter again. After 36 African safaris, I still don't have any photos of the elusive rosy-patched shrike, but I've sure learned to favor larger memory cards!

One last thought on memory cards—if you do use large capacity memory cards, if you are shooting fast-action wildlife, and if your card is getting near the end, change cards when you have a shooting break. Don't wait until the card is completely filled. We have made it a habit to change our big cards even with a few dozen shots remaining on the card. If there's a sudden opportunity needing quick shooting, we'll always have card space available.

EXTENSION TUBES

In much of our wildlife photography, we use longer lenses, such as those in the 200mm to 500mm range. Those lenses, like all lenses, have a minimum focus distance (MFD). The MFD varies from lens to lens and can range from about 4 feet up to 15 feet or even more. Suppose we encounter an opportunity to photograph a small bird or tiny mammal. When we

Rosy-breasted longclaws thrive in the Masai Mara grasslands. A 25mm extension tube let me make the 500mm lens focus closer to capture a large image of this colorful small bird. Canon EOS-7D, Canon 500mm f/4.0 lens, Canon 25mm extension tube, f/7.1 at 1/320 second, ISO 320, and Shutter-priority at a +2/3-stop exposure compensation.

Extension tubes permit lenses to focus closer than their built-in minimum focusing distance. They must frequently be used to photograph small birds and mammals with telephoto lenses. The tube on the left is a Canon 25mm extension tube. The set of three extension tubes on the right is made by Kenko for the Canon system. Kenko builds a set of extension tubes for other camera systems, too.

move close enough to make a frame-filling shot, we might discover that our lens will not allow focus at such a close distance. We solve this problem by using an accessory called an "extension tube."

An extension tube is a cylindrical spacer that fits between the camera body and the lens. It contains no lenses or glass of any kind, it's just a hollow metal tube configured to fit both camera and lens. By moving the lens away from the camera body, we can obtain focus at subject distances much closer than that allowed by the MFD of the lens itself. So why didn't those lens designers just make the lens that way in the first place? Because there's a trade-off. The trade-off is that the lens, now spaced away from the camera, will no longer focus at great distances, having now acquired a hitherto absent maximum focus distance, or more easily said, will not focus at infinity. So, we take the tube off and put it back on as needed.

The distance at which one can focus when using an extension tube depends on the lens focal length, its MFD, and the length of the tube. Tubes are available in several lengths, from about 8mm up to about 50mm. One of my favorite combinations for tiny birds is a 300mm lens with a 25mm extension tube. The combination allows me to fill the frame with tiny birds.

Extension tubes are simple to use, and the absence of glass means there's no loss of image quality. Some light is lost, but your in-camera exposure meter readings, as confirmed by your histograms, compensates for the light loss.

Tubes are available in different lengths, and from camera manufacturers and third-party manufacturers. Kenko, for example, offers sets of three tubes of different lengths, and available for different camera systems. An important consideration when selecting extension tubes is whether the tubes maintain the electrical connections between lens and camera body.

These are called "automatic" extension tubes, and they ensure that the autofocus and auto-aperture operations of the lens are not disrupted. So, we urge you to always carry a selection of automatic extension tubes if you're going to encounter subjects needing an approach to closer distances than allowed by your lens itself.

Choosing and Using Lenses

Selecting Quality Lenses

Lens-makers generally build two classes of lenses. Prosumer lenses are made for the mass market and do a fine job most of the time. However, because these lenses must be affordable to everyone, they are made with less expensive glass and not built to the same construction standards as professional grade lenses. Lower glass quality means your images may be slightly less sharp (assuming you did everything else right) and the lens is more likely to malfunction at the worst possible time because it isn't built as ruggedly. That said, prosumer lenses still do a quality job. If your photography technique isn't flawless, you may never notice a slight loss of sharpness from the lower quality glass used in them. Many of our workshop clients do well with them. If price is a barrier, don't be afraid to buy less expensive lenses. In reality, your personal shooting technique is far more critical than the glass used in the lens.

Some lenses are less expensive for other reasons that have nothing to do with quality. For example, a 400mm f/5.6 lens is considered a "slow" lens and may not have image stabilization. A 400mm f/2.8 lens is a "fast" lens, and if it has image stabilization, it will be considerably more expensive than the 400mm f/5.6 lens even though the quality of the lenses is the same.

Professional grade lenses use the best optical quality glass and are ruggedly constructed to withstand the elements and abuse from serious photographers. They have seals to protect them from inclement weather

LEFT: Golden-mantled ground squirrels are ridiculously tame at roadside picnic areas in the Canadian Rockies. This squirrel became especially curious when Barbara photographed it. Canon 5D Mark II, Canon 70-200mm f/4 lens at 131mm, f/11 at 1/250 second, ISO 250, and Shutter-priority with a +1/3-stop exposure compensation.

and typically have other features not found on less expensive lenses. Pro lenses tend to be fast lenses, which means the optical glass is physically larger and heavier, thus they cost considerably more. Canon designates their best lenses with the letter "L" while Nikon uses the letters "ED," which stands for extra low dispersion glass.

Compare lenses carefully when selecting a new one. For an example, let's compare two popular Canon lenses. Canon sells a 75-300mm f/4-5.6 lens for the low price of $155. Canon also sells the popular 100-400mm f/4.5-5.6 IS USM for $1590. Wonder why one lens costs $1435 more than the other? Actually, there are several good and rational reasons! The 100-

400mm f/4.5-5.6 lens covers a larger zoom range. The optical glass is superb because it is an "L" lens which means this lens uses the very finest low-dispersion optical glass. That accounts for much of the difference in price. The most expensive lens also has two critical features that the other lens does not. The 100-400mm f/4.5-5.6 lens has IS which means it is image-

A steady line of pelicans flapped by my Land Rover along the shoreline of Lake Nakuru. Though I rarely attempt this, but having no other choice, I hand-held my 500mm lens and panned with it as smoothly as I could. By using a fast shutter speed, I managed to shoot a few sharp images. One advantage of a fast f/4 lens is it focuses faster which is crucial for action photography. Canon 7D, 500mm f/4.0L lens, f/8 at 1/1600 second, ISO 500, and Shutter-priority with zero exposure compensation.

stabilized, so it can be successfully hand-held at slower shutter speeds and still produce sharp images. Finally, this lens uses an ultrasonic motor (USM). This motor focuses the lens rapidly, making it ideal for action photography. Which is the best lens to buy? It depends on how much you want to spend, how much weight you are willing to carry, and what you plan to photograph. The expensive lens is much heavier at 3 pounds than the 75-300mm f/4.0-5.6 lens at 1.1 pounds.

Many photographers don't want to carry extra weight. If you tend to photograph still objects, then you don't need the ultrasonic motor of the high priced lens either. There is no wrong answer here. It depends on your needs and budget.

Here's our strategy for buying lenses. Our career depends on us capturing high quality nature images shot after shot. We are competing against the finest photographers in the world since we sell to the same markets and compete for the same workshop clients. We need the best tools to help us capture quality images efficiently and quickly. Therefore, we always buy the best quality lenses made by Canon and Nikon, no matter what the cost and weight. We are believers in buying

This mountain gorilla hugs her baby in a dense Rwanda forest. A fast f/4.0 lens was used, along with ISO 500, to sharply photograph them hand-held in the dim light. Nikon D200, 24-85mm f/4 lens at 42mm, f/5.6 at 1/160 second, ISO 500, and manual exposure.

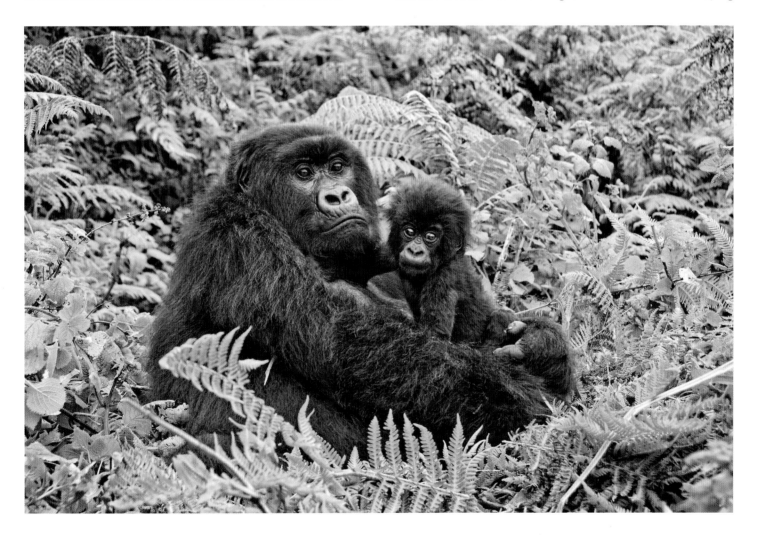

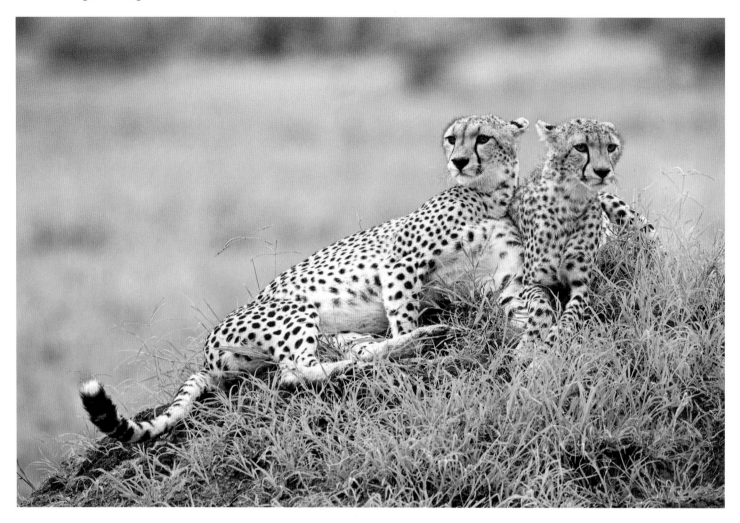

These two male cheetahs rest on a small observation mound in the Masai Mara. The thick overcast forced the use of ISO 800 and a slow shutter speed. A large bean bag, careful focus, and activating image-stabilization were necessary to improve the odds of shooting sharp images. Canon 5D Mark II, 500mm f/4 lens, f/6.3 at 1/100 second, ISO 800, and Shutter-priority with a +2/3-stop exposure compensation.

the best lenses made, but we prefer to save money by not buying (usually) the top-of-the-line cameras which are far too expensive compared to the cameras for the semi-pro market. Due to rapid changes and constant advances in technology, cameras quickly become seriously outdated as well as obsolete while lenses do not. We believe in spending our dollars on quality lenses.

The best quality lenses are more critical for wildlife photography than for landscape and macro photography for a couple of key reasons. The majority of wildlife images are captured with lenses longer than 300mm in focal length. Translated, this means you must shoot using high shutter speeds to capture sharp images. This forces you to shoot fairly wide open most of the time, so you'll be using apertures in the f/4 to f/5.6 range a lot.

Due to the laws of optics, most lenses are sharpest two to three stops down from the fastest aperture on the lens. With a 300mm/4.0 lens, the sharpest apertures will be at f/8 to f/11. The highest quality glass delivers sharper images wide

open than lenses with normal quality glass. Second, expensive lenses tend to be faster. For example, a 300/2.8 lens is two stops faster than a 75-300/5.6 lens. The viewfinder is two stops brighter with the 300mm lens than the slower zoom lens. This means autofocus is more accurate and much quicker. If you must focus manually, it is easier to do this with the faster lens because seeing the subject in the brighter viewfinder is much easier. It is easier to focus with less depth of field appearing in the viewfinder as the subject snaps into focus.

LENS SPEED

Dividing the maximum diameter of the aperture into the focal length of the lens determines the speed of the lens. Let's compare two lenses currently offered by Canon to examine the pros and cons of lens speed. Canon offers a 300mm f/4 and a 300mm f/2.8 lens. The 300/4 lens costs $1260 while the 300/2.8 lens empties your wallet to the tune of $4200. The main difference in the price of these lenses is the size of the high-quality optical glass being used. Both are "L" lenses, but the glass required to make the f/2.8 lens is considerably larger than the f/4.0 lens. It is easier to use a faster shutter speed with the f/2.8 lens. The viewfinder is brighter which helps the camera autofocus faster, more accurately, and preserves autofocus in dimmer light. Teleconverters work better on faster lenses because you are more likely to maintain fast autofocus. Finally, f/2.8 delivers a shallower depth of field than f/4, which is useful for creating a soft background without detail.

Unfortunately, fast lenses are heavy, often a few pounds heavier than a slightly slower counterpart. They are painfully expensive and use larger, more expensive filters. Finally, they are more difficult to travel with because they are both heavy and large, so they take up a lot of space. Despite their weight and size, fast lenses are such pure joy to use once you accept their size, and develop the superb shooting techniques required to achieve the quality they are capable of delivering.

IMAGE-STABILIZED LENSES AND CAMERAS

Image stabilization is a fairly new feature built-in to many lenses or built-in to the camera body itself. If it is built-in to the lens, some optical elements move to counteract lens movement, producing sharper images. Some camera systems, such as Sony, have image stabilization in the camera body and not in the lenses. Both systems seem to work.

Unhelpfully, different companies use various terms to describe image stabilization. Canon calls their lenses image-stabilized (IS) while Nikon calls them vibration reduction (VR) lenses. No matter what the company calls it, image stabilization allows you to capture tack sharp images using slower shutter speeds. Image stabilization is especially useful when shooting hand-held, something you should do only when there is no way to use a tripod. It is also helpful for photographing in high wind or when shooting on a tripod or a bean bag from a vehicle.

Image stabilization is useful and necessary at times. Beware, do not use it as a crutch. Too many photographers have adopted image stabilization to avoid using a tripod. That's a huge mistake! While image stabilization does help you shoot sharp images, it does have its limits. Using a 500mm telephoto lens still works best on a tripod in all situations where using a tripod is possible. Focusing carefully and using fast shutter speeds are crucial for achieving sharp images with telephoto lenses because they magnify the image greatly. It's simply too difficult to hand-hold a large lens and keep it still to maintain your composition. Like it or not, using a sturdy tripod is still the best answer in most situations.

Image stabilization is enormously useful when using a telephoto lens on a tripod during windy conditions. The wind causes the tripod-mounted lens to steadily vibrate, but image stabilization counteracts the effect, producing sharper images. This technology is also invaluable when photographing from a boat. A tripod actually makes things worse if the boat is rocking at all.

When the boat is rocking, you are much better to shoot hand-held, use fast shutter speeds, and use image stabilization because your body absorbs some of the rocking motion. We use large bean bags on Kenya wildlife safaris and in national

wildlife refuges where we photograph from the car window. Even though the vehicle ignition is turned off, the camera isn't perfectly still as it rests on the bean bag. Image stabilization is extremely helpful in this situation. We also sometimes use image stabilization when photographing action, especially birds in flight, but use it as an option where the lens only stabilizes one direction, usually vertical, and not the horizontal direction we are panning.

While image stabilization is useful at times, it does have its disadvantages. First, it tends to make some photographers lazy. They decide to shoot hand-held and not use a tripod when they easily could. That's always a bad choice and their images suffer for it. Of course, we know *you* don't fit into that category because you want the best possible images. Second, the number of images-per-second (burst rate) that you can shoot may decline. This is the main reason we normally don't use image stabilization when photographing wildlife in action. Third, batteries are depleted faster.

Be aware that most image stabilization systems have two modes. The standard mode (Mode 1 if shooting Canon)

Lake Nakuru often attracts more than one million flamingos. This pair of lesser flamingos is fleeing from a marauding spotted hyena. Due to the high 1/2000 second shutter speed, image stabilization is not helpful and therefore turned off. Canon 7D, 500mm f/4 lens , f/8 at 1/2000 second, ISO 500, and Shutter-priority with no exposure compensation.

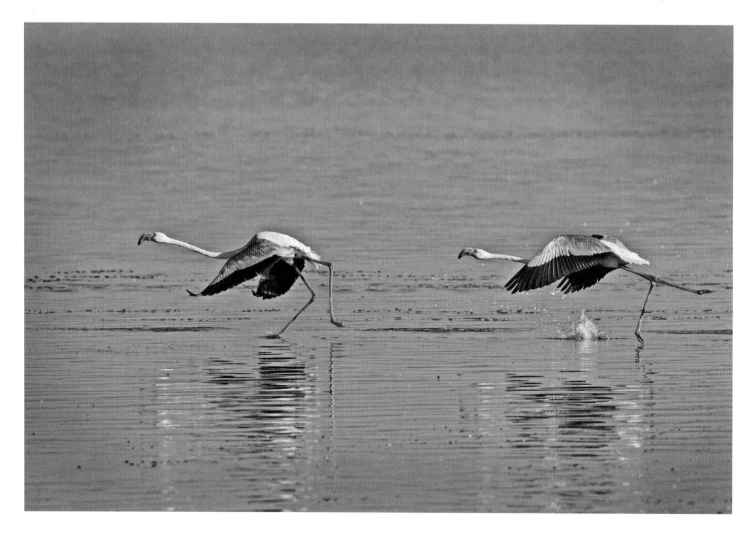

reduces vibration in both the horizontal and vertical directions. If you are panning with a moving subject, use Mode 2. This stabilizes the lens only in one direction and not in the direction you are panning. To illustrate this, imagine panning with a Canada goose flying from left to right. The motion is horizontal, so in Mode 2, the lens only stabilizes the lens for up and down vertical movement, not horizontal movement. Unfortunately, Canon puts the off/on and Mode 1/2 switch on the lens. When shooting on a bean bag, pushing the lens forward on the beanbag often turns off the IS and changes the mode switch to Mode 2. This problem is easily solved by using duct tape. I set the IS switch to On and the Mode to Mode 1. Then I duct tape these switches to keep them in place. Of course, when IS isn't wanted or Mode 2 is wanted, then the duct tape must be removed to change the switches. Hopefully, lens builders will offer better lenses in the future that let photographers lock switches in place.

PRIME VS. ZOOM LENSES

Canon 600mm f/4, Nikon 300mm f/2.8, and Sigma 150mm f/2.8 lenses are all examples of prime lenses because they have fixed focal lengths. Zoom lenses offer a variety of focal lengths within a set range. Examples include Canon 100-400mm f/4.5-5.6, Nikon 200-400mm f/4, and the Tamron 200-500mm f/5.0-6.3 lenses.

PRIME LENS ADVANTAGES

Prime lenses offer many advantages over zoom lenses. Most have faster lens speeds, faster autofocus, produce sharper images, and most focus closer than zooms covering the same focal length. With all of these advantages, are prime lenses the best way to go? Well, uh, it all depends.

Faster lenses are a joy to use, but being able to shoot using higher ISOs removes some of their advantages. The autofocus may be slightly slower with a zoom lens, but that is only critical when photographing really fast action. Zoom lenses have more glass elements than prime lenses. This means they may be slightly less sharp and are more prone to flare than

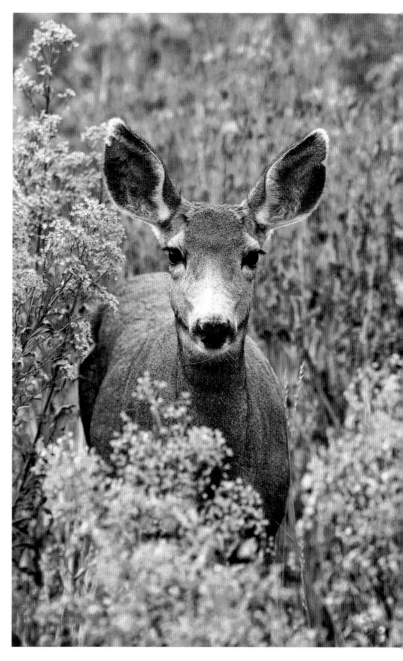

This mule deer doe is calmly looking at us, and the flowers she hopes to eat, in Barbara's garden. The fast f/4 lens provides the shutter speed necessary to shoot sharp images. Canon 1D Mark III, 300mm f/4 lens, f/4 at 1/250 second, ISO 400, and manual exposure.

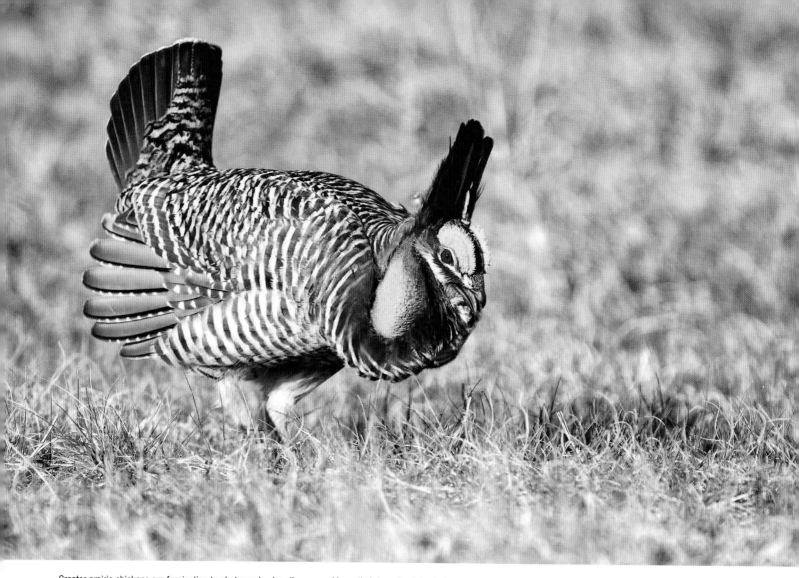

Greater prairie chickens are fascinating to photograph when they assemble on their breeding leks during April in Nebraska. It's necessary to hide in a blind and be in position at least one hour before sunrise because they dance most vigorously at first light. Anytime you must stay in one spot, such as in the blind, and the subject is free to move closer or farther away, a zoom lens is vastly superior to fixed focal length lenses. Barbara's superb Nikon 200-400mm f/4 lens works perfectly here. Nikon D2X, Nikon 200-400 f/4 lens with a 1.4x teleconverter at 550mm, f/6.7 at 1/250 second, ISO 100, and manual exposure.

fixed focal length lenses, but these differences are quite minor and not a significant enough reason to avoid using zoom lenses, especially if the zoom lens is made with the best quality glass. Your photography technique is far more crucial for achieving sharp images than the lens. A lens that is capable of focusing close is beneficial, but with the use of extension tubes, even zoom lenses can be made to focus close. These negative factors for zoom lenses do push many serious pho-tographers (including us) toward prime lenses. We often use prime 500mm f/4.0 and 300mm f/4 lenses in our wildlife photography, but do use zooms quite often as well. Indeed, our favorite wildlife photography lens is a Nikon 200-400mm f/4 lens.

ZOOM LENS ADVANTAGES

Regardless of how you look at it, zoom lenses have some tremendous advantages for wildlife photographers that must not be forgotten. First, they contain many focal lengths in a single package. A 70-200mm f/4 zoom lens has every focal length between 70mm and 200mm inclusive.

Covering this range with three prime lenses is incomplete, far more expensive, and generates a lot more bulk and weight to carry with you. Second, zooms make it easy and quick to change compositions for both still and moving subjects. Anyone who has ever been anchored to one spot while hiding in a photo blind, or when shooting from a vehicle, knows the frustration of having the subject move too far away or too close when using a prime lens. A zoom works far better in this situation. Third, while most wildlife photographers use few filters, if you do use any, you will find that a single filter that is made for your zoom lens works at every focal length contained in that lens.

TYPES OF ZOOM LENSES

VARIABLE APERTURE

Most zoom lenses are built to allow the maximum aperture to vary with the focal length as you zoom the lens. The Nikon 80-400mm f/4.5-5.6, for instance, begins with a f/4.5 lens speed at the 80mm setting. As you zoom to longer focal lengths, the maximum aperture gradually slows until you reach f/5.6. Lenses are made this way because they are lighter, more compact, and much less expensive to build. This means the lens-maker can sell a bucketload of them.

CONSTANT MAXIMUM APERTURE

The maximum aperture of these zooms does not vary. Examples include the Canon 70-200mm f/2.8, Nikon 200-400mm f/4, and Sigma 24-70mm f/2.8. Since the aperture does not vary, the glass elements must be extra large to maintain the maximum aperture over the zoom range. These lenses are pricey, heavy, and bulky. Since they don't slow down as you zoom to the longer focal lengths, your viewfinder stays bright and the autofocus is both faster and more accurate.

Many "pro grade" zoom lenses maintain the constant maximum aperture. Maintaining lens speed is a highly worthwhile feature because you need shutter speed when photographing wildlife to stop subject motion and arrest camera movement. However, once again, the ability to use higher ISOs, such as the ISO 800 with excellent quality, reduces the constant maximum aperture advantage somewhat.

OUR RECOMMENDATIONS

We greatly prefer prime (non-zoom) lenses for any focal length over 400mm. Many world-class wildlife photographers are our personal friends and virtually all of them use a prime 500mm or 600mm super-telephoto as their main lens for capturing exquisite wildlife images worldwide. Canon even offers a fine 800mm f/5.6 lens that works beautifully. Unfortunately, the $10,000 plus price tag prohibits many photographers from buying it, including this author, who would be wild about using it. For the record, I use a Canon 500mm f/4.0 while Barbara uses a Nikon 500mm f/4.0 lens.

As I write this, I do plan to switch to the new Canon 600mm f/4.0 lens for a bit more magnification.

To cover the shorter focal length ranges, most wildlife photographers tend to use zoom lenses, both variable aperture and constant maximum aperture models. Barbara uses her Nikon 200-400mm f/4.0 lens for the vast majority of her wildlife images. She only uses her 500mm lens when she needs the absolute maximum magnification possible. Otherwise, the capability of being able to zoom from 200mm to 400mm is just too much of an advantage to give up. She also uses a Nikon 24-85 and 70-200mm lens. I do well with my Canon 24-105mm f/4 and 70-200mm f/4 lenses. I have used the Canon 100-400mm f/4.5-5.6 lens, but sold it a couple years ago as I do not like push–pull zooms. I am eagerly awaiting the arrival of the Canon 200-400mm f/4 lens that hopefully will become available by 2013. Although we use plenty of zoom lenses, we always spend the extra money to buy the professional grade lenses with the best optical glass. We feel the difference is crucial to our ongoing success in the brutally competitive field of wildlife photography.

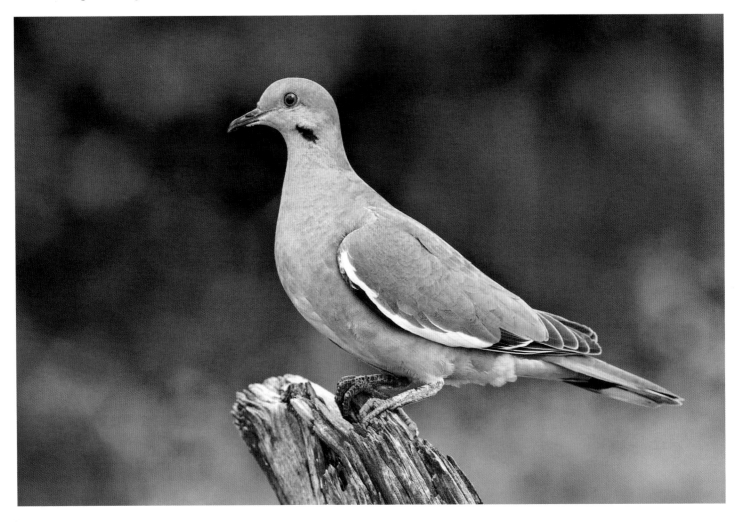

White-winged doves are popular game birds. Being hunted during the autumn makes them less approachable than non-game species. A 500mm lens was necessary to maintain a substantial working distance, even when hidden in a photo blind, to avoid scaring it away. Canon 1Ds Mark II, 500mm f/4.0 lens, f/9 at 1/125 second, ISO 250, and manual exposure.

WIDE-ANGLE LENSES FOR WILDLIFE

Beginners to wildlife photography might think everything is done with a long lens. But, there are wildlife hot spots around the world where a wide-angle lens works best for capturing fine wildlife images. We have been fortunate to be able to travel the world during our 35-year career. In years past, we have photographed in the Arctic Circle, Antarctica, Midway Atoll, the Galapagos Islands, Tanzania, Kenya, Rwanda, northern Japan, the Falkland Islands and Alaska, to name but a few spots. Unfortunately, most of these places were visited during our film shooting days, but we hope to return eventually to use our new digital cameras. Since we feel every image in this book should be produced from a digital camera, we have not used any of our film images in any digital books, magazine articles, or classroom teaching. On many oceanic islands, wildlife is unaccustomed to land-based predators and show little fear of humans. It is often easy and safe for the photographer and the animal to be very close together.

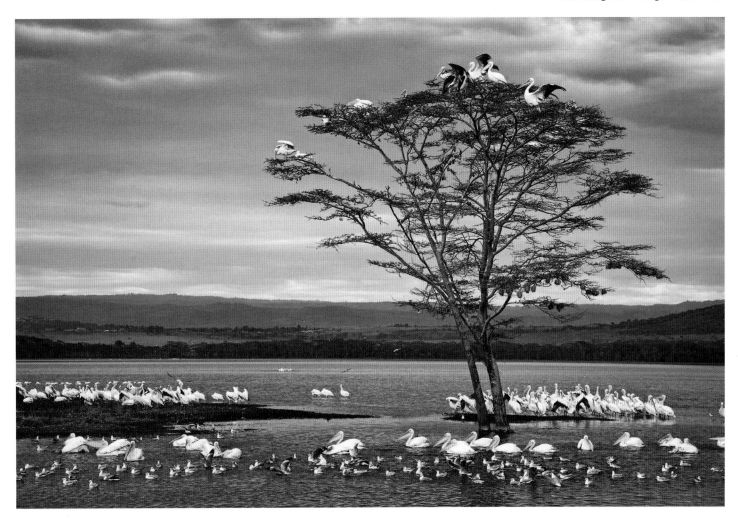

African white pelicans and gray-headed gulls crowd into a freshwater stream that enters alkaline Lake Nakuru. The 35mm setting on the zoom lens nicely frames the whole scene. Canon 5D Mark II, 24-105mm at 35mm, f/9 at 1/200 second, ISO 640, and Shutter-priority with a +1-stop exposure compensation.

Wide-angle lenses are terrific for photographing large groups of animals at close range. These lenses let you capture wildlife in the foreground and the landscape behind them. Lenses such as the 17-40mm f/2.8 and 24-105mm f/4 are excellent for these types of images. During our film days, we commonly photographed busy colonies of penguins in the Falkland Islands and Antarctica with short zoom lenses. We did use our digital cameras recently in northern Japan to photograph whooper swans. Using a 17mm lens only a couple feet from the nearest whooper swan produced a compelling foreground full of swans with the snow-covered mountains in the background.

Many short zoom lenses are offered today. As a guideline, look for two or three zoom lenses that cover the 17-200mm range. I use Canon's 17-40mm f/2.8, 24-105mm f/4, and 70-200mm f/4 lenses to nicely cover this range. Resist the temptation to buy one lens that covers everything.

Lenses do malfunction, and usually in remote places when they are hard to fix or replace. It's wise to have at least two

lenses covering similar, but not exactly identical focal lengths, rather than using one lens to cover everything. If the only lens you have malfunctions, what will you do? Losing your only lens might not be a serious problem when you are at home, but what if you are on a once-in-a-lifetime photo tour in Kenya?

I listed above the zoom lenses I use with my Canon system. Lenses tend to come and go. Therefore, rather than list a bunch of lenses for each system that may or may not be around when you read this, just look at the lenses made for your camera and consider selecting similar ones to duplicate my strategy. These zoom lenses have worked well for me, but your needs may differ, so consider what I use merely as a guideline to follow.

INTERMEDIATE LENSES

Lenses that cover the 100-300mm focal lengths are intermediate telephoto lenses. These lenses are useful for wildlife photography when you can get very close to small animals or

Greater kudus are spectacular mammals. We sometimes find them at Samburu National Reserve. This buck posed nicely when it caught the scent of a nearby leopard. The Canon 300/4 lens framed the animal perfectly. Canon 5D Mark II, 300mm f/4 lens, f/8 at 1/800 second, ISO 400, and manual exposure.

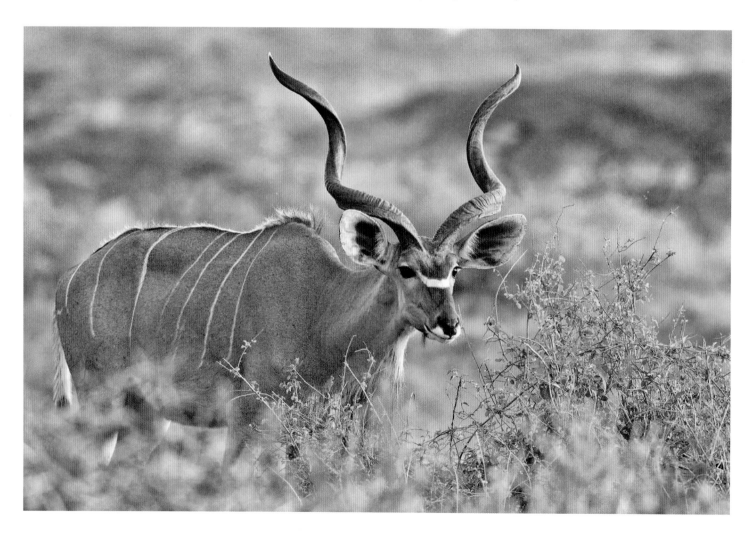

a bit farther away for larger animals. A 75-300mm zoom is terrific for capturing images of wildlife while preserving the flexibility of being able to change the composition easily by zooming the lens. For example, a 300mm lens is all you need to photograph yellow-bellied marmots at Sheepeater Cliffs in Yellowstone National Park during the summer months when they are active. These animals are accustomed to seeing humans at close range. Marmots are adorable and beg for food, but resist the urge and don't feed them. It's against the park rules and unnatural human food isn't healthy for them anyway.

During late September in Yellowstone, elk bugle in the meadows along the road. Often, all you need is a 300mm lens to fill the frame with the magnificent bull elk. Always avoid blocking their path and always stay at least 25 yards away from them. Park rules prohibit approaching closer and it isn't safe anyway because sometimes elk do attack humans. Although the elk in the front country of Yellowstone are habituated to humans, I prefer to stay about 40 yards away and use 300mm focal lengths for safety and to avoid disturbing them.

LONG LENSES

Prime lenses of 500mm and larger are widely used by professional and serious amateur wildlife photographers. Long prime lenses have many advantages. They offer great working distance and high magnification. This lets you fill the image with a subject some distance away. These long focal lengths have a narrow angle of view which tends to produce uncluttered backgrounds, a very pleasing side benefit.

On the negative side, long lenses are extremely expensive, $5000 to $8000 is a typical price for a new one. They are both heavy and bulky, making them more difficult to carry with you on airplanes and in the field. Most don't focus particularly close, so you may not be able to fill the image with a small subject such as a wren, but you can add extension tubes as explained in Chapter 1. Your shooting technique must be superb to consistently capture sharp images with these lenses as well. If you make a mistake with these big lenses, you'll see it in your images!

THREE WAYS TO OWN A SUPER-TELEPHOTO LENS

BUY A PRIME 500MM OR 600MM LENS

Your choices are simple if you are using Canon or Nikon. Both offer 500mm f/4 and 600mm f/4 lenses. The 600mm lens is larger and heavier than the 500mm lens. Therefore, we have always used the smaller 500mm lens for both our Canon and Nikon systems. However, if we photographed wildlife exclusively (we are avid macro and landscape photographers, too), we would use the 600mm lenses to get more magnification. If you use Olympus, Pentax, Sigma, or Sony/Minolta; Sigma offers a 50-500mm f/4.0-6.3 telephoto zoom for a little over $1000. We are not fond of zooms in this range because they tend to be slow to autofocus and may suffer from sharpness problems. It is difficult to make a truly sharp lens when such a wide zoom range is covered. Besides, you can't expect a $1000 lens to perform as well as one that costs thousands of dollars more. You get what you pay for. However, this lens may be perfectly suitable for your needs.

USE TELECONVERTERS ON 300MM OR 400MM LENSES

Using a teleconverter behind a 300mm or 400mm lens is a high quality way to get a super-telephoto lens at a lot less cost. Nikon offers a 300mm f/4 lens for about $1400. Add a 1.4x or 1.7x Nikon teleconverter for a couple hundred dollars more and you have a far more affordable super-telephoto lens that is easy to carry and produces excellent image quality—if you do your part by employing superb shooting techniques. Nikon offers three teleconverters, the 1.4x, 1.7x, and 2x. Teleconverters multiply the focal length of the lens by the power of the teleconverter. Here's a table to simplify it.

Look at the table. Note that multiplying the power of the teleconverter by the focal length of the lens determines the new focal length. Also, notice the teleconverter costs you lens speed. A slower lens means the viewfinder is darker, you can't shoot as wide open to blur the background, and your autofocus may slow down or you may lose autofocus

Nikon teleconverters and lens speeds

Focal length	Lens speed
No teleconverter 300mm	f/4.0
1.4 × 420mm	f/5.6
1.7 × 510mm	f/7.1
2 × 600mm	f/8.0

altogether. Some cameras cannot autofocus at f/8 maximum apertures. Teleconverters are a superb way to reach the longer focal lengths, but don't overdo it. They have glass elements that are added to the optical path, so expect to lose some sharpness. The more powerful the teleconverter, the more sharpness you lose. We suggest starting with the 1.4x teleconverter, especially if the camera you use has a crop factor. Although teleconverters have some disadvantages, they also have important positives which include making the lens longer to let you capture bigger images of the subject. The angle of view is narrower, too, so it produces less cluttered backgrounds due to the reduced field of view. To achieve the best quality, it's a worthwhile practice to buy teleconverters made by the lens manufacturer and not by third-party vendors.

Many photographers immediately buy the more powerful 2x teleconverter, even though the optical quality is slightly less than the 1.4x or 1.7x teleconverter and they may lose autofocus with the slower lens. They want to double the image size of the subject. Question: Does the 2x teleconverter double the image size? Suppose you are photographing a Canada goose with a 300mm lens and the area occupied by the goose on the imaging sensor is 1/4 × 1/4 inch. If you add a 2x teleconverter to the lens, it does double the height and width of the goose to 1/2 inch on the sensor. However, the area occupied by the goose is not doubled. Rather, the area is quadrupled and may be more magnification than you need. The 1.4x teleconverter approximately doubles the size of the goose in the image and the sharpness quality will be better. Therefore, consider buying a 1.4x teleconverter first. Only go

to more powerful teleconverters if you really need them and can live with their disadvantages.

Always test a lens and teleconverter combination to make sure it works well together. Use a newspaper or magazine page with fine print for the test target. Tape the test target to a wall to keep it completely still. Using a tripod, manually focus the lens/teleconverter combination to make the print as sharp as possible. It helps to use a magnified live view image to make sure you precisely focus on the print. Make sure the plane of the imaging sensor and the test target are parallel. This is easy to do. Focus the test target on the right side of the image. Now look at the left side. If the print isn't in equally sharp focus, then you are not perfectly parallel. Use flash to illuminate the newspaper. The short flash duration freezes any camera

European storks winter in central Africa and gather in Samburu National Reserve when the grasshoppers are abundant. This individual let me easily back-button focus on its eye and then recompose to improve the composition. Canon EOS 1D Mark III, Canon 500mm f/4 lens, f/7.1 at 1/1600 second, ISO 400, and manual exposure.

It wasn't possible to drive closer to this European stork. Therefore, I put a Canon 1.4x teleconverter behind the lens to approximately double the size of the bird in the viewfinder. Many photographers assume a 2x teleconverter is needed to double the size. In reality, the 2x teleconverter doubles the height and the width which comes closer to quadrupling the size of the subject. Canon EOS 1D Mark III, Canon 500mm f/4 with a 1.4x tele-converter, f/10 at 1/800 second, ISO 400, and manual exposure.

movement that might be caused by wind, mirror slap, or any other reason. Flash provides a true test of what this combination of glass elements really can do. Once you know the glass can get the sharpness you want, try some shots using natural light to see if your shooting technique is adequate. Be sure to keep the shutter speed at 1/125 second or more, even on a tripod.

USE THE CROP FACTOR FOR A LONGER LENS

Except for a few much more expensive cameras that have a full-frame sensor size of 24mm × 36mm, most cameras have a smaller sensor. Therefore, crop factor refers to the relationship between a "full-frame" sensor and some smaller sensor. Common crop factors are 1.3x, 1.5x, 1.6x and 2x. This means any lens appears to have a longer focal length when it is used on a camera with a crop factor. If you attach a Nikon camera, such as a D300s, with a 1.5x crop factor to the 300mm f/4 lens, it changes the field of view to that of a 450mm lens. Although the lens is still a 300mm lens, it really acts photographically like a 450mm lens because the field of view is cropped, making the subject appear larger in the image. It seems that there is more magnification, but this apparent increase in magnification is merely a cropping of the image that would have been captured with a full-frame sensor. Some authors and photo teachers call it the magnification factor, but nothing is really being magnified. Therefore, "crop factor" seems to be the more accurate and descriptive term to use.

Whether you wish to think of it as the "crop factor" or the "magnification factor," your subject still appears pleasingly larger in the viewfinder. A larger subject in the viewfinder is easier to focus precisely on the eye with both autofocus and manual focus techniques. The "crop factor" is one of the great equalizers in digital photography. With a small sensor camera, everyone can enjoy the benefits of a long lens if you obtain any lens with a 300mm focal length or greater.

THE CROP FACTOR WITH A TELECONVERTER

Almost anyone can afford a used 300mm f/4 lens. With a 1.4x teleconverter, the lens optically becomes a 420mm f/5.6

lens. With a 1.5x crop factor, the lens now provides a field of view of a whopping 630mm f/5.6 (420 × 1.5 = 630) super-telephoto lens. You do lose one stop as the lens slows from f/4 to f/5.6 due to the 1.4x teleconverter, but you still have a fairly fast lens that will autofocus! Now everyone can enjoy the benefits and advantages of a long lens. It is affordable and the weight is easily handled by most photographers.

Crop Factor Advantages

You'll remember that the crop factor makes the lens appear to be a longer focal length. It really isn't, but it feels that way. Small sensors tend to have fewer pixels than larger sensors. This means you can shoot more images per second for a faster burst rate than cameras with full-frame sensors.

Also, since file sizes tend to be smaller with the small sensor cameras, the burst depth—the number of images you can shoot continuously before filling up the camera's buffer—is greater. These two items are hugely advantageous for capturing wildlife action and the primary reason we normally use small sensor cameras to photograph wildlife.

Crop Factor Disadvantages

The smaller number and size of the pixels are the main drawbacks to using small sensor cameras. As pixel size decreases, the signal-to-noise ratio becomes more unfavorable, which increases digital noise. Further, since you typically have fewer pixels to begin with—compared to a full-frame sensor—you have less opportunity to crop the image later on and still retain sufficient image quality. Cropping the image too much may lose too many pixels to make the print size you want and have it still look sharp. The crop factor does make wide-angle lenses longer. This means a 24mm lens used on a camera with a crop factor of 1.5x generates a field of view of a 36mm lens. This is a frequent problem for landscape photographers, but not so serious to the wildlife specialist. We do shoot wide-angle wildlife scenes, but use our large sensor cameras when doing so.

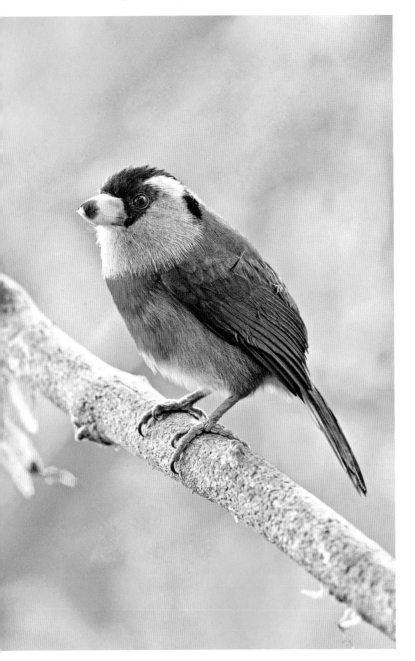

Ecuador's exquisite toucan barbet is readily attracted to bird feeding stations offering fruit. This medium-sized bird required a 400mm focal length plus a 1.4x teleconverter to make it fairly large in the image. Barbara used a fast 1/250 second to help her get a sharp image. She used tele-flash to improve the colors in the feathers and brighten up the dull natural light in the forest canopy. Nikon D300, Nikon 200-400mm lens at 400mm, 1.4x tele-converter, f/5.6 at 1/250 second, automatic flash, ISO 640, and manual metering.

TILT/SHIFT LENSES

These unique lenses have features that other lenses don't have. They are made to permit the image to be shifted about the sensor. The lens can be bent to allow Scheimpflug's principle to be used to maximize depth of field.

The shifting capability is ideal for keeping vertical lines vertical. Thus, landscape photographers greatly appreciate this feature, especially if they photograph tall trees or buildings. There is little need for being able to shift the image on the sensor in wildlife photography. However, the tilting mechanism is incredibly helpful to wildlife photographers in situations where numerous animals are crowded close together and you want to get everything sharp. Penguin and albatross nesting colonies, herds of wildebeest or zebras, a shoreline of marine iguanas in the Galapagos, dense flocks of whooper swans in northern Japan or mallards at the local park are all perfect subjects for a lens that can tilt.

During two trips to Antarctica, Canon's 45mm and 90mm T/S lenses worked tremendously well to photograph magnificent colonies of penguins. The tightly packed nesting colonies could be approached closely without disturbing the birds. The nearest penguins were only a few yards away and the densely packed colony extended for a hundred yards or more. At this shooting angle, you could stop down a normal 50mm lens to f/22 to extend the depth of field through the penguins, but some of the most distant penguins still weren't sharply focused because the plane of focus was almost perpendicular to the plane that passed through all of the penguins. Stopping down to f/22 forced a slower shutter speed. Although the penguins remain stationary as they incubate their eggs, they still move their heads a lot as they squabble and poke at their hostile neighbors. Higher shutter speeds are necessary to arrest this motion. If proper exposure at ISO 400 is 1/250 second at f/11, stopping down to f/22 will cost you two stops of light, forcing the use of a slower 1/60 second shutter speed. Unfortunately, the 1/60 second shutter speed doesn't arrest the head motion of the quarreling penguins.

With a Canon 45mm tilt/shift lens, a colony of penguins is easily sharply shot. Begin by focusing on the head of the

nearest penguin. Looking through the camera's viewfinder, notice the birds in the background are seriously out of focus. Now tilt the lens a couple degrees down, refocus on the foreground bird, and peer at the birds in the background. They should be getting sharper. Keep adjusting the tilt down until all of the heads are sharp from foreground to background. If you tilt the lens too much, some of the heads go out of focus again. When you determine the proper angle to make all of the heads sharp, meter in the usual way, and shoot the image. You don't need to stop down the lens to f/22 because all of the heads are sharp wide open due to Scheimpflug's principle. Now you can keep the camera set at ISO 400, f/11 and 1/250 second. The higher shutter speed helps to freeze bobbing heads and the tilt feature of the lens lets you align the plane of focus with the heads of the penguins.

Sadly, you may not be able to get a lens like this because most camera makers do not offer tilt/shift or perspective control lenses. Fortunately, the two camera systems most used by wildlife photographers—Canon and Nikon—do offer several. Canon offers 17mm, 24mm, 45mm, and 90mm tilt/shift lenses. Nikon has 24mm, 45mm, and 85mm PC lenses. Generally, for wildlife photography, the longer focal lengths are the most useful.

LENS ACCESSORIES

POLARIZING FILTERS

Wildlife photographers tend to avoid using polarizing filters because these filters cost them 1.5 to 2 stops of light. Thus, you lose two shutter speeds, making it more difficult to capture sharp images with long lenses. However, now that cameras offer excellent quality when using higher ISOs, such as ISO 400 and ISO 800, it is easier to use polarizers and still maintain sufficient shutter speed.

During a couple of photo safaris we were leading in Kenya, we used polarizers more, but found they had little positive effect on lions, giraffes and other furry critters unless they were against a blue sky background.

After extensive experimentation, we have largely abandoned polarizers for wildlife photography, except for certain subjects or situations. Polarizers are useful for reducing glare on highly reflective animals like crocodiles and hippos. Polarizers do improve colors when photographing birds against a blue sky that has an abundance of polarized light. If the sun is due east and close to the horizon, draw an arc that begins due north and goes up and over you and down to due south. That portion of the sky has the greatest amount of polarized light. When turned properly, the polarizer removes much of the polarized light, darkening the sky in the process. The polarizer has little to no effect when shooting directly at or away from the sun. The polarizer is incredibly useful for reducing glare associated with animals in the water such as the enormous flocks of lesser flamingos at Lake Nakuru.

Polarizers that fit super-telephoto lenses, such as a Canon 500mm f/4 are huge and expensive. Fortunately, these big lenses accept small drop-in polarizing filters. Drop-in filters are much less expensive, lighter to carry, and easier to use than large polarizers that screw onto the front of the lens. With smaller lenses like a 300mm f/4, the regular polarizers that attach to the front of the lens work fine.

PROTECTION FILTERS

It appears the vast majority of amateur nature photographers and many pros use UV or Skylight filters on their lenses to protect the lens. However, be aware the lens manufacturer optimizes the lens performance to produce the finest quality without any extra glass being added to the optical path. Adding any glass to this optimized optical path will decrease the quality of your images, though the decrease may be slight. A single well-made filter will cost you a little quality, but the image is probably fine for professional needs. However, some really cheap "protection" filters degrade the image horribly. In the field workshops we teach, some "protection" filters are so bad that it is impossible to achieve sharp focus. If you believe you need a "protection" filter, then go ahead and use an expensive high quality one.

However, if you use a polarizing filter at times, never stack the polarizer on top of the "protection" filter. Adding all of

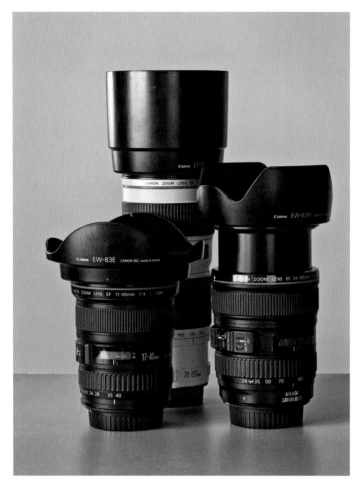

Lenses with Hoods. It's crucial to develop superb photographic habits! Always use clean lenses that are protected with a properly installed lens hood. Avoid using protection filters. Instead, handle your lenses carefully and always use the lens hood to protect it. Canon EOS 5D Mark II, Canon 100mm macro lens, f/22 at 1 second, ISO 500, and manual exposure.

that extra glass to the optical path may seriously degrade image quality. You will lose sharpness, obtain less color saturation, and suffer problems from flare more often.

In the interest of full disclosure, we haven't owned or used a "protection" filter in more than 35 years. Instead, we always use a lens hood, handle our equipment carefully, and have yet to suffer any damage that could have been prevented by using a "protection" filter. Have we damaged lenses? Yes. Once we dropped a small lens that fell 100 feet to the rocks below, but no "protection" filter could save it. The sound of

a $300 lens disintegrating as it explodes on the rocks below does make your hair stand up on end!

Although you know our extreme dislike of "protection filters," we do use polarizing filters when their benefits outweigh the slight loss of image quality and the inconvenience of using them.

LENS HOODS

Sadly, some photographers fail to use lens hoods, even when it is built into the lens. All they have to do is pull it out, yet many don't. Part of superb shooting technique is always using your lens hood. The hood greatly reduces flare in the image. Flare is created when light strikes the front glass of the lens from the side. Instead of this light being focused on the sensor, it bounces around among the glass surfaces inside the lens and causes out of focus hot spots (flare) in the image. This reduces contrast and diminishes color saturation.

It is always wise to use the lens hood. The hood not only helps you capture higher image quality, but it nicely protects the front of the lens. The hood deflects sticks that might scratch the lens. If you happen to drop the lens, should it fall on the lens hood first, the hood might bend, but save the expensive parts of your lens. The hood keeps snowflakes and raindrops away from the glass, helping to prevent smudges from forming on the glass.

It's true the lens hood makes it more difficult to use a polarizing filter because the filter has to be turned to get the effect you want. If you can't reach in with one finger to turn the filter, then take the lens hood off, turn the filter to the desired position, and replace the lens hood. It really doesn't take much extra effort or time to shoot this way.

CLEANING LENSES AND FILTERS SAFELY

The high-grade optical glass in your lenses and filters directs the rays of light to the imaging sensor. The glass must be as clean as possible for it to perform at its best. Keeping lenses clean is absolutely crucial to image quality. Everyone must

master the techniques for keeping the glass clean. Fortunately, cleaning lenses well is easy. Follow these simple steps to become a lens cleaning "guru."

PREVENTION

Always keep the front and back lens caps on your lenses anytime you aren't using them. Preventing dirt and smudges in the first place is always the best policy. However, no matter how careful you are, dirt will eventually find its way to the glass. This dirt must be removed to maintain the quality of your images. Smudges degrade the image even more because they cause relatively large out of focus blobs in your images. Fortunately, smudges are easy to prevent. Never touch the glass with your fingers. Most of the smudges that appear on our lenses are caused by wayward raindrops, water drops thrown at the lens from waterfalls, or melted snowflakes. Each of these causes a smudge when the water dries on your lens.

CLEANING YOUR LENS

There is always a bit of dust on the lens when you take the protective caps off of it. Use a Giotto Rocket Blower to blow the dust off. Often, this is all that is necessary. When both ends of the lens are clean, mount the lens on the camera and the hood on the other end. Don't use canned air to clean the lens. Canned air sometimes squirts a liquid on the glass, causing a somewhat difficult to remove smudge.

If the Giotto Rocket blower doesn't remove all of the dust from the surface of the glass, then you must gently and carefully rub the glass with a clean microfiber cloth. Then blow the lens off again with the rocket blower. This should work most of the time.

If a smudge, dust, or other debris remains stuck to the lens, put a few drops of lens cleaning solution on the clean microfiber cloth or lens paper expressly made for this purpose—not directly on the lens to avoid having excess fluid leak into the interior of the lens—and gently rub the lens. Begin in the middle of the lens and rub the lens in a circular motion until you get to the outer edge of the glass. Make sure all of the lens cleaning fluid is removed. Blow the lens off again with the rocket blower to remove any lint from the cloth.

This cleaning procedure works perfectly for us. We do occasionally wipe the metal surfaces of the lens off, too, with a damp microfiber cloth. Do make sure the cloth isn't too damp. You don't want water seeping into the interior of the lens. It helps to wash both the front and rear lens caps from time to time to remove any dirt they contain. Vacuuming your camera bag occasionally is helpful, too.

Exposure Strategies

The speed of the action is one of the main thrills in photographing wildlife. Birds and mammals often move and even disappear so abruptly and swiftly that the unprepared can be left empty-handed. The photographer soon appreciates that camera operating speed, shooting speed, and accuracy in both are all needed to take advantage of most wildlife shooting opportunities. Luckily, obtaining correct exposures in digital photography is rather easy. We'll begin with some basic exposure information and some guidelines, and we'll gradually move onto the exposure strategies that work exceedingly well for us.

EXPOSURE GUIDELINES

RAW IMAGES

The well-known rule for exposing RAW images is to expose as much as one can without overexposing important highlights. Those are the highlights in which we must preserve detail. This technique is often called, "Exposing to the Right," or ETTR. We'll learn later in the chapter about successfully balancing the desire for high exposure levels with the danger of losing detail in desired highlights.

JPEG IMAGES

Expose JPEG images by keeping the right-most data about 1/2 to 1 stop shy of the right edge of the histogram. Do not allow any overexposure in important highlights. It's because JPEG images and RAW images represent differing amounts of data.

LEFT: This doe topi and fawn posed nicely for our safari group in the Masai Mara. The golden dawn light nicely accentuates the warm colors in their fur. Using a 1.4x teleconverter on a 500mm lens gave me a 700mm lens. Canon 5D Mark II, 500mm lens with 1.4x teleconverter, f/5.6 at 1/400 second, ISO 400, and Shutter-priority with +2/3-stop exposure compensation.

HOW NOT TO JUDGE EXPOSURE

USING THE CAMERA LCD MONITOR

It's a very big mistake to evaluate your exposure by the brightness of the image on the LCD, and *this improper use of the LCD may be the most common exposure blunder of all.* Photographers who are new to digital and even experienced shooters too often succumb to the temptation of examining their images on the camera's rear LCD to judge exposure. Don't do it! Major exposure errors arise from this habit.

Several characteristics of the camera LCD monitor cause it to utterly fail as a means of judging exposure. Consider the available light. If one views an LCD on a bright day, the images will look dark, perhaps wrongly concluding that they are underexposed. On a darker day, the images will look bright and mislead the unwary photographer to think they may be overexposed.

Cameras generally have an internal control of LCD brightness to allow the user to set it for their own convenience. The unwary photographer may not realize the brightness setting

is only arbitrary and unrelated to the images to be displayed. If you like a bright image monitor and set it high, and have set it so, all images will look bright. If it is set low, though, they will all look dark. Get the idea? Your laptop computer likely exhibits the same behavior.

So how then does one judge exposure?

THE WORST EXPOSURE OF ALL

This is the one that overexposes highlights in which you want to see detail because that detail will be forever lost. If we overexpose the image of a nice white swan with all its pretty and delicate feather detail, all of the detail in the overexposed feathers will be irretrievably lost. Our lovely white swan will just look like a plain white long-necked featureless cotton ball. Even extensive post-capture editing will never recover the lost feather detail.

We'd also like to avoid underexposure of the shadow areas of the image, but with technical limitations sometimes prohibiting both goals in one image, we practically always prefer to do the right thing with our highlights. Beyond preserving highlight detail, there are other benefits of good exposure. One example is image noise, those little intrusive specks of color that can creep into the shadow areas of an image. Noise is best minimized by ensuring proper highlight exposure. The optimum exposure allows the sensor to capture the greatest amount of information which helps to produce smoother gradations between colors and brightness in the final image.

WORKING WITH STOPS

From the earliest days of photography, practitioners have used the word "stops" in discussing exposure. You may well ask, "Exactly what is a stop?" Perhaps the term "stop" is best thought of as a measure of how camera settings affect exposure.

We generally refer to lens apertures as "f-stops." For any shot, there's a given amount of light available, and we set a certain f-stop to control how much of that light is used for the

I slowly stalked this red-necked grebe while concealed in my floating blind. The grebe accepted my close approach and continued to feed and preen. Wildlife photography is particularly enjoyable when the subject is completely unaware of me and behaving naturally. Canon EOS 1D Mark III, 500mm f/4 lens , f/8 at 1/1000 second, ISO 400, and manual exposure.

This whooper swan was sleeping quietly on the ice a few feet from shore. Barbara slowly crawled closer to it. Because she was careful and gave the bird time to accept her, its only reaction was to open its eyes a bit more often to check on her. Nikon D3, Nikon 200-400 f/4 lens, f/16 at 1/250 second, ISO 400, and manual exposure.

exposure. Likewise, we refer to stops of shutter speed. The speed at which a mechanical shutter operates is an important camera setting that controls for how long, and thus how much, light is used to make the exposure. Lastly, we refer to ISO ratings in stops. The ISO rating (more about that later) is a measure of the camera's *sensitivity* to light, that is, how the sensor responds to the light admitted, thus establishing the degree of exposure resulting from that light.

The crux of it all is that the term "stop" is the most widely used term to describe the effect of camera settings on exposure. Lens apertures are commonly designated by a series of stops. They're called f-stops, and a common series used by many lenses is: f/2.8, f/4, f/5.6, f/8, f/11, f/16, f/22, and possibly f/32. The basis of those strange numbers will be explained shortly. For now though, it's important to *remember that any change of f-stop, from one to another in the series, causes the light for the exposure to be doubled or cut in half.* As examples, an aperture of f/4 gives twice as much exposure as f/5.6. And f/16 gives only half as much exposure as f/11. Note the counterintuitive fact that the larger the number, the

smaller the aperture and vice versa. F/22 is a smaller aperture than f/16. Don't worry—you'll get used to it.

Going further with that thinking, if a 1-stop increase in aperture, say, from f/4.0 to f/2.8, causes twice as much light to fall on a sensor, then it follows that a 2-stop increase in aperture, as from f/11 to f/5.6, causes four times as much light to fall on the sensor. The next larger stop, f/4, results in twice as much light as the last stop, f/5.6, so there is eight times as much sensor light at f/4 as there was at the original f/11. It works the opposite way, too. A 2-stop reduction in aperture, say, from f/11 to f/22, will reduce the exposure to one-fourth of what it was.

Shutter speed is the measure of the length of time the shutter is open, allowing light to strike the digital sensor. The speeds are given in a series of "shutter-speed stops." The number of shutter speeds offered by a specific camera, and the exact shutter speeds within the series, can vary from model to model, but are generally close to this: 30, 16, 8, 4, 2, 1, 1/2, 1/4, 1/8, 1/15, 1/30, 1/60, 1/125, 1/250, 1/500, 1/1000, 1/2000, 1/4000, and 1/8000. In this series, whole numbers are in seconds and fractional numbers are portions of seconds.

At a crane-feeding area in Japan, little did we expect white-tailed eagles to put on the best show as they maneuvered through the masses of flying birds to grab the fish that were tossed their way. Although the overcast sky is mostly white, we still like the pose and fine detail in the feathers of this aggressive bird. Nikon D3, Nikon 200-400mm f/4 lens at 400mm, f/5.6 at 1/500 second, ISO 500, and manual exposure.

The above series of shutter speed stops can cause the push of a shutter button to result in a shutter opening for 30 full seconds down to an ultra speedy one eight-thousandth of a second. Here too, just like aperture f-stops, *a one-stop change in shutter speed causes the light for the exposure to be doubled or cut in half.* A 4-second shutter speed gives twice as much exposure as a 2-second shutter speed, and a 1/500-second shutter speed gives only half the exposure as a 1/250-second shutter speed. And just like lens apertures, a 2-stop change in shutter speed changes the light on the sensor by four times and a 3-stop change in shutter speed changes the light on the sensor by eight times.

And now for ISO stops. The camera's sensitivity to light, called ISO ratings, is designated by a series. A typical series for a modern DSLR is: 100, 200, 400, 800, 1600, and 3200. Some cameras offer smaller and larger choices, too. Here, however, we're not talking about controlling the amount of light that enters the camera. Instead, we're talking about controlling the camera's *response* to that light. For our frolicking black-backed jackals, we control depth of field and action stopping by selecting an appropriate f-stop and shutter speed. The combination determines how much light is admitted to the camera when we push the shutter button. The ISO setting determines

These crowned cranes were hunting for insects. Since I hoped to make both birds sharp, I used ISO 400 to use f/9 for more depth of field. Canon EOS 5D Mark II, 500mm f/4 lens, f/9 at 1/400 second, ISO 400, Shutter-priority with a +2/3-stop exposure compensation.

how much exposure is achieved by that light. For any specific amount of admitted light, higher ISO settings give greater exposure, and conversely. As in f-stops and shutter speeds, it's convenient to think of ISO ratings in stops. Use higher ISO ratings, such as ISO 800, when it's important to use a fast shutter speed to stop action. Summarizing, we properly think of the term "stop" as describing the effect of camera settings on the exposure.

In our discussions above, we gave examples of f-stops, shutter speed stops, and ISO stops. Many, if not most cameras, also provide in-between settings in fractions of a stop, either 1/2 stop or 1/3 stop. Usually the fraction is user-selectable. If

using half-stops, the camera offers one additional shutter speed halfway between each of the major speeds of the series. The camera also allows *one* additional lens aperture halfway between each of the major apertures of the f-stop series. ISO ratings do not offer 1/2 stop settings, but some cameras do offer 1/3 stop ISO values. But if using 1/3 stops, then the f-stops, shutter speeds, and ISO ratings, would all have *two*

A snowstorm and bitterly cold temperatures descended on this northern Japanese lake, driving most of the swan viewers into the warm nearby shops. We struggled in the brutal wintry conditions and did the best we could to photograph flying swans in the blizzard conditions. Driving snow (and rain) always add a special appeal to wildlife images. Nikon D3, Nikon 200-400mm f/4 lens, f/5.6 at 1/800 second, ISO 500, and manual exposure.

additional settings between each of the major series numbers. For example, between ISO 100 and ISO 200, there are two intermediate settings that include ISO 125 and ISO 160.

SLOW OR FAST? SELECTING THE SHUTTER SPEED

What is the best shutter speed for a particular wildlife shot? Choosing the best shutter speeds depends on several factors. Below are some factors to consider.

- *Do I need to stop action?* If the subject is in motion, and I want to stop the action to get a sharp image, I must select a fast enough shutter speed to do so. This is true regardless of whether using a tripod or other support. I must consider how fast the subject is moving, how far away it is, and the angle at which it's moving. Birds in flight typically require shutter speeds in excess of 1/1000 second to achieve a sharp image. By shooting with big apertures, such as f/4.0, and using ISO 800, it is possible to reach the 1/2000 second

Sometimes you get lucky! The motion of this running leopard was enhanced by using a slow shutter speed while panning with it. Barbara had no idea there was a leopard hiding on the porch of the warden's home at Lake Nakuru until it suddenly emerged and bounded into the dense forest. She was quick enough to get it in the viewfinder, but had no time to adjust the exposure. This ghostly leopard image was achieved with a shutter speed of 1/3 second. Nikon D3, Nikon 80-400mm lens, f/6.3 at 1/3 second, ISO 200, and Aperture-priority with a +2/3-stop exposure compensation.

shutter speed which makes it quite easy to capture a sharp image of a flamingo flying by if you pan carefully with the subject and precisely focus on the bird.

- *What if I don't want to stop the action?* Oftentimes, the motion of wildlife can be deliberately allowed to cause blur, sometimes to impart the idea of motion to the image, and sometimes for other artistic effect. If blur is desired, then slower shutter speeds are in order. A shutter speed of 1/15 second or so might be a good starting point, depending on subject speed, distance, angle of movement, and the desired amount of blur. Slow shutter speeds are effective for conveying the lightning fast movement of a leopard as it runs through an opening in the forest.

LARGE OR SMALL? SELECTING THE F-STOP

A while back, I said that we'd explain the relationship between the aperture of a lens and the associated f-stop. The term "aperture" describes the nearly round hole in an adjustable diaphragm within the lens. We change the size of the aperture by turning a dial on the camera. At whatever aperture area we select, there is a defined f-stop, and we generally refer to the aperture size by that term. The f-stop is calculated from the focal length of the lens and the diameter of its aperture. It goes like this:

f-stop = lens focal length divided by the diameter of the aperture

Here's an example: Consider a 200mm lens with a maximum aperture that's 50mm in diameter. The maximum f-stop = 200/50 = 4. It's an f/4.0 lens.

For a given f-stop, the size of the aperture varies as the focal length of the lens changes. Thus, for any specific f-stop, such as f/16, shorter lenses have smaller apertures than longer lenses. However, all of these lenses pass the same amount of light when set to the same f-stop, even though the size of the aperture varies with the focal length.

THE LAW OF RECIPROCITY

The behavioral relationship between shutter speeds and f-stops is called a "reciprocal" relationship. Suppose it's a clear and sunny day and we use the histogram to conclude a proper exposure of ISO 100, 1/100 second, and f/16. In this instance, we use manual exposure to avoid some serious autoexposure problems. Since we are photographing bald eagles snatching fish at Homer, Alaska, we want images of the eagles with their wings frozen in flight and we already know 1/100 second will not succeed and that we must use a much faster shutter speed. Suppose we increase the shutter speed by 3 stops, taking it to 1/800 second. Our majestic bald eagle just became a black eagle because now we are 3 stops underexposed. Now we must quickly adjust. We previously raised the shutter speed by 3 stops, so we open the lens by 3 f-stops, changing it from f/16 to f/5.6. Now, at 1/800 second and f/5.6, we've got our desired higher shutter speed and also have the correct exposure.

But, suppose that at f/5.6, we don't have enough depth of field to adequately cover the eagle. Okay, we'll use stops to make that change, too. If adequate depth of field would be at f/11, we close our aperture 2 stops, from f/5.6 to f/11. Again we suffer the dark bird blues. No problem. We just compensate by increasing the ISO by 2 stops, from ISO 100 to ISO 400. Now we have it all. We have our needed fast shutter speed, our needed depth of field, and a correct exposure. We went from ISO 100, 1/100 second, and f/16 to new settings of ISO 400, 1/800 second and f/11. And we needed no miserable messy math manipulations. We just clicked a few stops this way and a few stops that way and it was all so easy!

To summarize, the law of reciprocity tells us that a change in exposure of a certain amount of stops caused by one control, can be perfectly compensated by a reciprocal change of the same number of stops in another control. Open the lens a stop—increase shutter speed by a stop. Decrease shutter speed by 2 stops—reduce aperture by 2 stops. Change either one by 3 stops—change ISO by 3 stops. Reciprocity, and the use of stops, give us great flexibility in speedy and simple control. Reciprocity lets us select apertures, shutter speeds, and ISOs

to get the depth of field and action stopping ability demanded by our subject.

Perhaps a small chart will illustrate this law of reciprocity better. Let us assume the optimum exposure is 1/250 second at f/11 with ISO 400. All of the following shutter speed and aperture combinations produce the same exposure if everything else (ISO and available light levels for example) remain the same.

Reciprocity chart

Shutter speed	f-stop
1/2000	f/4.0
1/1000	f/5.6
1/500	f/8.0
1/250	f/11
1/125	f/16
1/60	f/22
1/30	f/32

MORE ON ISO

The abbreviation "ISO" stands for "International Organization for Standardization," a group that sets worldwide standards of many things to ensure there is a level playing field for us all. Standards help protect the public by establishing, for example, that when you set your Nikon D300s, your Canon 60D, or your Sony Cyber-Shot, all to the same ISO settings, the three cameras will each exhibit the same sensitivity to light.

A modern digital camera offers a wide range of ISO settings. The Canon 7D is a good example, having major ISO choices of 100, 200, 400, 800, 1600, 3200, and 6400. That's seven major settings. However, in that camera, a precision-seeking photographer can easily select intermediate settings in 1/3-stop increments between the major stops. For example, between the major stops of 200 and 400, the user can select 250 or 320. When expanded that way, the camera provides

for 19 selections of ISO, plus an important automatic setting cleverly called "Auto" and a supersensitive setting called "H," which gives ISO 12,800. Not all cameras offer the intermediate stops, but it's not a serious shortcoming.

We're continuing to use the language of stops in our ISO discussion here because it's always so convenient when discussing exposure. Note in the ISO discussions above, the setting called "Auto." This setting instructs the camera to automatically determine, and set with no further user intervention, what the camera considers a proper ISO setting. It can be a handy feature when using the Shutter-priority exposure mode in dim light.

Also shown in the Canon 7D list of available ISO settings is the "expanded" H setting, which allows an ISO of 12,800. Indeed, the Nikon D3 offers expanded ISO ratings up to 25,600, and some later models have ISO selections even higher than that. Exposure control often needs compromises, though, and extreme ISOs are no exception. They are achieved by electronic amplification of the sensor data, and the higher the ISO setting, the more amplification. The more amplification, the more undesired image noise. In some circumstances these sky-high ISO settings can rescue a shot. The experienced wildlife shooter knows that many subjects are more active at dawn and dusk when the light is low. The spotted hyena sneaking through the underbrush a half-hour before a cloudy morning sunrise just might be recordable at an ISO 12,800 or a stop greater at ISO 25,600. While very high ISO settings can occasionally be a shooting lifesaver, my Canon, for example, protects me from inadvertent selection of its noisier ISO settings by requiring that I invoke it with a custom function selection.

We've mentioned before that a digital camera's higher ISO ratings are achieved through electronic amplification of its "native" ISO. The native ISO is generally ISO 100 or ISO 200, depending on the camera, and because it requires no amplification, the native ISO produces the lowest noise in the image. As ISO settings are increased by amplification, we increasingly suffer the spurious light and dark specks called luminance noise, and the colored specks called chrominance noise. These

noises vaguely resemble the grain effects we saw in film, and if severe, can mute our images and cause an apparent reduction in sharpness.

The additional noise of higher ISO settings may be an acceptable compromise when conditions require those ISOs to get a decent exposure. We try to always use our native ISOs and usually can in landscape and macro work. Generally, those

subjects are not moving and the light is reasonable, allowing our choices of apertures and a "who cares?" attitude about shutter speeds. Fast-moving birds and mammals are a different kettle of fish, however. One might need a higher shutter speed to arrest subject motion, to say nothing of the higher shutter speed occasionally needed to compensate for the magnification of the longer lenses commonly used. A 300mm lens, for example, will magnify camera vibration or other motion by about six times over that of the "normal" 50mm lens, and higher shutter speeds help tame the effects of that motion. When we compound high shutter speeds with a small aperture that we may need for adequate depth of field, often

This captive mandarin duck swam repeatedly in front of me at the Sylvan Heights Waterfowl Park in North Carolina. Digital cameras are excellent at capturing the incredible variety of hues in the plumage. Photographing captive animals is a superb way to perfect your shooting skills. Canon EOS 5D Mark II, ISO 800, 1/500, f/6.3, 500mm, and manual exposure.

the only way to maintain a proper exposure is to raise the ISO considerably above its native setting. That may get us a little noise, but a slightly noisy picture is usually better than a totally fuzzy one.

THE CAMERA'S DIGITAL SENSOR

All digital cameras have a device called a "sensor" that converts the incoming light into electrical signals to be further processed. The sensor has millions of "photosites," each one making up one element of the millions used in forming an image. Writers oftentimes will refer to the photosites as "pixels," a word coined from the term "picture-element." However, the data from several different colored photosites is generally combined to make each pixel of the resultant image, so there's a distinct difference between a photosite and a pixel. If you wish to see a pixel, enlarge an image on your computer monitor until it breaks apart into little squares of color. The squares are pixels.

PHOTOSITES AND PIXELS

Think of the photosites that are packed into your sensor as millions of tiny color-filtered buckets that collect the light coming through the lens. Each bucket receives a certain amount of red light, green light, or blue light, according to its position in the sensor. The electronics of the photosites convert the light quantity into corresponding electrical signals. The electrical signals are then converted into their digital equivalents by an analog-to-digital converter (ADC). The ADC produces a digital representation of the pixel groupings with brightness levels from 0 to 255.

We mentioned above that the photosites are "color-filtered." That means that each of the millions of sites has either a red, green, or blue filter over its top, and thus collects light only of that color. So, we can refer to red photosites, green photosites, and blue photosites, where each site generates the electrical signal proportional to the received amount of light of its particular color. Light of any color is some combination of the primary colors of red, green, and blue, so the output of

all the sites can easily be combined by an onboard computer (a microprocessor) to produce a set of pixels forming an image of the gorgeously hued mandarin duck.

THE ALL-IMPORTANT HISTOGRAM

This incredibly important tool is a simple bar graph depicting certain characteristics of the exposure. *Its display on the camera LCD is the fastest and most accurate means of ensuring optimum exposures.* It's well worth your time mastering and comprehending a full understanding of the histogram.

The histogram graph is an LCD display of data arranged in a manner that conveniently shows the distribution of dark tones and light tones in your image. This histogram graph makes your exposure easy to accurately and quickly evaluate once you understand exactly what it means. It's a major benefit of digital photography. The camera derives histogram data from JPEG format data files. The data is taken directly from your JPEG images, but if you shoot RAW images, it's taken from an embedded JPEG that's a component of the RAW file.

This graph that is easily viewed on your camera's LCD display shows you the relative brightness distribution of every photosite on your sensor. There are 256 possible brightness levels. A photosite that received little to no light has a brightness level of zero. A full saturated photosite has a brightness level of 255, the maximum possible value. Everything else falls somewhere in-between. The higher the vertical line, the more photosites that have that particular value.

NIX TO THE IDEAL HISTOGRAM

There is no "right" shape for a histogram. The shape of a histogram is wholly determined by the character of the specific image. New digital photographers often wrongly have a feeling that a "perfect" histogram should look like the classical symmetrical bell curve, but that's dead wrong. It is true that one can tell something about an image from looking at the spread of tones represented by its histogram, but it's absolutely false that there's any such thing as an ideal histogram. Consider these examples: A "high-key" image having

We spotted 24 bears in late June during a 12-day personal photo trip to Jasper, Yoho, and Banff National Parks in the Canadian Rockies. This black bear calmly walked along the roadside, stopping here and there to eat the grass. The histogram shows this image has many dark tones with the large mass of data left of the center. However, the few brightest tones in this image do snuggle up to the right wall of the histogram showing it is a superb exposure. Nikon D3, Nikon 200-400mm f/4 lens, f/4.0 at 1/400 second, ISO 3200, and manual exposure.

lots of lighter tones (think white swan on a midday foggy lake), would have much greater area developed on the right side of the histogram (brighter tones) with less area developed on the left side. Conversely, a "low key" image full of darker tones (black bear) would have few pixels contributing to the right side of the histogram and most of the histogram area would be toward the left. Even if both images were perfectly exposed, neither would produce a symmetrical histogram. So, while there's no "right" histogram that works for all images, I can use whatever histogram is produced to tell me something about the spread of tones in an image, and perhaps more important, I can easily tell whether the image is overexposed or underexposed. We'll discuss that in more detail shortly.

The pounding rain forces this impala herd to bunch tightly together to protect themselves from wind, driving rain, and the big cats that may be hunting them. In this overall mid-tone subject, most of the histogram data appears near the middle left of the graph. Canon EOS 1D Mark III, Canon 300mm f/4 lens, f/4.5 at 1/125 second, ISO 1000, and Shutter-priority with a +1 1/3-stops exposure compensation.

CLIPPING

"Clipping" is a term used to describe histogram data that is at the extreme left edge or the extreme right edge of the histogram graph. Remember that pure black pixels have a brightness = 0, and saturated pixels of any color, including pure white pixels, have a brightness = 255. Thus, if our histogram graph shows the presence of a significant quantity of

"0 pixels" as evidenced by having definite vertical height at the *extreme left edge* of the graph, the recorded image has pure black areas without any detail. If the scene being imaged has pure black areas, then OK. But, if the scene has only dark areas that aren't quite black, then we have underexposed those black areas to some degree, i.e., we have "clipped" the shadow areas. We should also remember that the camera's inescapable electronic noise, while not actually generated by the darker areas of the image, is often evidenced by bright specks that are far more visible in the shadow areas of the image.

Some histogram graphs show a definite quantity of "255 pixels" by showing definite vertical height at the *extreme right*

Steller's sea-eagles winter along the ocean beaches of northern Japan. We boarded a fishing boat to motor one mile out to the floating sea ice where they readily accept scraps of fish thrown by the boat crew. Due to all of the light tones in the bird and the ice, most of the histogram data appears on the right side. Canon EOS 1D Mark III, Canon 500mm f/4.0L lens, f/8 at 1/200 second, ISO 1600, and manual exposure.

edge of the graph. If the histogram has significant vertical height at the right edge, then the recorded image has saturated pixels, image areas so bright that they have no detail. There are scenes with highlights of unimportant detail and it's quite okay if those highlights are overexposed. Far more often, though, we wish to preserve highlight detail. There we avoid

overexposure by always guarding against any "clipping" shown by vertical histogram development at the right edge of the LCD graph area. If the histogram shows clipping of important highlights, retake that picture at a lower exposure.

RE-PLACE THE HISTOGRAM

No, don't *replace* the histogram—we need it. Just *re-place* it. If the histogram shows an unsatisfactory exposure, we correct the exposure and the different exposure will have moved the histogram. Suppose we had a clipped histogram shown by vertical development at one end of the graph or the other, or both. We don't change the basic shape of the histogram, but we can move the histogram back and forth between the left and right graph edges by changing the exposure.

Assume a histogram shows underexposure by clipping on the *left* side of the graph. To move the entire histogram to the right, increase the exposure to get more bright tones in the image. Use a larger aperture, slower shutter speed, or higher ISO—any or all will work. Change one or more as dictated by the subject. If the image is overexposed, as revealed by clipping on the *right* side of the graph, we can reduce the exposure and move the histogram to the left, by reducing exposure. Use a smaller aperture (f/11 to f/16 for instance), faster shutter speed, or lower ISO—any or all will work. Here too, select the one best suited to the subject.

COMPENSATING THE EXPOSURE

Aperture-priority, Shutter-priority, Program, and manual are all exposure modes you may decide to use. We will cover these in more detail shortly. Changing the f-stop, shutter speed, or ISO only changes the exposure when using the manual metering mode. Changing the shutter speed, for instance, from 1/60 second to 1/250 second will reduce the exposure by two stops in the manual mode, but not in the others. The automatic exposure modes adjust the f-stop to compensate for a change in shutter speed and vice versa to maintain the identical exposure. Fortunately, all cameras have an exposure compensation control that permits changing the exposure to allow the histogram data to appear in different

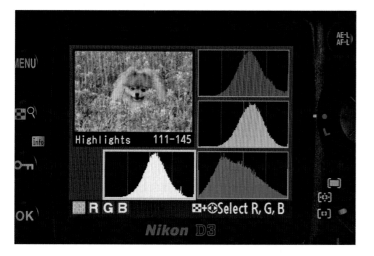

The Nikon D3 histogram display shows both the luminance (averaging) histogram and separate histograms for each of the color channels. We always determine the optimum exposure by looking at the three color channel histograms. In this example with Barbara's dog, Boo, notice the red color channel is just beginning to climb the right wall of the histogram. This is a fine exposure. Never judge the exposure by how the image looks on the back of the camera. Viewing conditions and the brightness level setting for the LCD display vary too much to be meaningful.

places on the chart. In the example above, setting the exposure compensation to -2 will reduce the exposure by two stops if using an automatic exposure mode.

DIFFERENT KINDS OF HISTOGRAMS

LUMINOUS HISTOGRAMS

The luminous histogram, also called the brightness histogram, derives its data from the image by considering all three primary pixel colors: red, green, and blue. Many a photographer successfully relies on the luminous histogram to confirm his exposure judgment, yet that histogram has a trap for the unwary. The luminous histogram takes data from all three color channels, but is "weighted" toward the green channel because our eyes are especially sensitive to green. By so doing, it gives more credence to the presence of green pixels than to the presence of red and blue pixels.

Consider a northern cardinal in his bright red feathers, sitting in a green tree. We push the shutter button and check the histogram. The histogram, heavily based on the green leaves,

shows no overexposure. But when we study the image itself, the poor cardinal is a grossly overexposed red blob. All of the cardinal's fine feather detail is lost and gone forever. Luckily, if the bird has not flown, we can reduce the exposure a stop or so and all will be well. When using the luminous (brightness) histogram, be on the lookout for images with strong color-casts, especially red (sunsets, etc.), and make sure the resulting luminous histogram remains one-half to one stop away from the right edge of the graph. Due to the averaging nature of the luminous histogram, photographing a subject where one color greatly predominates or the color of the light is heavily biased by a single color, such as the red light at sunset, or the blue light in open shade, you may seriously clip a color channel. However, when this data is averaged together, no clipping is shown by the histogram.

RGB HISTOGRAMS

Many cameras offer a second kind of histogram, called an "RGB or Color Channel histogram." It's actually three histograms displayed together: red, green, and blue. Each histogram graph represents only one color channel and shows the brightness of the red, green, and blue pixels individually. To determine the optimum exposure for nearly any type of image, merely note which color is most highly exposed (farthest to the right on the graph display) and while quite ignoring the other two channels, expose to make the rightmost channel's histogram as far to the right of the graph as it can get without vertical development at the right edge of the graph. *This RGB histogram eliminates the pitfalls of the luminous histogram. If your camera manual tells you it's available, by all means activate it and use it.*

Every year we teach hundreds of workshop and seminar students the many merits of using RGB histograms in their quest for perfect exposures. Indeed, the exposure for every image in this book was arrived at with the aid of the valuable RGB histogram.

EXPOSE TO THE RIGHT (ETTR)

A SIMPLE PROCEDURE FOR EXPOSURE OF RAW FILES

The ETTR exposure procedure is based on a simple concept and is widely practiced among serious photographers.

- *Never* judge exposure by the brightness of the image on the LCD panel.
- *Always* use the histogram to judge the exposure. Use the RGB histogram if available, and if not, use the luminous histogram.
- If using the RGB histogram, make exposure adjustments based on the extreme right edge of the color channel that has data farthest to the right.
- If using the luminous histogram, make exposure adjustments based on the very right edge of the histogram area. If a single primary color dominates the image or the light, keep the rightmost data about one-half to one stop from the right edge of the histogram to avoid overexposure.
- Adjust the exposure so that the right edge of the histogram area just kisses the right edge of the graph display, with little vertical development of the histogram on the right edge. Vertical development at the graph edge is often called "climbing or clipping" at the edge of the graph display.

A JUST AS SIMPLE PROCEDURE FOR EXPOSING JPEG FILES

For JPEG files, we recommend exposing slightly differently. Set the rightmost edge of the luminous histogram, or the rightmost edge of the farthest right channel of the RGB histogram, not at the right edge of the graph, but instead about a half-stop away. You can get there by determining the exposure that puts the JPEG histogram at the extreme right edge of the graph, and then reducing the exposure about a half-stop, or you can more precisely use the vertical grid lines on the typical histogram display to judge the exposure. The spacing of the grid lines differs from camera to camera, but Canon lines are about 1-stop apart, and Nikon lines are about 1.5-stops apart.

HOW DOES OVEREXPOSURE LOSE DETAIL?

Photographers speak of image highlights being "blown out" when they're overexposed. What they are really talking about is the loss of highlight detail. Think of a "pure white" swan. We can see fine detail in the swan's feathers only because the feathers are really not all the same tone of white. Some are a tiny bit darker than pure white. Some are a wee bit darker than that. It's the differences in tonality between pixels and groups of pixels that give the detail.

Television "soap" hucksters notwithstanding, there is nothing whiter than white—at least not in photography. Assume my swan image has highlights with some white pixels and some slightly darker pixels. There is pleasing detail in the swan's feathers. Suppose I expose another image a bit brighter. Too much more exposure, though, can raise the brightness of the colors in the darker pixels to the 255 level, making the darker pixels become white, but the already white ones sure can't get any whiter. Now all the pixels are white, all have the same tonality, and I've completely lost the feather detail. As they say, I've blown out my highlights! You might even say my highlights have sung their swan song.

HIGHLIGHT ALERTS

Every digital camera we've ever seen, from the lowliest point-and-shoot to the fanciest DSLR, offers a highlight alert feature. Be sure to activate it because it allows a photographer to instantly see if any parts, and what parts of an image, are overexposed. Then the photographer can quickly make more informed decisions about exposure correction. Overexposed areas of an image conspicuously blink white and black, giving us the term "blinkies." As handy as blinkies are, there's a downside in that they show only overexposure and not underexposure. Consequently, blinkies should not be used alone, but as an aid to histogram interpretation. Between the two, perfect exposures are super-easy to repeatedly obtain.

METERING MODES

Most modern DSLR cameras offer three or more metering modes, or metering patterns. My Canon 7D and 5D Mark II offer modes called Evaluative, Center-Weighted, Partial, and Spot. Barbara's Nikons use three, called Matrix, Center-Weighted, and Spot. Irrespective of the metering mode in use, when the camera has reached a conclusion on the correct exposure, the exposure information is presented to the photographer for input to the camera when a manual exposure mode is in use, and is presented directly to the camera controls when an automatic exposure mode is in use.

CANON'S EVALUATIVE METERING AND NIKON'S COLOR-MATRIX METERING

These are unarguably the most technically and operationally sophisticated metering modes in the history of photography and both Barbara and I use them exclusively. Their meter electronics measure brightness in several areas of the image. Several? Nikon's D7000 measures brightness at an astonishing 2,016 locations within an image and actually measures the colors at all those places at the very same time!

After capturing the measurements, the camera's onboard microcomputer compares them with exposure data stored in the camera's data base, which had been derived from the manufacturer's distillation of thousands of test images. The metering system calculates a recommended (sometimes called standard) exposure based on that comparison, and delivers it to the photographer or to the camera, as discussed above. Not only does a modern DSLR make enormous numbers of light measurements, make comparisons to thousands of reference images, make intricate mathematical calculations, and reach and deliver excellent exposure recommendations, but also does it all in only a few milliseconds!

The multi-segmented metering pattern is the best one to use in almost all situations. It normally gets you close to the ideal exposure, though usually not the most optimum. To get that, most of the time you must compensate the exposure a bit. Situations that are most likely to need adjustment include scenes that are predominantly light or dark and those

in high contrast light. We see no reason to use any of the other metering modes, though spot-metering can be useful for determining the dynamic range of a scene.

AUTOMATIC EXPOSURE MODES

Today's cameras generally offer several automatic exposure modes and a manual exposure mode. Before we venture further, let us issue a warning: We've long ago lost count of the workshop and seminar attendees who confuse and thus misuse, the terms *metering mode* and *exposure mode*. Be sure that the difference is very clear to you—it's important. Returning to the subject, most cameras have a manual exposure mode and also have automatic exposure modes such as Aperture-priority, Shutter-priority and Program. Some cameras also offer some specialized automatic modes such as landscape, portrait, flowers, and so on. Barbara and I feel that for our wildlife photography, and for yours, only Aperture-priority, Shutter-priority, manual, and Program are worth considering.

THE PROGRAM EXPOSURE MODE

The "P" on your camera's dial doesn't stand for "Professional." It stands for, "this is a fully-programmed exposure mode and the camera will make all of your decisions for you although not necessarily very wisely." If in spite of my typing my little fingers to the bone on this book, exposure destroys your composure, if you still can't tell an f-stop from a bus stop, and you still can't speak in "stops," then Program may be the perfect mode for you. I do confess I use Program sometimes for special occasions. When friends and family visit and I drink a couple wine coolers too many, I sometimes use Program because it mercifully doesn't need any input from me. Perhaps "P" should mean "Party Mode."

In the Program *exposure mode*, the metering system uses your selected *metering mode* to automatically set the shutter speed and the aperture. Unfortunately, the camera makes assumptions that may not be at all valid. For example, the Program mode will increase your shutter speed when it detects the

presence of a long lens, assuming (incorrectly, we hope!) that you're hand-holding the camera. To compensate for the faster shutter speed, the camera then opens the aperture, thus perhaps undesirably reducing your depth of field. We definitely do not recommend this exposure mode for the serious shooters who want to be in charge photographically and exercise control over their camera.

Speaking of control, let's explore the all too common misconception that a photographer using a camera in an automatic exposure mode somehow gets better exposures than a photographer using the same camera in its manual exposure mode. *If any automatic exposure mode is used without photographer intervention, the image exposure will be identical, absolutely positively identical, to the same image made in the manual exposure mode without photographer intervention.* If the photographer ought to intervene, and doesn't, the results from both automatic and manual exposure modes will be equally poor pictures. And if the photographer is alert enough to properly intervene, the results from both automatic and manual exposure modes will be equally good pictures. We'll explore the reasons for this statement shortly.

THE APERTURE-PRIORITY EXPOSURE MODE

This exposure mode does exactly what it sounds like. The shooter sets a desired f-stop, makes an exposure measurement, and based on the exposure measurement, the camera, respecting the priority of the aperture, selects and sets a shutter speed. If on the next shot, the light has changed (the sun is setting), the camera will still respect the selected aperture by setting a different shutter speed.

Aperture-priority, generally designated on a camera's controls as "Av" or "A," is probably the most widely used exposure mode of serious photographers. It's very effective in rapidly changing light, when one wants to maintain a specific aperture. The constant aperture may be wanted to maintain a certain depth of field, a certain "sweet spot" in the particular lens, or perhaps the fastest available shutter speed.

Barbara prefers Aperture-priority for some of her wildlife work. She sets a large aperture in order to get a fast shutter speed, because she believes, as do all serious wildlife shooters, that a high shutter speed is crucial to obtain sharp images. This is especially true when using long lenses that bring the wildlife optically closer to the camera, but unfortunately magnify every little vibratory movement of that camera. The higher shutter speeds, with careful focusing and a stable camera support, will be a big help in ensuring sharp wildlife images.

None of the exposure modes are perfect and Aperture-priority is no exception. A common problem we've seen with workshop participants is that when beginning an early morning shoot in dim light, they set their apertures wide open to benefit from the sharpness of higher shutter speeds. As the sun gradually rises and the light gets brighter, the camera selected shutter speeds get faster and faster, sometimes faster than reasonably necessary. Students sometimes forget to react to the new light. Maybe in those circumstances it would be better to reduce the aperture a bit and benefit from the increased depth of field. After all, you really don't need 1/2000 second to stop the action of a motionless red fox curled up in the snow, when you're using a 300mm lens well supported by a tripod or bean bag. And if you want to keep the wider aperture to deliberately limit depth of field and help isolate the red fox from its background, you could still take advantage of the increase in light. Where you can tolerate a lower shutter speed, but want to maintain the aperture, just reduce the ISO an appropriate number of stops, and enjoy the better quality image realized from the lower shadow noise.

A far more serious problem can happen later in the day. Kenya's famous tourist and photographer attraction, the Masai Mara game reserve, is bathed most afternoons in some very bright light indeed. You've set your camera to Aperture-priority and decide to use f/11 because you want extra depth of field. Your camera faithfully considers all of the light reflecting from the scene, and sets your shutter speed to 1/250 second. It's a suitable shutter speed for the Defassa waterbuck standing in the marsh that you're shooting. But, along comes sunset and the light is dropping fast. While you're concentrating on the bat-eared fox that has just emerged from its den, the shutter speed automatically goes down and down and

This red fox became a regular visitor at our Idaho home for five consecutive winters. It happily accepted small dog treats from our hand. She is waiting patiently for us to offer her another tidbit. A tripod-mounted camera and a perfectly still fox let Barbara use a relatively slow shutter speed of 1/90 second. Nikon D70, Nikon 70-200mm lens, f/5.6 at 1/90 second, ISO 400, and manual metering.

down, maybe as low as 1/30 of a second. The bat-eared fox images continue to look great on your LCD panel, but when you look at them later, on the laptop in your luxury tent, they're just not very sharp. Drat! Sharpness is everything and you're very disappointed. As you lie in bed dozing off, you realize you must remember a million simple little things to shoot excellent images time after time. You resolve to watch your shutter speed more carefully.

Barbara uses the Aperture-priority exposure mode successfully because she constantly keeps a critical eye on her f-stops and shutter speeds. I, on the other hand, am not so fond of it. I'm just too occupied with the wildlife to want to break my concentration to worry about f-stops and shutter speeds. I much prefer to use the Shutter-priority exposure mode for some of my own wildlife shooting.

THE SHUTTER-PRIORITY EXPOSURE MODE

Once again, this exposure mode does exactly like it sounds. Select the shutter speed and the camera automatically adjusts the aperture to produce a standard exposure. Most camera

systems use "S" to indicate this exposure mode. Unhelpfully, Canon uses "Tv" (time value) to indicate Shutter-priority. I set the shutter speed and the camera, based on the metered light and the ISO I set, will automatically set the aperture. If the light changes, so will the aperture. I use this mode approximately 50 percent of the time for my wildlife work and manual metering for the rest. Shutter speed is usually crucial for stopping action in fast-moving animals, especially when using long lenses. I'm generally satisfied with a 1/320 second shutter speed when using long lenses on a good support, so I set my shutter speed there and let the camera set the aperture as it sees fit, based on the metered exposure and my ISO. Suppose I start out at 1/320 second and the camera sets f/8. As the light diminishes little by little later in the day, the camera gradually goes to f/5.6, then to f/4, then to f/2.8. Oops! My 500mm f/4.0 lens can't do f/2.8, and remains at its maximum aperture of f/4.0. My images are badly under-

Yellow-billed oxpeckers search large mammals to feed on insects that are attracted to them, benefitting both the bird and this African Cape buffalo. Depth of field (f/10) was favored to get the bird and the face of the buffalo as sharp as possible. I would have preferred the horizon line did not pass through the head of the buffalo, but I have no time to select another shooting spot. Canon EOS-7D, 500mm f/4.0L lens, f/10 at 1/200 second, ISO 400, Shutter-priority with a -1/3-stop exposure compensation due to the overall dark buffalo.

exposed. What now? Fortunately, I've been keeping my eye on everything, so now I just raise my ISO a stop or two and keep on shooting.

The example above illustrates a serious problem with Shutter-priority. Look back at our discussions of stops, and you'll note that a common lens might offer a range of f-stops from f/2.8 to f/22. That's a 7-stop range. Cameras with shutter speeds from 30 seconds to 1/8000 second have a 19-stop range. In Aperture-priority mode, at a fixed aperture, the camera can accommodate a huge 19-stop range of light and still get a good exposure. In my preferred Shutter-speed priority mode, at any fixed shutter speed the camera can accommodate only a 7-stop range of light. Some writers argue that this limitation points to Aperture-priority as the better mode. But watch out—that's a very specious argument. Just because a camera in Aperture-priority mode can accommodate a 19-stop range of light doesn't mean the photographer can. When I'm furiously photographing a spotted hyena in the fast-fading evening light, my camera may be blissfully happy in allowing my shutter speed to drop to 30 full seconds, but I'm sure not!

THE AUTO ISO

Most serious photographers like to be in full control of the picture-making process, so they usually avoid Auto ISO. Consider though a situation in which you set the camera to Shutter-priority. You've set the camera to the lowest shutter speed you think the subject will allow, say, for example, 1/125 second. And let's say you've set the ISO at 200 and are using a 300/4.0 lens. Measuring the light, the camera responsively sets the aperture to f/8. As the light goes down, the aperture automatically opens, to f/5.6, then to f/4, and that's the end of the line for aperture adjustment. The camera, not to be foiled by dim light underexposure, automatically increases the ISO to produce a good exposure. Yes, the increased ISO comes with some increase in image noise, but that increase may not be noticeable, and even if some noise does creep in at higher ISOs, it beats an unsharp picture or one grossly underexposed.

Barbara and I led a photo tour to the Galapagos Islands two weeks before writing this. We intensively photographed the unique Galapagos penguins and other wildlife from zodiacs bobbing in the ocean swells. To improve the odds of capturing sharp images of the penguins in the dim afternoon light hand-held—a very tough shooting situation indeed—we set Shutter-priority and selected a shutter speed of 1/1000 second. By using Auto ISO, the camera sets the aperture wide-open (f/4.0 with our lenses) and lets the ISO move up and down to produce a fine exposure. When you must lock in a fast shutter speed and keep the lens wide open, Auto ISO works incredibly well for adjusting to changing light. This technique is widely known among sports photographers, but little known to wildlife shutterbugs. This sad situation has got to change. At times, in certain situations, combining Shutter-priority with Auto ISO is enormously useful!

EXPOSURE COMPENSATION

A thorough understanding of exposure compensation is what separates the experienced photographer from the newcomer. There's not much that's more important to your photography than a good understanding of how an exposure meter works, why it needs intervention much of the time, and when and how the photographer must intervene to compensate for the meter's shortcomings. Although we're delving into meter behavior in this section on automatic exposure modes, do remember that *the meter has exactly the same shortcomings when using the manual exposure mode and is equally in need of photographer intervention.*

Let's start by noting that we conventionally use reflected-light meters, meaning that these meters measure the amount of light reflected from our subject. The amount of reflected light depends on two factors. One, is the brightness of the available light, also called the incident light, that is falling on the subject. Two, is the percentage of that available light that bounces off the subject because of the subject's reflectivity (also called subject reflectance).

The bright light of a sunny day can be falling on our subject, or the dimmer light of a cloudy day. So, the available light

varies. Suppose we want to photograph black bears today and white mountain goats tomorrow. We recognize that white goats have a higher reflectivity than black bears. However, our light meter is unable to tell whether a metered scene is dark because it is a black bear in overcast light, or because it is the white goat in the very dim light of late evening. The converse is true, too. A scene that is metered as quite light might be the white goat in overcast light or might be the black bear in very bright sunlight. Yet, in order to provide proper exposure information—to make our black bears black and white goats white—the meter has to know.

Back at the camera factory, the poor overworked meter engineer has a conundrum. Is it the light, is it the subject, or is it both? But, the meter must know, so the engineer designs the meter to make a major assumption and it's this assumption that's so critically important for the photographer to understand and to remember with every shot:

> The meter is designed to assume that all subjects are of medium reflectivity.

Medium reflectivity is the reflectivity of most of the world we live in, whatever that means. There's been decades of controversy, but meter designers have largely accepted that our world in general reflects about 18 percent of the available light, so they design their meters to think that everything, absolutely everything, reflects 18 percent of the light that falls on it. The brainwashed meter "thinks" that the black bear reflects the same amount of light as the white goat. With that assumed, any measurement of the reflected light can easily be extrapolated into a measurement of the available light. Now we can do business! Sort of, anyway. What do we do about the fact that our bear really reflects only 7 percent of the available light and our goat really reflects 75 percent of the available light?

Using the assumption that all subjects have the same reflectivity, the meter is able to offer a result based presumptively on the available light. That assumption, however, results in meter readings that if slavishly followed, would make every

subject mid-toned in the image. The meter makes everything mid-toned, but who wants a gray goat? Enter the photographer. Understanding his/her meter, the skilled photographer knows that he/she must not always rely on its data. Consider the subject and the metering mode, and then decide whether to modify the meter's data and compensate the exposure.

The meter will properly expose a mid-toned subject, but when the subject is not mid-toned, exposure compensation is required and it boils down simply to a matter of how to do it, which way to do it, and how much to do it.

The how-to part depends on the camera and the exposure mode. Compensation in automatic exposure modes is usually done by entering the desired number of stops or partial stops into a "compensation" knob or into a menu setting. Compensation is generally done in the manual exposure mode by merely changing the aperture or the shutter speed (in some cases, the ISO) to provide the desired reading on the exposure meter scale.

Do you add light or subtract light? A polar bear walking on a bank of clean white snow will surely need some plus compensation. Will it need plus compensation if it is walking on a Hudson Bay shoreline of dark rocks? If you use the multi-segmented metering pattern as we strongly suggest, the metering mode considers both the light fur of the bear and the dark rocks. The tones of the white bear tend to cause underexposure, but the dark rocks tend to cancel out the influence of the white fur, but probably not perfectly. The best way to know how much compensation is needed is to shoot a quick image of the bear, check the rightmost data of the histogram, use the exposure compensation control to adjust the exposure, if necessary, and then shoot excellent exposures. Remember to expose your RAW or JPEG image according to the guidelines we have already spelled out. If the rightmost data on the histogram is one-stop short of the right edge, then use the exposure compensation control and set it to +1-stop for any automatic exposure mode or do it manually with manual exposure.

Let's use a real-world example from four consecutive July mornings. I was wearing chest waders and slowly moving

about a nearby marshy bay while hiding in my camouflaged floating blind. I shot more than 5,000 images of red-necked grebes, Forster's terns, ruddy ducks, and yellow-headed blackbirds. Although I prefer manual exposure, I used Shutter-priority because the blind—which resembles what might be imagined as a floating muskrat condo—is a bit cramped and dark, making it difficult to see the information display panel

on top of the camera. If the light is ample, I like to use ISO 640 and a shutter speed of 1/1000 second to arrest the continuous camera movement created by ripples in the water. Often this ISO and shutter speed let me stop down to f/5.6 or f/8.0. I always use the Evaluative metering mode with my Canon digital cameras. Because the Evaluative metering mode considers everything in the viewfinder, I don't dwell too much on whether the subject is the white Forster's tern or the darker red-necked grebe. I simply set my exposure compensation dial to the zero (null) position and shoot the image. Then I immediately check the histogram to see where the rightmost data lies. If the data falls short of the right edge of the histogram,

This bald eagle calmly perches on a deck railing eight feet away in Homer, Alaska. During February, eagles converge on Homer for hand-outs from eagle viewers and many tolerate a close approach. Barbara stopped down to f/18 to make its face as sharp as possible and focused slightly in front of the eyes to make its beak sharp, too. Nikon D3, Nikon 200-400mm f/4 lens, f/18 at 1/125 second, ISO 640, and manual exposure.

I add light by turning the exposure compensation dial to plus compensation and shoot another image to check it. If the rightmost data just touches the right edge of the histogram, then all is fine. If the rightmost data is climbing the right edge (clipping), then I subtract exposure with the exposure compensation control until everything is just right. In short, I compose the subject and shoot the image to get the histogram to determine the exposure.

In practice, don't worry too much about the reflectance of the subject and its surroundings. For example, even though Forster's tern has brilliant white feathers and you might think adding light is necessary, the dark vegetation and shadows around the tern are dark. The meter considers everything in the image and suggests a standard exposure. Since the tern was surrounded by mostly dark areas, setting a minus 2/3-stop compensation to keep detail in the whitest feathers was necessary. If one used a spot meter and metered only the whitest feathers, then a +2 compensation may have been necessary. Truly, exposure is quite simple. Shoot a quick exposure to get the histogram and make an exposure compensation (if necessary) according to what the rightmost data of the histogram indicates. Be aware most cameras have two exposure compensation controls: one for flash, and another for natural light. Be sure to use the natural light one!

AUTOEXPOSURE PROBLEMS

Autoexposure modes can offer several valuable benefits for certain kinds of shooting. But, like the manual exposure mode, they are only as good as the shooter's willingness to understand the exposure meter and properly use compensation. We rarely use autoexposure for macro or landscape work, but we do use it 50 percent of the time for wildlife photography. When we do use it, though, we always keep on guard for a few serious problems with its use.

CHANGES IN SUBJECT REFLECTANCE

A word of caution while you are busily filling the camera's viewfinder frame with an immature bald eagle sitting on a snag in a dead tree. Immature bald eagles are generally dark with a few white feathers. The mostly dark bird causes the camera to overexpose a bit. You cleverly remember to compensate by using a bit of negative compensation to preserve detail in the few white feathers this young eagle has. You dial in a stop or so of minus compensation, take another shot, and confirm the new exposure by ensuring that the histogram area representing the white feathers is ETTR. No sooner have you acted, when papa eagle comes along, scares away the youngster, and sits on the same snag. Papa eagle is adorned with far more white in his neck and head feathers. Your meter sees the extra white and reduces the exposure. You forget to readjust your compensation. You get one very dark eagle. The moral of the story is that your must always monitor your histogram and adjust compensation, *any time* a changing subject introduces a change in reflectivity.

CHANGES IN BACKGROUND REFLECTANCE

Many animals rapidly move between dark backgrounds and light backgrounds, creating a serious challenge for autoexposure. You're flat on your belly photographing a sandpiper on the beach. The feisty little bird is erratically flitting back and forth between the bright white dry sand and the dark wet sand. At every transition, your meter dutifully responds with an exposure change. But, do you really want a change? Most likely you don't. You want the bird properly exposed, with the sand being a lower priority. Yet, wherever the bird runs, he's in the same light and once having confirmed a good exposure with your histogram, you sure don't want the autoexposure system to keep changing it because of changing backgrounds.

Sandpipers on sand are but one tiny example of this problem. If you are fortunate enough to photograph a Steller's sea eagle flying in a deep blue Japanese sky, then diving down so the background is a white ice floe, and then flying over a background of dark green seawater, you must contend with at least three radically different background reflectances. The meter offers three different exposures, but as long as the eagle is in the same light, you want the one exposure and only the one

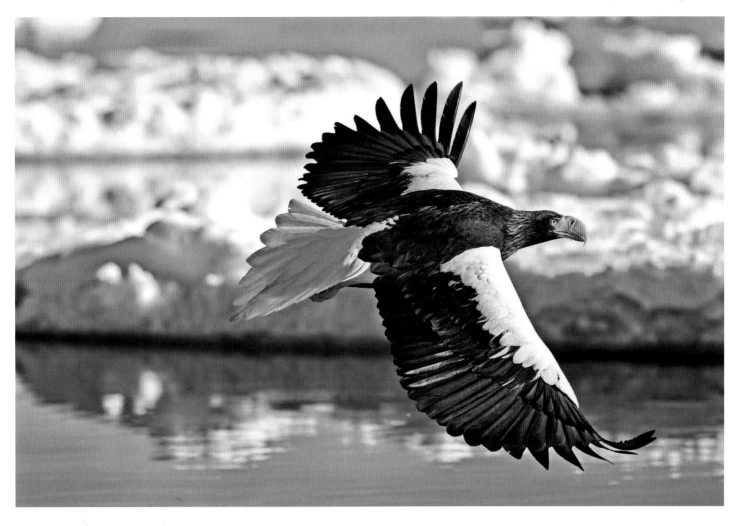

exposure, that results from ETTR with no blinkies on the white feathers. If the automatic exposure is set to properly expose the eagle against the blue sky, the camera will underexpose it against the white ice background and overexpose it against the dark ocean water. Manual exposure is the best answer here.

In the above examples and whenever faced with rapidly changing background reflectivity, autoexposure is not a good idea and may produce an exposure disaster. *Use manual exposure to set the proper exposure for the available light and the subject, and let the lower priority background exposure wander around as necessary.*

This awesome Steller's sea-eagle passed by the eagle viewing boat in northern Japan. By using a 500mm lens mounted on a Wimberley Sidekick and Kirk BH-1 Ballhead, I panned smoothly with it to capture a sharp image. Canon EOS 1D Mark III, Canon 500mm f/4 lens, f/8 at 1/1000 second, ISO 400, and manual metering.

CHANGES IN COMPOSITION

Changes in composition that affect meter readings must be accompanied by changes in exposure compensation. You're photographing a handsome all-white snowy egret that's perched on a floating log in a Florida pond. The pond is filled with dark green vegetation and the egret fills about 40 percent of the frame. You've taken a meter reading, checked your histogram, added +1/3- stop of compensation for ETTR with

no clipping, and checked again. All is well, and you make a nice shot. You decide to move closer, or zoom in, for a tighter shot. The all-white bird now fills about 85 percent of the frame, displacing some of the darker vegetation. The meter acknowledges by reducing the exposure, as meters will do,

Gerenuks are graceful desert mammals commonly found in Kenya's Samburu National Reserve. They are uniquely adapted for desert life because they obtain all of their water needs from the food they eat. They often stand on their hind legs to eat succulent leaves that other herbivores can't reach. I used f/13 to maximize the sharpness of each animal in the group. Canon EOS 5D Mark II, 500mm f/4, f/13 at 1/250 second, ISO 400, and Shutter-priority with a minus 1/3-stop exposure compensation.

when it "sees" more light tones. If you're not on your photographic toes, you forget to change the exposure compensation. By forgetting in the egret example above, you'd allow the histogram to move left, you'd lose valuable detail in your image highlights, and you'd pick up additional shadow area noise, resulting in a degraded picture. The opposite circumstances might even be more dangerous. When the white snowy egret is made smaller in the frame, and the dark pond larger, the obedient meter would tend to cause overexposure, thus "blowing out" the delicate egret feathers and ruining the image.

The moral of the story is those changes in composition that make a difference to meter readings must be recognized as necessitating changes in exposure compensation. In this case, too, manual metering is really more efficient. Once the optimum exposure is set by using ETTR, the manual exposure remains excellent, no matter how large or small the egret is in the frame.

SUMMARY OF AUTOEXPOSURE

Autoexposure can be a fast and accurate means of camera operation as long as you remember its major shortcoming— its propensity to change its exposure recommendations when you don't want it to. It can make those unwanted changes when the subject changes, when the background changes, and when the composition changes.

The solution for those problematic changes is simple—just use the manual exposure mode. You manually adjust your exposure for the available light, the subject, the background, and the composition, to get an ideal histogram with no clipping. Then, as long as the amount of available light doesn't change, your subject will be properly exposed.

Notice that I just said "as long as the light doesn't change," and therein lies the true value of an autoexposure mode. When the light is rapidly changing, such as when the sun is flitting in and out of the clouds, one oftentimes just can't keep up manually, and autoexposure does come to the rescue. Both Aperture-priority and Shutter-priority are efficient if you must change the depth of field quickly. Perhaps a stately group of giraffes is approaching your safari vehicle. Your camera's exposure is set to f/8 at 1/500 second. To get all of the giraffes as sharp as possible in the image, you set the aperture to f/16. If using Aperture-priority, simply set the aperture to f/16 and the camera automatically changes the shutter speed to 1/125 second. In the Shutter-priority exposure mode, lowering the shutter speed to 1/125 forces the camera to change the aperture automatically to f/16. Either way, you get two stops more depth of field. Let us not forget the enormous power of using Shutter-priority along with Auto ISO to handle low light situations where high shutter speeds must be maintained.

USING MANUAL EXPOSURE

First, we need to locate the one or more metering scales that are used to set the exposure. There will be a metering scale in the viewfinder, perhaps horizontally on the bottom or perhaps vertically on one of the sides. There may also be a metering scale presented on an LCD display, or on some cameras, even on 2 LCD displays. A metering scale will look something like this:

$$-3 .. -2 .. -1 .. 0 .. +1 .. +2 .. +3$$
$$|$$

In some cameras, the scale won't go from −3-stops to +3-stops, but only from −2 to +2. And depending on camera and user selection, the two intermediate dots each representing 1/3 stop may be replaced by one dot that represents 1/2 stop.

Let's photograph an inquisitive Columbian ground squirrel in Jasper National Park. Use your evaluative or matrix metering mode and set the camera to manual exposure. The squirrel is eating dandelions and to freeze the movement of the squirrel and arrest any camera shake, you set a shutter speed of 1/320 second. Now adjust the aperture control until the exposure indicator mark centers by pointing at the "0" position on the scale. Don't waste time trying to decide if the overall image (squirrel plus its surroundings) is brighter or darker than mid-tone. Just shoot the image and quickly check the histogram and take notice to see if any "blinkies" are present. If the histogram is exactly what you want, then go ahead and shoot more images. If the exposure is a little dark, according to the histogram, manually add light by opening up the aperture and shoot another image to check the histogram. If the image is overexposed, stop the lens down more to reduce the exposure. Use the ETTR guidelines we described earlier to shoot superb exposures time after time. Naturally, you confirm your exposure by using your histogram to ensure ETTR and no blinkies. That's all there is to it! There is no extra exposure compensation setting to make, as you must when using autoexposure.

Be certain to watch for the following:

Columbian ground squirrels are curious and fun to photograph. I lay on the ground and spread the tripod legs widely to use a low shooting viewpoint. This position made me seem smaller to the squirrel and less threatening. This one quickly resumed picking and eating dandelions. Canon EOS 5D Mark II, 500mm f/4 lens, f/7.1 at 1/320 second, ISO 500, and manual exposure.

- If you're metering an exposure that's off-center by more than the maximum 2 or 3 stops than the scale presents, the indicator may be off the scale. In some cameras, the direction of that indicator is shown by a flashing signal or an arrow. If the indicator is on the underexposure side, add light with the aperture, shutter speed, or ISO to move the exposure mark back on the scale. Do the reverse if the indicator is on the overexposure side of the scale.

- Do remember the following: If the amount of available light changes, manually change your exposure!

KNOW YOUR HISTOGRAM

Look carefully at your camera's histogram display. Other than the lines forming the right and left edges of the display, most cameras have three or four vertical lines in-between the edges. It's quite handy in judging exposure changes, to know how many stops are represented by the spacing of those lines. Here's how to tell: Shoot a white piece of paper in even light. With the entire subject having only one tonality, the histogram should be a narrow vertical line itself. Take several

successive exposures, a third of a stop apart, and watch how the histogram moves across the display. My Canon cameras have four vertical lines between the left and right edges of the histogram display and they're spaced about 1.2 stops apart, which I usually just consider as a rounded-off one stop. Barbara's Nikons have three vertical lines spaced about 1.6 stops apart.

Knowing the histogram makes for speedy operation. Say you shoot an image with your Canon and your histogram's right-most data falls "one line" away from the right edge. You've learned that's about 1.2 stops. You know that for ETTR, you must bring the histogram up close to, but not climbing, the right graph edge, so you immediately decide to add 1 stop. No complicated arithmetic here! Not only that, but you don't even have to look in your viewfinder. If your camera is set to work in 1/3 stop increments, merely rotate your shutter speed control or your aperture control in the direction that adds light by 3 clicks and you're there—just count three clicks.

REVERSING THE CONTROL DIALS

Another way to speed up your camera operation is to carefully check to see which way your controls work. To add light, do you turn your aperture control clockwise or counterclockwise? Do you increase shutter speed by turning the knob right or left? Do you have to fiddle with the knobs to find out? Sometimes the controls seem "backwards" because they are counterintuitive. Generally, most folks prefer to "add" or "increase" the exposure by turning a knob to the right (clockwise). After all, adding light moves the histogram data to the right and vice versa. Doesn't it make more sense to turn the dials to the right to add light, too? Either way, if your camera controls seem backwards to you, explore whether there's a custom function or menu choice allowing reversal of the control directions. Most Canon cameras have a custom function called "Dial Direction during Tv/Av." Choose Option #1 to reverse the dial direction. Although unstated, it works in manual exposure, too. Many Nikons also do this via their menu choices. Indeed, some Nikons let you reverse the metering scale in the viewfinder so plus compensation is on the right and minus is on the left. To learn whether your controls can be reversed, study the manual, contact your camera maker, or ask this question on the Internet photo forums.

OUR METERING PREFERENCES

Our own metering techniques continue to evolve as we develop new strategies to solve the exposure problems we encountered in the field. New technologies, such as Auto ISO, suggest new metering methods. Certainly no metering method works for all people, or for all circumstances, so we do our best to clearly explain how we do things and the reasons for it. You can select the strategies that work best for you. Even Barbara and I occasionally differ on which exposure tool is best for a given situation.

BARBARA'S METERING METHODS

Aperture-Priority

Barbara uses Aperture-priority for much of her wildlife photography, when conditions involve changing light. She sets the aperture and lets the camera select the shutter speed necessary to obtain the standard exposure, that is, the metered exposure before she applies any compensation. She carefully checks her histogram and her highlights, just as we so strenuously recommend to all. Then she introduces any compensation necessary to make her histogram ideal and without blinkies in important highlights. Even with that perfect histogram, though, Barbara diligently remains aware of her shutter speed and her ISO, to ensure that changes in the light don't make the shutter speed so slow that her image sharpness is at risk.

Manual Exposure

Manual exposure is certainly Barbara's choice of exposure when shooting wildlife and the light is not rapidly changing or anytime the background is white ice or snow.

JOHN'S METERING METHODS

Shutter-Priority

When I choose to use an automatic exposure mode, I much prefer Shutter-priority in my wildlife work to ensure image sharpness is not degraded by unarrested subject motion or camera shake. Generally, I start with 1/320 second, as that freezes the movement of most animals and minimizes the problem of camera shake. The camera determines and sets the standard exposure. As always, I do enter whatever exposure compensation is needed to obtain that ideal histogram, the one obtained by ETTR and having no blinkies. While on the histogram soapbox once again, we both use the RGB histogram because of its greater accuracy compared to the luminance channel (brightness) histogram. If the light diminishes to the point where I need a larger f-stop than my lens offers, and I risk underexposure, I set my Canon's Auto ISO feature to make it automatically and effectively come to the rescue.

Manual Exposure

I use the manual exposure mode for at least 60 percent of my wildlife photography and 99 percent for everything else. That said, most animals are not only black or only white—they generally offer a mid-toned or near mid-toned subject to meter, thus they're reasonably good targets for automatic exposure, too. However, I've long perceived and recognized that manual exposure offers me a more convenient way of dealing with the occasionally changing photo situation like a dark brown bison walking past me in the newly fallen snow of a Yellowstone meadow. As the bison becomes larger in the image, manual exposure preserves the highlight detail in the snow. Any autoexposure mode quickly overexposes the snow, unless there is a way to lock the automatic exposure for *as long as necessary*. Most cameras don't offer such a control, but some do.

CONCLUSION

This chapter has covered a large amount of details and strategies. Give yourself plenty of time to assimilate them. And perhaps the most important conclusion of all is to be truly diligent in using your histogram. Unrelenting careful use of the histogram and blinkies will eventually, but inevitably, make you an exposure expert. Exposure will no longer occupy very much of your mind when you're shooting. Then, you can "take your wildlife photography to the next level" by concentrating on the light, the composition, and the image sharpness.

CHECK OUR WEBSITE

Many of the topics in this book are covered in far greater detail in articles posted on our website. Back-button focusing, manual metering strategies, and even an expanded version of this chapter is more thoroughly explained in these articles. They are free to read on: www.gerlachnaturephoto.com.

4

Precise Focusing Techniques

THE ART OF FOCUSING

Shooting images that aren't as sharp as they should be is an enormous problem for beginning and experienced photographers alike. Capturing truly sharp images is the result of using excellent lenses, employing superb shooting techniques, and pinpoint focusing.

Focusing strategies are so crucial and poorly understood that they deserve a detailed discussion all by themselves. From our experience in teaching many thousands of students in the field how to shoot excellent images, we see the many small mistakes they must correct to capture high quality images. Everyone shoots unsharp images at times, but there are numerous ways to significantly improve the odds of making truly sharp images.

YOUR FOCUSING GOAL

In wildlife photography, the main goal is to focus precisely on the eyes of the subject to make them as sharp as possible. In some ways, this makes wildlife photography easier than landscape or macro photography because everyone instantly knows where the pinpoint focus should lie. There are exceptions, though. Some birds have long beaks and some mammals have long noses. When these subjects look directly at the camera, focusing precisely on the eyes may cause the tip of the beak or nose to be too far out of focus because the depth of field isn't adequate. In this case, use a smaller f-stop, f/11 over f/5.6, and focus between the tip of the beak or nose and the eyes. Hopefully, this makes everything acceptably sharp.

LEFT: These common zebras were part of a large herd that waded into a small pond to drink. These two are especially cute because they crossed their necks while drinking. Nikon D3, Nikon 200-400 f/4 lens, f/13 at 1/250 second, ISO 400, and manual exposure.

ADJUSTING THE CLARITY OF THE VIEWFINDER

Most cameras offer a dioptric adjustment knob that lets you adjust the clarity of the viewfinder to best suit your eyesight. Do this before anything else because you can't determine when you have pinpoint focus unless you can see the subject clearly in the viewfinder. Adjusting the viewfinder clarity has nothing to do with focusing the lens directly. Rather, it simply lets you see the image in the viewfinder clearly, so you can see when the lens is well-focused.

Here's an easy and precise way to adjust the viewfinder clarity. To avoid confusion, take the lens off the camera. Now point the camera at the sky or any bright area and look at any lines, such as AF points, that are etched in your focusing screen. Turn the dioptric adjustment knob until these lines are sharply focused. When you reach the point of greatest sharpness, the viewfinder is set for your vision. Always recheck the setting from time to time. It's all too easy to accidently turn the dioptric adjustment knob on many cameras and your eyesight may change over time.

USE FILTERS ONLY WHEN NECESSARY

Avoid Protection Filters

Your lens maker puts plenty of expensive research, thought, and time into the making of your lens to optimize its performance. Any extra glass you add to the optical path can cause a slight to serious loss of sharpness. Putting a glass "protection filter" on the front of your lens is widely advised, but not by us. We never use "protection filters," do not own any, and do not recommend them! The quality of the really cheap filters is so poor that image sharpness is seriously compromised.

We understand your passionate interest in protecting your expensive lenses. Instead of using protection filters, we hope you will be careful to avoid dropping or bumping your lenses. Always use the lens hood because it greatly reduces the chance of having rain drops splash on your lens. This creates a smudge when it dries and fuzziness in the image. The hood keeps objects that may scratch the glass away from it.

We seldom use polarizing filters to photograph wildlife. The polarizer costs two shutter speeds, so it is difficult to give those up. However, when photographing shiny animals like hippos and crocodiles, or animals in the water, the polarizer removes the glare and darkens the blue water behind this spur-winged plover. Notice the spurs emerging from the bends in the wings. Canon EOS 5D Mark II, 500mm f/4.0L lens, f/11 at 1/250, ISO 400, polarizer, Shutter-priority with a +2/3-stop exposure compensation.

Polarizing Filters

Because polarizing filters absorb 1.5 to 2 stops of light, this will cost the photographer about two shutter speeds. Since using high shutter speeds is so crucial to sharp images, often you must use higher ISOs (more noise) or larger apertures that offer less depth of field. We don't use polarizers very much in wildlife photography because we don't find them to be that helpful in most cases. However, they are useful and we strongly advise using them for shiny "critters" like hippos and crocodiles. Polarizers are effective for reducing glare on water and saturating colors when photographing aquatic animals and wading birds. If the shooting angle isn't directly toward or away from the sun, the polarizer will nicely darken a blue sky. Animals against the darker sky look more dramatic.

Lens Speed

A camera's autofocus system is the fastest and most accurate when it "sees" plenty of light. Of course, it is easier to auto-focus in bright available light conditions. However, lens speed is another crucial factor. Serious amateur and professional wildlife photographers generally opt to use fast lenses such as a 300mm f/2.8, rather than a 300mm f/4, which is 1-stop slower. Although the f/2.8 lens is only one stop faster than the f/4.0 lens, the 300mm f/2.8 lens offers three valuable advantages:

1. *Brighter viewfinder.* The 300mm f/2.8 lens passes one more stop of light through the lens. The camera's viewfinder is twice as bright. This gives the autofocus system more light to work with to achieve sharp focus. Autofocus may be faster and more accurate. If you must focus quickly, the details in the subject are brighter and easier to see, enabling you to find sharp focus faster.

2. *Less depth of field.* A lens with a f/2.8 maximum aperture shows less depth of field than f/4 when you view the subject in the viewfinder. When you manually focus, the subject appears to "snap" into focus with the shallower depth of field. This greatly improves your chances of sharply focusing the lens. Also, if you do shoot at f/2.8, the background, and foreground in some cases, will be more diffuse than if you use f/4.0.

3. *Easier to use high shutter speeds.* A fast lens lets you use higher shutter speeds more easily and often. If the optimum exposure is 1/125 second at f/4.0 at ISO 200, the fastest shutter speed you can use with a lens that has a maximum aperture of f/4.0 is 1/125 second, unless you increase the ISO. If you have a maximum aperture of f/2.8, you can open up the aperture to f/2.8 which adds one stop of light. To maintain the optimum exposure, change the shutter speed to a more advantageous 1/250 second.

DON'T NEEDLESSLY USE ACCESSORIES THAT COST YOU LIGHT

Common lens accessories that photographers use include polarizing filters, extension tubes, and teleconverters. All of these devices cost you light. Don't use any of them unless you have an exceptionally good reason to do so. Some photographers put a teleconverter on their zoom lens, just in case they need to photograph something far away. If the subject you are photographing is nicely covered within the zoom range of the lens—without the teleconverter—take it off. It's unhelpful to needlessly use a teleconverter because the light it absorbs hinders autofocusing. It also adds more glass to the optical path, and we all know that isn't good for image sharpness. Obviously, if you truly need the teleconverter to increase the magnification, the polarizer to eliminate glare, the extension tube to focus closer, then go ahead and use them.

MANUAL FOCUSING TECHNIQUES

We tend to be suspicious of automation, especially in our photography equipment. Our careers began before autofocusing lenses were considered reliable. For more than 15 years, we relied exclusively on our ability to manually focus the lens to achieve sharp focus. Over time, the precision of autofocusing lenses has greatly improved while our eyesight has slowly declined. Eventually, we realized autofocus is more accurate and much faster than we are at manually focusing lenses. We now use autofocusing most of the time. If you are older than 40, it's likely autofocusing will do a much better job than you do, even if you refuse to admit it. There is nothing to be gained by denying the aging factor. It's best to adopt autofocus and learn to use it well.

However, no matter how good autofocusing is, there are times when you must use manual focus. Remember to set the viewfinder diopter for your vision, take your time, slowly rotate the focus mechanism back and forth until you arrive at the best focus, and hope for the best. Many use the focus indicator light in the viewfinder to help them, though we tend to ignore it and rely instead on how the focus appears in the viewfinder.

WHEN MANUAL FOCUS WORKS BEST

Placing the Depth of Field

Although modern autofocusing lenses are amazingly precise, at times they must be focused manually. Animals with long noses or beaks that are looking directly at you should be focused slightly in front of the face to let the depth of field cover everything better. It is easier to select this spot by manually focusing the lens. Do stop the lens down a bit more (from f/5.6 to f/11 for instance) to gain depth of field.

FOREGROUND OBSTACLES

Sometimes you must shoot through foreground vegetation to capture a fine image of a subject such as a lion or burrowing owl. Autofocus tends to focus on the nearest object—the grass—instead of the subject. When it is necessary to focus past foreground objects, manual focusing works best for most photographers. However, a new autofocusing feature of the Canon 7D, called Spot AF, now lets me handle this situation most of the time by combining Spot AF with back-button focusing.

LOW CONTRAST

Autofocusing mechanisms must "see" contrast to sharply focus the lens. Sometimes autofocus struggles to hit sharp focus on dense foggy days when the fog greatly reduces the contrast in the scene. If the camera "hunts" for focus, switch over to manual focus. However, a little known, but enormously powerful technique called back-button focusing still allows you to use autofocusing in the fog most of the time. We'll discuss back-button focusing shortly.

HEAVY SNOWFALL

Autofocusing doesn't work well in dense falling snow. The focusing mechanism "sees" the falling snow, causing the lens to focus back and forth as it detects snowflakes at different distances from the lens. Manual focusing is the best way to handle falling snow. We live in the mountains near Yellowstone National Park where snow falls and blankets the landscape from late October through early May. We get plenty of experience photographing in falling snow. Let's look at some solutions.

Heavy snowfall creates a magical situation for wildlife photographers. Manual focusing does a fine job most of the time. But snow can be so thick that it makes manual focusing difficult. While leading a photo tour in Yellowstone National Park, we discovered the best way to manually focus the lens when the snow makes it difficult to see the subject well. Early one morning while leading a group, we found ourselves to be the first ones to discover a pack of gray wolves eating an elk on the other side of the Madison River. The animals were more than 50 yards away, so our group members used their longest telephoto lenses. Staying on the groomed road, they set up their 500mm lenses and tripods, metered to keep detail in the snow using ETTR, composed the wolf, and focused by turning on their live view. This let them view the image that will be recorded by the camera on the LCD monitor. Magnifying the face of the wolf in the live view image by 10x enabled us to easily focus manually on the eyes in the swirling snow. This strategy works beautifully. Always remember to use the magnified live view image in tough manual focusing situations.

TELECONVERTERS MAY PREVENT AUTOFOCUSING

Cameras typically require a specific lens speed for autofocus to work. Indeed, many cameras require a speed of at least f/8 and sometimes f/5.6. If the lens speed is any slower than f/8, such as f/11, the camera can't autofocus. Almost all lenses are f/8 or faster, so this problem shouldn't happen when you shoot with a lens without accessories. However, when teleconverters are used, the problem of losing autofocus becomes

The Grizzly Bear and Wolf Discovery Center in West Yellowstone, Montana, exhibits both species for public viewing and education. Since we live nearby, we visited the center during a blizzard. About six inches per hour fell as we photographed the captive grizzly bear in the dense snowfall. Manual focusing is required because the falling snow confuses autofocus. Fortunately, the snow does hide the obnoxious fences behind this magnificent bear. Nikon D3, Nikon 200-400mm f/4.0 lens, f/5.6 at 1/125 second, ISO 1600, and manual metering.

common. For instance, if you put a 2x teleconverter behind a 300mm f/5.6 lens, the lens now acts like a 600mm lens with a maximum aperture of f/11. The subject is suddenly much larger in the viewfinder. But the autofocus will not function with such a slow lens speed. This forces you to use manual focus.

TILT/SHIFT AND PERSPECTIVE CONTROL LENSES

These lenses do not offer autofocus because the lens is designed to tilt (bend) in the middle and to shift the image about the sensor. These moving parts of the lens make it difficult to build autofocusing into the lens. Therefore, careful manual focus is required to effectively use them and we use live view to help us.

AUTOFOCUSING TECHNIQUES

All of our Nikon and Canon cameras offer numerous autofocus options by using menu choices and/or custom functions. No doubt, your camera offers far more autofocus controls than you realize. Sadly, the vast majority of wildlife photographers fail to avail themselves of many wonderful autofocus controls. These controls could help them capture exquisite wildlife images more easily. Unfortunately, they either don't know they exist, or fail to perceive their powerful benefits.

Let's open up a wonderful toolbox of autofocus controls and strategies for you. Unfortunately, all cameras don't offer the same autofocus tools. Even when tools from two or more camera makers do the same thing, often different names are used. This creates a dilemma. Do I write about autofocusing options that your camera may not have, or be called something else, or not? Or, do I show what is possible with a camera I use and encourage you to study your camera manual carefully to see if you have these likely options? We all agree the camera manual isn't the most exciting instruction book to read. However, it is worthwhile to spend a lot of time studying it. Today, many books are written on specific camera models. These are far better than the brief and poorly illustrated instructions in the camera manual.

Perhaps the best way to cover autofocusing options is to generally describe those offered by the Canon 7D. It's an intermediate level camera that is similar to those used by most nature photographers. I will briefly describe some options and point out where, when, and how these options are useful for capturing exciting wildlife images. I realize you probably aren't shooting this camera, so take the time to look carefully at the autofocus controls offered by your camera to see if it has similar ones.

SETTING AUTOFOCUS

Read the instruction manual that comes with your lenses and cameras carefully to determine how to set manual focus and autofocus. The method depends on the system. For example, Canon has switches on the lens to set it to manual or autofocus. Nikon uses switches on the camera body to do the same.

THE FOCUS LIMITER

Some lenses allow you to limit the autofocus search range to speed up autofocusing. For example, the Canon 500mm f/4 lens offers three choices. The lens can be set to search between 4.5 meters to infinity, 4.5 meters to 10 meters, and 10 meters to infinity. Precise focus acquisition is speeded up if you know you don't need the lens to look for focus at certain distances. For instance, if you are photographing geese flying overhead and you know nothing will be closer than 10 meters, selecting 10 meters to infinity as the focusing search range prevents the lens from trying to find focus closer than 10 meters, reducing the time it takes the lens to acquire precise focus on the more distant geese. Conversely, if all of your shots are closer than 10 meters, then setting 4.5 meters to 10 meters increases autofocusing speed. In most cases, I continue to use the full range of autofocus from 4.5 meters to infinity, since the back-button focusing method I use (to be covered shortly) largely eliminates the problem of the lens searching for focus at the wrong distance. However, having switches on the lens does create problems at times. When shooting on bean bags in Africa, the movement of the lens on the bean bag sometimes moves the switches which may cause missed opportunities. Duct taping the switches in place may be necessary to avoid the problem.

Many long macro lenses that are incredibly useful for photographing reptiles and amphibians have focus limiting switches, too. Check your lenses carefully to see if they do. If

Secretary birds nest on top of flat-topped trees. Our driver parked in the spot where the two birds were parallel to us. This helped us get both of them sharp with f/8 depth of field. I set the focusing distance limit switch on my 500mm lens to 10 meters to infinity. There is no point in wasting time and batteries by letting the lens focus to the minimum focusing distance of 4.5 meters when the subject will always be at least 10 meters away. EOS 5D Mark II, 500mm f/4 lens plus a 1.4x teleconverter, f/8 at 1/250 second, ISO 400, and manual exposure.

you discover your macro lens doesn't focus as close as you think it should, or fails to focus to infinity, check the focus-limiting switch to see if it is set.

FOCUSING POINTS

If you look in your camera's viewfinder, you should see many AF points that look like little square boxes. These are used to focus the lens and they may or may not be created equal. Usually, the center AF point is the most accurate one because it is designed to detect both vertical and horizontal lines of contrast. The outer AF points may only detect vertical or horizontal lines, but not both. The cross-type AF points are the most accurate. If you have a choice, use your most accurate AF point or points. Check your camera manual for more info on the focusing points.

FOCUSING POINT OPTIONS

19-Point AF Auto Select

This Canon 7D option is similar to most digital cameras. The number of AF points varies from model to model. Some have nine AF points while more expensive models offer 45 AF points. Check the camera manual to see how many AF points your camera offers. The idea is simple enough. Point the camera at the subject, press the shutter button down halfway, and the camera automatically selects one or more AF points to focus on. Then press the shutter button all the way down to shoot the picture.

This is probably the default setting on your camera. As a result, many photographers use this option and don't consider other possibilities. It sounds exceptional—almost foolproof—but we never use it. How does the camera automatically know where you want the sharpest focus? Does it know you want

Never activate all of the AF points because the camera will fail to precisely focus on the optimum spot much of the time. In this case, the camera will focus the lens on the grass in front of the spotted hyena. Instead, point the center focusing point (the only one activated) at the forehead of the hyena and press the back-button focusing control in to make the camera focus the lens. When the hyena's eyes are sharply focused, let up on the back-button focusing control to lock the focus. Adjust the composition to make a pleasing image and push the shutter button all the way down to shoot the image. Canon EOS 1Ds Mark II, 500mm f/4 lens, f/5.6 at 1/250 second, ISO 640, and manual exposure.

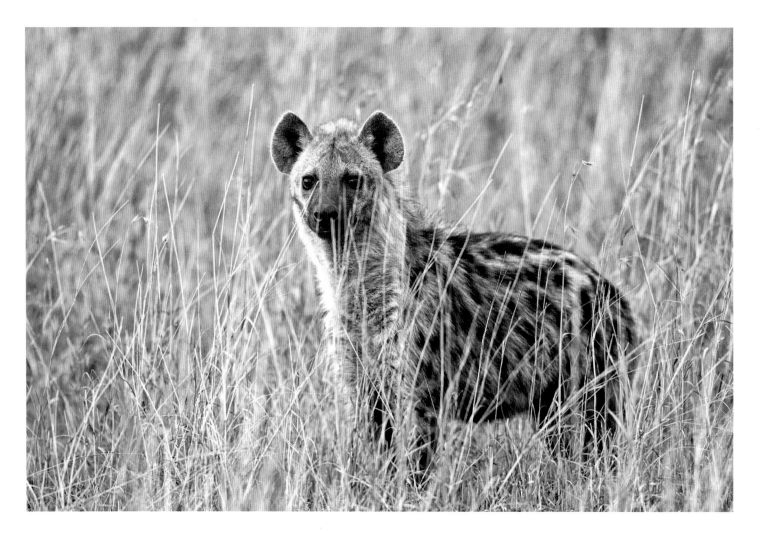

the focus precisely on the face of the subject? Obviously, it doesn't!

The most serious problem in using the multiple focusing point option is it tends to focus on the nearest object in the scene. Photograph a hyena peering through the grass and it will quickly and precisely focus on the grass in front of it. Even if you are shooting a full-frame image of a blue-footed booby, the multiple focusing points option will probably focus precisely on the shoulder that is two inches closer to the camera than the face where the sharpest focus should lie. This option does focus close to the desired spot most of the time, but that isn't good enough for capturing truly sharp images. Unfortunately, the camera doesn't know you want the face focused as sharply as possible. Therefore, while we do favor autofocus, we don't let the camera decide what part of the image should be most sharply focused and do not recommend activating all of the AF points.

Single Point AF Manual Select

This option is simple enough, incredibly precise, and probably offered by your camera. We use it most of the time and you should, too. Look in the viewfinder and select the single AF point where the sharpest focus should be. All other AF points are inactive. If you are photographing a plump pine grosbeak perched in a tree, compose the image, select the AF point that coincides with the face of the bird, press the shutter button down halfway to make the lens focus, and then press it the rest of the way down to capture a fine image.

The key is to always select the AF point that coincides with the exact spot where you want the sharpest focus. It helps to learn how to select the AF point quickly. Most cameras offer multiple ways to select the AF point. Sometimes you must fuss with two buttons to do this and sometimes only one control selects the AF point. I prefer to use a single joystick button to select the active AF point. On the Canon 7D, I use custom function #1 in Group #4 to directly select the AF point using the Multi-controller button on the rear of the camera. This is the quickest way to select the desired AF point. Selecting the AF point rapidly is crucial, especially when photographing

wildlife, because their face doesn't stay in the same spot as the critter moves about. This makes it necessary to keep selecting new AF points to coincide with the animal's face to keep it sharply focused.

Zone AF Manual Select

This is a new option for Canon, but has been found on Nikon cameras for quite some time. This option lets you select a small area of AF points in a given zone. With the Canon 7D, five zones can be selected. These choices include a group of AF points in the center of the viewfinder, on the left, right, top, and bottom.

Zone AF is effective if you know where the action will happen in the image. A few years ago, one of our favorite clients, Steve, was photographing at our hummingbird photography workshop. Being an elderly gentleman, Steve tended to doze off from time to time. The hummingbirds were frequently visiting a sugar water feeder right in front of him that was disguised with a flower. The flower occupied the right side of the image and the hummingbird always appeared on the left side. Steve is a Nikon shooter and set his camera to Zone AF. Then he activated only the AF points on the left side of the viewfinder. He attached a 20-foot cable release to his camera and sat in a comfortable chair 15 feet from the set-up in the warm morning sun. He composed the image a bit loose to avoid cutting off part of the hummingbird and planned to crop the image later. Relying on Zone AF to hit sharp focus on the hummingbird, he settled back into his comfortable chair and fell asleep during a lull in the hummingbird activity. As I walked past his station, I noticed he was sleeping when a male calliope hummingbird began its dazzling "buzzing" display in the perfect spot. I hollered "shoot" to Steve and he immediately tripped the camera without ever opening his eyes. A year later, this image won first prize in a *National Wildlife* magazine photo contest. Imagine shooting a major contest winning photograph with your eyes closed!

We don't find a lot of uses for Zone AF, but do keep it in mind. Anytime a subject suddenly appears briefly at a known spot, and then moves on, Zone AF is useful. I was photographing

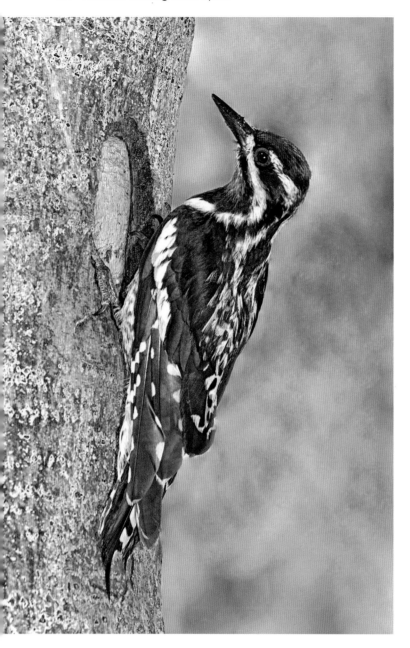

Red-naped sapsuckers nest in holes they drill into the aspen trees around our home. This nest was in the dense forest, but the background is a mountain three miles away. I set up a main and fill flash that was two stops weaker to light the bird. Once I arrived at the best f/stop to properly expose the woodpecker with the flash, I metered the distant background and slowed the shutter speed until it was nicely exposed, too. The woodpecker was lit entirely with flash and the background was all available light. Canon 5D Mark II, Canon 500mm f/4 lens, f/16 at 1/60 second, ISO 400, and manual metering for both flash and the natural light.

a red-naped sapsucker at the nest before I had Zone AF. Every 20 minutes, a woodpecker suddenly appeared at the nest cavity, fed its young in seconds, and flew off to find more food. There was precious little time to focus manually or select a single AF point that corresponded to the face. That's a case where Zone AF is certainly worth a try.

Spot AF Manual Select

This new Canon option is similar to Single Point AF manual select, only it covers a much smaller area. Think of it as "dot" AF. The camera uses a tiny portion of a single AF point to focus on wherever it is pointed. It lets you focus precisely on a tiny spot. Unfortunately, Canon must feel it isn't going to be that widely used because they make you activate it with custom function #6 in Group #3 with the Canon 7D. See how important it is to know what the custom functions offer?

You know what a stickler we are on focusing on the most important spot in an image. Since spot AF lets you focus on a tiny object, it is terrific for focusing right between the eyes of an owl, for instance. Spot AF is my favorite focusing point option by far. It is possible to focus right through the grass if there is a small spot where the grass isn't concealing a portion of the animal's face. Here's how I use it. With spot AF selected, I point the manually selected AF point at a part of the face of an animal in the grass, then I push a button on the rear of the camera to make the lens focus (we'll cover back-button focusing shortly). If the face of the animal looks sharp, I shoot the image. If it doesn't, then the lens is focusing on the grass, so I try again. Usually, one to three attempts does it. If not, then I switch to manual focus.

AF Point Expansion Manual Select

This is a terrific focusing mode for photographing running animals and flying birds. It's easy to keep a single AF point on a wandering African elephant, but far more difficult on a vulture plummeting out of the sky to feed on a lion kill. To keep the vulture in good focus overall, I select this option. I can still pick a single AF point to coincide with the position where I want the vulture to be in the image for compositional

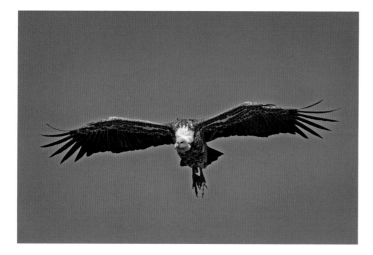

Finding the remains of a hapless herbivore killed by lions is quite common in Kenya. We don't photograph the gore, but do photograph the scavengers that arrive to eat the scraps. This Ruppell's vulture plummets out of the heavens to feast on the remains, providing excellent flight photo opportunities. Nikon D2X, Nikon 200-400mm f/4 lens, f/6.3 at 1/640 second, ISO 200, and manual exposure.

purposes. However, this mode activates the neighboring AF points, too. If a part of the vulture coincides with any of these AF points, you'll get the focus some place on the vulture which may be close enough, considering the tough circumstances.

This focusing point option of activating a small cluster of AF points works well for me. However, in my teens and early twenties, I was a competitive skeet shooter. I am lucky to be naturally skilled at tracking fast and erratically moving objects. Indeed, action is my favorite type of photography. Photographers who struggle with tracking moving subjects may do better by activating more AF points. Indeed, for many, using Zone AF in the middle of the image, or even activating all AF points may be the best answer. Your natural skills at tracking action will determine the focusing point option that best suits your natural abilities.

FOCUS MODES

Your DSLR offers at least two focusing modes and possibly more. The two most common ones include One-Shot AF (also

conveniently known as single focus) and continuous focus (unhelpfully called AI Servo by Canon). Most photographers use both, depending on the situation. Here's how they differ and when you might use one over the other.

SINGLE AUTOFOCUS

Single autofocus does not track a moving subject. Point the AF point(s) at a mule deer and gently push the shutter button down halfway. The lens focuses on whatever the active AF points coincide with in the viewfinder. Once focus is acquired, press the shutter button the rest of the way down to shoot the picture. It's simple enough and does work well. Unfortunately, if the deer walks toward you slowly, the camera won't adjust the focus to stay sharply focused on the magnificent animal if you keep the button pressed down halfway. You must fully let up on the button and then press it down again. Single autofocus does not offer focus tracking. But, this isn't a problem if the subject remains still.

The single autofocus mode is designed to give *priority to the focus* (sometimes called focus-priority) on most cameras. This means if the active AF points aren't on something that is in focus, the camera won't let you shoot the image. This becomes a huge problem if you are in focus, but there isn't any contrast where the active AF points are located. However, in most circumstances, single autofocus does work fine for subjects that aren't moving. It's no wonder single autofocus is wildly popular among most photographers—but not us. We never use the single autofocus mode. We'll explain why shortly.

CONTINUOUS AUTOFOCUS

This mode constantly monitors and adjusts the focus when the distance between the lens and the subject changes. It doesn't matter if the photographer is moving, the subject, or both are. The lens continually refocuses to keep whatever coincides with the active AF point (or points) in focus. In an atypical situation where you are moving and the subject is not, continuous autofocus helps a lot. Photographing penguins or a leopard seal resting on floating ice in Antarctica

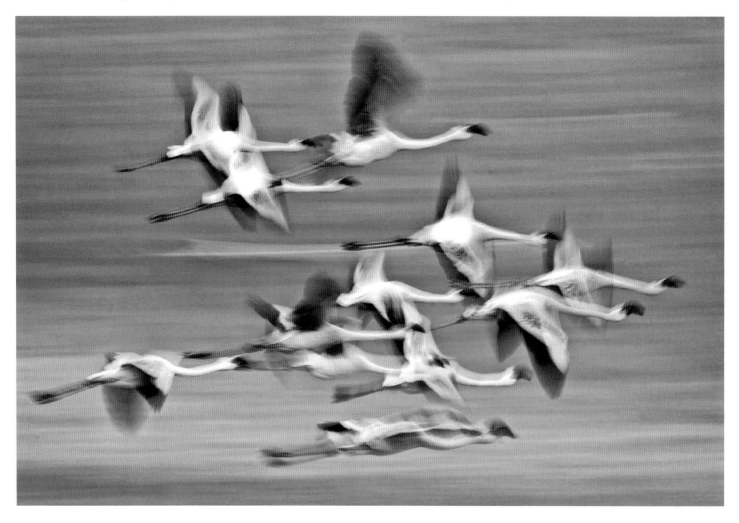

Panning smoothly with these lesser flamingos while using a fast shutter speed is a well-known way to capture sharp action images. However, for artistic reasons, sometimes it is best to reveal the motion in the subject. I used Aperture-priority to lock in f/22 and force the camera to use the slow shutter speed of 1/10 second to blur the flock. Canon EOS 20D, Canon 100-400mm lens, f/22 at 1/10 second, ISO 100, and Aperture-priority with minus 1/2-stop exposure compensation.

from a slowly drifting Zodiac (an inflatable boat) is an example. As long as the active AF points are on the subject, the camera will do its best to keep it in focus. Many cameras offer autofocus that predicts where the rapidly moving subject will be and adjusts the focus accordingly. This is often called "Predictive Autofocus."

Predictive autofocus is easy to use. Put the active AF points on the subject, hold the shutter button down halfway, and the lens continually refocuses to keep the subject sharply focused. Of course, the faster the subject moves, the harder it is for the autofocus to keep up with it. Use continuous focus for all action images such as flying birds, running cheetahs, and bounding deer.

The big problem with continuous focus is continuous focus. That's not a typo! If you are photographing a hawk soaring overhead, continuous focus does a terrific job until the AF points wander off the hawk and "see" a cloud, causing the camera to focus on the distant cloud. Clear blue sky shouldn't

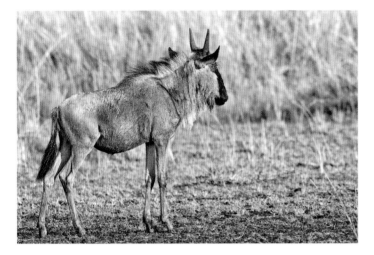

Back-button focusing solves the problem when a motionless subject suddenly moves steadily away. Set the camera to continuous focusing. When the wildebeest is still, focus on its face and then let up on the back-button focus control to lock the focus. When the wildebeest runs, press the back-button focusing control down, and hold it down, while you aim the AF point at the animal as you pan with it and press the shutter button all the way down. There isn't time to switch between single focusing and continuous focusing by changing the focusing mode. Mastering the back-button focusing technique is the single most important skill you can learn to increase your percentage of well-focused images. Canon EOS-7D, 500mm f/4 lens, f/7.1 at 1/800 second, ISO 400, and Shutter-priority with a +1/3-stop exposure compensation.

As soon as this wildebeest began to run, I pressed the back-button focus button down—and held it down—while panning with the running animal and pressing the shutter button at the same time. Canon EOS-7D, 500mm f/4 lens, f/7.1 at 1/800 second, ISO 400, and Shutter-priority with a +1/3-stop exposure compensation.

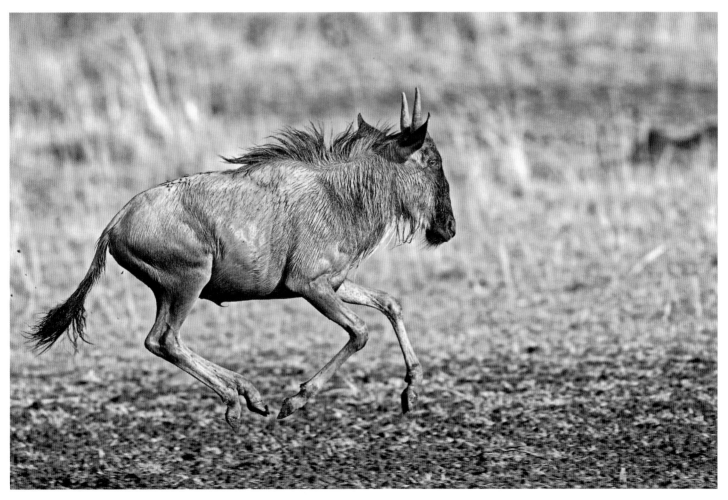

be a problem, though, as the lack of contrast makes it difficult for the autofocus mechanism to "see" it.

Modern continuous focus that locks on to and even predicts the position of a moving subject is amazingly good. Some claim they can do it better with manual focus, but we sure can't. One thing we know for certain is that autofocus does a better job than we do with manual focus in most circumstances. While we tend to be skeptical of anything automatic, we prefer to use autofocus whenever possible.

There is another difference between single focus and continuous focus. As we mentioned, single focus tends to be *focus priority*. If the object the active AF points are on isn't in focus, the camera may not allow you to shoot an image. Continuous focus systems tend to be *shooting priority*. The camera will shoot the image even if the object where the active AF points are isn't in focus. Be sure you understand these focus and shooting priority differences.

A HUGE FOCUSING PROBLEM

Imagine a handsome Canada goose confidently perched on top of a muskrat house. It isn't moving much, so you decide to use single focusing. You point the middle AF point at its head, press the shutter button down halfway to focus on the head, continue to hold the shutter down halfway to keep the focus locked, recompose to make the goose look into the image, and finally press the shutter button all the way down to capture the image. That's easy enough.

However, what happens when the Canada goose leaps into the air and steadily flaps toward you? A gorgeous mirror reflection appears in the quiet blue water during the take-off. Did you get the shot? Not likely. Since the camera is set to single focusing, as soon as the goose flies toward you, the focus is behind the bird because the goose is reducing the distance between it and you. You might try to quickly switch the camera from single focus to continuous focus to track the bird. However, if you are like us and everyone else we know, by the time you find the AF mode switch and change it, the goose is already gone. Is there a good solution to this problem of having to switch AF modes immediately—not a few

seconds later? Absolutely! We began calling it "back-button focusing" 20 years ago to describe what it does. Regrettably, it seems all camera makers call it something else that isn't terribly descriptive. Fortunately, the vast majority of today's cameras—especially Nikon and Canon—do provide for back-button focusing. They just don't go out of their way to tell you about it.

We use the back-button autofocusing technique about 90 percent of the time. It is easily the fastest and most precise way to use autofocus for the vast majority of wildlife photography. It solves many autofocus problems, including the Canada goose. Most workshop participants use cameras that offer back-button focusing, but are unaware of what it is and how to enable it. It isn't a new feature, either. We commonly used it with our professional grade film cameras in the late 1980s.

Regrettably, the odds are many readers of this book have never heard of it. There is a good reason for that. It is rarely mentioned in photo magazines and books. Even your camera

Notice the AF-ON button and the two buttons to the right of it on the Canon EOS-7D. The addition of the AF-ON button is relatively new. Previously, cameras let you remove the autofocus control from the shutter button and reassign it to the button immediately to the right of the AF-ON button with a menu choice or by setting a custom function. We find the AF-ON button is a bit hard to reach, so we still use the other button if permitted. Indeed, on the Canon 7D, I have programmed both the AF-ON button and the middle button to serve the same purpose of controlling the autofocus using custom function #1 in Group #4.

manual virtually ignores it. I have yet to read a camera manual that calls it back-button focusing. All of the camera manuals we read don't really call it anything that is terribly meaningful. I actually started to call it back-button focusing when I referred to it in my teaching programs around 1995. I began using this term because it is descriptive. Back-button focusing (some call it thumb focusing) is exactly what it sounds like. The autofocus control is removed from the shutter button and reassigned to a button on the back of the camera, usually located about an inch to the right of the viewfinder. Using this button, autofocus is now controlled with your right thumb. The shutter button turns the meter on and takes the picture when pressed all the way down, but it no longer has anything to do with autofocus. The shutter button and the focusing control are separated from each other. This delivers huge control benefits to the photographer.

Back-button focusing techniques will be explained soon enough. First, here's some observations regarding back-button focusing and learning how to do it. We all have habits that are hard to break. Most photographers have a habit of pushing the shutter button to initiate autofocus. That can be a hard habit to break, but break it you must. Some photographers give up on back-button focusing rather quickly because they keep forgetting to push the rear button that controls it. You must stay with it longer to create a new habit. Eventually, controlling the autofocus by using your right thumb to press a button on the rear of the camera becomes automatic. Others give up on it because they don't really perceive the many enormous benefits it offers, even when those benefits are carefully explained to them. It takes shooting many images in different situations before most photographers become comfortable with it. Only then do they really perceive its tremendous benefits for helping them to focus precisely, fast, and to successfully capture images that otherwise would elude them. Once you "get it," you'll wonder how you ever managed without it. Changing your shooting habits to back-button focusing is the single best focusing technique we can offer. The control it gives you is absolutely enormous! We hope you'll make it a habit, too. The sharpness of your images will dramatically improve.

HOW DO YOU SET BACK-BUTTON FOCUSING?

That is a great question! Almost every Nikon and Canon camera has back-button focusing capability and most other brands do, too. Yet, we haven't seen any camera maker call it back-button focusing in their manuals. Companies use terms for the control that give you no hint as to what it does. Canon offers many custom functions, one of which gives you the ability to set the camera to back-button focusing. Unfortunately, the custom function number that controls it varies among models, so I can't tell you to go to custom function #4 and set option #2 for example. Nikon cameras offer the control using a menu selection. For example, if you have a Nikon camera with an AF-On button on the rear of the camera, you have back-button focusing for sure. You must go to the autofocus menu and, oddly enough, turn AF off. This deactivates autofocus from the shutter button, but it remains activated on the AF-On button.

You still must figure out if your camera offers back-button focusing (most do) and how to set it. Try reading your camera manual carefully and pay extra attention to all of the autofocus controls. You may find it on your own. Try contacting your camera maker, or an online forum that discusses your camera brand. Ask if anyone knows how to set your camera model (be sure to mention what model you have) to back-button focusing or thumb focusing. Tell them you want to control the autofocus on the back of the camera and remove it from the shutter button. Among a large group of photographers who frequent a forum, it's likely someone knows what you are talking about and how to set it. If you attend our field workshops, with your camera in our hands, it's easy for us to find your back-button focusing control. Barbara is brilliant at finding the control, even for cameras we seldom see such as Sony and Olympus.

BACK-BUTTON FOCUSING BENEFITS

The Camera Setup

Remove the autofocus from the shutter button and assign it to a button on the rear of your camera. Now set the autofocus

mode to continuous autofocus and leave it there. You no longer need single autofocus because you always have it! Anytime you let up on the rear focusing button, the focus locks, just like single autofocus. To easily and immediately switch to continuous autofocus, push the back-button focus control down, and hold it down with your right thumb, while you shoot photographs.

THE REMOTE RELEASE AND SELF-TIMER PROBLEM

Perhaps you are photographing a land iguana in the Galapagos Islands. In the soft overcast light, a tripod is used to capture the sharpest image possible. With the autofocus control on the shutter button, instead of the back-button control, point the active AF point at the eye of the iguana and push the shutter button down halfway to make the lens focus on the eye. Now let up on the button and recompose to prevent the iguana's eye from being in the middle of the image. You also noticed the lizard's leg is cut off when the eye is in the middle of the image. Tripping the shutter with your finger vibrates the camera a bit, causing a loss of sharpness. Since you are a quality conscious photographer who demands the ultimate

Galapagos land iguanas often hold perfectly still for long periods of time. This habit makes it easy to use a cable release to trip the shutter for sharper images. Nikon D3, Nikon 200-400mm f/4.0 lens at 300mm, f/8 at 1/125 second, ISO 200, and manual exposure.

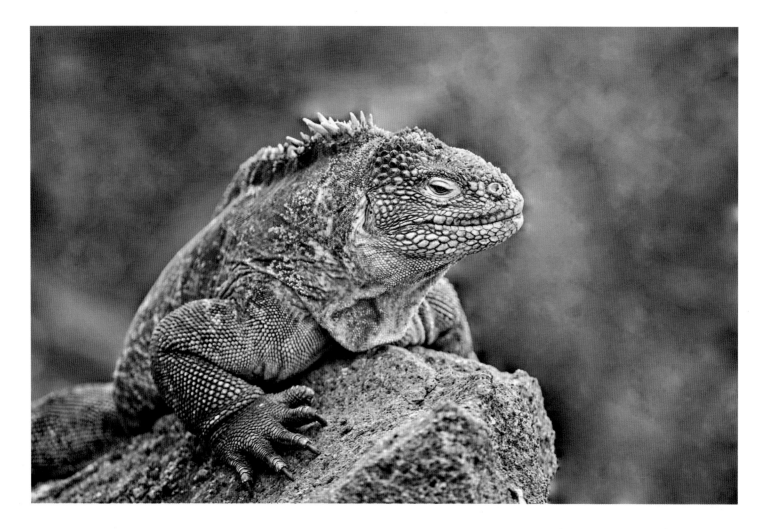

image sharpness, it is essential you use a cable release, a remote infrared or radio release, or a 2-second self-timer delay to trip the camera. Any one of these three methods removes your pulsating body from the camera. Now trip the camera and view the image. Unfortunately, the iguana is now out of focus. What happened? Using the cable release, remote release, or the 2-second self-timer to trip the shutter causes the camera to refocus with most cameras. Why? When the camera is adjusted slightly to recompose the iguana, the active AF point settles over a spot on the background. The camera refocuses automatically on the background behind the iguana. This problem is easily solved by focusing on the eye and then turning the AF switch off. But, frequently turning the AF switch on and off becomes a nuisance factor and slows you down.

Back-button focusing eliminates this problem completely. Activate only the middle AF point, set the camera to back-button focusing, and the AF mode to continuous. Point the middle AF point at the eye and push the button in on the rear of the camera that initiates autofocus. The camera focuses on the eye. Raise your thumb off the button to lock the focus instantly. Recompose the iguana and use any one of the three remote ways just mentioned to trip the camera. Shoot the image. The iguana is perfectly sharp, especially around the eye and your body doesn't cause the camera to vibrate at all, producing a superbly sharp image. With practice, you will be able to back-button focus on the eye and recompose in a second or two. It really does become that easy.

Why is it best to set the camera to continuous focus, rather than single focus? After all, the iguana was perfectly still. Good question! As mentioned earlier, many cameras are focus priority in the single focus mode and shooting priority in the continuous focus mode. That's a hint. If the camera is set to single focus and the active AF point isn't on something in focus when you recompose the image, many cameras will not shoot the image, even though the eye of the iguana remains perfectly in focus. With the camera set to continuous focus, it will shoot the image because it is in shooting priority. This is a simple, but important concept. Be sure you understand

it. In field workshops, when a student shouts, "my camera won't fire," we immediately check to see if the camera is set to single autofocus. Usually, that's the problem.

THE PROBLEM WITH SWITCHING THE AF

Let's assume you are photographing a wintering trumpeter swan in Yellowstone National Park during January. The swan is beautifully posed on a shallow spot in mid-river with a gorgeous mirror reflection. Since the swan is motionless, you use single autofocus. You point the middle autofocus point (the only one that is activated) at the head of the swan and press the shutter button down halfway to make the lens focus on the head. While holding the shutter button down halfway to lock the focus, you recompose and press the shutter button all the way down to make the picture. Single autofocus is a simple enough procedure, but what do you do if a low flying bald eagle frightens the swan? The swan erupts into flight, paddling its large feet on the surface of the river while sending water flying everywhere as it begins to gain momentum and altitude. Now you have a moving subject, but the camera isn't set on continuous autofocus. Since the distance between the swan and the camera constantly changes, all of the images will be out of focus. Of course, many photographers attempt to quickly change from single autofocus to continuous autofocus. Even if you can make the change in a few seconds, it is already too late. The swan flies quickly away from you, offering only an unappealing rear-end shot.

The simple solution to this problem of having to quickly go from single focus to continuous focus and vice versa is back-button focusing. This technique handles the situation perfectly. Leave the camera on continuous autofocus all of the time. When the swan is in the river, point the middle AF point at its head and push the button in on the rear of the camera to autofocus. When the lens focuses on the head, *let up on the button*, recompose, and shoot the image. If the swan suddenly takes flight, *press the focusing button down, and hold it down*. Quickly put the activated AF point on the swan as you pan with it and shoot away. The lens will constantly adjust focus as the distance from the swan to the camera changes. It

literally takes only a split-second to go from single autofocus to continuous autofocus. To be specific, you really aren't changing focusing modes. You are merely using continuous autofocus effectively for both action and still subjects. It does take a little effort to become confident with back-button focusing, but once you really get it, you'll wonder how you ever shot images without it. It is an enormously powerful technique that everyone needs to add to their focusing strategies!

OUR FOCUSING STRATEGY

Barbara uses back-button autofocusing for all situations (the vast majority) where autofocusing works best. There are some lenses, such as tilt/shift lenses, where there is no autofocus capability. Autofocus doesn't work well in snowstorms either. When shooting macro images, both of us use manual focus and enlarge the live view image to make manual focusing much easier and more precise.

I use back-button autofocusing for almost all wildlife photography, with the exceptions mentioned above, and one more. If I know I will be photographing action, and there is virtually no possibility of a still shot, I do switch the autofocus control from the back-button to the normal shutter button. It makes things a little easier for me. Using back-button focusing to photograph birds flying past or running mammals does require me to hold the back-button in, while simultaneously pressing the shutter button to shoot images. If the focusing control is on the shutter button, then it is only necessary to hold the shutter button down to have continuous autofocus and shoot images. However, if a running mammal suddenly stops, or a bird lands next to me, I will have problems focusing on the creature's face with the autofocus on the shutter button and set to continuous autofocus. Unless I want the animal's face in the center of the image, it is impossible to recompose, while keeping the autofocus locked on the subject's face. As soon as I move the autofocus point away from the animal's face, the lens refocuses on the wrong spot.

OTHER FOCUSING OPTIONS

Cameras offer more ways to use autofocus than most photographers realize. Often these highly useful specialized controls are hidden in custom functions or menu choices. Your images will improve considerably if you carefully explore all of the options offered by your camera. Sadly, it appears most photographers, including pros, don't do this and miss out on wonderful tools that will easily improve their focusing precision. Unfortunately, these options vary from camera to camera. This makes it impossible to cover all of them in a book such as this.

At the risk of being too specific for one camera, I do wish to point out a few more autofocus capabilities offered by the Canon 7D. Perhaps your camera offers similar controls. If you are not even aware these focusing options are possible, you might not look for them. Let's describe a few of these options to let you know what to look for.

USE THE BACK-BUTTON TO LOCK FOCUS

Many cameras that offer back-button focusing provide a way to designate a button on the back of the camera as a focus lock button. The AE Lock button that is slightly to the right of the AF-On button on the 7D can be set to AF-Off using custom function #1 in Group #4 with this camera. Why do you want to do that? Here's a situation where I effectively use it. I love photographing hummingbirds in flight with natural light. Though it sounds impossible, it is easy to do. I modify a hummingbird feeder by taking the perches off of it to prevent them from landing. The hummingbirds still come to the sugar water feeder, but they must hover, as they normally do, to sip the sugar water. The incredibly active birds tend to sip a little, then pop up several inches above the feeder to look around, and return to the feeder. Every time they hover above the feeder, it offers the perfect opportunity to photograph them without the feeder appearing in the image. Since hummingbirds move rapidly, I use continuous autofocus, the highest shooting speed (images-per-second), and put the focus control on the shutter button. Now I don't have to hold the back-button in while pressing the shutter button at the same time.

Rufous hummingbirds are easy to photograph in flight with natural light. Attract them to a flat sugar water feeder and remove all plastic perches. Hummingbirds eagerly sip the sugar water and frequently hover a few inches above the feeder before returning to the feeder or flying away. Bright overcast light increases the iridescence in the feathers and the grass field behind the bird produces a pleasing out-of-focus nondistracting background. Canon EOS 1D Mark III, Canon 300mm f/4 lens, f/5.0 at 1/640, ISO 640 and manual exposure.

A conifer twig placed five inches in front of a single port hummingbird feeder enticed this male rufous hummingbird to perch on it. EOS 5D Mark II, Canon 300mm f/4 lens, 25mm extension tube, f/6.3 at 1/200 second, ISO 500, and manual exposure.

Here's the reason I set the AE Lock button to AF-OFF. To the left and right of the hummingbird feeder, I put a photogenic twig for the hummingbirds to perch on. Usually, they simply hover about the feeder and dart away when they finish feeding. However, every once in a while, a hummingbird perches on the twig. With the camera set to continuous autofocus and controlled by the shutter button, I have a serious focusing problem when the hummingbird perches. I point the middle AF point at the face of the perched hummingbird, press the shutter button down halfway to initiate autofocus on its face, but notice the tail is chopped off by the poor framing. When I recompose to include the tail in the composition, the AF point now moves to the lower half of the hummingbird, causing the camera to refocus on the wrong spot. Now the face is no longer as sharp as it should be.

This problem disappears when the AE Lock button is set to AF-Off. Point the AF point at the face of the perched hummingbird, press the shutter button down halfway to focus on its face, now press the AE Lock button down and hold it down, recompose, and press the shutter button down all the way to shoot the image. The lens stays perfectly focused on the face of the hummingbird. Remember, the AE Lock button must be held down while shooting the image with the shutter button. It does take a little practice to do this precisely and fast, but anyone can learn to do it quickly.

Another way to handle this problem is to select a single focusing point that happens to correspond with the face of the hummingbird when you have the composition you prefer. Hopefully, your camera provides an easy way to do this.

AI SERVO TRACKING SENSITIVITY

This useful autofocus control can be set with custom function #1 in Group #3 with the Canon 7D. Hopefully, your camera offers a similar control. If it doesn't, write to your manufacturer and suggest they add tracking sensitivity to their cameras.

This control offers a choice of five settings from slow to fast. Like most photographers, when I first saw it, I assumed I wanted the sensitivity set to Fast. However, through experience and careful study of this feature, I believe most wildlife photographers will do better with it set to Slow. This custom

function does not affect how fast the lens focuses on a rapidly moving subject, as you might assume. Instead, it affects how quickly the lens reacts to focusing on another object at a different distance.

Let's illustrate what it does with an example. Photograph an eagle flying by with some clouds in the sky. Using continuous autofocus, you attempt to keep the middle AF point (the only one that is activated) on the head of the flying eagle as you pan with it. The camera continually adjusts the focus to keep the eagle's head in focus. Of course, it is difficult to always keep the AF point on the eagle since its flight path may be erratic. If the AF point momentarily drifts off the eagle and overlaps a distant cloud, the camera instantly refocuses on the cloud and the eagle goes completely out of focus. If this custom function is set to Slow, the lens doesn't immediately refocus on the cloud, but delays or slows its response, giving you time to move the AF point back to the eagle where it belongs.

I feel the Slow setting works best because most wildlife photographers tend to photograph a specific subject at a certain

This drake ruddy duck slowly swam by me while I hid in a floating blind. I used the fastest shooting speed possible (eight images per second) and the multi-controller button on the back of my camera to quickly change the AF point to coincide with the face of the duck. Canon EOS-7D, 500mm f/4.0L lens, f/11 at 1/800 second, ISO 640, and Shutter-priority with minus 1-stop exposure compensation.

distance, rather than jumping from one subject to another at widely varying distances. Of course, this all depends on the situation. When I am photographing dancing greater prairie chickens on a lek in central Nebraska, chickens are dancing at various distances. If I use a 300mm lens, I have some chickens (hopefully) at just the right distance from me. Some birds will be too far away for the 300mm lens and others may be too close. Due to the fixed focal length of this lens, it's unlikely I will jump from one bird to another at different distances. Therefore, I set the focusing response time to Slow. This keeps the lens from instantly autofocusing on the grass behind the bird if the activated AF point wanders off the bird a tiny bit. On the other hand, with a 75-300mm zoom lens, the ability to quickly change the focal length makes it possible to successfully photograph birds at widely varying distances. In this case, selecting the Fast choice is sensible.

CHOOSE MANUALLY SELECTED AF POINT FOR HORIZONTAL AND VERTICAL SHOTS

This is another incredibly useful focusing option that is enabled by selecting Option #1 in custom function #12 of Group #3 with the Canon 7D. Often, it doesn't make sense to use only the middle AF point in the viewfinder. When you are panning with a swimming duck, you must use another AF point that coincides with the duck's head as it paddles about in front of you. Frequently, to avoid cutting off a portion of the gorgeous mirror reflection of the duck, using an AF point above the middle of the image is necessary. Perhaps you selected an AF point above the middle and slightly to the left that coincides with the bird's head as it swims from right to left in a horizontal image. If the bird turns toward you, you switch to a vertical composition. Now that AF point is left of center and low in the image. It isn't anywhere near the duck's head which forces you to switch to another AF point.

When this focusing orientation control is enabled, you are able to manually select an AF point that works for horizontal (landscape) compositions and a different AF point for vertical (portrait) compositions. When you change from one orientation to the other, the camera automatically switches to the AF point you selected for that orientation. It works like a charm! Hopefully, your camera offers this incredibly useful feature.

STUDY YOUR AUTOFOCUSING OPTIONS

The Canon 7D and the camera you use offer many auto-focusing options. It is worth your time to carefully go through each one to determine what options can help you capture exquisite wildlife images. Sadly, your camera manual isn't as helpful as it should be. Often, features are poorly explained. Reasons for using various options are seldom offered. There are ways to find more information about an option you don't totally understand. Send an email question to your camera manufacturer via their official website. Your camera maker wants you to be happy and successful. It is in their interest to provide good answers. You might try posting your question on a popular photo discussion forum. Whichever camera system you shoot, post on the camera forums for that system. You'll likely get plenty of advice. Some advice is terrific and some is unhelpful. Don't believe everything you read! Many popular cameras have entire books written about them. These can be a gold mine of great information and most are better than the official camera manual.

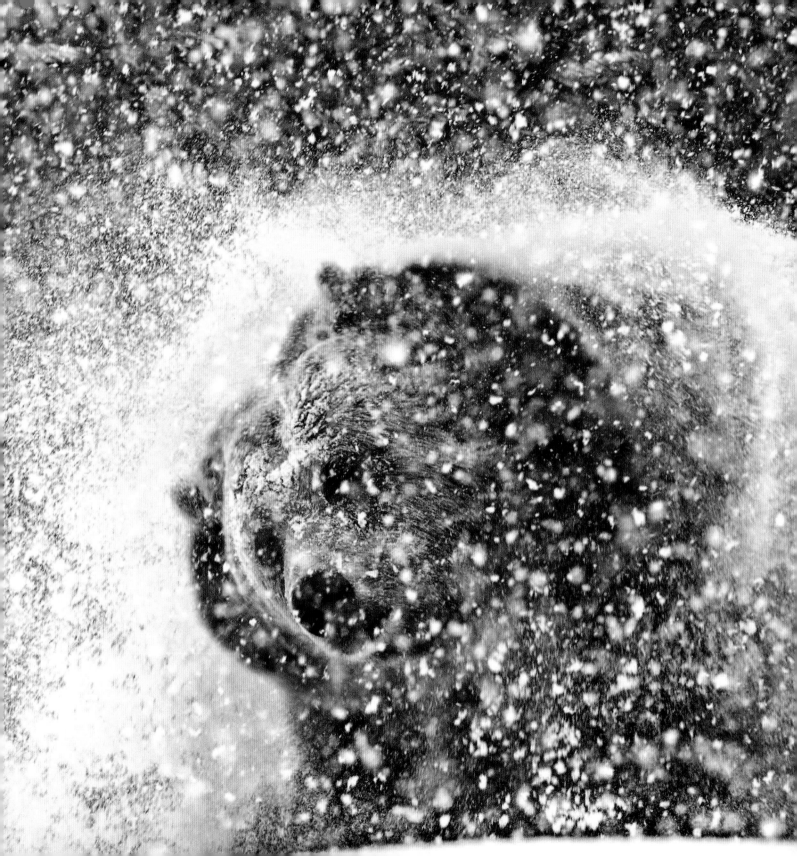

Shooting Quality Images

WHAT IS A QUALITY IMAGE?

A quality image means different things to different photographers. There is no universal definition that works for everyone, but all of us know quality when we see it. We wish to humbly offer our view of what makes a quality image. Let's discuss some of the key factors that affect quality. Some of these factors, such as exposure and focus, are covered in Chapters 3 and 4. We realize some information is being repeated here and we'll try to minimize repetition, but we wish to bring everything together in one place.

EXPOSURE

Quality images must be optimally exposed to preserve important highlight detail, collect the maximum amount of exposure data, and reduce noise—especially in the dark portions of the image where noise is most noticeable. As described in Chapter 3, using ETTR to quickly and accurately arrive at a superb exposure is effective and easy to do.

COMPOSITION

Successful images are carefully and thoughtfully composed in-camera. If you find you must significantly crop many of your images, you may be shooting too loose. However, in the case of erratically moving subjects, it helps to shoot loose enough to allow the image to be cropped later to make a pleasing composition.

LEFT: Catching the decisive moment is something all photographers strive to do. Barbara managed to shoot just as this captive grizzly bear shook the snow off of it at the Grizzly Bear and Wolf Discovery Center in West Yellowstone, Montana. Nikon D3, 200-400mm f/4.0 lens at 220mm, f/5.6 at 1/125 second, ISO 1600, manual metering.

SHARPNESS

Shooting sharp images is a serious problem for wildlife photographers. Unlike macro and landscape subjects, wildlife tends to be highly mobile, moving here and there in an unpredictable fashion. Superb poses or peak action are often fleeting. Many animals are only active when light conditions are normally dim. All of these factors make it challenging to shoot consistently sharp images, even for the most highly skilled wildlife photographers.

The calm blue water and the golden dawn sunshine generate a gorgeous reflection of this feeding lesser flamingo at Lake Nakuru. Barbara asked her driver to take her directly to the shoreline at dawn in the hopes of shooting images like you see here. Nikon D200, Nikon 200-400mm f/4.0 lens at 400mm, f/8 at 1/500 second, ISO 200, and manual metering.

The percentage of sharp wildlife images you capture will improve if you carefully and quickly focus on the face of the animal, favor faster shutter speeds, and adopt superb shooting techniques.

A PHOTOGENIC SUBJECT

Selecting a worthwhile subject to photograph is a crucial key to producing quality images. Perhaps a flock of ducks is swimming about in front of your lens. Spend your time photographing the most attractive individuals, the best poses, or perhaps two individuals that are interacting with each other. Always look for mirror reflections, too.

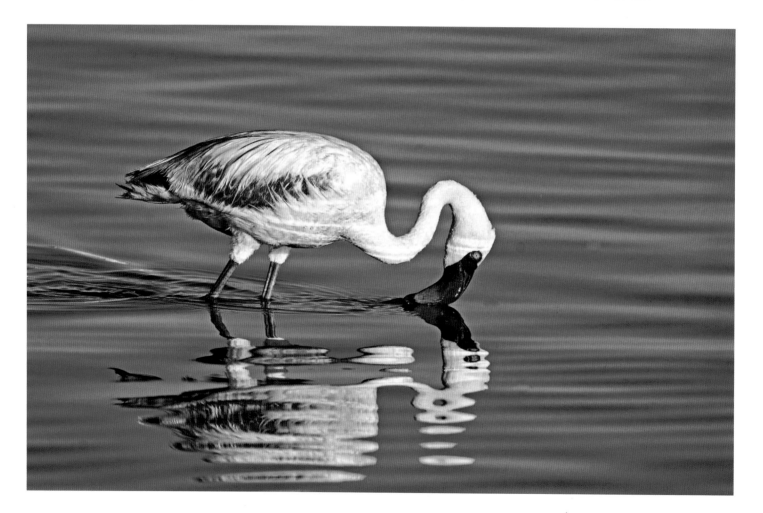

QUALITY IMAGE GUIDELINES

There is no need to create a rule for producing quality images, but there is a guideline we feel is worth considering. All of the images that Barbara and I really like—whether shot by us or the multitude of superb wildlife photographers around the world—have three things in common.

This male rufous-tailed hummingbird is molting its wing feathers. Of course, since the wings are beating sixty times per second, Barbara can't tell if the hummingbird is photogenic or not. The missing feathers make this bird a poor photo subject. Nikon D3, Nikon 200-400mm f/4.0 lens, f/20 at 1/250 second, ISO 200, four SB-800 flashes at 1/16 power, and manual metering.

This gorgeous rufous-tailed hummingbird was easily photographed at the fabulous Tandayapa Bird Lodge in Ecuador. Nikon D3, Nikon 200-400mm f/4.0 lens, f/20 at 1/250 second, ISO 200, four SB-800 flash units at 1/16 power, and manual metering.

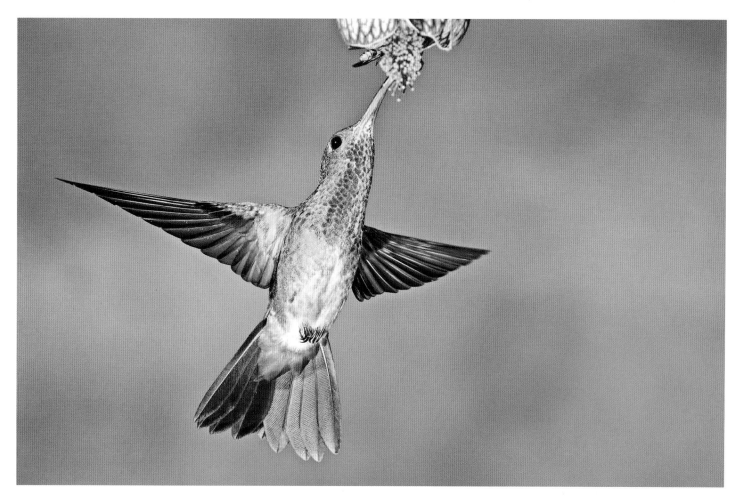

First, all images feature a photogenic and interesting subject that grabs your attention right away. Second, the photographer uses superb technique. The image is properly exposed, sharply focused, and pleasingly composed. Third, the situation is highly photogenic. Many variables determine a pleasing situation. Perhaps the red light at dawn or dusk lights the subject well. Perhaps the shooting angle nicely isolates a perched bird against a diffused out-of-focus background. Perhaps the twig the bird is perching on has a few buds or colorful flowers. The shooting angle greatly affects the situation, too. Photographing the animal at eye level or slightly below eye level is almost always better than shooting down on the subject from a high viewpoint.

To help you remember these three key factors for producing quality images, here's a simple guideline to follow:

A Quality Image = Subject × Technique × Situation (STS)

FACTORS THAT AFFECT IMAGE QUALITY

LENS CONSIDERATIONS

High Quality Lenses

Using the highest quality lenses made for your camera does help produce quality images. Though they are more expensive, lenses made with special glass elements do produce slightly sharper images with better color and contrast. This is especially true when you must use the maximum aperture of the lens because the defects all lenses have when used wide open are better corrected with the high quality glass. Of course, these advantages assume you are using an excellent shooting technique. Those who prefer to shoot hand-held will see little to no benefit from using a lens made with the best optical glass. We strongly suggest using a stable shooting platform whenever possible.

However, expensive lenses tend to be faster (f/2.8 or f/4.0 maximum apertures, for example) than less costly lenses. Having a larger maximum aperture makes it easier to focus accurately and use faster shutter speeds. These two factors are enormously helpful in producing sharp images.

Use Clean Lenses

Dirt, smudges, and other debris on the optical elements of your lens promote flare, reduce image detail, and generally lower image quality. Always use clean lenses! It is easy and safe to clean lenses yourself. Make it a habit to keep them clean. For instance, dust is a problem in Kenya. After every game drive, we wipe off the outside of our cameras and lenses with a damp cloth. Then all lens surfaces on both the front and rear of the lens are carefully cleaned. Two of our big lenses have internal drop-in filters and these are cleaned, too.

Protection Filters

These filters are widely recommended and used by many photographers. Nevertheless, we aren't fans of protective filters. We never use add-on protection filters, haven't owned any in 30 years, and *do not* recommend their use.

All lenses are made to produce the best quality "as is" with the lens shade properly installed. Adding any extra glass to the optical path tends to reduce sharpness and increase flare problems. While there are times to add extra glass elements, such as a quality teleconverter or polarizing filter, do this only when absolutely necessary and the benefits clearly outweigh the negatives. Use your equipment carefully and always use a lens hood. In more than 60 combined years of professional nature photography, we have damaged only two lenses. In each case, a "protection" filter would not have prevented the damage.

KEEP THE SENSOR CLEAN

Any dust, dirt, or hair that settles on your camera's imaging sensor will be in every picture you shoot. It appears as an out-of-focus blob in the image. While tiny bits of dust and dirt can be eliminated later with software, it does take time to do this tedious work. A hair on the sensor is much more difficult and time-consuming to hide. Although many DSLRs have self-cleaning sensors, these are far from perfect. Dirt on the sensor remains one of the most prevalent and annoying problems in digital photography. Therefore, it's crucial to take steps to minimize the dirt problem.

Prevention

Keep unwanted debris from entering the inside of the camera in the first place. Always keep a lens or body cap on your camera. Never leave the camera uncovered any longer than necessary. Any debris that enters the interior of the camera will eventually find its way past the mirror, shutter curtain, and attach itself to the sensor. By the way, the front and rear lens caps and the camera's body cap attract dirt, too. Keep the caps as clean as possible by washing them occasionally. However, no matter how careful you are, and how good your self-cleaning sensor is, you will eventually have stubborn bits of dirt attached to the sensor.

Blow the Dust Off

We use a large Giotto Rocket blower to blow dirt off the sensor with good results. Use the camera's manual cleaning mode to gain direct access to the sensor. Make sure the battery is fully charged since you don't want the fragile shutter to unexpectedly close on the tip of the blower if the power fails. The shutter could be damaged. Do not touch the sensor with the tip of the blower. Hold the camera above you and face the front of the camera down. This reduces the chance of dust settling into the sensor box. Also, dust dislodged with the blower brush is more likely to fall out and away from the camera.

Sensor Cleaning Kits

If prevention and the blower brush fail, then you must use more risky techniques to clean the sensor. We (and many other photographers) buy our own sensor cleaning kit and do it ourselves.

We happen to use a cleaning kit made by Delkin devices, but other good ones are available from Photographic Solutions and Visibledust. The Delkin kit includes a tiny vacuum for cleaning contaminants off the sensor and from the box containing the sensor. The kit has a lighted magnifier that lets you directly see the contaminants on the sensor. It has high quality lint-free swabs and a solution for removing even the most stubborn contaminants.

Follow the cleaning directions precisely. It isn't that difficult, but you must be dexterous while doing it. Doing it incorrectly or too roughly can damage the expensive sensor in your camera. Briefly, here's how it is done. Apply the proper amount (usually a drop or two) of fluid to the swab. Again, follow the directions precisely. Gently wipe the sensor from one side to the other. Wipe the sensor, don't scrub it! Then turn the swab over and wipe the other half of the sensor. Be sure to wipe the entire surface area to avoid leaving particles on one edge of the sensor. Check the sensor surface to make sure the vast majority of debris is removed. If you only have a few tiny spots remaining, leave it. Trying to remove the last few bits of debris is difficult because the cleaning process always seems to move around a few of them and seldom removes everything.

Hire a Professional

If you don't feel comfortable cleaning the sensor, send the camera back to the manufacturer or to a local camera repair shop for cleaning. These places clean sensors all of the time. They should have no trouble doing yours. It does cost $30 and up to have a professional cleaning, and your camera isn't available to use while it is being cleaned, but it may be the best method for many photographers.

ISO CONSIDERATIONS

The native ISO of your camera's sensor is probably ISO 100 or ISO 200. This ISO setting gives you the highest quality image with the best colors and the least amount of noise and other artifacts. However, there are many trade-offs in photography and this is one of them. Since using the native ISO speed makes it more difficult to use a fast shutter speed, it is usually best to use a higher ISO choice, such as ISO 400, even though your images will have more noise. This makes fast shutter speeds easier to use and greatly increases the probability of capturing critically sharp images.

Fortunately, the negative effects of noise, which appear as unexpected and random colors or brightnesses in the image,

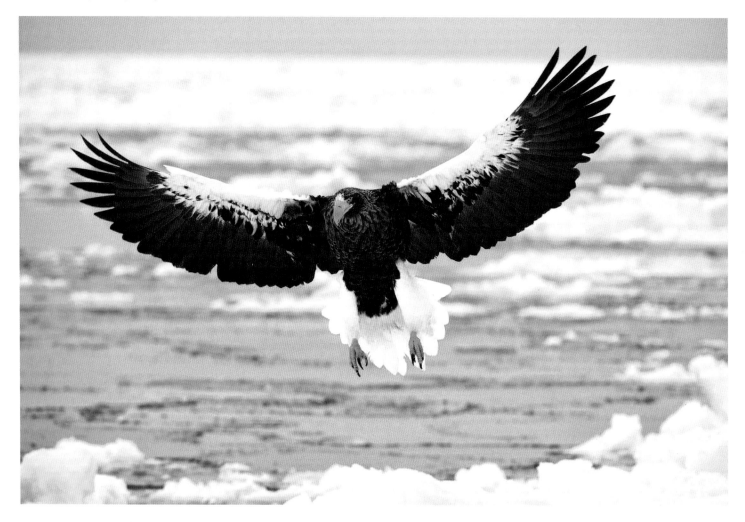

The dim light on this cloudy morning in northern Japan forces Barbara to use ISO 3200 to have any chance of freezing the action of this Steller's sea eagle as it prepares to land on floating ice. Although the image does have noise at such a lofty ISO, it still looks good. Nikon D3, Nikon 200-400 f/4.0 lens, f/8 at 1/1250 second, ISO 3200, and manual metering.

are being reduced with each new camera generation. Noise is created at high ISOs when the sensor signals are amplified. Although noise is present, it is amazing how good the images look even when shot at ISO 800 and ISO 1600. Due to the dim light on a cloudy morning, Barbara used ISO 3200 to freeze a Steller's sea eagle in flight in northern Japan. Although the noise at ISO 3200 is clearly evident in the digital image when viewed on the computer, little noise is detected in the final print after careful processing. Being able to capture fine images at ISO 3200 has profoundly altered how wildlife photographers work today. It is quite possible to capture wildlife action when natural light levels are incredibly low. The ability to capture low-light action images will only improve in the years to come, a change we heartily welcome. While it's true that higher ISO settings produce more noise, the trade-off is worthwhile if more shutter speed is necessary to capture the action. If it's impossible to get enough shutter speed without increasing the ISO, then go ahead and increase it. You are better off to have a noisier image that is sharp, than an image with little noise, but too fuzzy to use. At

times, increasing the ISO is necessary to obtain more depth of field.

OUR ISO GUIDELINES

Bright Sun

ISO 200 is normally adequate for wildlife that is still or slowly moving. For wildlife action, such as running cheetahs and flying birds, switching to ISO 400 makes perfect sense. In bright sun at ISO 400, it is possible to use shutter speeds greater than 1/1000 second. For example, a likely exposure combination in bright sun at ISO 400 is 1/1600 second at f/8. This is plenty fast enough to freeze a bird flapping by if you pan with it carefully and sharply focus the bird as it passes.

Overcast Light

Clouds cost you 2–4 stops of light, depending on their thickness. Therefore, start at ISO 400, but don't be afraid to use ISO 800 if you need the extra shutter speed or depth of field. IS0 800 delivers an amazingly good image if it is properly exposed, especially with the latest digital cameras.

Dim Light and Sunrise and Sunset

Many wildlife species are most active before sunrise and after sunset. These dim light conditions are incredibly problematic for wildlife photographers. Now, it is possible to use ISO 800, ISO 1600, and even ISO 3200 to photograph action in dim light. If you must, use ISO 6400 if there is no other choice. Yes, there will be noise in the image. But using software to reduce the noise may well make the image satisfactory.

THE FUTURE OF ISO

The quality produced by using higher ISOs will continue to improve in the years to come. This trend is terrific for wildlife photographers. Being able to capture exquisite images of wildlife using ISO 12,800 and greater will make it possible to capture images with natural light that once were considered impossible.

FILE CHOICES

RAW

Shooting RAW images gives you the best potential image quality and control. It is much easier to adjust the white balance, contrast, color saturation, and exposure if you start with the RAW data. Every wildlife photographer we know shoots RAW, so this is nothing new, as it is well-known among this group of dedicated and highly skilled photographers. Once the RAW image is adjusted, that image can always be converted into a JPEG if that works best for the way you wish to use the image, such as posting it on the internet. Indeed, all of the images in this book started as RAW captures, were processed in PhotoShop, and then converted to JPEGs.

LARGE JPEG

Selecting the highest quality JPEG your camera offers is the best choice if you don't wish to work with RAW files. This choice is superb for web use, projection, and making prints. However, it is crucial to properly expose and set the optimum white balance for the image at the time of capture. Of course, for web use, you'll want to reduce the size of the image to allow it to pull up faster on the internet for easy viewing.

At times, there is a crucial advantage to shooting large JPEGs exclusively. A RAW file is much larger than a large JPEG. That means shooting a continuous series of RAW images fills up the camera's buffer faster. When the buffer fills to capacity, you can't shoot until enough data is written from the buffer to the memory card to free up some space in the buffer. Filling the buffer at the peak of the action will cost you memorable images. If you find you are filling the buffer too often, then shoot large JPEGs. You'll be able to shoot many more images before the buffer fills to capacity. Hopefully, future cameras will offer a larger buffer to eliminate this problem.

RAW + LARGE JPEG

Your digital camera can probably be set to capture RAW and JPEG images at the same time. This gives you a choice of both file types. We often do this when we aren't shooting many

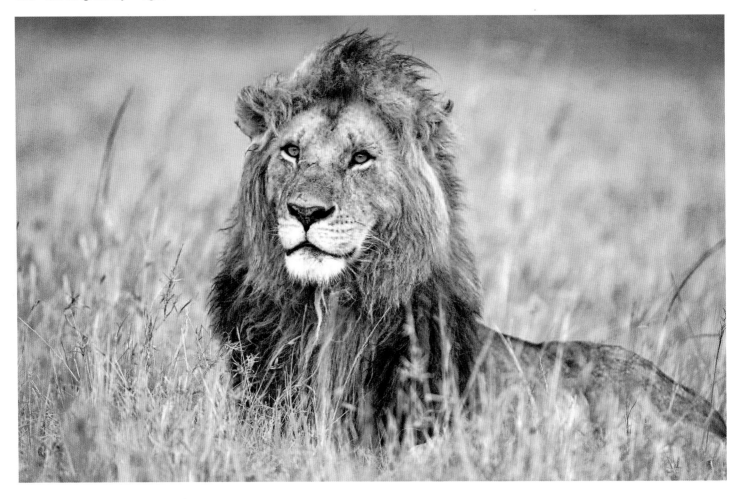

The dimming light forced Barbara to shoot wide open at f/4.0 to permit a fast enough shutter speed to shoot a sharp lion image. Although all lenses are sharpest around f/8, f/4 still does quite a fine job, especially if the lens has the highest quality glass elements. Nikon D300, Nikon 200-400mm f/4.0, f/4 at 1/400 second, ISO 1600, and manual metering.

images continuously. Saving a RAW and JPEG version of each image fills up the memory card and buffer faster. If we are short on memory (which seldom happens with the high capacity CF cards we use) or shooting action sequences, then we switch to RAW only.

OPTIMUM F-STOPS

All lenses have inherent lens defects that reduce the quality of the image. Among these defects are chromatic aberration, spherical aberration, astigmatism, coma, curvature of field, and diffraction. You don't need to know what these are, but it is helpful to know how to reduce these negative effects in your images. Your lens maker carefully builds the lens to reduce these imperfections, but can't eliminate them entirely.

Diffraction becomes a serious problem when tiny apertures are used. Diffraction will make f/22 on a 300mm f/4 lens less sharp than f/16. As the aperture size decreases, a larger percentage of light passing through the small aperture touches the edge of the aperture and bends (diffracts). This reduces the overall sharpness of the image. On the other hand, using f/4 largely eliminates diffraction, but chromatic aberration increases. This means the colors that make up the light don't

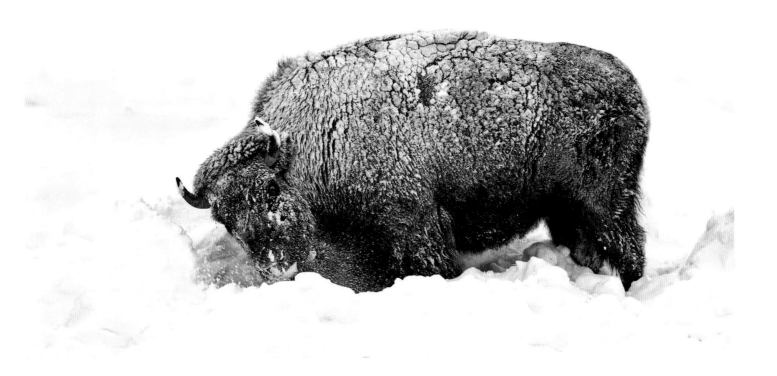

focus at precisely the same plane. Stopping the lens down a stop or two reduces this problem. Therefore, lenses tend to produce the best image quality two to three stops down from the maximum aperture of the lens. If the maximum aperture of the lens is f/4, then f/8 to f/11 are likely the best f-stops to use for the highest quality images. If the lens is a 300/2.8 telephoto, then f/5.6 to f/8 are superb f-stops to use.

Since most wildlife photography is done with long telephoto lenses that require fast shutter speeds for sharp images, it isn't likely you'll be tempted to use f/22, thereby avoiding diffraction problems. Remember lens defects when shooting wide open, though. While you shouldn't be overly concerned about

Bison easily push snow out of the way by sweeping their massive heads back and forth to find the grass hidden underneath. Manual metering works best in a field of snow. Expose as far to the right as possible without overexposing the snow and focus on the head of the bison. Nikon D200, Nikon 70-200mm lens at 183mm, f/4.0 at 1/350 second, ISO 100, and manual metering.

shooting at the fastest f-stop your lens offers, only do so when you have little choice because you need the shutter speed or wish to completely blur the background with a shallow depth of field. Otherwise, with a 500mm lens that contains a range of f-stops from f/4 to f/22, it is successful practice to use f/5.6 to f/11 most of the time to achieve the best image quality. However, when dim light demands the use of the fastest f-stop on the lens, f/4 in this example, go ahead and use it. The

quality is still quite acceptable. To be honest, the quality difference between f-stops is quite minimal, so don't be overly concerned about it.

TRIPODS

A sturdy tripod that is able to support your heaviest lens is absolutely crucial to consistently shooting sharp images.

While hand-held sharp images are possible by using ultra-fast shutter speeds of 1/1000 second and faster, a tripod makes it much easier.

Tripods give you options. Instead of always using high ISOs and shooting at maximum aperture, the tripod lets you use lower ISOs, such as ISO 200 or ISO 400, stop down the lens more to increase depth of field, and use slower shutter speeds when necessary.

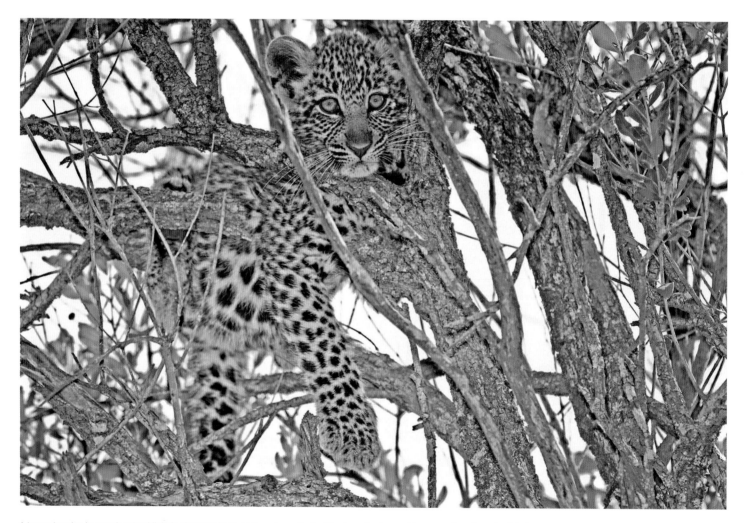

A leopard posing in superb natural light is abnormal because they choose to dwell in dense bushes and tree canopies where the light is either too high in contrast if it is sunny or dim and blue if it is cloudy. This leopard cub is a hopeless subject without flash. If the leopard is well-exposed, the bright background is completely overexposed. If the sky is well-exposed, the leopard is severely underexposed. Barbara used flash to properly light the leopard and greatly reduce the contrast between the leopard and the sky background. Nikon D300, Nikon 200-400 f/4.0, f/6.3 and 1/250 second, ISO 400, and manual natural light metering along with automatic flash.

TRIPODS SUPPORT THE WEIGHT WHILE YOU WAIT

Tripods provide other benefits. Not only does the tripod hold the camera still, it maintains the composition while you wait for the animal to assume a more interesting pose. When photographing bison "plowing" the snow as they look for grass in Yellowstone, we wait for the bison to lift its head to improve the pose. Often, several minutes pass before the bison's face becomes visible. It's impossible to hand-hold a big lens for that long and be ready when the pose finally materializes.

The tripod is helpful for supporting the weight of the camera and lens while waiting for the subject to appear. Tripods are handy when you are waiting for a woodpecker to return to its nest or a red fox pup to emerge from the den. Anyone who photographs hummingbirds at sugar water feeders will appreciate having the tripod hold the camera and lens in position while they wait for a hummingbird to visit the feeder.

TRIPODS FREE UP YOUR HANDS

When photographing small animals such as lizards, snakes, frogs, and toads, the tripod supports the camera. This leaves one hand to trip the shutter while the other can hold a flash or reflector to improve the light on the subject.

SUGGESTED TRIPODS

Wildlife photographers use a huge variety of tripods successfully. In no way do we wish to suggest that the tripods we use are the only ones to consider. Many tripods work well for wildlife photography. However, we have been perfectly happy with our tripod choice for many years. Unfortunately, the Gitzo 1325 model we use has been discontinued.

WHAT TO LOOK FOR IN A TRIPOD

The tripod must be heavy enough to support your equipment solidly. Tripods that are too light for the equipment are more harmful than useful. They are a danger to your equipment and tend to cause you to shoot unsharp images because they are unsteady. Well-made tripods that use as few nuts, screws, and bolts as possible work best because you don't spend so much time tightening these fasteners—a nuisance that is best avoided.

The tripod legs must let you spread them out flat to allow you to shoot very close to the ground. Many animals like ground squirrels and shorebirds are most effectively photographed at ground level. The low angle offered by lying on the ground to photograph them provides a captivating viewpoint. Not only must the tripod legs spread out flat, but you must have a tripod that comes without a centerpost. If it has a centerpost, then it must be easy to remove. If the tripod has a centerpost that can't be removed, even if the legs do spread out flat, you can't shoot near the ground because the long centerpost precludes it.

Your tripod must be able to extend the legs far enough to let you shoot the camera at eye-level while standing. Often you must shoot over foreground obstacles such as bushes, so getting the camera up high enough is necessary at times. Essentially, you want a tripod that lets you shoot easily from ground level to the height of your eyes while standing. To get the camera up high, your tripod may have three or four leg segments. This is another choice you must make. Tripods with four leg segments often go up higher and they pack down to a shorter overall piece of equipment. However, tripods with three leg segments are quicker to set up since there are fewer leg segments to extend. Therefore, we tend to prefer tripods with three leg segments.

TRIPOD MODELS

Manfrotto and Gitzo are two of the most widely used brands of tripods among nature photographers. Both brands are effective for our photography workshop participants. We see a lot of them and are quite familiar with both.

Gitzo Tripods

At the beginning of our photo careers, we began with Gitzo tripods and continue to use them successfully today. For years, we used the Gitzo 1340 model, but eventually upgraded

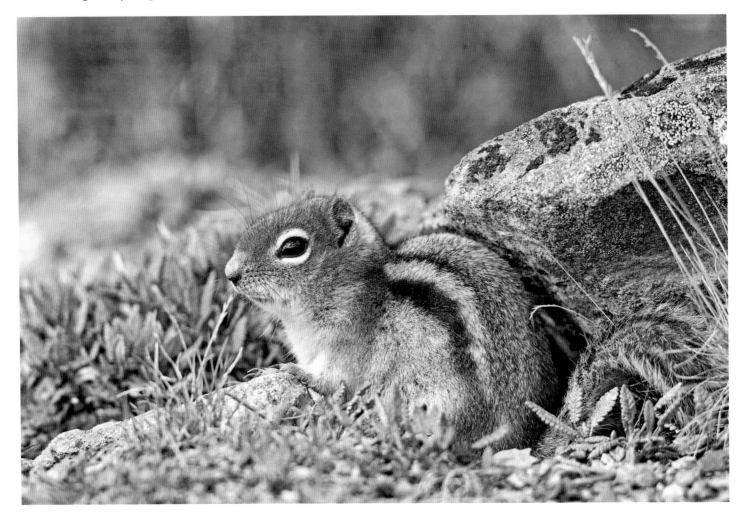

to the carbon fiber Gitzo G1325 CF Studex 3 tripod we use today. Both of these models have been discontinued as the company continues to improve their product line—though we do not feel the need to upgrade. A popular current model is the Gitzo 3541XLS, but many similar models of various sizes are available. The best way to pick the perfect tripod for you is to visit a large camera store that stocks many tripods and try them out—keeping in mind the features we mentioned.

Manfrotto Tripods

These tripods tend to be less expensive than Gitzo, so many of our friends and workshop clients use them. They do work

Lie on the ground to capture an intimate face-on shot of this adorable golden-mantled ground squirrel. The tripod must let you spread the legs out flat to put the camera near the ground. Avoid tripods that include a centerpost that is not easy to remove because the centerpost prevents you from getting the camera close to the ground. Canon 5D Mark II, Canon 500mm f/4.0L lens, f/7.1 at 1`/400 second, ISO 500, and Shutter-priority with zero exposure compensation.

well, but have a lot of nuts, bolts, and screws that can work themselves loose and get possibly lost—if you don't notice the problem in time. The Manfrotto 055X series is quite popular among wildlife photographers.

TRIPOD HEADS

Once you own a fine tripod, you'll need a head to go on it. Many types of heads are offered, but the vast majority are undesirable for wildlife photography. Many are too slow, not robust enough to support heavy lenses, require their own proprietary quick release plates that don't work very well, or simply have too many gizmos on them that get in the way. Fortunately, the best tripod heads are well known among wildlife photographers.

TILT-PAN HEADS

These common tripod heads are designed to let you use separate controls to tilt the camera up and down and pan the camera left and right. This sounds like an obvious way to make a tripod head. Yet, most don't work very well for nature photography and wildlife photography in particular. While there may be some tilt-pan heads that work well, we haven't seen one yet.

BALL HEADS

Kirk Enterprises (www.kirkphoto.com)

Mike Kirk and I became friends around 1977 when he was a machinist. He could design and build anything photographic. Mike built custom flash brackets to use in macro photography for me and other photographers. Eventually, he created Kirk Enterprises that specializes in building custom photographic equipment. All photographers owe Mike a huge debt of gratitude for starting the trend to custom photographic gear that works much better than standard equipment. Sadly, Mike is with us only in spirit now, but this fine company continues to be run by Jeff Kirk, his hard-working and talented son.

Obviously, with our decades-long relationship with Mike and Jeff Kirk, we tend to favor and promote their products. Everything is well designed and works beautifully. We are completely happy with all of the photo equipment we use from them which includes ball heads, lens plates, L-brackets, window mounts, camera plates, and more. We've used Kirk BH-1 ball heads for decades and continue to use them without any problems.

If the largest lens you own is a 300mm f/2.8, then Kirk's smaller BH-3 ball head is all you need. We use this smaller head when shooting macro images and when photographing hummingbirds with our smaller 300mm f/4 lens. The BH-3 can easily support the weight of these smaller lenses, but it is too small if you plan to use a 400mm f/2.8, 500mm f/4, or larger lens.

Really Right Stuff (www.reallyrightstuff.com)

This company also builds excellent custom photographic equipment. While we haven't used their products, many of our workshop clients and other serious photographers do. Our clients are happy with their ball heads, lens and body plates, and other devices from this company.

Wimberley (www.tripodhead.com) and the Gimbal Head

I met them years ago when I was conducting a photo seminar. They were developing a new kind of tripod head that featured a "gimbal" style. Little did I realize at the time that the gimbal head would become the favorite head for photographers who specialize in action images and shoot big lenses. It doesn't matter if you are photographing birds in flight, running pronghorns, racing cars, or galloping horses. The gimbal head is easily the best tripod head for action photography. It is designed to support the camera and lens in perfect balance. This makes it easy to pan the camera left and right and tilt it up and down without having to lock up the head because that isn't necessary. If you let go of the camera, it stays wherever it is pointed. Balancing the lens makes it easy to track action.

The Wimberley gimbal head is superb. Of course, all great products attract the attention of competitors and now similar heads are offered by many. Since Wimberley developed the fantastic "Wimberley" head first, we think it is wise to consider purchasing their fine product. But it doesn't hurt to compare features and prices. Visit them at www.tripodhead. com. Other companies that build gimbal heads include Custom Brackets (www.custombrackets.com), Jobu Design (www.jobu-design.com), ProMediaGear (www.promediagear.

Barbara is using the fabulous Kirk BH-1 ball head with a convenient Wimberley Sidekick to balance her Nikon lens. This gimbal-style set-up lets her easily pan horizontally and vertically. If she lets go of the camera, the lens remains perfectly balanced. Every serious wildlife photographer we know uses gimbal-style heads because they work far better than any other tripod head. Go to www.kirkphoto.com and www.tripodhead.com for more information. Canon 5D Mark II, 300mm f/4.0L lens, f/13 at 1/20 second, ISO 400, and manual exposure.

com), Kirk Enterprises (www.kirkphoto.com), and Really Right Stuff (www.reallyrightstuff.com). We enjoy using Kirk's Cobra on our floating blind.

Wimberley Sidekick

We use this wonderful device constantly for wildlife photography. The Sidekick converts a ball head that has a compatible Arca-Swiss quick-release clamp (such as the Kirk BH-1 ball head) into a gimbal head in seconds. The Sidekick and the BH-1 ball head are smaller than a regular gimbal head, but it solidly supports our 500mm lens and lets us easily pan when shooting wildlife action.

When we aren't tracking action or using telephoto lenses, then we easily and quickly remove the Sidekick from the BH-1 ball head. We don't wish to use the gimbal head all of the time because it is cumbersome for photographing landscapes and macro subjects, especially with short lenses. When using a short lens, we prefer the Kirk BH-1 ball head alone.

ATTACHING THE CAMERA AND LENS TO THE TRIPOD HEAD

Quick Release Plates

To use a quality ball head or gimbal head, you must attach a quick release plate to the camera body, or the tripod collar on the lens if it has one. Many different tripod head and plate systems have evolved. Avoid the vast majority of them. The best systems are well known. We encourage you to adopt the system we'll describe shortly.

Be certain the plates you buy to attach the equipment to the tripod head work together. The easiest way to do this is to buy the plates from the company that also makes your tripod head. In other words, if you shoot with a Kirk BH-1 ball head, then buy your plates directly from them. If you use the Really Right Stuff ball head, then buy from them. However, Really Right Stuff, Kirk Enterprises, and Wimberley all tend to design their products in similar ways, so most of their accessories are interchangeable with each other. Still, always ask the company you are buying an accessory plate from if it is suitable with a competitor's product.

The L-plate

This special plate (L-bracket) is invaluable to all photographers who use a tripod, no matter what they photograph. As the name suggests, the plate is shaped like the letter "L." This plate attaches directly to the camera by screwing one side of it into the screw hole found on the bottom of the camera. The L-plate is two quick release plates in one. It lets you mount the camera horizontally or vertically on top of the tripod head. This means it isn't necessary to flop the camera over to the side of the tripod head to shoot a vertical image and eliminates creating a balancing and stability problem on the tripod head. While this may seem like a small thing, it makes shooting vertical images on the tripod much easier and far more convenient. We have a custom L-plate attached to every camera body we own.

Some companies offer generic L-plates to fit a variety of cameras. However, it is best to avoid them because all generic plates have their shortcomings. Instead, we highly recommend using a custom L-plate made for your specific camera model. A custom plate is carefully designed to let you change camera batteries, remove your memory cards, and provides access to all of the controls on your camera without forcing you to remove the L-plate first. If you go with a generic L-plate, and then find out you have to take it off every time you change the batteries, you'll soon hate it and won't continue to use it. Using custom quick release plates for the tripod collars that some lenses have and L-plates for cameras is the best way to go.

FIRING THE CAMERA

CABLE RELEASE

This 6–10 inch cord contains an electrical connection and attaches directly to the camera. It has a push button on one end (that can be locked for long exposures) and a connector for fastening it to the camera on the other end. Press the button to trip the shutter. The primary purpose of the cable release is to prevent your quivering body from causing the camera to vibrate at the moment of the exposure. Of course, the camera must be mounted on a tripod. It doesn't do any

good to hand-hold the camera while using a cable release, although we have seen some photographers shoot that way.

Wind can easily vibrate a sturdy tripod. A cable release won't help you capture sharper images in a constant wind, unless you wait for a lull when you fire the camera. The cable release works best when there is no wind, no subject movement, and the mirror is locked up to eliminate any vibration that might be created by the motion of the mirror during the exposure.

REMOTE RELEASE

This release uses a wireless system to trip the camera, so it isn't directly attached to the camera. The inexpensive versions tend to use infrared signals to fire the camera. The more expensive remote releases use radio signals. Unlike the infrared release, radio releases don't require line-of-sight to work successfully and they work over much greater distances. However, we find the infrared release works fine for us since we are normally near the camera anyway.

USING CABLE AND REMOTE RELEASES

Both cable and remote releases are incredibly valuable for all macro photography and quite useful for most landscape photography. However, for wildlife photography, neither are especially useful. Can that statement be true? You bet! Most wildlife photography is accomplished with lenses longer than 200mm. Lenses in the 200mm focal length range and longer magnify the subject greatly. These lenses also magnify camera shake. Although long focal length lenses are heavy, which helps to stabilize them, they also have a much larger surface area. Any steady breeze, even a 5 mph cross-wind, may cause the tripod-mounted camera to vibrate. It is a serious problem. If you don't believe it, mount a 300mm lens on a tripod when a stiff wind is blowing and carefully focus on anything with fine detail. Carefully look through the viewfinder without touching the camera or the tripod. You'll see the image gyrating all over the place. It looks like an earthquake is happening inside the viewfinder. If the shutter speed is only moderately fast, such as 1/60 or 1/125 second, the resulting image will surely be soft due to wind-induced camera shake.

Both wind and flowing water can and do vibrate the tripod-mounted camera. Using a remote release does not solve the problem. Instead, you'll shoot sharp images more consistently by hanging onto the camera with one hand and pressing down on the top of the lens with the other hand. While the camera isn't completely still due to body movement and moving air, you'll greatly reduce camera shake caused by the wind when you add your body mass to the camera. Now focus carefully while favoring fast shutter speeds of 1/250 second and greater to capture sharp images. We have shot over a million images with lenses of 300mm and longer and have used this strategy for more than 30 years with super results. It will work perfectly for you, too.

WHEN THE REMOTE RELEASE DOES WORK

Firing the tripod-mounted lens and camera with a release does make sense at times. Perhaps you have found a bird quietly incubating its eggs. If the bird is completely still, there is absolutely no breeze, and you lock up the camera's mirror to avoid any vibration, then it does make sense to trip the camera with the remote release. This situation doesn't happen often, but it is possible. The well-known "mirror-slap"

Barbara used a cable release to trip her tripod-mounted camera on this motionless magnificent frigatebird with its chick in the Galapagos Islands. She favored f/10 depth of field to make both birds sharp. Nikon D3, Nikon 200-400mm f/4.0 lens, f/10 at 1/100 second, ISO 640, and Aperture-priority with a minus 2/3-stop exposure compensation.

problem is most serious at shutter speeds from 1/4 second to 1/60 second. If you use shutter speeds faster than 1/60 second or slower than 1/4 second, the loss of sharpness from the motion of the mirror is insignificant. If you focus with live view and shoot, you don't need to lock up the mirror because the mirror is already up!

We normally use a remote release when photographing small animals like frogs, lizards, snakes, and turtles with our long macro lenses. Sometimes we use a 300mm lens with a 25mm extension tube for these creatures. Therefore, make sure you always have some sort of remote release (wireless or cable) for those times when you need it.

Recently, a few new cameras have been introduced by Panasonic, Sony, and others that let the light pass through the mirror. Since the mirror doesn't move, this eliminates the "mirror-slap" problem completely. A stationary mirror improves autofocusing on moving subjects and lets the camera shoot faster burst rates. Hopefully, this new design will improve and be adopted by all camera companies.

These African white pelicans are waiting patiently at Lake Nakuru for thermals to develop. When the air begins to rise, they fly off by soaring in large circles to favored feeding spots. Using f/20 to get more depth of field helps to sharply record all of the birds in this image. Canon EOS 5D Mark II, Canon 70-200mm lens at 176mm, f/20 at 1/400 second, ISO 400, and Shutter-priority with +2/3-stop exposure compensation.

TRIP THE SHUTTER WITH YOUR FINGER

This is the time-tested way we and most other wildlife photographers use to trip the shutter. Support the camera and lens on a sturdy tripod and head or bean bag. Focus on the eye of the animal and use fast shutter speeds. An old guideline says, "You should use one over the focal length to shoot a lens hand-held for sharp images." To illustrate this simple concept, use 1/300 second with a 300mm lens and 1/500 second with a 500mm lens. Supposedly, these are the shutter speeds you need to shoot these two lenses hand-held. Of course, some photographers are steadier than others, so this guideline depends on the individual shooter.

We suspect this hand-held shooting guideline is optimistic for most photographers. We tend to be conservative and use the one over the focal length guideline for shooting on a tripod. We think it is too slow for hand-held shooting, if you want really tack-sharp images. Perhaps we are shakier than others, but I doubt it. Our quality standards are exceedingly high. We simply don't cut any corners needlessly and don't think it's in your best interest, either.

WHEN SLOW SHUTTER SPEEDS MUST BE USED

Many animals are active early and late in the day, when the available light is dim. There are plenty of times when it is impossible to use faster shutter speeds because the light is too dim. Keeping in mind it doesn't cost anything to shoot digital images, when there is no other choice, continue to attempt to shoot sharp images even at 1/60 second with a tripod-mounted 500mm lens. Most likely the vast majority of images will be unsharp, but you may capture a few critically sharp images, making it all worthwhile. Anytime it is necessary to shoot below 1/250 second, we tend to use the image stabilization feature on our Canon and Nikon lenses. We feel image stabilization is overused, but it does help produce sharper images when slower shutter speeds must be used.

Photographing groups of animals, such as a large flock of pelicans, is another time when slower shutter speeds may be necessary. When there are two or more animals in the viewfinder, it is important to get more depth of field to sharply focus all of the individuals in the group. Using f/16 for more depth of field forces the use of slower shutter speeds. Do the best you can and hope for the best. Your percentage of sharp images will drop, but you should still capture some pleasing ones. If the brightness of the available light permits, keep the shutter speed up while favoring depth of field. Don't forget to increase the ISO if necessary.

IMAGE STABILIZATION

This popular feature helps you shoot sharp images in certain situations. If camera shake occurs, this reduces the apparent shaking and captures sharper images. Image stabilization does help you shoot sharper images, especially at slower shutter speeds of 1/125 second and slower. Just remember image stabilization is helpful for arresting camera shake, but does not freeze subject motion. Image stabilization may be built in to the lens or the camera. If it is built in to the camera, then

This Galapagos sea lion swam around our panga for several minutes. I used image stabilization to help me capture a sharp image. Generally, once I reach a shutter speed of 1/320 second, I turn off image stabilization. Canon EOS-7D, Canon 300mm f/4.0L lens, f/8 at 1/200 second, ISO 400, and Shutter-priority with a minus 1/3-stop exposure compensation.

all lenses used on the camera are stabilized. Both systems seem to work.

One advantage of having image stabilization (vibration reduction) built in to the lens is that the image is stabilized as you view the image through the viewfinder. If the image stabilization is in the camera body, the image in the viewfinder still shakes. No matter which image stabilization your camera system uses, it is helpful when slow shutter speeds must be used or when you must photograph from a boat bobbing in the swells. We recently used image stabilization a lot while photographing noddy terns and Galapagos penguins from a small boat in the Galapagos.

PHOTOGRAPHING FROM VEHICLES

WINDOW MOUNT

This wonderful camera support attaches to the door and window of your vehicle. It holds your camera still if the wind isn't blowing too hard. Of course, be sure to turn the ignition off to eliminate motor vibration.

The window mount lets you screw a ball head to it. We use Kirk's superb window mount and screw their BH-1 ball head to it. If we know we are only going to be shooting out one window, this method works well. Since the window mount is somewhat bulky, it is slow to move from one window to another. The best answer to shooting out multiple windows is to have more than one window mount, or use less expensive bean bags.

Some window mounts, like Kirk's, also double as a ground pod to let you lie on the ground for a low viewpoint. Such a viewpoint is effective for all animals that dwell on the ground. Of course, it doesn't work well in wet areas, or for those who physically might have a hard time getting back up.

BEAN BAGS

These simple cloth or nylon bags are filled with beans, but not too full, to allow the lens to settle into a slight depression. They support the lens easily and greatly reduce camera shake.

Since bean bags are inexpensive, it is easy to afford several of them. Put a bean bag in every window you might shoot through. On Kenya photo safaris, we tell our clients to tie one bean bag (so it doesn't fall off when the Land Rover moves) to the top railing on both sides of the Land Rover. Also, it is helpful to use a third bean bag that can be moved into position easily for the lower two windows. This provides a better shooting angle for small creatures on the ground such as a black-backed jackal or bat-eared fox.

MOLAR BAG

This bag looks like a molar tooth and nicely fits over both sides of the car window. It offers superb support for big telephoto lenses because it is large. It takes a lot of beans to fill it which makes it heavy, though. The molar bag is a fine choice if you always plan to shoot from a single window, so you don't have to move it around.

OTHER BEAN BAGS

Many bean bags are made for photographers. Offerings come and go. Search the web for "photographic bean bags."

PHOTOGRAPHING FROM BOATS

We've photographed in the enchanting Galapagos Islands and in the magnificent ice fields of Antarctica several times. Both trips require you to photograph wildlife from boats at times. Unless the boat is completely still, you are better off to shoot hand-held and not use a tripod because any boat movement makes the tripod move, too. Using a tripod under such conditions will increase the problem of capturing sharp images. Instead, hand-hold the camera, favor fast shutter speeds, activate image stabilization, and use your body to absorb as much of the motion of the rocking boat as possible. If the boat is bobbing up and down, try to time the movement and shoot at the top or bottom of the bob, when the boat is momentarily still.

HAND-HELD SHOOTING SITUATIONS

Without a doubt, using a good tripod whenever feasible will improve your image sharpness. This is especially true in wildlife photography where telephoto lenses are used most of the time. If you hope to earn money from your wildlife images, it's important to realize nature photography is a highly competitive business that is brimming over with superb photographers around the world. It is difficult to compete with the other talented photographers if you choose to needlessly cut corners that reduce the quality of your images. There are times, though, when you must shoot hand-held, such as for flight photography and panning.

I panned smoothly with this laughing gull as it flew along a Florida beach. It is especially important here to use manual exposure. All automatic exposure modes change the exposure as the size of the mostly white bird varies in the viewfinder, causing less than optimal exposure much of the time. Canon EOS 1D Mark III, 300mm f/4.0 lens, f/7.1 at 1/1600 second, ISO 200, and manual metering.

OVERHEAD BIRDS IN FLIGHT

Hand-holding works better for some flight photography. Midway Atoll is famous for the Battle of Midway and less well known for the hundreds of thousands of nesting seabirds on the tiny islands. Laysan and black-footed albatross nest here in incredible numbers. During the late afternoon, thousands of them return from foraging at sea. Many of them soar directly over you. Photographing straight up when the camera is mounted on a tripod is difficult, even on a gimbal tripod head. It is much easier to track the albatross and keep the AF points on the bird if you hand-hold and pan with the subject as it flies overhead.

PRECISE FOCUSING

Keeping a single, or perhaps a small cluster of AF points, on the subject as it passes is effective for keeping the lens sharply focused on the subject. Strive to keep the AF points on the

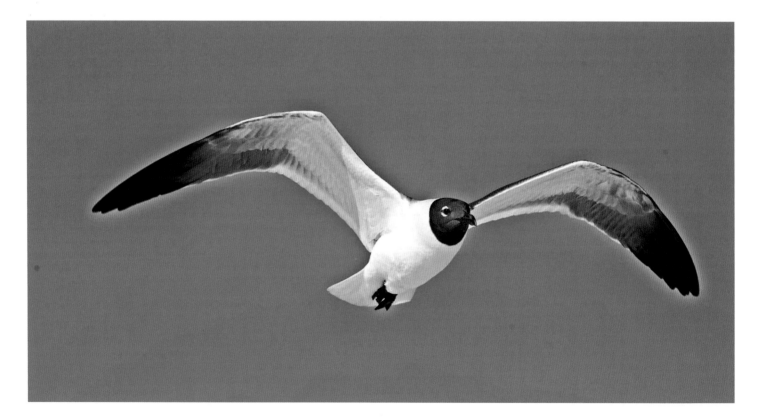

head of the subject. Naturally, make sure the camera is set to continuous autofocus to permit the focus to change as the shooting distance changes. Of course, if the subject is stationary, then focus on the head. Lock in the focus by using back-button focusing, or hold the shutter button down halfway if the focus is on the shutter button. Focus, recompose, and press the shutter button all the way down to capture the image.

USE FAST SHUTTER SPEEDS

Photographing wildlife hand-held with a fast shutter speed is usually required to capture sharp images. These three strategies help you get to fast shutter speeds. First, try using ISO 400 or 800. Although the noise at these elevated ISOs is greater, their use lets you use much faster shutter speeds. Second, use smaller f/numbers, f/4 rather than f/11, to let more light through the lens. Changing the f-stop from f/11 to f/4 adds three stops of light. Now you can use a shutter speed that is three stops faster, 1/1000 second instead of 1/125 second, for example. Third, you have little immediate control over how bright the available light is when you are photographing. But it's helpful to plan your photo outing to coincide with favorable weather that provides an abundance of available light. By shooting more wide-open, bumping up the ISO a bit, and shooting when the available light tends to be brighter, a large choice of fast shutter speeds becomes available to you.

PANNING

Swinging the camera to keep the AF points on an animal as it passes by is called panning. Excellent panning technique keeps the subject in the same position in the image. If you do it well, focus accurately, and keep the shutter speed fast, it can produce critically sharp images.

Successful panning is an art. The more you do it, the better you get. Here's an effective way to do it. It is helpful to begin panning with the subject before it is as close as you want it. Twist your shoulders and knees while swinging the camera to keep the subject nicely framed in the viewfinder. As the subject reaches the desired size in the viewfinder, continue to pan with it while firing as many images-per-second as possible. Shooting many images increases the chance of catching a spectacular pose. Be careful to avoid cutting off the tail or feet of the subject.

Remember, panning does take practice. It doesn't hurt to have a friend throw a frisbee or football past you to provide practice. We sometimes entice our 8-pound Pomeranian to scamper past us (with a dog biscuit incentive) to shoot action images.

DEVELOP SUPERB PHOTO HABITS

We've explained many factors that are enormously important to shooting high quality and critically sharp images. It may seem like a lot to remember, and it is, unless you make good shooting strategies a habit. All of these strategies are habits for us. We concentrate on finding the best subject, consider what direction the light is best, and how the background enhances the subject. We choose the best viewpoint and eliminate obnoxious merging lines, consider how the animal's body is positioned, and finally determine the overall best composition. With some field experience, using excellent photo strategies will become an automatic habit for you.

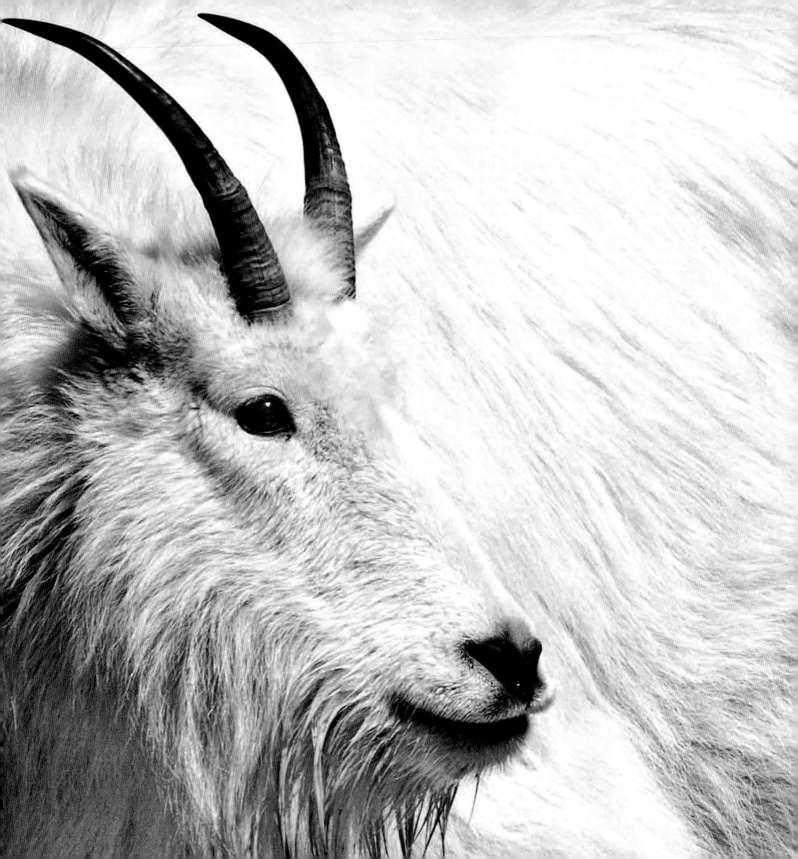

6

The Crucial Role of Light

I was incredibly lucky at the beginning of my photography career 40 years ago because Larry West, my accomplished instructor and a brilliant nature photographer, freely gave me sound advice for becoming a competent nature photographer. I remember him asking me, "John, what do you get when you photograph a subject in bad light?" I pondered the question for a moment in the hopes of coming up with a profound and all-encompassing answer. I said, "The picture would have too much contrast, the highlights would burn out and lose detail, the shadows would go too black and lose detail, and the shadows would be unflattering." Larry smiled softly and simply said, "You get a bad picture." I was merely describing some of the symptoms of a bad picture. He said, "If you photograph anything in bad light, you will surely get a bad picture." He went on to stress how it is crucial to photograph the subject with light that is favorable to it. I have used his observation about light for decades to achieve success far beyond my wildest dreams. To this day, I avoid wasting my time photographing subjects that are illuminated by unsuitable light that cannot be modified to make it photogenic.

Barbara and I teach dozens of nature photography workshops and seminars every year. During the workshops, we often critique the images our students bring from home. Many of these images are absolutely breathtaking, but others suffer from serious faults. The single most common problem we see is that the subject has been photographed with unflattering or downright horrible light. Other common problems include unsharp images, distracting backgrounds, poor subject selection, and boring compositions. On Friday evening of our summer and

LEFT: Mountain goats sometimes eat grass close to the highway near Alpine, Wyoming, in February and March. At least ten goats approached within 25 yards of us late in the morning. Nikon D300, Nikon 22-400 f/4 11 lens, focal length 390mm, f/10 at 1/500 second, ISO 200, Aperture-priority with a +1-exposure compensation.

autumn Michigan workshops, we project the students' ten best images they shoot during the week with us. Apparently, our workshop leadership is effective because seldom do we see light problems in these images. When leading photo workshops, we carefully select the field trip destination to insure we take our group to an ideal location where the light and wind conditions are suitable for the subject matter. It is a decision that we take seriously because we know the success of our students in producing memorable images depends on picking the right location. For our own photography, we choose our shooting location exactly the same way because it is absolutely crucial to shooting successful images.

Regrettably, too many photographers assume they "see" the light. While everyone knows when there is light, many really don't see it photographically. Instead, they just see that there is light on the subject. Seeing the light photographically requires understanding how the camera "sees" the shadows and highlights, not how you with a human eye do, as they are quite different due to the limited dynamic range the camera can record. Is the light direction suitable for the subject? What

The backlighting nicely outlines these downy Forster's tern chicks. The golden sun brings out the colors in the chicks and beautifully separates them from the background. Canon EOS-7D, Canon 500mm f/4L lens, f/7.1 at 1/500 second, ISO 640, Shutter-priority with a minus 2/3-stop exposure compensation.

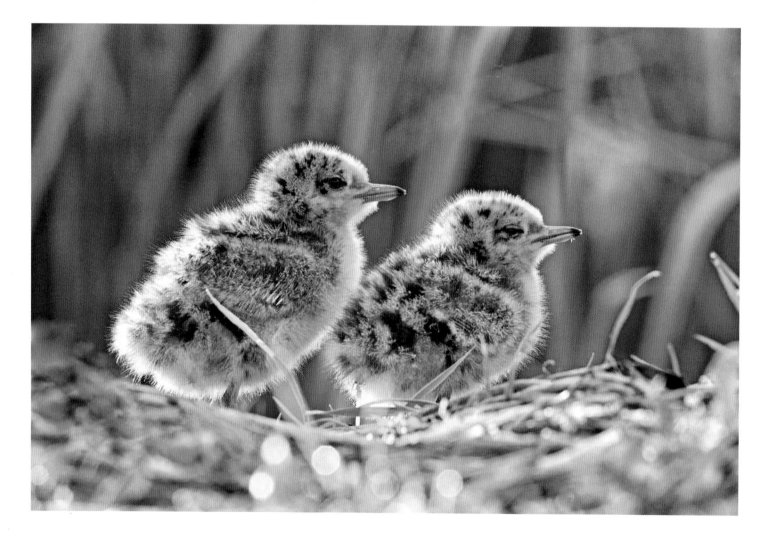

about the color of the light? Does a distracting shadow fall on the subject? Does the eye have a catchlight? Is the background too light or dark for the subject? Can a different angle improve the light? Can you modify the light? All of these and more are questions that must pass through your mind instantly as you select, approach, and photograph a subject. There is plenty to think about, but it becomes automatic after a while. It is in your best interests to avoid assuming you are naturally skilled at seeing good photographic light because most of us aren't. Fortunately, we can all easily learn to improve our ability to "see" the light.

Light has four qualities that dramatically affect how you photograph and what the final image looks like. These qualities are intensity, direction, color, and contrast. Let's explore these factors individually to see how each of them affects how you photograph.

This serval cat unexpectedly appeared near the trail as we were driving back to our game lodge in the Masai Mara. I was using manual exposure and had not metered anything for the past 15 minutes. Since the natural light had fallen during that time interval, my images were underexposed by at least two stops. Still, digital software makes it easy to increase the exposure and minimize the noise that is created when the subject is underexposed and made the image quite useable. Canon EOS 1Ds Mark II, Canon 500mm f/4L lens, f/6.3 at 1/400 second, ISO 160, and manual metering.

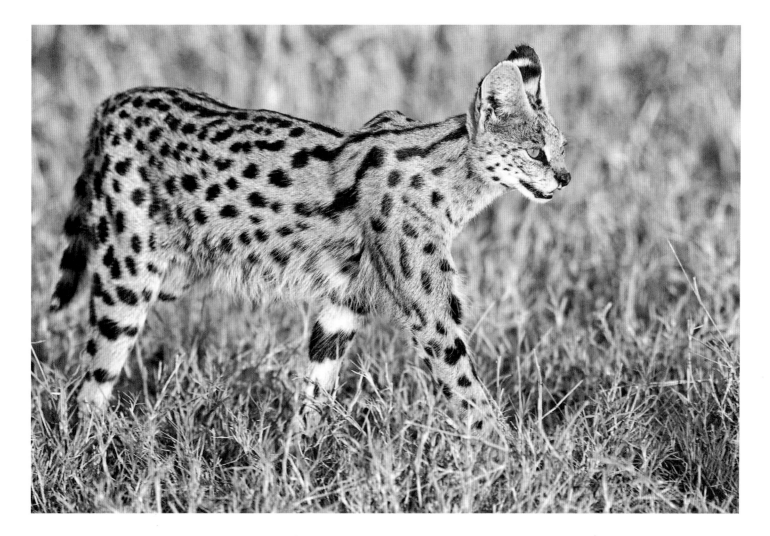

INTENSITY

Intensity refers to the amount of available light that illuminates the subject. This factor is less critical for digital capture (compared to film) because the qualities of high ISOs are incredibly good and constantly improving with each new camera generation. Still, low light levels make photographing wildlife more challenging. While you can use high ISOs, such as ISO 800 or 1600, to obtain sufficient shutter speed for sharp images, there are still problems that must be overcome. Autofocus is slower and less accurate when the light is dim. Indeed, if it becomes dark enough, your autofocus will completely fail to work. This forces you to use manual focus, but that isn't easy either because it is challenging to see fine detail in the dim viewfinder. Fortunately, autofocus continues to improve, viewfinders are brighter, and high ISOs are improving. This means light that is low in intensity is much easier to use successfully than a few years ago. Indeed, these advances let us photograph earlier and later in the day than ever before. All of us have more productive time to shoot images as a result.

LOW LIGHT SHOOTING STRATEGIES

Let's briefly highlight several key strategies for photographing in dim light. Use the most solid shooting platform you can. Usually this is a sturdy tripod, but it could be a bean bag or some other device. Keep the shutter speed fast by opening up the aperture to let more light strike the sensor and use high ISOs. If the shutter speed is 1/250 second or slower, use image stabilization if you have it. In some cases, you may have to add light with a flash and possibly a flash extender to successfully photograph the subject.

There is one more tactic that many photographers don't think about. If all else fails, go ahead and underexpose the subject. Underexpose? Absolutely! Properly exposing the subject costs you shutter speed. Suppose proper exposure is f/4 at 1/60 second with a 500mm lens. You'll have a tough time shooting consistently sharp images at 1/60 second, even on a tripod. If you underexpose the image by two stops, you could use 1/250 second which is plenty of shutter speed for most subjects.

Then use software to brighten up the image. Sure, your image will be noisier and may exhibit less overall detail, but the resulting image may still be satisfactory anyway. Aren't you better off to capture a sharp image that is a bit noisy over an unsharp one that has little noise?

I once got lucky in Kenya thanks to accidently underexposing the image. I used manual exposure to photograph lions in late evening light. Eventually, we had to drive quickly back to the lodge to avoid a possible fine if the driver was late getting through the gate after sunset. As we sped bouncing along, a seldom seen stealthy serval cat magically stepped out of the tall grass a short distance from the road. In only a few seconds, the driver immediately stopped, I threw my 500mm lens on the bean bag, back-button focused on the face of the cat, and fired off three quick shots before it disappeared for good. The first image was super sharp of the walking cat and the other two were fuzzy. Of course, during the time that elapsed between the lions and the discovery of the serval cat, the natural light had dropped by two stops. Since I was using manual exposure and didn't have time to meter again, the camera didn't change the 1/400 shutter speed I was using with the lions. The three serval cat images were two stops underexposed. Still, with Barbara's computer magic, we think the sharp image looks fine. If the camera had been set to Aperture-priority, the shutter speed would have dropped to only 1/100 second. The images would be beautifully exposed, but none would be sharp with the slow 1/100 second shutter speed. Therefore, if you have no other choice, and you must have more shutter speed, deliberately underexpose the image to maintain a suitable shutter speed.

AN IMPORTANT LOW LIGHT EXPOSURE STRATEGY

Today, in the low light situation at sunset just described with the serval cat, I would use matrix metering, Shutter-priority, and Auto ISO. Using Auto ISO is covered in Chapter 3, but it's worth repeating here because it is such an effective strategy that is not widely known among nature photographers. With Shutter-priority, the camera maintains the selected shutter speed, opens up the lens as far as possible, and boosts the

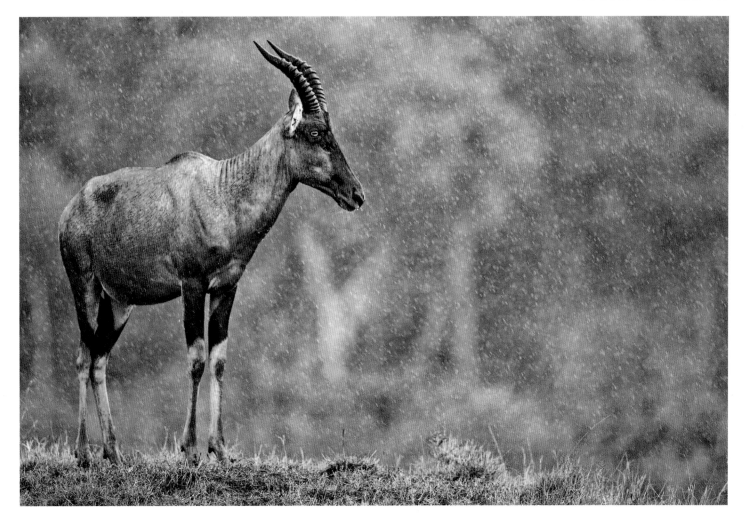

ISO automatically, when necessary, to maintain a suitable exposure.

On a January 2010 Kenya safari, I used this Auto ISO strategy to photograph topi and Defassa waterbucks in a downpour. Naturally, the dense cloud cover and driving rain created dim light, but I did the best I could. I closed the roof hatch, opened a side window, and used a bean bag to continue shooting images in the downpour. I covered the lens and camera with a plastic bag to keep the equipment as dry as possible. Animals photographed in a driving rain or heavy snowfall make fascinating and unique images.

Photographing any animal in a snowstorm or driving rain makes for a memorable image. This topi quietly waited for the rain to pass as it stayed alert for approaching predators. Canon EOS 5D Mark II, Canon 500mm f/4L lens, f/4.0 at 1/640 second, ISO 1250, Shutter-priority with Auto ISO and a +1-stop exposure compensation.

DIRECTION OF LIGHT

Light can illuminate the subject from a variety of directions. The direction of the light greatly influences how well the subject detail is seen, how high the contrast is, how the background appears relative to the subject, the colors in the image, and the overall appearance of the image. Light direction is a

critically important variable that always must be considered when you choose your shooting angle. The five major light directions are frontlight, backlight, sidelight, top light, and diffused light. Let's explore what these are and consider when they are helpful or detrimental to your images.

TOP LIGHT

Having the primary light directly above the subject may be the worst light you can use for the vast majority of wildlife subjects. For example, photographing an elephant during the middle of a sunny day is nearly always pointless. While it is easy to properly expose the sunlit back of the elephant, the belly and legs are hidden in dark shadows that can easily be five or more stops darker than the sunlit portions of the elephant. This enormous contrast range is not covered well with a digital camera and almost always produces ugly images. It's possible to reduce the contrast range and make a more pleasing image later in the digital darkroom. Still, high sun is

The sidelight on this Masai giraffe nicely adds depth to its face. Sidelight is especially effective for revealing texture and shape due to the increase in contrast. Nikon D300, Nikon 200-400mm f/4 lens , f/9 at 1/160 second, ISO 400, Aperture-priority with a +2/3-stop exposure compensation.

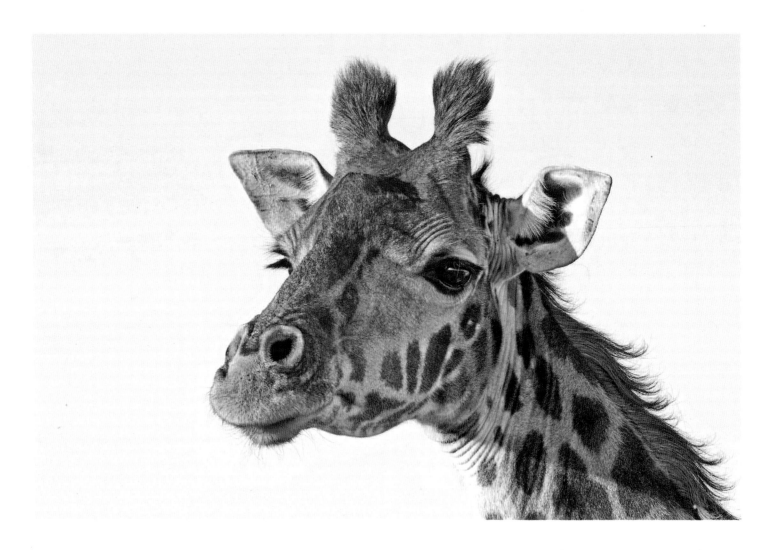

something to be avoided most of the time. Obviously, it can be useful if your shooting viewpoint is above the subject, so you shoot down on it. Sometimes you need high sun to shoot into water to show detail. Still, top light remains the least desirable light direction most of the time. When photographing near the equator where the sun rapidly ascends into the sky, try to do as much photography as possible during the first two and last two hours of the day if the sun is shining brightly. Should cloudy conditions prevail, then photography is favorable all day long.

FRONTLIGHT

This light comes from behind the camera, or nearly so, to illuminate the subject. Since the side of the subject facing the camera is lit, the shadows fall behind the subject. Therefore, few shadows are recorded by the camera. Contrast on the subject tends to be low, making it easy to capture good detail throughout the subject. However, frontlight is flat light because it creates few shadows. This often causes the image to lose the appearance of depth. Frontlight tends to reduce surface detail due to the lack of shadows and does not show texture well at all. Nevertheless, frontlight is easily the most used light direction by wildlife photographers because it does work quite well for many furry and feathered beasts. However, if you always use frontlight, your images will assume a boring look of sameness. Accomplished wildlife photographers are quick to use other light directions, especially backlight and sidelight, whenever it's effective.

SIDELIGHT

This light illuminates the subject from the side. Sidelight is especially effective anytime you wish to show fine detail in a subject or reveal the texture in an uneven surface such as a sand dune. Sidelight that lights the subject slightly from the front is effective for many animals, especially if the face is nicely illuminated and a catchlight is present in the eye. Of the five light directions, sidelight is likely the second least used light direction for wildlife. It tends to create contrast that is too high for the sensor to capture excellent detail in the bright-

est highlights and the darkest shadows at the same time. We tend to use sidelight far more in landscape photography where it really brings out the texture in sand dunes or a field of foxtail grass. However, soft sidelight is quite useful under bright overcast skies because the sidelight rims the subject, but the overcast keeps the contrast manageable.

BACKLIGHT

This light comes from behind the subject and travels to the camera. It is a terrific light for fuzzy or translucent subjects. For example, the throat pouches of some birds light up beautifully when backlit. Shadows fall on the side facing the camera, so it tends to produce high contrast images. This contrast is challenging for the digital sensor to record excellent detail in the highlights and the blackest shadows due to the wide dynamic range. Backlight works best when the light is golden early in the morning and late in the evening when an animal is nicely isolated against a dark background. This light beautifully rims the subject with a golden edge. The side of the subject facing the animal may be somewhat underexposed, but the effect is still attractive. Software is used to bring out more detail when desired. Most of us should use backlighting more than we do as it is terribly underutilized, to the detriment of our images.

SILHOUETTES

Silhouettes are often thought to be a backlight situation, but it isn't quite the same. For example, if you silhouette an animal against the red sky of dawn, the light isn't lighting up the back side of the subject, so it isn't being strongly rimmed with light. The subject is merely isolated against the much brighter red sky. Although not strictly backlighting, silhouettes are fun to shoot, compelling to look at, and make highly worthwhile additions to your image collection. While we tend to think of silhouettes against a colorful sky, the background could be a glorious forest in autumn color or nearby mountain. Imagine finding a handsome deer posing on a hill in front of you that is in the shade. The background is lit with golden frontlight at dawn. Focus on the silhouetted

The golden sunshine nicely warms the colors and the soft backlighting rims this black-backed jackal puppy beautifully. Always consider early morning and late evening warm sunshine as a terrific backlighting opportunity. This light is especially effective against a darker non-distracting background. Nikon D300, Nikon 200-400 f/4.0 lens at 400mm, f/6.3 at 1/640 second, ISO 800, and Shutter-priority at a +1/3-stop exposure compensation.

deer, expose for the much brighter background, and shoot a fine silhouette.

DIFFUSED LIGHT

This light comes from many directions at the same time. It is plentiful on thick overcast days, in the fog, or when the entire subject is in the shade. In each case, the light is highly diffused as it bounces off the sky, clouds, trees, and all of the objects around the subject. This light is terrific for photographing wildlife because it is inherently low in contrast. This diffused light simplifies capturing detail everywhere in the image. Low contrast light is especially useful for photographing animals in the grass, bushes, or in trees. Bright sun in these situations creates far too much contrast for the camera to properly record. Diffused light is much friendlier to the camera. In 2002, when Velvia 100 was the fastest film Barbara and I would use, we looked for warm sunlight early and late in the day for most of our wildlife photography. While we continue

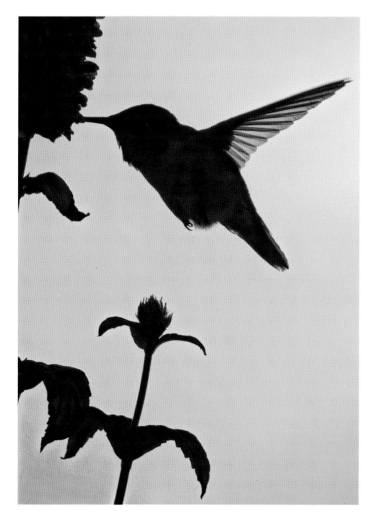

Barbara used a single flash to light the background which is a photo of out-of-focus yellow flowers. She turned off the three flashes that were being used to light the hummingbird, but continued to focus on the hummingbird to make this image. Nikon D3, Nikon 200-400mm, f/20 at 1/250 second, ISO 200, manual exposure, one Nikon SB800 flash to light the background.

to love this light, now that it is practical to use higher ISOs, we often prefer the low contrast light of bright overcast when photographing backyard birds and mammals that are attracted to our feeders and water drips. The reduced contrast on both the subject and the background lets us capture more detail throughout the image. Although diffused light has a blue color-cast, using the Cloudy white balance preset conveniently compensates for this excess blue light.

THE COLOR OF LIGHT

Everyone is familiar with the red light at sunrise and sunset. Why is it so red? The atmosphere is full of dust and water molecules that selectively filter out certain colors of light. Meet Roy G. Biv. This is a memory device that physics students learn to remember the sequence of colors making up visible light. This color sequence is *r*ed, *o*range, *y*ellow, *g*reen, *b*lue, *i*ndigo, and *v*iolet: Roy G. Biv. The red component has the longest wavelength and violet has the shortest. The shorter the wavelength, the easier it is absorbed or scattered by the atmosphere. Long wavelengths like the red, orange, and yellow ones penetrate the atmosphere much easier than the shorter wavelengths. The light is red and orange at sunrise and sunset because the atmosphere absorbs most of the other colors, leaving primarily red and orange wavelengths to illuminate the subject.

In a similar fashion, during the middle of a bright sunny day, the sky is blue because it primarily scatters the blue component of the visible light spectrum. This is important because available light has a high blue content when shooting in the shade. Since the warmer light of the sun is blocked by an obstacle, thus producing the shade, the reflected blue light from the sky lights up the shaded area, accounting for the strong blue color-cast. This is most pronounced when it is open shade. This means there is no obstacle above the subject, such as a canopy of tree branches, to block the blue light from the sky. If there is something blocking the light from the sky, the light still has a blue cast, but it isn't quite as pronounced.

Even on a cloudy day, the light has excess blue in it, making subjects have a slight blueish color-cast. While this can be sometimes desirable, especially for a blue subject like a blue-and-yellow macaw, normally it is best to correct the unwanted blue color-cast. The color of light on a cloudy day gets even more challenging if you photograph a subject that is perched on a branch in a forest of green leaves. Leaves appear green because the chlorophyll in the leaves reflects primarily green light while absorbing the other colors. This light now has a strong blue component from the overcast light and an unflattering green color-cast from the leaves. Fortunately, this

The natural blue light on a cloudy day, or in the shade on a sunny day, is helpful for improving the blue tones in this captive blue-and-yellow macaw. Blue light increases the color saturation in the blue feathers. Use the Sun white balance to keep the blue color cast for blue subjects. Canon EOS-7D, 300mm f/4.0L lens, f/4.0 at 1/320 second, ISO 400, Shutter-priority with a +1/3-stop exposure compensation, and handheld so the image-stabilizing mechanism was activated.

witches' brew of blue-green light is not nearly the problem for digital as it was for film. We'll discuss solutions for this situation shortly. Although this blue-green color is real and present, as you look at the subject, you don't really notice it because our brains tend to compensate for color-casts, making it difficult for us to see it. But your camera has no brain to interpret and modify the colors. It records the colors as it "sees" them, including unwanted color-casts.

WHITE BALANCE

The color of light varies considerably so digital cameras provide a way to adjust color to make it more suitable for the subject to produce more pleasing images. Cameras offer a number of color presets and a few variable color controls. Be aware a preset choice corrects the light by a fixed amount. The Canon 7D, for example, offers Daylight, Cloudy, Shade, Tungsten, White Fluorescent, and Flash. Three variable white

balance choices are offered, too. These include Auto, Custom, and Color Temperature. The Nikon D700 offers the same nine choices and your camera likely offers similar choices. Unhelpfully, camera makers sometimes use different names for the same thing. Nikon calls the Sun white balance preset "Direct Sunlight" and Canon calls it "Daylight." It would be helpful if camera companies adopted standard terminology to make it easier for all of us to use their equipment.

JPEG VS. RAW WHITE BALANCE CONSIDERATIONS

RAW image files contain all of the information collected by the sensor. Some cameras offer small RAW files that do discard a significant amount of information, though we never use this option. It is easy to adjust the colors in the RAW image at a later time without losing any quality. This is one of the huge advantages of RAW. As a result, selecting a white balance to match the light you are photographing with isn't critical. RAW images are typically captured in 12-bit or 14-bit files, depending on the camera. A 14-bit image has 16,384 brightness levels for each color channel. Since there are so many brightness levels, adjusting the overall exposure in the image by making major level adjustments to the blacks, whites, or mid-tones, tends to create fewer artifacts and other problems. RAW files tolerate computer software adjustments better than JPEGs.

On the other hand, a JPEG image is nothing more than a RAW image that is processed by the camera. When the image is processed, much of the information is permanently discarded to make the file size smaller. Further, the image is reduced to an 8-bit file which has only 256 brightness levels for each of the green, blue, and red color channels. A JPEG does tolerate some adjusting after capture. However, due to the relatively few brightness levels contained in the image, it doesn't permit as much adjustment before creating image problems. Making large exposure adjustments to a JPEG may cause posterization which appears as an abrupt change in tone or color instead of a smooth transition.

A number of white balance choices are listed in the following discussion. The first name for each choice is the term Canon

uses. The name followed by another name in parentheses is the term Nikon uses for the D700.

DAYLIGHT (DIRECT SUN)

This is the obvious choice to use when the subject is illuminated by direct sunshine. It gives you neutral colors without undesirable color-casts. However, in the red light of sunrise or sunset, the highly desirable warm colors still appear in the image. This white balance is normally the best choice for wildlife photography when the sun shines on the subject.

CLOUDY

Cloudy skies produce available light with a slightly blue color-cast. The Cloudy WB preset forces the camera to add some yellow to the image to counteract the excess blue light. We use this WB choice much of the time, even in the sun because it produces slightly warmer (more yellow) images. Barbara prefers to view her RAW images when they are slightly warmer in appearance. I used to do this too, but now use AUTO WB most of the time because I usually shoot only RAW images. Once we have selected the images we wish to keep and deleted the rest, we store them on external hard drives as unprocessed RAW images. When we wish to use an image for a book, slide program, print, post on the internet, or any other use, Barbara processes the RAW image using the RAW converter in Photoshop CS5. Since adjusting the color in the image is part of the processing procedure, she tends to leave her camera set to Cloudy most of the time, no matter what light conditions prevail. Again, she is shooting RAW. If you shoot JPEGs or JPEG plus RAW, then it is best to match the color of the light in most cases so the JPEGs will look their best, unless you wish to deliberately create a color-cast.

SHADE

Light in the shade with blue sky overhead exhibits a strong blue color-cast. The Shade WB adds more yellow than the Cloudy WB choice, so it compensates for more blue light. The ability to select a white balance setting to counteract excess blue light is a wonderful digital camera advantage. During the

White-tailed ptarmigan thrive in the rocky alpine slopes of Jasper National Park. The problem is spotting them. I searched the slopes for hours until another visitor finally spotted this one. I shot as close to the ground as possible and used Cloudy white balance to reduce the blue light in the overcast. Canon EOS 5D Mark II, Canon 500mm f/4.0L lens, f/10 at 1/200 second, ISO 400, and Shutter-priority with a +1-stop exposure compensation.

film days, the dim light in the shade and the strong blue color-cast created a huge problem. To reduce the blue, a warming filter, such as an 81C was used, but this filter absorbs 1/3 stop of light, making it somewhat more difficult to use fast shutter speeds. Now, with your digital camera, you can use ISO 800 for plenty of shutter speed and set the white balance to Shade without using a light-reducing warming filter. This is one reason why wildlife photographers are now capturing action images of wildlife in low light that was thought nearly impossible during the film era.

TUNGSTEN (INCANDESCENT)

Light from this source is extremely red. This WB preset adds blue, thereby reducing the excess red in the light. Wildlife photographers seldom use this type of light. The color is far too red and usually it is too weak in intensity. If you are photographing wildlife indoors, a flash is the better choice because it is easier to use, delivers a lot more light to the subject, and the color of the flash is more suitable.

WHITE FLUORESCENT

If at all possible, avoid using fluorescent light, especially for wildlife. It tends to be too dim to use on wildlife, making it difficult to use fast shutter speeds. Plus, fluorescent light is highly variable in color output. The make, coatings, and age

of the lamp all affect the color of the light. If you must shoot indoors, use one or more flash units for best results.

FLASH

Many flash units emit a slightly blue light, though some have a weak yellow filter over the flash to compensate for it. This WB choice adds a small amount of yellow to eliminate the blue color-cast. Electronic flash is incredibly useful for photographing wildlife in dim light or when you wish to freeze action with short flash durations.

AUTO (AUTO WHITE BALANCE)

This WB choice automatically adjusts for color-casts to create images with neutral colors. It does a fairly good job, especially when using outdoor natural light. It is far less capable, though, if you are shooting with artificial light sources. However, Auto WB is a viable choice for wildlife photographers who primarily use natural light, electronic flash, or a combination of the two. If you prefer to let the camera determine the white balance, Auto WB is a successful choice. Many photographers, including your author, who shoot RAW, use Auto WB because they intend to tweak the colors anyway when the RAW image is processed. One of the huge advantages of shooting RAW is that the white balance can be adjusted with the RAW converter software without losing any quality. Even the colors in JPEG images can be tweaked, though, to a lesser degree.

Auto WB is a splendid choice for anyone who primarily shoots RAW images and doesn't mind making color adjustments later. JPEG shooters can get by with Auto WB, especially when using natural light outdoors, but JPEG shooters will do better by selecting the WB choice to match the light. There is no wrong answer here. Using Auto white balance or matching the light with the appropriate white balance choice both work quite well.

Let's review our white balance options. Barbara leaves her WB on Cloudy with her Nikon cameras most of the time. I normally use Auto WB for wildlife because it is one less thing I need to be concerned with when the photography is fast and

Kori bustards display to attract females during January in the Masai Mara. They walk slowly, but do steadily move along. I used continuous focus and selected a single AF point that corresponded to its head to keep the focus there. With so many details to monitor, it makes sense to eliminate one decision by using Auto white balance. I used a -1/3 stop exposure compensation to keep detail in the white neck feathers. Canon EOS 5D Mark II, Canon 500mm f/4.0L lens, f/13 at 1/640 second, ISO 400, Shutter-priority with a −1/3 stop exposure compensation.

furious. For landscapes and macro, I prefer to match the WB with the available light. Remember Auto WB tries to make the light neutral. If you photograph wildlife in golden light or against a red sky, Auto WB will drain the warm colors out of the image to produce more neutral colors. We want the golden light to appear in the image and not have Auto WB reduce it. However, always remember it is easy enough to bring a favorable color-cast back during the processing of the RAW image.

CUSTOM (PRE)

Wildlife photographers seldom use this choice because it takes time, but it is sometimes useful for landscapes and frequently beneficial for macro. However, this choice is invaluable if you are shooting JPEGs only and must correct two or more color-casts at once. Suppose you are photographing a robin quietly sitting on her nest from the open window of your home. The cloud cover creates light with a blue color-cast. The green leaves surrounding the bird reflect primarily green light, producing that dreaded mixture of blue-green light. Setting the WB to Shade does compensate for the excess blue light, but merely warms up the green light. Instead, photograph the neutral gray bark of the tree, select that image, and set the camera to Custom WB. This procedure varies somewhat among cameras, so check your manual for the exact method. By selecting the image of the neutral gray tree bark and setting Custom WB, you will enable the camera to minimize unwanted color-casts in the image. The camera creates a Custom WB correction to accomplish this goal and reduces both the excess blue and green light at the same time. Then it applies this correction to all of the robin images you shoot. As long as the color-casts in the natural light don't change, you'll capture fairly neutral colors. Of course, if you move onto another subject where the color of the light is different, you must photograph another neutral object—such as a Kodak gray card in that light—and select that image to produce a new Custom WB for this new light.

This choice is difficult to use in wildlife photography because you must have a neutral object in the same light as your subject to begin the process. Normally, it is best to insert a gray card into the scene to photograph. Obviously, this isn't terribly viable with wildlife as you'll most likely scare the subject away. It would work, of course, if you knew the subject was going to appear later. Although Custom WB could be used, we think it makes sense to shoot RAW and not worry about multiple unwanted color-casts. Correct them later in the RAW converter of your favorite software such as Photoshop, Lightroom, Aperture, or any proprietary software your camera maker provides.

COLOR TEMPERATURE (K)

This choice is little used by most photographers because you need an expensive color temperature meter to set accurate color adjustments. You are better off to save your money and not have to carry this expensive meter with you. Instead, select the optimum white balance preset, use a custom white balance setting, or shoot RAW and adjust the color later.

However, if you wish to pop the colors in a sunrise or sunset, here's a little-known trick. Set the camera to the Color Temperature white balance and dial in 10,000K. This tells the camera you are shooting in extremely blue light—which is a lie—since the light is red. The camera dutifully adds plenty of warm tones to counteract the imaginary blue light, making the sky and everything else in the image strongly magenta.

CONTRAST

Although we have mentioned contrast already, let's describe what it is and how to counteract its often highly negative effects in your images. Subjects exhibit a range of brightness. Contrast is the range between the lightest and darkest brightness values in an image. This is often called the dynamic range. A foggy scene has a smaller range of brightness than a forest scene that is illuminated by bright sunshine. In other words, the forest scene has far more contrast than the foggy scene. Your camera's digital sensor can capture detail over a contrast range of six to eight stops, depending on the sensor and the camera. However, many scenes exhibit a much higher range of contrast. Our eyes easily see detail throughout the

scene because our pupils quickly adjust for different brightness settings. Photographers are limited to the smaller contrast range camera sensors can capture, rather than the wider contrast range our eyes easily handle.

Excessive contrast hides detail in dark shadows and/or eliminates it from bright highlights. Even if details are preserved, contrast often makes images look ugly. Usually, contrast must be controlled or avoided, if possible, to produce attractive images. We critique thousands of images our workshop clients bring from home. Too much contrast is a prevalent problem for many of them. Often, photographers think they have a metering problem. In reality, they have a contrast problem that makes arriving at a pleasing exposure for the overall image impossible.

AVOID CONTRASTY LIGHT

Photographing early or late in the day when bright sunshine isn't present does reduce contrast problems. Naturally, over-

Even in highly diffused overcast light, some subjects exhibit high contrast. The brightness difference between the white feathers on this swallow-tailed gull and the black rocks behind it is huge. Therefore, expose to the right as far as possible without clipping (overexposing) the white feathers. Canon EOS-7D, Canon 300mm f/4 lens, f/4.5 at 1/1000, ISO 640, Shutter-priority with an exposure compensation of minus 1 1/3-stops to keep detail in the white feathers, hand-held from a rocking boat.

cast days are low in contrast. However, even in highly diffused light that is inherently low in contrast, some subjects still are plagued with high contrast. A swallow-tailed gull perched on a rocky outcrop against a dark background is high in contrast, even if the available light is low in contrast. We call these types of images, "skunk pictures" because they have a wide dynamic range due to the pure white subject and nearly black background. However, if you shoot RAW and use software carefully, contrast that is primarily caused by black-and-white objects appearing in the same image are more manageable under diffused natural light conditions.

USE FRONT LIGHT OR BACKLIGHT TO AVOID CONTRAST

Photographing any subject where the light passes right over the camera on its way to the subject is frontlight. This light is low in contrast because the shadows it creates fall behind the subject, hiding the shadows from the lens. Backlight is inherently high in contrast, but is effective for revealing the shape of the subject. Backlight comes from behind the subject on its way to the lens. Due to the dramatic look of backlight, it is fine to allow the side of the animal facing the camera to be somewhat underexposed, especially if it is nicely rimmed with golden light.

PHOTOGRAPH IN THE SHADE TO AVOID CONTRAST

The light is always highly diffused in the shade because light bounces off objects all around the subject. In ugly midday bright sun, we often seek subjects on the shaded side of a mountain, rocky outcrop, forest edge, or large bushes to avoid bright sunshine and the high contrast it creates.

USE A FLASH OR REFLECTOR TO AVOID CONTRAST

At times, it is possible to reduce the contrast that bright sun so often creates. For some highly approachable animals that are habituated to humans, it might be possible to use a gold or gold and silver reflector to throw light into the shadows. This added light fills in the shadows, effectively reducing the overall contrast. A gold reflector adds a golden color-cast which is often desirable.

A portable electronic flash, especially one dedicated to your camera, is easy to use and throws the light much farther than a reflector. Use the flash exposure compensation control to adjust the light output from the flash to open up obnoxious shadows as much as you want. You could also set the flash on manual and use the power ratio control to adjust the flash output.

THREE TYPES OF NATURAL LIGHT THAT ARE TERRIFIC FOR WILDLIFE

GOLDEN LIGHT AT DAWN AND DUSK

Wildlife is especially active at dawn and dusk. If the sky is clear, or partly cloudy, the rising or setting sun envelops wildlife with wonderful golden light. Early and late in the day is the favorite time to photograph for serious photographers who seek outstanding images. Soft warm sunshine not only produces gorgeous color, but the low angle of the sun reduces contrast, especially underneath the animal, which is a serious problem when the sun floats high in the sky. This low angle increases the chance of having a catchlight appear in the eyes of the animal, making it look more alive. Golden sunshine is especially good for including mirror reflections of the subject in calm water that reflects autumn colors, golden cattails, the red rocks of a canyon wall, or the blue sky.

Although golden sunshine is ideal for many subjects, it doesn't work especially well for animals that dwell in the forest, in high grass, or in the bushes. The vegetation blocks much of the light, creating ugly shadows on the subject. It creates a dynamic range that is too large for the sensor to successfully capture.

OVERCAST LIGHT

Bright cloudy days are terrific for wildlife photography. Thin clouds keep the available light levels high, permitting the use of fast shutter speeds. The huge overcast advantage is the light is low in contrast, making it possible to photograph animals

Yellow-billed storks are plentiful around wetlands in Kenya. Barbara was attracted to this one because it had a mirror reflection and was bathed in golden early morning sunshine. The bird gaping widely made this image one of her favorites. Nikon D300, Nikon 200-400mm f/4.0 lens, f/7.1 at 1/640 second, ISO 400, Shutter-priority and a +1/3-stop exposure compensation.

in the vegetation or out in the open without obnoxious and distracting shadows. The slight blue color-cast in this light is easily eliminated by using the Cloudy white balance preset. Bright overcast is a superb time for backlit images. You still capture the rim light effects produced by the soft backlighting, while easily keeping detail in the side of the subject facing the camera.

Thick clouds absorb plenty of light. Often, low light shooting tactics (high ISOs, large apertures, image stabilization, under-exposing on purpose to permit higher shutter speeds) must be used for sharp images. Although photographing wildlife is more difficult in low light, it still is far better than midday bright sun.

SHADE

At the middle of a sunny day, look for subjects in the shade. Once again, this light has low contrast, making it possible to capture more detail in the subject and its environment. Use the Shade WB preset to reduce the strong blue color-cast in the light or shoot RAW and adjust the colors later. For best results, make sure the subject and the environment around it that will appear in the image are all in the shade. If the animal is in the shade, but the left corner of the bush is in bright sun, the severe contrast will be objectionable.

THE IDEAL LIGHT DAY ON A KENYA PHOTO SAFARI

Let's share some observations about the light in Kenya that applies everywhere, though, perhaps to a lesser degree at higher latitudes. We are lucky to have spent almost two years leading safaris in Tanzania and especially Kenya. The wildlife photography opportunities are simply spellbinding. The variety of species, huge number of individuals, and access to wildlife is absolutely terrific. Our native Kenyan driver-guides are a joy to work with and happily share a wealth of natural history knowledge.

However, Kenya straddles the equator. The sun rises and sets quickly, shortening the length of time golden light prevails.

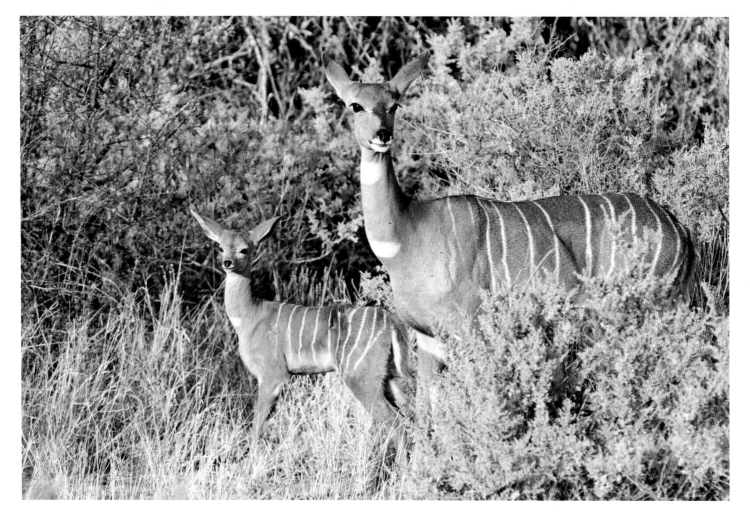

Samburu National Reserve is a favorite haunt of Greater Kudu. Barbara found this doe and fawn at dawn, but had to wait at least 30 minutes for them to emerge from the dense bushes. It was worth the wait! Nikon D300, Nikon 200-400mm f/4.0 lens, f/7.1 at 1/800, ISO 1000, Aperture-priority with a +2/3-stop exposure compensation.

While on safari, we sometimes wish we could quickly move Kenya up to Greenland to make the golden light period last much longer. Of course, no amount of wishing has made this happen. The sun shines a lot near the equator, so Kenya gets plenty of bright sunshine. Unfortunately, because the sun rises almost directly up near the equator, the sun loses its golden color quickly. Fortunately, digital images are easily tweaked with software to create the golden light look. However, the contrast problem soon becomes highly problematic. By 9:00 a.m., harsh shadows are appearing underneath the animal. These terrible-looking shadows are typically three to five stops darker than the sunlit portions of the animal. Although this contrast can be mitigated somewhat with software, the results aren't nearly as good as photographing in bright overcast light during the middle of the day.

Between 10:00 a.m. and 4:30 p.m., on a sunny day, the extreme contrast makes it incredibly difficult to shoot excellent wildlife images. This is frustrating when many willing subjects readily pose for you. We try anyway, but delete almost everything due to the harsh light. Occasionally, luck

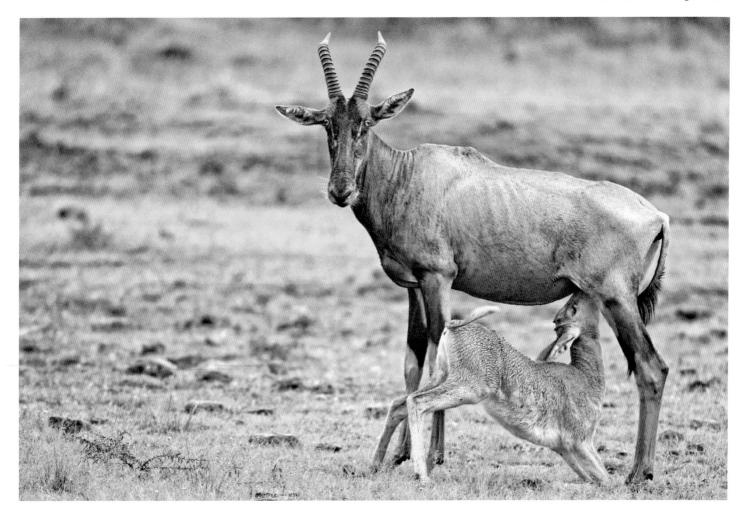

The equatorial sun rapidly rockets high into the sky. Between 9:00 a.m. and 4:30 p.m. in Kenya, the sun creates dark shadows on the bellies of the animals and the overall contrast is far too much to adequately capture in a single image. However, middle of the day overcast light is ideal for photography and helped Barbara capture a fine image of a topi nursing its fawn. Nikon D300, Nikon 200-400mm f/4.0 lens, f/4.0 at 1/400 second, ISO 800, Aperture-priority with a +2/3-stop exposure compensation.

prevails and clouds drift over, diffusing the light from time to time. If we were a weather wizard who could control the light, we would opt for golden sunshine for the first and last 1.5 hours of the day. Then we would schedule bright overcast between those two periods of time to provide excellent photography light for the entire day. It doesn't happen like that very often, but when it does, shooting numerous rewarding images is easy. The color of the landscape matters, too. Early and late light tends to look good longer if the vegetation is green, rather than the typical yellow-brown during the dry season. Although the dry August–September migration period is enormously popular for the number and variety of animals that are present, and the chance of seeing thousands of animals cross the famous Mara River, sunshine doesn't look nearly as good on yellow grass. Green vegetation makes the light look better longer.

Of course, nobody has control over the sun and the clouds. Hope for the best and make do when the light is challenging.

However, when we do get perfect photo conditions, we work the subjects thoroughly and keep photographing as long as pristine light conditions remain. Never waste highly photogenic light because it is all too fleeting. You can eat and sleep when the light is less favorable.

REMEMBER THE CRITICAL ROLE OF LIGHT

If you pay attention to the light and consider the color, contrast, direction, and intensity whenever you shoot images, you'll quickly become better at judging it. After a while, seeing the photographic possibilities in the light doesn't take any time at all. Of course, once you really learn to see it, you also see the problems that are difficult or impossible to solve, too. Sometimes we wish we could be beginners again who simply enjoy photographing everything, no matter how bad the light. Then reality soon hits again and the words of Larry West remind us, "Shooting photos in bad light produces bad photos." It is a simple statement that really says it all. Thanks, Larry! We can all benefit by remembering that.

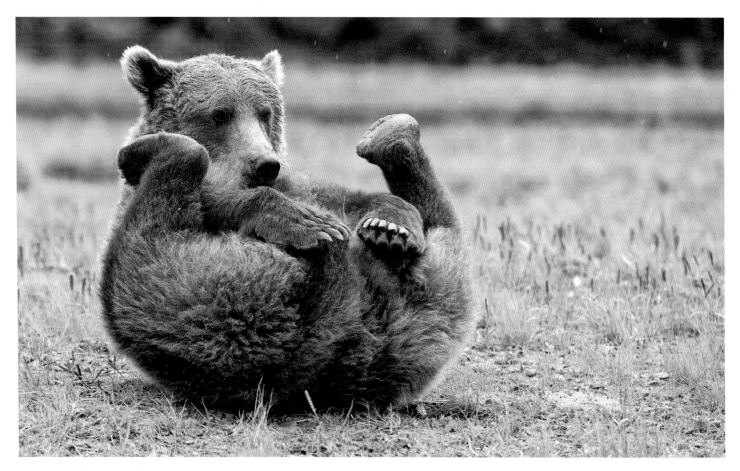

After eating its fill of salmon at Geographic Harbor, this Alaska brown bear rested between fishing sessions and assumed many comical poses. More than 20 bears fished the river at the same time, but they were quite relaxed with each other and us with the abundance of fish crowded into a shallow river on this early September morning. Nikon D4, ISO 1600, Aperature-priority, f/5.0 at 1/640 second with no exposure compensation, Nikon 200–400mm lens at 330mm.

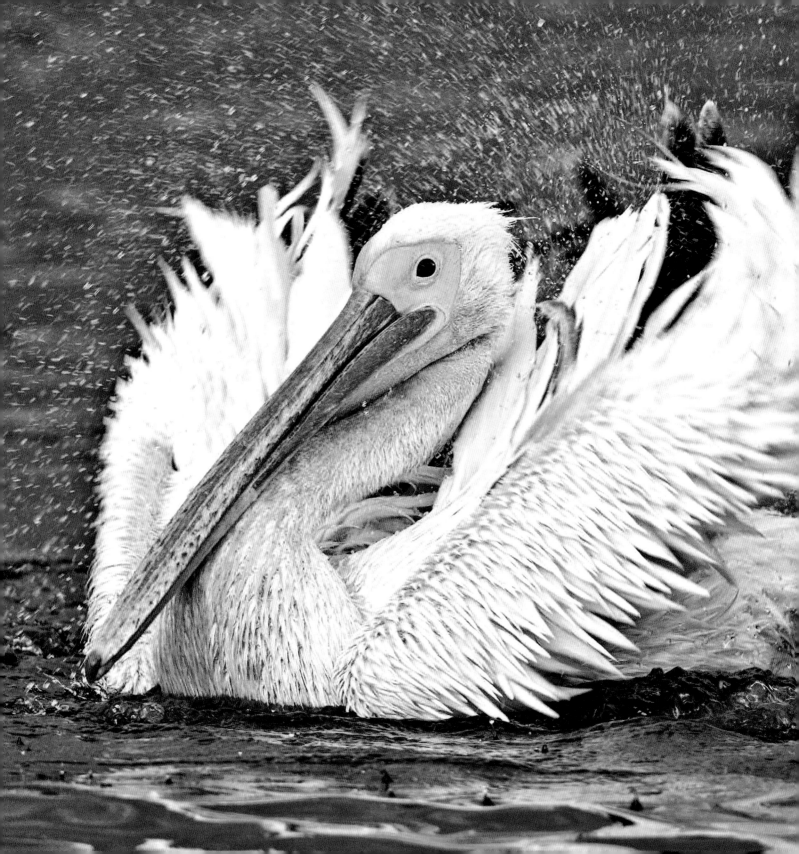

7

Composition

WHAT IT IS PHOTOGRAPHICALLY

Composition is the thoughtful placement of visual elements—a worthy subject and its environment—to make the strongest possible image. This sounds simple enough. But, what makes a worthy subject? Where should the subject appear in the image? How big should it be? Is the foreground important? What about the background? How does the light affect everything? Are there some perspective choices? Should you use a shallow depth of field or a lot? What direction should the animal be facing? Do you photograph it from a low viewpoint or a higher one?

Composing well requires you to answer a lot of questions quickly, before the light or subject disappears. In many ways, composition is far more difficult than exposure or shooting sharp images. Either the exposure is right on or it is not. Either the image is sharp or it isn't. The "gray" areas for exposure and sharpness are few. Composition, however, is highly subjective. A fine composition often depends on the eyes of the beholder and varies from person to person. There are few absolutes in composition, but endless variables and possibilities.

We assume you want us to be completely honest with you in this book—so we will be. Even after decades of professional nature photography experience, we are still steadily improving our ability to see fine images and to make pleasing compositions. All of the mechanical aspects of photography—focusing the lens, exposure, flash, white balance, using tripods—are much easier to master than composition. Unfortunately, many photographers and especially beginners assume their ability to see a terrific composition is naturally easy for them. Usually, this is not the case. But it is easy to understand this because everyone knows when their images aren't perfectly exposed or sharp,

LEFT: This freshwater stream is entering alkaline Lake Nakuru. Birds prefer to bathe in fresh water, rather than salt water. This great white pelican comically splashed about in the fresh water for several minutes before flying off to join a group of pelicans fishing. Nikon D3, 200-400 f/4 lens, f/8 at 1/320 second, ISO 500, and manual metering.

but who is to be the judge of whether the composition works or not? After all, if the composition works for you, then it does, but it may not be all that pleasing to most who view the image. The problem with composition is there is no definite wrong or right composition that we can all agree on.

We hope you will read this chapter carefully and work to assimilate some of the "guidelines" we offer into your photography habits. Often we hear about "Rules of Composition," but we find there are so many valid exceptions to the rules that it is more useful to say everything is a "guideline," rather than a rule. Please consider the guidelines to follow, but feel free to modify or ignore them altogether. We'll stress the concepts that have proven to be especially valuable to us over four decades earning a living from wildlife photography.

PAINTERS AND PHOTOGRAPHERS

Wildlife painters approach their final print quite differently than photographers do. Painters begin with an image in their heads, or perhaps a simple drawing or photograph to work from. They begin with a clean canvas when they start their painting. Gradually, they add elements to the painting. For example, as I write this, I am looking at my 2010 Federal Duck Stamp that showcases a wonderful drake American wigeon on it by master wildlife painter Jim Hautman of Minnesota. Perhaps Jim started with the duck and its reflection. Then the cattails were added to the left and middle portions of the painting. Finally, the light tan background is added to complete this simple, but elegant wildlife painting. By simple, I mean the subject is obvious and the painting is uncluttered. Only enough reflection and cattails are included to create a sense of the marsh where American wigeon live. No unnecessary elements are included.

The wildlife painter enjoys the advantage of starting with a clean canvas to paint on and chooses the elements they wish to include. Of course, painters have a critical disadvantage. They must have the talent in their eyes and hands to make the wigeon actually look like one. If I painted one, it would be a huge success if some viewers could recognize that it was

Lilac-breasted rollers are spectacular birds that thrive in grasslands with some acacia trees in many Kenyan parks. By driving slowly up to them, and being in position ahead of time to shoot as soon as the Land Rover ignition is turned off, it is often possible to photograph them at close range. This composition is simple and the uncluttered background really makes the bird emerge from the image. Canon EOS 7D, Canon 500mm f/4.0 lens, f/11 at 1/640 second, ISO 500, Shutter-priority with a +2/3-stop exposure compensation.

some sort of duck-like bird. I actually tried painting early on, but the results were dismal!

The wildlife photographer has a very different task. They must find a place where American widgeons are approachable. Then they must use their camera lenses and photo skills to select a fine specimen and isolate it as much as possible. In other words, the photographer begins with everything in the marsh and the sky and then simplifies the image by excluding unnecessary or distracting objects as much as possible. Often this requires waiting for the duck to swim to a favorable spot and assuming an interesting pose. If all goes well, unwanted distractions like ugly branches, litter, or the bill of another duck don't appear in the image. The photographer must be ready and hope it all comes together for a moment to capture the image. The painter's composition is determined by what they include and where they put it. They start with nothing and add the elements they want. The photographer begins with everything in the marsh and arrives at their composition by excluding much of what is present while thoughtfully placing the widgeon somewhere in the image.

GUIDELINE 1: DETERMINE THE CENTER OF INTEREST

This is easy because it is usually the animal you are photographing. However, if a variety of critters are frolicking in front of your lens, be careful to select the better-looking individual or groups for your images. Some birds may be missing feathers while others of the same species sport a pristine plumage. Some mammals may have an immaculate fur coat while others don't. Look for dirt and twigs sticking to the creature, too. Some animals are unappealing because an insect pest, such as a swollen tick in the ear, makes it undesirable as a photo subject. However, ticks and other blemishes are part of nature, so don't reject all animals for these problems.

At the beginning of my career in 1975, I remember photographing Belding ground squirrels near Yosemite National Park. Only when I reviewed the images later did I notice the objectionable tiny metal ear tags a researcher had fastened to them. In Ontario years ago, Barbara and I found a group of easily approached gray jays. Unfortunately, all had a few colored bands on their legs in various color combinations. Later we met the jay researcher and mentioned the colored bands. We told him we caught the birds and removed the bands. After photographing the birds, we caught them again and put the bands back on—though not necessarily in the order we took them off. We laughed when we saw his look of alarm, but he soon realized we were just kidding. Marked wildlife with ear tags, neck collars, and leg bands are surprisingly common. Many elk, bison, and wolves in Yellowstone National Park wear neck collars for tracking purposes. However, we know the head wolf researcher who told us some especially photogenic wolves aren't collared because, in his words, "the photographers complain too much." For those who are handy with Photoshop, small imperfections such as bands and tags can be removed or covered using software solutions. Some purists are against this sort of thing, and Barbara rarely does it, but it remains a legitimate tool for removing small distractions. If you are against it, then don't do it. If you don't mind working some magic, then go for it. It's your choice. We prefer to keep our images as natural as possible.

Along with selecting the subject, as a gentle reminder, make sure the light on the subject is favorable. If the unattractive subject is in photogenic light and the pristine subject is in harsh light, wait until the reverse happens. Remember, any great-looking subject in poor light will most likely produce a poor image. Don't waste your time and effort fighting bad light.

SIZE OF THE SUBJECT

Once the subject has been selected, how big do you make it in the image? Of course, this depends a lot on how long your lens is, how close you can approach the subject, how big the subject is, and what type of statement you are trying to make. Shoot first to capture a record shot is common advice. How valid this advice is depends on your purposes. If you do indeed want a record shot of everything you see, then it is

Golden-mantled ground squirrels love to eat succulent flowers, such as this dandelion. I spread my tripod legs out flat and lay on the ground to get this low shooting viewpoint. Canon EOS 5D Mark II, Canon 500mm f/4.0 lens, f/7.1 at 1/320 second, ISO 640, Shutter-priority with a +1/3-stop exposure compensation.

valid. We depend on using our images to earn a living or make fine prints for our wall. We have absolutely no use for a record shot of a creature that is uselessly tiny in the image. We never shoot record shots. The problem with shooting a record shot is it takes time. Most animals remain near you for only a short period. Why waste this often fleeting amount of time by shooting a poor image? Since we can only use quality images, we continue working closer to the animal until we can actually shoot a quality image.

Our primary interest in quality once was a problem for our Kenya safari drivers. They are accustomed to driving up to lions, cheetahs, elephants, and giraffes that normally completely ignore the Land Rover. Most of the bigger animals never look at the vehicle or the humans within it. Unlike most photo safari groups, though, we photograph many of the small gorgeous birds of Kenya. At first, our drivers were reluctant to drive close enough to a small bird, such as a lilac-breasted roller or little bee-eater, until we got a record shot. Eventually

Vermilion flycatchers are tiny active birds that are impossible to photograph with a tripod because they constantly flit about the forest. Barbara hand-held her camera, favored ISO 800 to get more shutter speed, shot with a big aperture, activated the vibration reduction mechanism on her Nikon lens, and shot as many images as possible hoping to capture a sharp image. Nikon D3, Nikon 200-400mm f/4.0 lens, 1/250 second at f/4.5, ISO 800, and manual metering.

we convinced them to keep on slowly approaching until we were close enough to capture a nice image when we stopped the first time. We all realize small birds are far more likely to fly away than larger animals. We told the driver, "If it flies, it flies." We understand the small bird might flush on approach and we don't blame the driver if it does. We realize we may not get the shot, but if we don't try, we are guaranteed we won't get the shot. We don't consider flushing a small bird that isn't nesting to be harassment. They fly all over the place anyway. One more short flight surely isn't harmful. Just don't keep after it if the subject clearly doesn't want you that close. Fortunately, the use of long lenses, teleconverters, and camera crop factors now allows us to capture a large image of many small birds, while still keeping a non-threatening distance away.

ANIMALS IN THE ENVIRONMENT

As you approach an animal, always consider the environment. Many fine wildlife images keep the animal small to reveal more of its immediate surroundings. This works especially well when the surroundings are highly photogenic. A sea of green or golden grass, a shoreline of colorful pebbles, a field of snow, a pool of floating ice chunks, or a canopy of red maple leaves are good examples of desirable photo environments.

Keeping the primary subject, such as a grouse, small in the image gives you a few advantages. First, it isn't necessary to approach as closely, reducing the chance of frightening it away. Second, by keeping your distance, the animal is more likely to exhibit normal behavior. Third, magnifying the subject less gives you more depth of field to work with at all f-stops. This makes it easier to cast enough depth of field on the subject to sharply focus the subject adequately.

GUIDELINE 2: MAKING ANIMALS LARGE IN THE IMAGE

There are no fixed parameters for this category, but let's say if the animal occupies one-third to three-quarters of the image, then it fits. A Unita ground squirrel that fills 1/3 of the image reveals plenty of detail in the squirrel and shows some of its environment. Many wildlife photographers shoot these kinds of images with fine results. By not filling the frame too tightly, there is more room to crop the image, if necessary. And there is less chance of unintentionally cutting off the feet or tail of the subject. When photographing running animals or flying birds, it helps to avoid overfilling the image. All too often, the best pose, or the only one that is super-sharp, cuts off an important part of the subject.

FULL-FRAME

These are captivating images that clearly reveal the animal and minimize the environment. Filling the frame works best with really cute creatures, especially if their faces have interesting expressions. Many photographers seek to shoot this tightly much of the time. It does work well, but composing all of your subjects this tight becomes boring after a while. It is always best to vary how much the subject fills the frame. Be careful to avoid cutting off the nose, tail, ears, or feet of the animal. Sadly, we often see images of an outstanding subject

Mountain goats frequent the high peaks of the northern and Canadian Rockies. This one peers down at me from its lofty perch near Alpine, Wyoming. Animals don't always have to be large in the image. Sometimes composing them small in the image amid their environment tells their story better. Canon EOS 5D Mark II, Canon 500mm f/4.0L lens, f/7.1 at 1/1000 second, ISO 160, manual exposure.

where the feet or tail are inexplicably cut off. Be careful and always watch the edges of the frame in your viewfinder to avoid this common problem.

PORTRAITS

While it makes little sense to cut off a small portion of the animal, portraits are the exception. A full-frame image of an animal's head and neck does work as a fine portrait. Do remember the magnification is quite high when you do this. Increasing magnification reduces depth of field, so stop the lens down more, if possible, to increase the depth of field. Generally, portraits work best as head and shoulder compositions. It makes little sense (usually) to cut the animal in half—compositionally speaking, of course.

HORIZONTAL AND VERTICAL COMPOSITIONS

Your camera's imaging sensor is probably rectangular in shape and not square. Since one side of it is longer than the other, you'll make more interesting images if you make

This blue-headed parrot was a captive at a nature center in Ecuador. We visited the park because the Galapagos boat we hoped to board that day was adrift at sea from engine failure. Since Barbara could not get to her packed tripod, she shot hand-held, used vibration-reduction, and teleflash to capture a sharp well lit image. Nikon D3, Nikon 200-400mm f/4.0 lens, auto projected flash, f/5.6 and 1/250 second, ISO 500, and manual metering.

both horizontal and vertical compositions when it suits the subject.

Horizontal compositions work best when the subject is wider than it is tall. An elk standing broadside to you that is looking to the left is an obvious horizontal. Place the elk on the right side of the image, avoid cutting the tail and feet off, and let it look left into the frame. It is a simple guideline that works incredibly well. However, if this same elk turns toward you and raises its head, it now is much taller than it is wide and makes a vertical composition more desirable and compelling.

Vertical compositions, of course, typically work well with subjects that are taller than they are wide. Giraffes, great-blue herons, and ground squirrels standing up on alert are obvious examples. Beginning photographers typically start out shooting nearly all horizontal images. Since the horizontal format seems natural, most of us shoot plenty of horizontals. However, make sure you shoot vertical compositions, too, especially when it really works best with the natural shape of the subject.

Reticulated giraffes suggest strong vertical compositions because they are tall. Canon EOS 1D Mark III, Canon 300mm f/4 lens, f/10 at 1/500 second, ISO 400, and manual metering. However, it is possible to shoot a fine horizontal composition by composing a little bit looser by allowing the giraffe to "look" through the image. An animal looking to the left as you see here works well on the right side of the image. If the animal looks to the right, then compose it on the left. Canon EOS 1D Mark III, Canon 300mm f/4 lens, f/10 at 1/500 second, ISO 400, manual metering.

Follow these horizontal and vertical guidelines loosely. Even a vertical subject can be a fine horizontal image if you work the environment into the composition. A giraffe that is standing straight up could be placed on the far right or left side of the image, and composed as a loose horizontal. Even tall animals like the giraffe don't work as a vertical composition when composed tightly if their head is down as they feed on a low bush.

It is easier to compose vertical compositions if you look through your camera properly. If you use your right eye to look through the viewfinder, how you orient the camera does matter. Photographers who use their right eye should rotate the camera 90 degrees counterclockwise. This position is more comfortable for pressing the shutter button and your nose clears the camera body, instead of being smashed into the back of the camera. Unfortunately, it isn't so easy for those who shoot with their left eye. If left-eyed shooters turn the camera clockwise 90 degrees, their nose clears the camera, but it is awkward to trip the shutter. Turning the camera 90 degrees counterclockwise makes it easier to trip the shutter, but they must smash their nose into the back of the camera. In cold weather, if you use the "smashed nose" style of peering through the viewfinder, you'll have another problem with fogging the viewfinder because you are more likely to breathe on the viewfinder when shooting this way.

VIEWPOINT

Camera placement determines the viewpoint. Many animals are most often photographed when they are on the ground

or in the water. Extending your tripod legs to let you look through the viewfinder while standing up is popular—unfortunately. This high viewpoint (low aerial) gets boring rather quickly and the images are far less intimate and appealing. Many photographers do this because it is easier for them. A high viewpoint can be quite effective, though, especially for large groups of animals. Penguin rookeries in the Falkland Islands or Antarctica photograph well this way because the individual birds show up better, revealing the magnitude of the dense nesting colony. We sometimes see fine images of birds incubating their eggs from directly above that are quite striking. The photographers use a wireless triggering system with a tripod-mounted camera to capture this aerial viewpoint.

A low viewpoint is best for many animals that are near the ground. This is a strong guideline that approaches the status of a "rule." By placing the camera at eye level to the animal or slightly below, the camera captures a more intimate and compelling image of the subject. Our favorite viewpoint for

This hoary marmot was eating grass along the highway between Canada's Banff and Jasper National Parks. I pulled off in a safe parking spot and slowly approached the marmot quietly. When I laid on the ground to use a low shooting viewpoint, it resumed feeding. Canon EOS-1D Mark III, 500mm f/4.0L lens, f/5.6 at 1/200 second, ISO 640, Shutter-priority with a +1-stop exposure compensation.

animals on the ground is slightly below the eye level of the animal. Admittedly, it isn't always possible to put the camera in this position. If the animal is lower than the ground you are on, then it isn't possible. However, if the animal is even a few inches above the ground you are on, it is quite feasible to use this low viewpoint. Lie on the ground, spread the tripod legs out flat, and shoot as close to the ground as possible. Capturing this low viewpoint is easier if you use long telephoto lenses, such as a 500mm or equivalent, because the angle between the subject and the lens is less with more distance from the subject. Of course, some of us rise from the ground easier than others. Do what you physically can. Being in excellent physical condition is enormously helpful for nature photography and wildlife photography in particular.

Of course, don't overdo the low viewpoint idea. Many birds and some animals are photographed perching in trees. Shooting up at steep angle toward their belly seldom makes a pleasing image.

GUIDELINE 3: CONTROL THE BACKGROUND

The background, whether soft or sharply focused, is critically important to the image. A distracting background competes for the viewer's attention, drawing it away from the subject. Specifically, what is a distracting background? A bare bush with lots of branches that appear as distinct lines behind a beautiful bird is certainly distracting. A bird in the shade photographed against a sunlit background is objectionable due to the extreme difference in contrast. The bright background pulls the viewer's eye away from the bird. Bright backgrounds occur on cloudy days, too. While the light under cloud cover is diffuse, photographing a bird against a light cloudy background is distracting. A white background is a contrast problem if the subject is quite dark. For many years, we avoided photographing animals against a white background. It became a habit, but now we find it is advantageous to use some white cloudy backgrounds, especially if they aren't too bright. While a white bird against white clouds tends to merge together, it can be an appealing image if there is a bit of color in the subject such as a yellow beak or eye. When nearly everything in the image is some shade of white, a small splash of color in the subject becomes a strong center of interest that makes a strong image.

Even a nicely illuminated completely out-of-focus background is often distracting. This is a common problem with, unfortunately, far too many wildlife images. Many animals like deer, elk, elephants, and giraffes are photographed as they graze in a field with a forest or skyline in the background. In many cases, the edge where the field meets the forest creates a distinct horizontal line in the background that passes through the head or neck of the subject. Even if this line is completely unfocused, it remains quite noticeable and objectionable. The same problem occurs when an out-of-focus field or treeline meets the sky. The last thing you want is the horizon line, even if totally unfocused, creating a line through the subject.

USE A LONGER FOCAL LENGTH LENS

Long lenses in the 300mm and up range automatically minimize background distractions. The longer the focal length, the smaller the angle of view. Therefore, the field of view covered by the lens is smaller, too. Since the lens "sees" less of the background, this makes it much easier to isolate the subject against a diffused out of focus background with similar colors and brightness. If a distracting background is a problem, switching to a longer lens or zooming the lens out to a longer focal length might solve the problem.

USE A LARGER APERTURE

Using f/2.8, f/4.0, or f/5.6 throws the background out of focus more because the depth of field is much less than you get with f/16 or f/22. The more out of focus the background is, the less distracting. Remember, aperture and f-stop are really not the same thing, though many photographers use the words interchangeably, including me sometimes. The aperture refers to a specific size hole in the lens that lets light pass through it. The f-stop refers to a mathematical ratio between the focal length and the diameter of the aperture (f-stop = focal length/

aperture). A large f-stop number such as f/22 is created with a small aperture. Conversely, a big aperture generates a small f-stop number like f/2.8 or f/4.0.

Using small f-stops (big apertures) to reduce depth of field is quite effective for concentrating the attention on the face of an animal. In fact, this has a name and is called "selective focus." Using the biggest aperture on your lens, such as f/4.0, throws the background far out of focus, forcing the viewer to look at the subject. This technique works quite nicely when shooting through foregrounds because they become unfocused splashes of color that beautifully frame the subject. Selective focus works exceptionally well when the foreground

is colorful wild flowers, especially under low contrast cloudy skies.

FILL THE IMAGE WITH MORE SUBJECT

Making the subject larger in the image offers benefits for controlling the background. First, if the image is occupied with

The magnificent antlers in velvet of this bull elk make a superb photo opportunity. I stayed with this elk for at least two hours while it fed. During this time, I got plenty of fine poses and good situations. This image is badly flawed because the white skyline bisects the elk. Canon EOS-5D Mark II, 500mm f/4.0L lens, f/5.6 at 1/500 second, ISO 400, Shutter-priority with a +2/3-stop exposure compensation.

Here is the same elk with an unobtrusive background. Always avoid unappealing backgrounds whenever possible!

more subject, there is less room for a distracting background. Second, filling the image with more subject increases the magnification, which reduces the depth of field and throws the background more out of focus. Both these factors make the background less noticeable.

CAREFULLY SELECT THE SHOOTING ANGLE

Although our native Kenyan driver-guides are superb, they aren't photographers. Therefore, I tend to carefully guide them (in a friendly way) to the best spot to stop the Land Rover as we drive up to the animal. I take into consideration how approachable the animal appears to be, where the best light is, what lenses the other folks in my Land Rover have, foreground obstacles, and the background. Often I stop the vehicle at a specific spot when many places seem like they should be equally good. Why? I am looking for the best background. There is no point in stopping the Land Rover at a spot where

These Masai giraffes are wonderfully spotlit by the golden sunshine against the black storm clouds behind them. Anytime you find golden sun and black skies, work quickly to find worthwhile subjects to photograph during this often fleeting, but tremendously magical light. Nikon D2X, Nikon 70-200mm lens, f/8 at 1/200 second, ISO 200, and manual exposure.

the horizon line bisects the head of the giraffe when moving over ten yards to park slightly higher up the gentle slope lets us isolate the same giraffe against an out-of-focus all-green background. At other times, we park the Land Rover lower down the hill to isolate the animal against the sky. This against-the-sky viewpoint is incredibly effective when the sky is boiling with formidable black storm clouds, especially if the giraffe is lit with golden sunshine.

SELECT SUBJECTS THAT ARE FAR FROM THE BACKGROUND

Sometimes there are numerous animals to choose from. Some are close to background distractions while others are farther away. The farther away the background, the more out of focus it will be, assuming focal length, magnification, and f-stop remain the same. Admittedly, you don't get as many opportunities to select an animal that is farther away from the background as you do if you were photographing wildflowers, but it does happen at times. More likely, though, this concept is incredibly useful if you are photographing squirrels or birds at your backyard seed feeders. I recently set up a feeding sta-

tion on my property in southern Idaho. Common birds in the yard during spring include American goldfinch, house finch, red-winged blackbird, white-crowned sparrow, California quail, and house sparrows. All of them are most comfortable when they are near thick cover to escape the predatory sharp-shinned hawks that cruise through at regular intervals. Therefore, I set up the tray seed feeder along the side of a thick brush pile. I put the blind on the south side of the feeder because the light is better more often when shooting north. The brush pile is only a few feet away, but does not appear in the background at all. A thick stand of hawthorn and Russian olive trees about 25 yards behind the feeder occupy the background. I selected this distance from the background, rather than having it closer, because our 400mm and 500mm lenses make the background completely out of focus at 25 yards.

GUIDELINE 5: CONSIDER THE DIRECTION THE ANIMAL IS LOOKING

Look for the flow. This is a simple concept that works remarkably well. If a single animal is looking to the left, the flow follows the direction it is looking. Put the animal on the right side of the image and give it room to look through the image to the left. Should it suddenly look to the right, recompose quickly and place it on the left side of the image, as the flow now goes to the right. Many perched birds constantly look left and right. If you try to change the composition each time they look the other way, you constantly fiddle with the camera and tripod head and don't shoot many images. We surrender to birds actively looking in all directions. We compose the image with the bird on the left side of the image and wait for it to look to the right, only shooting images when it does so. When we get enough, we recompose and put the bird on the right side of the image and shoot when it looks to the left. Letting the animal look into the image effectively solves two common problems. Composing by "going with the flow" tends to stop you from filling the frame too tightly all of the time. It also keeps the subject out of the middle of the image which gets boring if all of your subjects are centered.

WHEN TO LET THE ANIMAL LOOK OUT OF THE IMAGE

As with all guidelines, there are exceptions. A duck steadily swimming to the right with a perfect mirror reflection looks

Providing water in a dry environment will attract many animals. It's a successful strategy to compose the image to make the Gambel's quail look through the image, not out of the image as you see here. There is too much empty space on the left side of the bird. Canon EOS-1D Mark III, Canon 500mm f/4.0L, f/11 at 1/500 second, ISO 250, manual exposure.

This composition works much better because the inherent flow in the image is the direction the quail is looking. In this quail example, the quail was centered in the middle of the original frame to allow us to easily compose it two different ways. Normally, we would compose the quail on one side of the image or the other, depending on the direction it is looking.

good on the left side of the image. This subject placement provides empty space to the right for the duck to swim into. However, if water ripples or downy ducklings follow the swimming mother duck, then it works to put her on the right side of the image, allowing the ripples or ducklings to occupy the space behind her.

MULTIPLE COMPETING FORCES

What do you do with a giraffe that is standing upright, but looking to the left? There are two competing forces. The vertical posture of the animal strongly suggests a vertical composition. However, the animal looking to the left creates a force in that direction and suggests a horizontal composition. Here's two ways to handle competing forces. First, compose a tight vertical, but allow a little extra space on the left side. Second, shoot a loose horizontal and place the giraffe on the right side. Let it look left through the image. Both work! If you see other possibilities, then go for it.

AVOID DEAD CENTER COMPOSITIONS

Avoid putting the primary subject right in the middle of the image, especially if it occupies less than half of the image. We find this bull's-eye subject placement is a common problem among our clients. Perhaps this is true because their autofocus points are centered around the middle of the frame, so it's easy and seems natural. However, placing the subject in the middle of the image all of the time ignores the natural flow and quickly becomes boring, especially to an audience that has to look at the same uninspired composition shot after shot. It's better to compose more thoughtfully to keep your images interesting to the viewer. This dead-center habit (we call it the bull's-eye syndrome) is a widespread problem for many photographers. Examine your images to see if you are prone to centering all subjects. If so, follow these guidelines to acquire a new habit of using the natural flow to compose more appealing images.

There are times to dead-center the subject, though. If the animal looks directly at the camera, especially if it appears formidable and dangerous, placing it dead-center in the image

works nicely. The flow travels straight at the viewer, making the dead-center placement dramatic with intimidating animals such as lions, buffalos, and leopards.

Sometimes it is best to "temporarily" dead-center the subject. Soaring birds and loping cheetahs are challenging to compose to give them room to move into the image without cutting off their tails or feet. Therefore, a successful strategy is to bull's-eye them and don't fill the frame quite as much as you would like to provide a wee bit more empty space around them. This greatly reduces the chance of cutting off part of the animal. Then crop the image a small amount to let the animal move into the image a bit without cutting any portion of the creature off. Now the subject is no longer centered in the image. That's why it is a "temporary" dead-center composition. Don't shoot too loose, though. Some people shoot far too loose and they don't have enough pixels left when they make a print to get good resolution.

Groups of animals can suggest a flow, too. Several zebras quietly resting in a row suggest a strong horizontal flow. Conversely, a herd of wildebeest and zebras running down the steep bank of the famous Mara River is clearly a strong vertical image as the action flows primarily up and down.

OVER THE SHOULDER

Photographing an animal from the rear as it looks back over its shoulder toward the camera is a captivating composition. This angle is especially beneficial for birds because it nicely reveals their tail and wing details, while keeping their face as the primary interest in the image.

THE "RULE" OF THIRDS

This concept is widely known and used, so let's not spend too much time rehashing it. It is a simple idea that does work nicely. Divide the image into thirds, both horizontally and vertically. The lines intersect at four points called "points of power." According to the rule (guideline), the main subject should be on one of the power points. This does not mean all power points work equally well for every image, however.

Early one morning in the Masai Mara, we happened upon a lioness carrying a cub. It was the first of four cubs she would carry to a new hiding spot. Since lions pay no attention to safari vehicles, we parked near the path she would use to bring the other three cubs. We got three good chances to capture this motherly behavior. Nikon D2X, Nikon 200-400 f/4 lens, f/5.3 at 1/500 second, ISO 400, Shutter-priority with a +2/3-stop exposure compensation.

They don't. You must still keep in mind the natural flow in the image. The power point idea does work quite well, especially for an animal amid the landscape. If you fill the frame tightly, though, it is less useful because the subject overlaps two or more power points. You could put the eye of an animal on a power point, though. This guideline reduces the tendency to shoot bull's-eye composition a lot, so it is quite valuable there.

PERSPECTIVE

Perspective is often confused with viewpoint which is a different concept altogether. If you photograph a robin while lying on the ground and then stand up and photograph it from that height, you have changed the viewpoint, but not the perspective. To change the perspective, you must change the shooting distance which changes the size relationship between the subject and the background. For example,

imagine photographing a black-browed albatross incubating eggs on Saunders Island near "the neck" in the Falkland Islands. These large birds are unafraid of humans, making them easy to closely approach. If you photograph it full-frame with a 300mm lens, you'll capture a fine image, especially if you isolate it against the wildflowers growing immediately behind it. But, what if you wish to include more of its sea cliff environment, and continue to keep the nesting albatross equally large in the frame? How do you accomplish this? Change your perspective by moving closer to the bird and shoot with a 24mm lens. Keep the albatross the same size in the image, but you'll notice the background now contains the

Whooper swans flock to northern Japan to winter along the coasts and at hot springs along the margins of ice-covered lakes. Nearby local shops sell tourists food to feed the swans. Therefore, they are easy to photograph well because they will approach you closely. The 70mm focal length nicely captures the two swans in the foreground while showing the larger environment in the background, too. Nikon D3, Nikon 70-200mm lens at 70mm, f/11 at 1/1600 second, ISO 500, and manual exposure.

flowers, sea cliff, ocean, and sky. The image still has a large albatross, but now includes far more background information. This effect is a result of a change in perspective.

Perspective is incredibly important to consider, but let's not make it too complicated. Let's summarize it. To isolate the subject against a small portion of the background, stay away

from it and use a telephoto lens. To show more background, while keeping the main subject large, move in much closer *to change the shooting distance* and use a wide-angle lens. Creating wildlife images with short lenses to achieve this wonderful perspective is only possible with trusting creatures or with remote triggering devices. Be careful where you do this. In many places there are rules about how close you can approach the subject. In Antarctica, for example, I read there are now rules where you must not approach an animal closer than 15 feet. This rule makes it impossible to shoot those dramatic wide-angle perspectives. Although 15 feet sounds close, it really isn't with wide-angle lenses.

GUIDELINE 6: WORK THE SUBJECT

SPEND THE TIME

We saved the most important "Rule" for last! Far too many photographers approach a subject, shoot a few images, and then move on. They photograph whatever the animal happens to be doing during the few minutes they spend with it. Often this only captures a static image of the animal staring at the photographer as it ponders what you are up to. This is a sure-fire way to capture many forgettable images. It is critically important to stay with a highly worthwhile subject and really photograph it. Oddly enough, many photographers move on long before they capture the best images a special opportunity offers. Of course, if it is their first Kenya safari, often they don't know that the animal or behavior that is happening before them is special.

For instance, on a Kenya photo safari, we discovered a set of four adorable lion kittens in a thick clump of bushes at dawn. The intertwined vegetation made it impossible to shoot decent images. No adult lions were around, but we knew they would soon arrive. We parked the Land Rover about 20 yards away from the bushes and waited for the lions to return. Soon we spotted a lioness about 200 yards away in the company of several others. Over the next 20 minutes, she slowly ambled back to her kittens. Judging by her bulging belly, we knew she had eaten well during the night. As she closed the distance, we set our exposure ahead of time and waited. When she was ten yards from the bushes, all four of the cubs excitedly bounded out to greet her. After hugs and kisses all around, the playful cubs wrestled with each other completely in the open for more than an hour as two lionesses rested nearby. This morning was unusually cool due to the steady drizzle that fell during the night. The cool temperatures encouraged the lions to remain in the open. On warm mornings, lions soon retreat to the bushes to hide from the hot sun. We stayed with them quietly, but shot thousands of images as they scampered to and fro. They persistently jumped on each other, "caught" their mother's twitching tail, and chased each other around. Eventually, all of the lions drifted into the dense bushes to snooze.

While we photographed these lions, other safari vehicles drove up, their clients quickly shot a few images, and then they sped away to find the next animal on their list. While this may be a way to see a large number of species, it is no way

Always work special opportunities thoroughly. We seldom see Egyptian vultures on our Kenya photo safaris. I noticed it quietly standing 20 yards away from a zebra the lions had killed. I carefully explained to my photo tour clients this is a rare opportunity and encouraged them to give this handsome bird some of their time. Otherwise, most of them would have photographed the more obvious lions, hyenas, and jackals surrounding the zebra carcass. Canon EOS-1D Mark III, Canon 500mm f/4.0L lens, f/7.1 at 1/160 second, ISO 800, Shutter-priority with a +2/3-stop exposure compensation.

to shoot memorable images. When a wonderful situation appears in front of you, spend the time to wait for the best action and poses. We are friends with Anup and Manaj Shah, both Kenyan wildlife photographers who work for *National Geographic*. They consider their day a huge success if they capture one super-image.

TAKE ADVANTAGE OF UNIQUE OPPORTUNITIES

Occasionally, you'll find an easily approached individual of a species that is normally wary. For whatever reason, the subject poses nicely and doesn't react to your presence. When you are the beneficiary of a trusting subject, spend extra time photographing it, as you may never find the same opportunity again. Once, while leading a fall color workshop along Lake Superior during mid-October, we spotted an American golden plover standing quietly near our group of photographers. This normally wary shorebird exhibited no fear of us. Perhaps it was tired from a long flight or simply was young and foolish. Although our group didn't have 500mm telephoto lenses in our landscape photo workshop, they did have 300mm lenses. As long as we slowly crawled up to the plover, it calmly rested near us. This plover easily let us and our workshop clients approach within 10 feet to photograph it without showing any signs of distress and made no attempt to move away. We took extra time working this plover because it let us.

ALWAYS CONSIDER THE WELFARE OF THE ANIMAL

It is productive to spend lots of extra time when a terrific opportunity comes your way. However, always keep the welfare of the subject in mind. Some subjects might slightly protest your presence at first, but once they learn you wish them no harm, they accept your presence, and go about their business. Still, if the subject begins to protest again, then back off and leave it alone. No subject should be harmed by the actions of a photographer. We don't think flushing a robin—once—that was perched on a branch will do it any harm. Birds are used to flying. Just don't do it over and over again. Naturally, nesting birds and mammals require extreme care. If the subject puts up any protest at all, back off and leave the area. The risk to the subject simply isn't worth the images you might get and your actions may be illegal in some places. By the way, the dictionary definition of "harass" is "torment by subjecting them to constant interference or intimidation." Always avoid harassing wildlife!

8

Electronic Flash

THE FEAR FACTOR

Many photographers are afraid to use flash. Many of you—as we did—learned photography years ago when flash was far less sophisticated and more difficult to use. Through-the-lens flash metering was in its infancy and flash manuals were poorly written. Using more than one flash at a time required the use of the intimidating guide number (GN) system or an expensive flash meter to arrive at the optimum exposure. Fortunately, this dismal situation has changed for the better. Dedicated flash is easy to use well. Metering for flash, along with combining it with available light, is simple and straightforward today.

Occasionally, some photographers say they don't need flash to capture wildlife images. Their assumption is correct if they limit themselves to the times when available light does work well. We prefer to use splendid available light whenever possible. However, there are many times, especially in wildlife photography, where flash must be used to capture nicely illuminated images. Flash offers many advantages. It is powerful for its size, easy to control, reliable, predictable, always available, and emits a light with a known and consistent color. Think of it as a small "sun in the box" that easily solves many problems wildlife photographers encounter. I have used flash extensively over the past 40 years and started with using two or three flashes at once to photograph nesting birds. During this time in the mid-1970s, I had to use the Guide Number system to set proper exposure. Over the decades that followed, I figured out ways to use flash to solve many lighting problems. To keep things simple, I use different terms to separate these uses.

LEFT: These young northern flickers are waiting for their parents to arrive with food. They poke their heads out of the nest cavity during the last week before fledging. Barbara used a single flash to light the chicks and slowed the shutter speed to allow the available light on the distant mountains to properly expose the background. Nikon D3, Nikon 200-400 f/4.0 lens, f/8 at 1/250 second, ISO 400, and manual exposure for the flash and the natural light.

FLASH DEFINITIONS

FILL-FLASH

When available light is unfavorable, it is effective to use flash as a supplemental light to open up deep shadows. This

The green-crowned woodnymph dwells in the dark forests of the highlands in Ecuador. Barbara manually set the natural light exposure to be at least one stop underexposed and used a flash mounted above the camera with a bracket to properly expose the hummingbird. The flash helps tremendously in capturing sharp images and really brings out the color in this bird. Nikon D300, Nikon 200-400 f/4.0 lens, f/7.1 at 1/125 second, ISO 800, manual natural light exposure and automatic flash exposure with a +2/3-stop exposure compensation.

reduces contrast and narrows the dynamic range. Using fill-flash lets the sensor record detail in both the shadows and the highlights. Available light remains the dominant light source and flash is the minor or secondary light source.

MAIN FLASH

Flash is the primary or dominant light, and available light now serves as the fill-light. This technique is incredibly effective for photographing small birds and mammals in the forest when the available light is insufficient to permit fast enough shutter speeds to capture sharp images. Flash is used to

properly light the subject while the available light exposure is set one or two stops underexposed. This strategy lets you stop the lens down more, use a faster shutter speed, or a combination of the two. It is incredibly effective for photographing hummingbirds perched in bushes.

We were thrilled when Jim Kenney hired us to help him photograph the swarms of hummingbirds that are attracted to the sugar water feeders at the Tandayapa Bird Lodge in the Ecuadorian highlands. Imagine having fourteen different species coming in at one time and sometimes getting to shoot 600 shots per hour. This iridescent sparkling violetear was one of the larger species at the lodge. Thanks Jim!! Canon EOS-1D Mark III, Canon 300mm f/4.0 lens, f/20 at 1/250 second, ISO 200, and four Canon 580 II flashes set to 1/16 power.

BALANCED FLASH

There are times when dim light illuminates the subject, but the background is far more brightly lit with available light. Flash is used to light the subject without having any effect on the more distant background. The flash *balances* the light between the foreground and the background. Sometimes flash is used to light a dark background to reduce the contrast between the background and a brightly illuminated subject in the foreground. In each case, flash lights one portion of the image (either foreground or background) while available light illuminates the other.

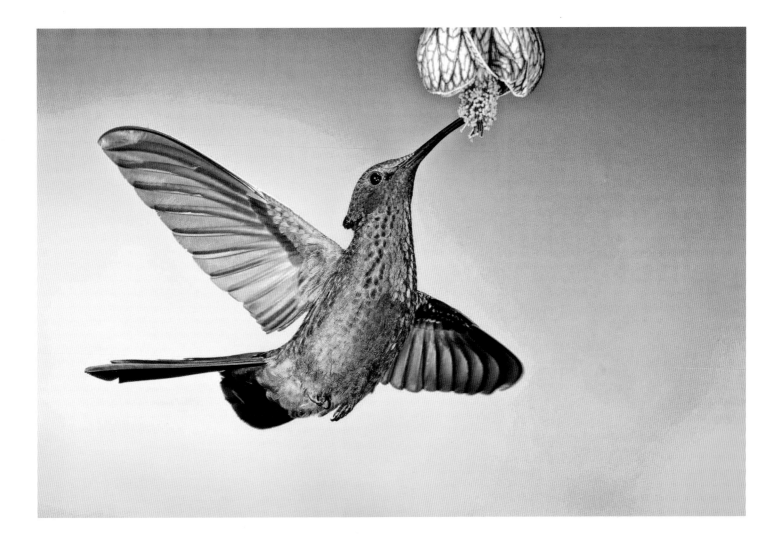

FREEZE FLASH

Advanced flash units let you adjust the flash duration by permitting different power levels to be set. For example, the flash duration at full power might be 1/1000 second. If the flash power ratio control is set to 1/16 power, the flash duration shortens considerably to 1/8000 second or less. If the only light on a moving subject is from a flash at 1/16 power, the short flash duration "freezes" the motion of the subject. Using short flash durations is precisely how sharp flight images of bats and hummingbirds are captured. Many photographers call this "high-speed flash," but we prefer to call it "freeze flash" to describe what it does.

FLASH BASICS

Flash is an electronic device that is usually powered with batteries, but some use AC power and others can use either. For most applications, rechargeable batteries work just fine. However, if you are photographing in a place that is close to AC power and your flash units have a way to plug into it, then use AC because the power never runs out. The flash has a storage device called a capacitor to store energy from the power source. When the camera is tripped, the shutter fully opens, and the capacitor releases the charge into a glass tube filled with xenon. The gas absorbs the energy and emits a brief flash when it ionizes. It takes a few to several seconds before the capacitor fully charges itself. This is called the recycle time. During this time, you can't shoot another properly exposed image unless you are using the flash with a low power ratio. Using a flash with a short recycle time or having one where the output is reduced with a power ratio control is crucial when you wish to shoot images rapidly. As you read your flash instruction manual, you'll notice the flash offers many options. It gives you plenty of control over how the light is emitted. Let's cover many of these options when we need them in the forthcoming discussion. Much flash information is crucial to everyone while some is useful to only a few photographers. Flash is a massive topic. I could easily fill an entire book on flash techniques for nature photographers, but I won't attempt that here. It is best to take it a little at a time

and learn the most important uses first. When the basics are learned, then expand your skills into more advanced uses.

FLASH CHOICES

BUILT-IN FLASH

Your camera probably has a built-in (pop-up) flash on top of the camera. This is a good place to start learning how to use flash. The pop-up flash is controlled by the camera with through-the-lens metering and a flash compensation control located somewhere on the camera or in a menu. However, the pop-up flash location is convenient for the camera maker, but it is a lousy place to put the flash. On-camera flash produces garishly flat light because all shadows fall behind the subject. Therefore, on-camera flash is horrible as a main light, but it can be used nicely as a fill-light to open up the shadows produced by bright available light or another flash.

DEDICATED FLASH

Serious flash photography requires at least one or more flashes that are built by your camera's manufacturer, though some third-party companies also offer dedicated flash units, too. These dedicated flashes are carefully made to communicate with the camera. Dedicated flash is especially good at mixing flash with available light, a technique that formerly was challenging to do back in the manual flash days.

Each camera maker offers one or more flashes to choose from. Typically, the biggest difference between them is price and power. Expensive flash units tend to be more powerful. They emit more light which lets you light subjects at greater distances, an important factor for wildlife photographers. However, less powerful flashes that are far less expensive work fine most of the time. This is especially true now that high ISOs produce such fine results. If you use Canon, consider the Canon 430EX II ($280) or the more powerful 580EX II ($420). The 430 EX II is two-thirds stop less powerful than the 580EX II. Both work well. For about $140 less, the 430EX II may be all you need. Nikon fans should choose between the SB-600 and SB-900. Both are gems! Barbara uses the SB-800

(now replaced with the SB-900) for her flash images. It works well for everything she wishes to photograph with it. Perhaps you could find some used SB-800s by searching the web to save money. Olympus, Sony, Sigma, and Pentax offer dedicated flashes for their cameras, too. Always consider using the camera makers' proprietary flashes first! They are more likely to work flawlessly with your camera.

THIRD-PARTY FLASH MAKERS

Metz, Sunpak, Vivitar, and others build flashes that can be used with your camera. They customize their flash models to work with different camera systems. Automation is built-in to permit the camera to work seamlessly with the flash. Of course, it is possible that not all of the features or controls are available, especially if you use a new camera model that didn't exist when the flash was designed. Still, it is best to look at flashes made by your camera maker first. Only if you don't find what you want from the camera maker, or the price doesn't fit your budget, should you consider independent flash companies.

DETERMINING THE FLASH EXPOSURE

DO YOU NEED A FLASH METER?

The camera's internal flash metering circuits measure the light output from a dedicated flash. When the camera determines the exposure is appropriate, it turns the flash off. Therefore, with most flashes and cameras, you don't need a flash meter any more. If the flash exposure requires adjusting, then use the flash compensation control that is found on the camera, sometimes on the flash, or both.

What if you wish to use a manual flash to save money or for some other reason? Do you need the flash meter now? Barbara and I run six flash photo stations simultaneously at our hummingbird photo workshops, and most are using non-dedicated flashes. Two Minolta hand-held flash meters that we used in the film days remain in our gadget bag. Are they needed today? No! Flash exposure with digital cameras is easy. Set up the flash (or flashes) and take a shot. Check the histogram. If the rightmost data is climbing the right wall of the histogram

graph and the highlight alert is flashing, reduce the flash exposure until the rightmost data is barely touching the histogram's right wall. If the rightmost data isn't snuggled up to the right wall, then add light until it does. Most likely you don't need a flash meter for wildlife photography. We certainly don't.

EXPOSURE COMPENSATION

Available Light

Most photographers use an automatic exposure mode such as Program, Aperture-priority, or Shutter-priority much of the time. These modes let the camera determine a standard exposure. However, in many cases, the exposure isn't optimum. You must check the histogram to make sure the rightmost data is close to the right wall of the histogram. If it isn't, how do you adjust the exposure when using one of these exposure modes? If you are using Aperture-priority and set f/8, the camera might set 1/250 second with ISO 400. How do you add one stop of light? Opening up the f-stop to f/5.6 lets in one more stop of light through the aperture, but the camera automatically changes the shutter speed to 1/500 second to compensate for it. The exposure remains the same, though the f-stop and shutter speed have changed. This is the "Law of Exposure Reciprocity" at work. Since some exposures must be compensated, your camera conveniently provides an exposure compensation control somewhere on the camera. Usually it is indicated with a + /- icon, though some cameras (Canon, for example) use a dial to set it that isn't labeled. Other cameras let you set it with a menu selection. In the previous example where we used 1/250 second at f/8, setting the camera to a + 1 exposure compensation changes the shutter speed to 1/125 second at f/8. Remember, Aperture-priority gives priority to the f-stop and varies the shutter speed. Obviously, Shutter-priority does the opposite.

Manual exposure users don't need the available light exposure compensation control. They easily adjust the exposure by changing the f-stop, shutter speed, ISO, or a combination of all three while using the metering scale inside the viewfinder to guide them.

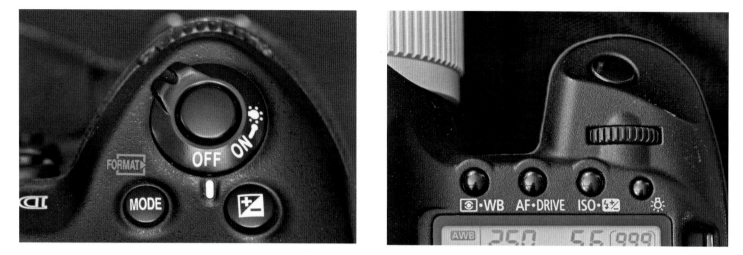

Your camera's flash and natural light metering system are separate from each other. This means both can be on automatic, both on manual, or one on automatic and one on manual. Therefore, your camera offers a separate exposure compensation control for the flash and natural light metering system. Make sure you know where each control is on your camera. Notice the flash icon includes a zigzag line (think lightning bolt) to tell you it does not control the natural light exposure, but only the flash exposure. Some cameras do not use icons to label the controls. Consult your camera manual to find out where they are located.

ELECTRONIC FLASH

The available light exposure compensation control does not affect the flash exposure. Therefore, your camera has a second exposure compensation control for flash. It is normally indicated with a + /- icon along with a zigzag arrow. Use this one to adjust the flash portion of the exposure. Take a break right now and find both the available light and the flash compensation control on your camera. Look in your camera manual if you don't see them right away. Some are hidden on dials with no icon to tell you where they are located. The flash compensation control might be buried in a menu list, too. It is critically important that you know where both the flash and the available light exposure compensation controls reside on your camera. The flash compensation control affects only the flash output and the available light compensation control only affects the available light.

OUR EXPOSURE METHOD

We meter with the histogram, but keep the highlight alert activated to help us detect overexposed portions of the image quickly. All of this is fully covered in Chapter 3, but let's briefly review the fast and precise exposure strategy we use with wonderful results.

Whether you use an automatic or semi-automatic exposure mode, or manual exposure, always determine the best exposure with the histogram. Your goal is to expose the image to make the rightmost data of the histogram nearly touch the right edge or wall of the graph. Exposing this way preserves highlight detail by preventing overexposed highlights, allows the sensor to collect the greatest amount of picture data, and reduces noise. Typically, we shoot a quick image of the subject that includes the most important highlights where we wish to retain detail to get the initial histogram. Then we adjust the exposure with the exposure compensation controls, or manual controls, and shoot another image to make sure the brightest highlights that contain detail are barely touching the right wall of the histogram.

THE INVERSE SQUARE LAW

The intensity of light from a point source falling upon a subject is inversely proportional to the square of the distance from the source. That should clear it up! This law describes what

We detest the black background behind this male rufous hummingbird. In this example, the background flash failed to fire. Notice how the dark edges of the hummingbird disappear into the background, providing little brightness separation between the two. If the subject is nocturnal, such as a bat, then a black background does work. Otherwise, it is best to use a flash to light the background or use a slow shutter speed to allow available light to serve the same purpose. Canon EOS-1Ds Mark II, 300mm f/4.0 lens, f/18 at 1/250 second (sync speed), ISO 125, manual metering for both natural light and flash.

happens to light from a point source as it spreads out. If your camera is set to properly expose a subject that is 8 feet from a manual flash, what happens to the flash exposure when the subject is 16 feet away from the flash? The flash to subject distance doubles, but the light isn't cut in half. Instead, only 1/4 of the light illuminates the subject. The distance doubles, but you lose two stops of light because the light is now spread over an area that is four times larger.

EXTENDING THE FLASH RANGE

Before explaining different ways to use flash, it's important to learn some methods for making the flash throw more light on the subject. When flash is used outdoors, much of the light is lost when it spreads out as described by the Inverse Square Law. Unlike indoor flash photography where the walls and ceiling reflect part of the wayward light back to the subject, the outdoors has few reflecting surfaces near the subject. This

makes flash weaker outdoors. Plus, many wildlife subjects are farther from the photographer which also reduces the amount of light from the flash that strikes the subject. Therefore, methods to increase the effective power of the flash are crucial in wildlife photography.

A flash has a maximum amount of light that it can emit at full power. This is expressed as a Guide Number (GN). For example, a flash that has a GN of 160 can emit more light than one with a GN of 110. It is one stop more powerful. This means it emits twice as much light. As you know, light can travel a long way if it is unimpeded. Think how far direct light from the sun travels to warm us on Earth. However, due to the Inverse Square Law which describes how light diminishes as it travels, the amount of light the flash can cast on the subject quickly diminishes. If the flash output permits f/16 at 10 feet, doubling the distance to 20 feet forces you to use f/8 instead. Doubling the flash to subject distance reduces the power of the flash by two stops. This means only 1/4 of the light that strikes the subject at 10 feet still lights it 20 feet away. This happens because the same quantity of light from the flash spreads out over an area four times as large. If you need the flash to be brighter on a distant subject, such as a robin 25 feet away, how do you increase the reach of the flash?

1 *Increase the ISO*: Increasing the ISO lets the camera amplify the electronic signal more. This produces a brighter image. Changing from ISO 200 to ISO 800 greatly increases the exposure. Remember, though, the amount of light from the flash striking the subject doesn't change. The light signal is merely amplified by the camera's sensor.

2 *Open up the f-stop*: Changing the f-stop from f/11 to f/8 allows twice as much light to pass through the aperture. This doubles the amount of light striking the sensor. If you find you are underexposed by one stop when the flash is firing its full charge, opening up the f-stop by one stop will solve the problem. If you need more light, then open up another stop to f/5.6. This increases the light by two stops, quadrupling the light striking the sensor.

3 *Zoom the flash head*: Many dedicated flashes offer a zoom function to match the field of view of the lens you are using. For instance, the

My Canon 580 II flash wasn't strong enough to add light to this red squirrel when the camera was set to f/11 at ISO 100. Therefore, I changed to ISO 200, opened up the aperture to f/7.1 and manually set the zoom on the flash to the longest focal length possible—105mm. This let me underexpose the natural light by a stop and properly expose the squirrel with light from the flash. Canon EOS-1Ds, Canon 100-400mm, f/7.1 at 1/200 second, ISO 200, manual natural light exposure and automatic flash set to a +1-stop exposure compensation.

Canon 580 EX II flash offers zoom settings of 24, 28, 35, 50, 70, 80, and 105mm. Increasing the zoom setting from 50mm to 105mm concentrates the light emitted by the flash considerably, permitting it to light subjects farther away. Cameras with an attached dedicated flash often set the zoom automatically to match the focal length being used. Of course, this assumes the focal length is included in the zoom range. Obviously, if the zoom range on the flash covers 24mm to 105mm, it can't match the field of view of a 17mm or 200mm lens. Instead, the flash will zoom to the closest possible focal length. It is possible to zoom the flash to the longest focal length and then use a lens with a shorter focal length. This lets you spotlight the subject amid its environment.

4 *Use a flash extender.* The longest zoom range available on a Canon 580 II flash is 105mm. That is insufficient if you use this flash with a 500mm lens. Only a portion of the light emitted by the flash strikes the subject. Since lenses longer than 105mm are commonly used for wildlife photography, it's helpful to concentrate the flash beam more when using telephoto lenses. Is it possible? Fortunately, a number of

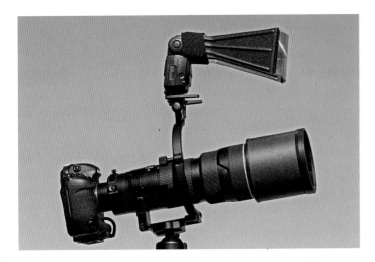

The flash extender attaches to the head of the flash and concentrates the light when it passes through a Fresnel lens. This lets you expose subjects with the flash that are much farther away than you normally could. The flash extender is incredibly useful when using telephoto lenses to photograph subjects that are many yards away. Every wildlife photographer can use projected flash from time to time for both fill-light and main light applications. To avoid the red-eye problem, use a flash bracket to move the flash several inches above the camera.

On a dark rainy day, I photographed this ruffed grouse in a cherry tree growing next to my deck. I underexposed the natural light portion of the exposure by about 1.3 stops of light. Then I used automatic flash to properly expose the grouse. The flash helped me capture a sharp image (short flash duration) and the light from the flash overpowers the blue color cast in the natural light to provide more pleasing colors. Using a flash extender was absolutely necessary to project the light far enough to light up the bird. Canon EOS-7D, 300mm f/4.0 lens, f/6.3 at 1/160 second, ISO 1250, manual natural light metering and automatic flash metering with zero exposure compensation.

flash modifiers are available that attach to the head of the flash. They use a Fresnel lens to concentrate the light. The light emitted from the flash passes through the Fresnel lens which greatly concentrates the light before it moves onward to the subject. These devices are simple to use and especially effective for lighting a distant subject. With a powerful flash and a Fresnel lens, it's possible to light a subject 25 yards away or more.

5 Two companies that offer the flash extenders include www.kirkphoto.com for their Flash X-Tender and Walt Anderson's Better Beamer.

6 *Reduce the flash to subject distance*: Placing the flash close to the subject works well if you know where it will be ahead of time. The lighting capability of the flash is determined by how far the flash is from the subject and *not* how far the camera is from the subject. This means the flash can be mounted on a flash stand or another support and placed near the subject. Now the camera can be much farther away. The flash is connected to the camera with a long dedicated flash cord, a simple PC cord and used manually, or a fancy wireless controller. By the way, a dedicated wireless controller is far more versatile and easier to use than a cord. We always use flash stands to put flashes closer to the subject when photographing nesting birds and hummingbirds feeding at our sugar-water photo stations.

7 *Add Another Flash*: If one flash doesn't quite do it, adding a second identical flash near the first one will double the light output. This lets you stop the lens down one more stop or casts more light on a subject that is farther away.

FLASH TECHNIQUES

FILL-FLASH

Although the substantial benefits of photographing when the available light is most desirable are well known, there are times when you must use less than ideal light. Available light often has too much contrast. This problem is easily reduced or eliminated by using a flash to add light to the shadows. Essentially, the flash fills in the shadows, so it's called fill-flash.

HOW TO USE FILL-FLASH

Mount the flash to the hot shoe of the camera or raise the pop-up built-in flash. We mentioned earlier that the top of the camera isn't the best spot for flash, but it does work well for fill light because you are filling in the shadows that the camera

Lilac-breasted rollers require a close approach even with a 400mm focal length. In this image, only available (natural) light is used. Notice the black shadows on the right side and bottom of the bird. Nikon D300, Nikon 200-400 f/4 lens at 400mm, f/10 at 1/250 second, ISO 200, Aperture-priority with a +2/3-stop exposure compensation.

Barbara used a flash extender on her Nikon SB-800 flash to add some fill-light and reduce the contrast. She set -1.3 stops of flash compensation on her camera to open up the shadows without overpowering the available light.

"sees." Available light is still the primary or main light. When fill-flash is used properly, soft shadows are preserved to reveal texture and suggest depth in the subject.

To begin, forget about the flash and keep it turned off. Determine the best available light exposure first. Use the available light exposure compensation dial to get the rightmost data of the histogram close to the right wall. Of course, if you are metering with the manual exposure mode, then turn the shutter speed or f-stop manually to adjust the exposure. Once the optimum available light exposure is achieved, look at the light in the image. Are the shadows too dark? Is the contrast too great? If it is, turn the flash on and set it to -1.3 stops as a starting point. Use the flash exposure compensation control to set this. Now, point the flash at the subject and shoot another image and check the shadows. The camera keeps the available light exposure and fires the flash. The camera monitors the flash exposure separately and turns the flash off when the exposure from the flash is still -1.3 stops underexposed. Now look at the shadows. Are they too dark, too light, or just right? If just right, then -1.3 stops of flash compensation did the job. If the shadows are too light, reduce the flash output more by setting -2 stops of compensation. If the shadows are too dark, try a stronger fill-flash by setting the flash compensation to -.7 stops. There is no definite right answer as it is a matter of personal taste. You've heard of "salt-to-taste." We call this "fill-to-taste."

SYNC SPEED LIMITATIONS

Fill-flash is commonly used to open up shadows on the face of the subject. To isolate the face from the background, big apertures such as f/4 or f/5.6 are effective. Suppose the available light exposure is f/11 at 1/250 second. You wish to shoot with less depth of field to throw the background nicely out of focus and change the exposure to f/5.6 at 1/1000 second to accomplish this. Unfortunately, the flash will not work properly at this fast shutter speed because you are using a shutter speed faster than the X-sync speed of your camera.

What Is the X-Sync Speed?

The camera uncovers the sensor by using two shutter curtains. When you shoot the image, the curtain covering the sensor opens, the flash fires, the sensor measures photons of light, and then a second curtain closes at the end of the exposure. This process happens at X-sync speed or *any slower shutter speed*. Most cameras have X-sync speeds in the 1/200 to 1/250 second range. Your camera manual will tell you precisely what the X-sync speed is for your camera. If the X-sync speed is 1/250 second, what happens if you shoot with a faster shutter speed? At 1/1000 second, for example, the first curtain begins to open up revealing the sensor underneath. However, due to the fast shutter speed, the second curtain can't wait for the first curtain to complete its journey across the sensor. Instead, the second curtain gallops after the first curtain. Essentially, a rapidly moving slit travels across the sensor, exposing the photosites in the sensor as it goes. This is no problem for continuous available light, but flash is instantaneous. Only that portion of the sensor that is uncovered by the shutter curtains when the flash fires is exposed and the rest remains unexposed. Only a portion of the image receives the fill light from the flash. Therefore, to avoid uneven fill-flash on the subject, you must shoot at the X-sync speed of the camera or any slower shutter speed. You cannot use a faster shutter speed. Most cameras will not let you use a shutter speed faster than the X-sync speed as the camera will default to that speed. It's worthwhile remembering you can use a slower shutter speed than the X-sync speed, though.

High-Speed Sync

Many cameras provide a way to use flash at shutter speeds that are faster than the X-sync speed, called "high-speed sync." How does the camera do this? The shutter curtains still resemble a rapidly traveling slit at high shutter speeds, but the flash fires many small bursts of light in succession. As soon as one burst begins to dim, another is fired and this keeps up throughout the entire exposure. The numerous small bursts of light essentially act like continuous light. Of course, all of these bursts of light must be accomplished on a single

charge of the capacitor because there isn't time for it to recharge. In those situations where you wish to use flash at shutter speeds faster than the X-sync speed, high-speed sync does work well. Why not use it all of the time? Since the flash fires all of these bursts of light from a single charge in the capacitor, the effective reach of the flash is greatly reduced.

Mounting the flash in the camera's hot shoe often causes the infamous "red-eye" problem where blood vessels in the eye reflect light from the flash and turn the eye bright red. That's why a flash bracket is needed to place the flash several inches above the camera. In this case, though, the masked flowerpiercer at Guango Lodge does have red eyes naturally. Canon EOS-1D Mark III, Canon 300mm f/4.0L lens, f/7.1 at 1/60 second, ISO 800, manual natural light exposure and automatic flash exposure at +1/3-stop exposure compensation.

If the subject is several yards away, as it often is in wildlife photography when long lenses are used, then you don't have enough light output to light the subject.

HOW TO USE MAIN FLASH

Main flash is the primary (dominant) light source. Available light is the fill light or secondary light source. Using main flash well is a hallmark of many exceptional photographers and stunning images. You must learn to master this easy use of flash.

This technique is incredibly useful when you must photograph an animal in dim light. Imagine photographing a hummingbird perching on a branch near a hummingbird feeder. The light is incredibly dull and weak due to the dense overhead canopy of branches and overcast skies. Even using ISO 800, the image still seems a bit muddy with dark shadows underneath the hummingbird and the slow shutter speed that must be used makes shooting sharp images a challenge.

Add a flash by mounting a single flash to the hot shoe of the camera. Better yet, mount a flash bracket that attaches to the camera or the quick release plate of a telephoto lens. This lets you place the flash above the camera to avoid the "red-eye" problem. Now determine the available light exposure for the hummingbird and the green leaves surrounding it. Set the exposure to make the available light one stop underexposed. Use the histogram to guide you. The rightmost histogram data should appear about one stop short of the right wall of the graph. We find it is easiest to use manual exposure and multi-segmented metering to do this. However, you could use Aperture-priority or Shutter-priority, along with the available light exposure compensation control to accomplish this as well. Now turn on the flash, set the flash exposure compensation to +1 stop, and shoot a single image of the hummingbird. Check the rightmost data of the histogram to make sure it is touching the right wall of the histogram. If it is, all is well with the exposure. If the rightmost data climbs the right wall, then highlights might be clipped and overexposed. Reduce the flash exposure compensation a bit—perhaps to +1/3 stop and shoot again. If the rightmost data

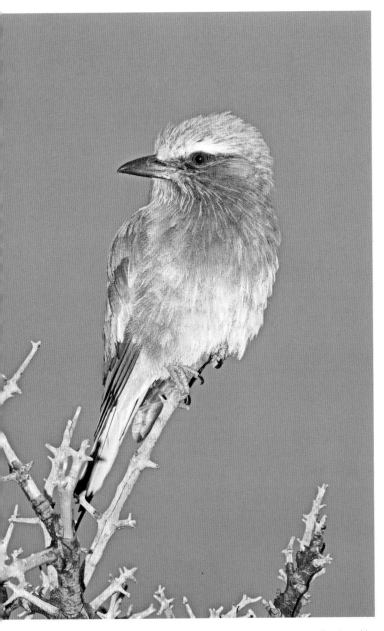

Until only recently, I foolishly ignored birds with a dull white sky behind them. Now I consider it a photo opportunity. This lilac-breasted roller stands out dramatically against the dark gray storm clouds. However, the clouds were actually very light gray in reality. I set the manual available light exposure to underexpose everything by 2 stops, darkening both the bird and the light clouds. Then I used automatic flash and set it to +1.3-stops of exposure compensation to expose the roller nicely while the clouds remained dark. Canon EOS-5D Mark II, Canon 300mm f/4.0L lens, f/22 and 1/200 second, ISO 640, manual natural light exposure set to underexpose everything by minus 2-stops. The Canon 580 II flash was set to +1.3-stops of exposure compensation.

doesn't touch the right wall, then add more flash compensation—such as +1.7 stops. Make adjustments until the rightmost data is touching or nearly touching the right wall of the histogram. Use that combination of available light and flash exposure for the rest of the images you shoot of the hummingbird. Continue to monitor the histogram as you go. Changing available light levels or changes in flash output must be noticed and adjusted for in order to reliably capture well-exposed images.

Using flash as the main light and available light as the fill light in this manner solves many problems. First, the flash provides excellent illumination on the front of the hummingbird and minimizes contrast in the subject. Second, the light in a green forest on a cloudy day exhibits an ugly blue-green color-cast. Flash is a fairly neutral light source that approximates sunshine during the middle of the day. This light produces more natural colors in the hummingbird. Third, using the flash as the main light and setting the available light one stop underexposed lets you use a faster shutter speed. For example, if the proper available light exposure is 1/60 second at f/5.6 when using ISO 800, underexposing the available light by one stop lets you use 1/125 second. This faster shutter speed helps you capture sharp images, even when using a telephoto lens on a tripod. Fourth, the flash creates a small catchlight in the eye of the hummingbird, making it look more alive. Fifth, the flash duration is probably at least 1/800 of a second or shorter. This means the major portion of the exposure from the flash will create a sharp image. If the available light portion of the exposure is only slightly soft due to subject or camera movement, it might not be objectionable. However, lots of subject or camera movement during the available light portion of the exposure may create a ghost image which appears as a double image of the subject. The flash produces a sharp image and the available light creates a blurry secondary image.

FREEZE FLASH

Often a single flash is used as the sole illumination for a nocturnal subject like a mouse, owl, or bat. Since there isn't enough available light to be recorded by the sensor, use

the fastest shutter speed (X-sync speed) your camera offers with flash. Check the camera manual to determine the exact X-sync speed for your camera. Most cameras automatically set the X-sync speed if you mount the flash in the hot shoe of the camera, use a dedicated cord, or raise the pop-up flash. Raising the pop-up flash is another way to determine the X-sync speed. However, if you are using a standard PC cord, the camera doesn't know you are using flash. This requires you to set the X-sync speed.

A single flash works best if you use a flash bracket to put the flash somewhat above the camera and to one side. This position helps to eliminate the dreaded and infamous "red-eye" look where light reflects off the red blood vessels in the eye, making the eyes bright red in the image. A second reason to do this is to create some small shadows in the subject. Shadows suggest depth in the image. On-camera flash tends to create unappealing flat lighting due to the lack of shadows.

Through-the-lens flash metering is ideal for most main flash applications. Use the flash compensation control to adjust the flash exposure. Once again, with a single main flash, judge the exposure by the rightmost data of the histogram. This data should touch the right wall of the histogram when shooting RAW images and fall a little short of the right wall when shooting JPEGs.

BALANCED FLASH

This powerful flash technique is used when you must photograph a creature in dim light that appears against a bright naturally illuminated background. It's especially useful for birds nesting in the shade when the background is illuminated by sun or bright overcast. Often the available light on the bird is four to six stops darker than the background. We call it balanced flash because the dimly lit subject is being nicely illuminated with flash to make the amount of light similar or balanced with the bright light on the background.

DETERMINE THE AVAILABLE LIGHT EXPOSURE FIRST

Using balanced flash is easy if you break it down into small parts. First, forget about the flash. If the background—such

as a sunlit meadow—is the bright portion of the image, determine the best exposure for only the background in the usual way. To review, set the ISO and the aperture you plan to use. Now meter the bright background and adjust the exposure manually by moving the shutter speed until the meter indicator aligns with the zero point on the exposure scale in the viewfinder. Shoot a picture and check the histogram to make sure you have the ideal exposure for the background. If the histogram isn't right, adjust the shutter speed, and shoot again until you get the ideal exposure for the bright background. Don't worry about the dark foreground. If you prefer to use an automatic exposure mode, select Aperture-priority and set the aperture to f/8 or f/11. Use your exposure compensation control for available light to get the optimum histogram to make the background nicely exposed. Of course, the foreground subject in the dim light will be silhouetted against the well-exposed background.

DETERMINE THE FLASH EXPOSURE FOR THE FOREGROUND

Let's use automatic flash exposure for this example. Turn the flash on, point it at the subject, and shoot the image. Review the image on the LCD display to see if the subject is exposed nicely. Make sure no clipping occurs and no flashing highlights appear in the image. If the subject looks too dark, relative to the background, use some plus flash compensation to add light to the subject. If the subject is overexposed, then use less flash compensation to darken the subject. In this unique case, you really can't judge the exposure of the subject by checking to see if the rightmost histogram data is touching the right wall because the available light exposure for the background already is doing that. If the subject looks good and there are no flashing highlights anywhere in the foreground, then you have arrived at a successful balanced flash exposure.

USING MULTIPLE FLASH

A single main flash tends to produce harsh light if available light isn't allowed to contribute to the exposure. This happens

because a single flash lights the portion of the subject it hits and the rest of the subject is hidden by deep shadows. Indeed, a single flash creates more contrast than bright sun because the sky on a sunny day serves as a fill light. Since contrast is a serious problem with a single off-camera flash, it may be necessary to use two or more flashes at the same time to pleasingly light wildlife subjects. Don't worry, it isn't difficult to do this. You'll be an expert at it in no time.

We commonly use two flashes for woodpeckers nesting in our yard and birds at the seed feeder or water drip. Being able to use two or more flashes simultaneously is a necessary skill all wildlife photographers must acquire if they wish to take advantage of many opportunities where available light isn't suitable.

FLASH SELECTION

Using dedicated flash is by far the best way to proceed for most flash applications. These flashes are made by your camera manufacturer and some third-party vendors. They are carefully designed to permit the camera and the flash to communicate with each other. This lets the camera control the flash easily, precisely, and efficiently. If you shoot Nikon, then buy Nikon flashes. Canon users should buy Canon flashes and so on. To reduce the chance of trouble, it's wise to consider flash units made by your camera maker first. If they don't make what you want, or in your price range, by all means consider independent flash companies.

Barbara uses Nikon SB-800s with her Nikon system. Nikon SB-900s are now available, but we see no need to upgrade. I use Canon 580 II flashes easily and efficiently. These flashes provide full compatibility with our Nikon and Canon camera systems, respectively. However, when our workshop clients photograph hummingbirds with three or four flashes at the same time, we use Sunpak 544 flashes on manual for our workshops because they accomplish the job well and are much less costly than our Nikon and Canon flashes. Since we use the Sunpak flashes manually for hummingbirds, we don't need dedicated units.

A TWO-FLASH SETUP

It's effective to use two flashes at the same time for small animals. One flash is the main (a.k.a. key) light and the second is the fill light. When photographing a nesting woodpecker, set up the main flash about 4 feet from the nest hole. The flash should be slightly higher than the camera and slightly to the right if the woodpecker is facing left when at the nest cavity. If the main flash is put on the left side of the camera, the tree could block some of the flash and cast a dreadful shadow on the woodpecker's beak or head. The fill-flash should be about two stops weaker to open up the shadows produced by the main light and simulate available light. Put the fill-flash 8 feet from the nest hole and on the left side of the camera, but as close to the imaginary line connecting the lens with the nest cavity as possible. These distances assume the flash is powerful enough to properly light the woodpecker with the f-stop and ISO that has been selected and both flashes are identical in all respects. Doubling the flash to subject distance reduces the output of the fill-flash by two stops. This is the Inverse Square Law at work again. If you want the fill-flash to be only one stop weaker, simply multiply the flash to subject distance of the main flash (4 feet in this example) by 1.4. Putting the fill-flash 5.6 feet from the cavity ($4 \times 1.4 = 5.6$ feet) makes it one stop weaker than the main flash. In this example, use the flashes set on manual. It also works if you are using automatic flash. There is a way to assign your flash units to different groups and use lighting ratios, but that is another entire chapter all by itself.

FIRING TWO OR MORE FLASHES AT THE SAME TIME

There are many ways to do this and each have their positive and negative aspects.

Slaves

An easy way to fire more than one flash simultaneously is to attach a small slave to each flash. Slaves are tiny photoelectric triggers that attach to the flash. Some slide into the hot shoe on the flash. Others attach to the flash with a short wire that plugs into both the slave and the PC terminal on the flash.

The slave fires the flash it is attached to whenever it detects a flash of light. This means continuous light—such as direct sunlight—doesn't make the slave fire the flash. The slave only reacts to a quick burst of light.

In practice, slaves are inexpensive, usually reliable, and easy to use. However, any flash of light will trigger them. If another person fires a flash nearby, the slave will fire the flash it is attached to as well. Therefore, slaves are horrible if other flashes are going off in the immediate area. Slaves do need line-of-sight. If the slave doesn't "see" the light from another flash, it won't trigger the flash it is attached to. Fortunately, if a ceiling or wall is nearby, the light from the flash bouncing off these objects will trigger the slaved flash. Flashes are not dedicated to the camera when they are tripped with optical slaves, so you don't have through-the-lens flash metering. Set the flash to the manual mode.

If you are using two flashes on manual at once, there are two ways to fire them with slaves. Attaching a slave to one flash is one way to do it. Now attach a 6–12-foot PC extension cord to the PC terminal on the camera and the second flash. If your flash doesn't have a PC terminal, you can purchase a hot shoe to PC adapter for the flash. The adapter slides into the hot shoe and provides the required PC terminal. A second way to fire both flashes at the same time is to attach a slave to both of them. Now use your pop-up flash to trigger them. Set the flash exposure compensation to -2 on the camera to keep the pop-up flash from adding any light to the subject.

Wiring the Flashes Together

This is an effective way to trigger multiple flashes when using them manually. We usually do this to photograph birds and small mammals in the yard. If your camera has a PC terminal (not all do), then use PC extension cords that are 6–12 feet long to connect everything together. If you don't have a PC terminal, purchase a PC adapter that attaches to the hot shoe of your camera. Unless you use dedicated wires (if available), you can only use your flashes manually because PC sync cords only send the signal to tell the flash to fire. There is no through-the-lens metering. Get a Hama three-way

flash connector (or another brand) to complete the wiring system.

The three-way flash connector may be stocked by large camera stores that sell plenty of flash equipment. We use Hama (www.hama.de) three-way flash connectors, but other brands exist. The three-way flash connector actually has four connectors, three female and one male, but only three flashes are wired to it. The fourth connector is used to wire the three-way flash connector to the camera with a PC extension cord that has a male connector on one end and a female connector on the other end. If you have trouble finding them, search the web for "three-way flash connector."

Wiring the flashes together completely eliminates the problem of having other photographers accidently fire your flash units. Once you buy the correct PC wires and three-way flash connector, it's simple to connect them with wires. The PC extension cords you need are not widely stocked for Canon flashes, so you may have to special order them at a large camera store or by calling B & H Photo in New York at (800) 947-9953. Most PC extension cords sold at local camera stores

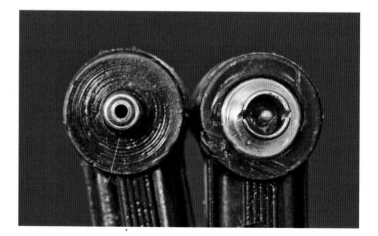

Wiring a single flash to the camera or multiple flashes together is fairly easy, inexpensive, and usually reliable. Save yourself a lot of trouble by learning to immediately recognize the female and male terminals. In this image, the female terminal (small hole in the middle of it) is on the left and the male terminal (pin in the middle of it) is on the right. Also check the sync terminals on your flash and camera if they have them. For example, the PC terminals on both my Canon 7D and the Canon 580 II flash are females. They require a male PC terminal to connect to them.

have a male connection on one end of the cord and a female connection on the other end. The male end has a small pin in the middle of the connector that inserts into the central hole of the female end. To wire Canon flashes together with a three-way flash connector, you must have PC extension cords that have male connections on *both* ends!

Here's what you need to wire three Canon 580 II flashes together:

- 3 approx. 8-foot PC extension cords that have male connectors on both ends;
- 1 8-foot PC extension cord with a female connector on one end and a male connector on the other;
- 1 three-way flash connector (this tiny device has three female connections and one male connection).

By the way, if you wish to wire four or five flashes together, attach two three-way flash connectors together. Now you have five female connections and a lone male connector.

Wire everything together by first taking the three PC extension cords with male connectors on both ends. Attach one end of each cord to the female PC connection terminal on the flash. Now attach the other end of the PC extension cord to the female connector on the three-way flash connector. Once all three flashes are wired directly to the three-way flash connector, take the fourth PC extension cord that has both a male and female end and attach the female end to the lone male connection on the three-way flash connector. Now attach the male end to the camera's female PC terminal. All three flashes are now wired directly to the camera and will fire simultaneously when you fire the camera.

This system isn't foolproof because there are so many connections. Sometimes you must twist the connections to make every flash fire. Solving connector problems can be touchy at times, but it does work reliably when you get it just right. Other photographers using flash do not affect your wired flash units. You don't have to worry about line-of-sight problems that sometimes trouble wireless signals. However, you must be diligent about making sure all of the flashes continue to fire during your photo session. For any number of reasons, a flash may stop firing part way through the photo session. Be

alert to this potential problem. We do wire our flashes together quite often with fairly good success.

Wireless Flash

This is by far the easiest way to use a single or multiple flash set-up. A good wireless system permits through-the-lens automatic metering, control over the power output of the flashes, and other features. Read your camera and flash manual to determine your options.

Most Nikon cameras offer built-in wireless flash control with their dedicated flash units. If your Nikon camera has a pop-up flash, you probably have wireless control, as long as you use modern Nikon flashes. Go into a menu in the camera to set the pop-up flash to the Commander mode. Then the external flash must be set to remote. If your Nikon camera doesn't have a pop-up flash, you can buy a separate Nikon SU-800 Wireless Speedlight Commander Unit that inserts into the hot shoe of the camera body to acquire wireless control.

Canon has only recently built-in wireless flash control into their cameras, such as the EOS 7D and the EOS 60D. Both cameras send the wireless signal through the pop-up flash. Hopefully, all future Canon cameras will have wireless flash control built-in. Canon is well aware of the benefits of wireless flash. The Canon Speedlight Transmitter ST-E2 that attaches to the hot shoe of the camera has been available for years. The ST-E2 is the "master" flash controller. Set your Canon flash to "slave." Now the camera can directly control the flash without wires.

Using wireless Nikon and Canon flash systems is our favorite way to use one or more flash units in our wildlife photography. Being able to avoid wires that get in the way, take time to attach, fail all too often when connected, and blow in the wind are enormous advantages. Wireless systems are exceptionally dependable. However, signals emitted by the master (commander) can be blocked, preventing one or more flashes from firing. Carefully check how you set up everything and test your flashes to make sure each and every one is firing. Most of the time, wireless flash works on the first try if everything is set properly.

Channels

While teaching a fall color workshop, three bright and eager students were working together to learn how to use their new Canon 580 II flash and the ST-E2 flash controller. I showed them how to set their Canon 580 II flash to slave and then walked around a bush to help another participant. Soon I heard all three students talking excitedly, so I quickly returned to them. As I walked into sight, I saw one student peering into the flash tube just as it fired a blinding burst of light directly into his eyes. They discovered that all three flashes fired any time one of them tripped their camera. Do you know the reason? Since all three of the students were using the identical wireless flash system, the signal from any ST-E2 flash controller fired every flash simultaneously. A wireless master unit will fire every slave flash that detects the signal, no matter if it is one flash or 50. For this reason, wireless flash systems provide channel choices. All three of the Canon 580 II flashes were set on channel one. The problem was solved by setting each Master/Slave combination to a different channel. If you find your wireless flash isn't firing, always make sure both the flash and the controller are set to the same channel.

Radio Controls

Many companies, such as Pocket Wizard and Hahnel, build radio-controlled flash triggers. These are more expensive than flash triggers that use infrared signals. However, they are more reliable and work over much greater distances. Many serious flash photographers use these radio triggers with excellent success. However, as we have enjoyed such good success with infrared triggers, we have never felt a compelling reason to upgrade to radio triggers and spend a lot more money. I suspect future flashes will have built-in radio controls, which could make third-party ones unnecessary.

Radio control triggers come in two major types. Some are manual triggers and others provide for through-the-lens metering. Manual radio triggers tell the flash to fire, but don't offer through-the-lens metering, flash exposure compensation, setting flash ratios, and other features. Only automatic radio flash triggers offer these features.

POWER RATIO CONSIDERATIONS

If you use manual flash, power ratios become enormously useful. With the flash set to manual, the camera sends a signal to the flash either wirelessly or through a wire to fire the flash. The flash fires the energy stored in the capacitor and then takes a few to several seconds, called the recycle time, to restore the energy in the capacitor to full power again. Alas, you can't shoot another well-exposed image until it is fully recycled. Using the entire charge in the capacitor drains the batteries quicker, too.

Since most wildlife photographers use flash far from AC power, batteries must be used (or a portable generator). It is easy enough to have extra fully-charged batteries on hand to solve the power issue, but that doesn't solve the recycle problem. We use fully-charged rechargeable AA batteries in our flashes. To avoid using the battery power faster than necessary, and to speed up the recycle time, we often set the power ratio on the flash to 1/4 or 1/8 power. If the flash is only a few feet away from the subject, this reduced light output is often more than adequate. We set our reduced power ratios on the flash directly, but many cameras, including some of ours, allow you to set it in the camera when using automatic flash.

HOW THE FLASH REDUCES THE OUTPUT

The method the flash uses to reduce its output is critically important in many wildlife photo situations. At full power, the flash duration is around 1/700 to 1/1000 second. This means the light from the flash only burns during this short period of time. If all of the light illuminating the subject is from the flash, and it is only on for 1/1000 second, essentially the effective shutter speed is 1/1000 second. This is true even if the camera's X-sync speed is a relatively slow 1/200 second. If you set the flash to 1/4 power, the amount of time the flash emits light (flash duration) shortens to perhaps 1/4000 second and the recycle time is much quicker. Therefore, the reduced power ratio makes batteries last longer, shortens the recycle time, and freezes action better.

Power ratios are the key to freezing rapidly moving subjects such as bats and hummingbirds in flight. At the 1/16 power

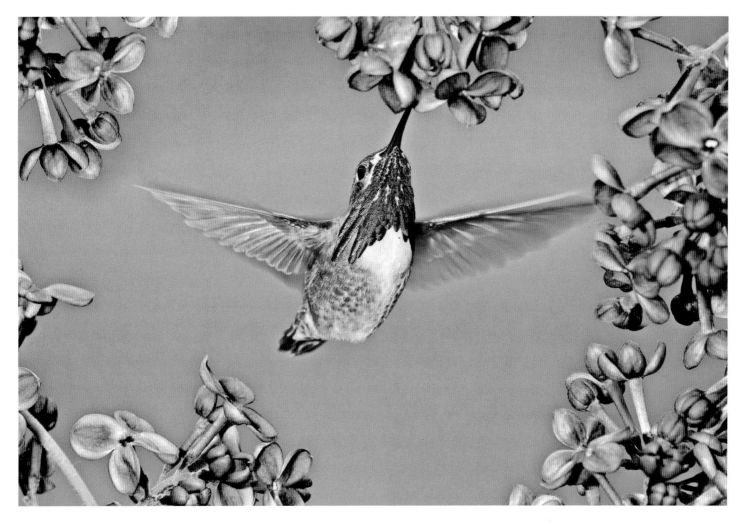

Calliope hummingbirds are abundant at the Bull River Guest Ranch in British Columbia. The Nikon 200-400mm f/4 zoom lens and a minimum of three (we sometimes use up to six) Nikon SB 800 flash units comprise an excellent setup for freezing hummingbirds in flight. Nikon D3, 200-400mm f/4.0 lens, f/22 at 1/200 second, ISO 160, and four Nikon SB-800 flashes set to 1/16 power and zoomed out to 105mm.

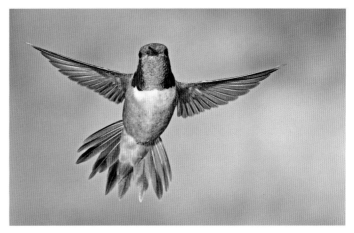

The wings of this rufous hummingbird are easy to freeze by using flash at weak power ratios. No available light appears in this image. All of the light is from my Canon flashes that are only on for approximately 1/10,000 second. Even though the shutter speed is set to the fastest sync speed the camera offers—1/250 second—the effective shutter speed becomes the much shorter flash duration. Canon 1D Mark III, 300mm f/4.0L, f/16 at 1/250 second, ISO 125, manual metering. Four Canon 580 II flashes are used manually and set to 1/16 power.

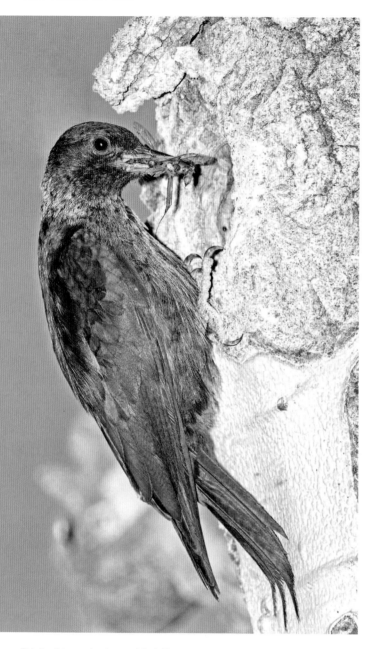

This Lewis's woodpecker was dimly illuminated in the shaded forest. However, the sky background is nicely lit up with sunlight. The available light exposure was set to slightly underexpose the blue sky. A +1-stop flash compensation was required to properly expose the bird and the nest tree. To summarize, the foreground is illuminated entirely with flash and the background is all available light. Mixing flash with available light is a crucial skill all good wildlife photographers must master and use frequently. Canon EOS-7D, Canon 500mm f/4.0L lens, f/14 at 1/200 second, ISO 200, manual metering with automatic flash set to a +1-stop exposure compensation.

ratio, many flashes have a flash duration less than 1/10,000 second. This easily freezes most action. We routinely use the 1/16 power ratio to freeze the rapidly beating wings of the hummingbirds we photograph in British Columbia, Idaho, and Ecuador. We would love to provide the details of how we do hummingbirds, but the information that must be covered is enough to fill a book all by itself.

DEVELOPING YOUR FLASH SKILLS: SUMMARY

Flash is incredibly useful, but it does take effort and time to fully master. You must learn the terms used in flash photography and become comfortable with the equipment. Learn where every setting is on your flash and what it does. When flash is used well, it doesn't look like the typical obvious flash image with flat light on the subject and a black background. Used properly and creatively, flash lets you capture fine images that aren't possible with available light only.

Accomplished flash users easily mix one or more flashes together and usually use available light for a portion of the exposure, too. It really isn't that difficult to mix flash with available light if you remember the following key points.

1 The ISO affects both the flash and the available light exposure. Increasing the ISO amplifies the sensor signal and moves the histogram data to the right. Lowering the ISO reduces the exposure and histogram data moves to the left. This relationship assumes, of course, that the f-stop and shutter speed remain the same.

2 Apertures affect both flash and the available light exposure. As an example, stopping down from f/11 to f/22 subtracts two stops of light from the exposure. Of course, this assumes manual metering. Automatic exposure modes change the shutter speed to compensate for the change in aperture to maintain the original exposure.

3 Shutter speeds affect *only the available light exposure*—not the flash. The typical flash at full power has a flash duration around 1/800 second. Since you are limited to the X-sync speed of the camera, typically 1/250 second, all of the light emitted from the flash hits the subject during a tiny portion of this 1/250 second shutter speed. Therefore, no matter what shutter speed you use between the

longest one your camera offers (30 seconds perhaps) and the X-sync speed, all of the light emitted from the flash that strikes the subject is measured by the imaging sensor. Therefore, use the aperture or ISO to adjust the flash exposure. *Use the shutter speed to control the available light.* If you commit this to memory, it's easy to mix flash and available light together to greatly improve the light in your images.

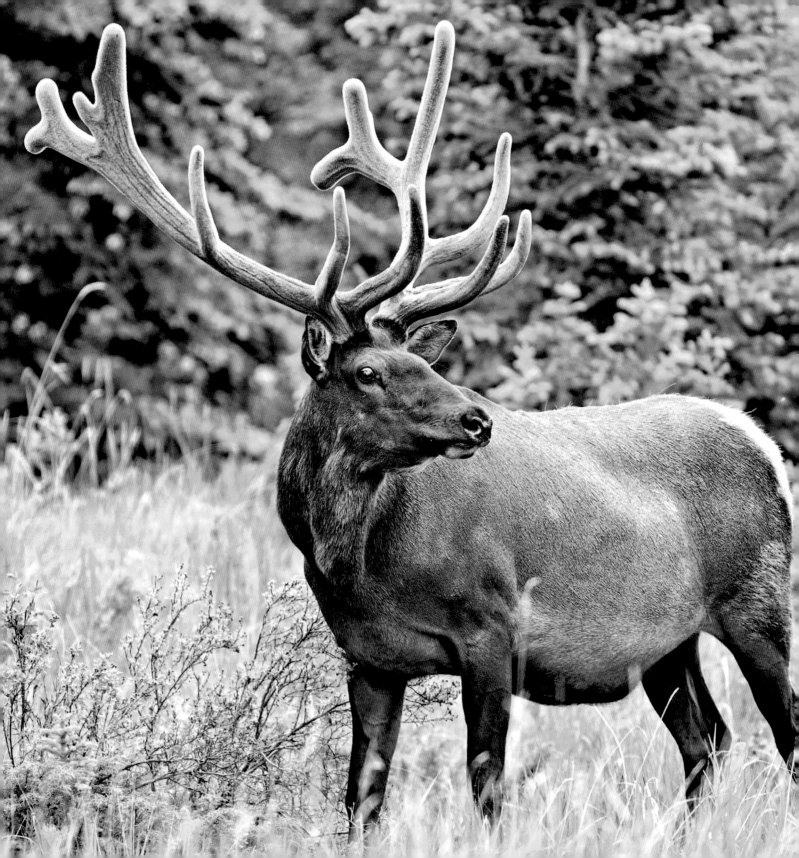

9

Getting Close to Wildlife

Getting within excellent photography range of wildlife can vary from incredibly easy to virtually impossible. Your ability to approach closely depends on many factors. Some species like pine grosbeaks and chickadees are unafraid of humans. Hawks and eagles are usually skittish and quick to flee. Location matters a lot, too. Bald eagles are not easy to get close to in northern Michigan, but on the spit in Homer, AK, some individuals are as easy to approach as pigeons in a city park. Time of the year matters since many birds and mammals are easier to get close to in winter when they are focused on eating and staying warm. Naturally, many animals are easy to approach—not that you should—when they are nesting. Occasionally, an individual of a normally nervous species accepts your presence for unknown reasons. Golden plovers tend to spook easily, but during the fall migration, we sometimes find an individual resting on a Lake Superior beach that ignores our presence. How you act around wildlife matters a great deal. Photographers who talk all of the time, bang things around, and continually make quick movements have an incredibly difficult time approaching wildlife. Once you master the mechanics of shooting fine images—exposure, focusing, light, composition—approaching wildlife closely enough to photograph is the major challenge you must continually solve.

USE CAPTIVE ANIMALS TO MASTER YOUR SHOOTING SKILLS

This book covers wildlife photography which assumes the animals are free to move about in their natural environment. Nevertheless, it's

LEFT: Jasper National Park is known for hosting a large number and variety of big animals like this magnificent bull elk in velvet. Barbara used her favorite lens to photograph this fine fellow over two hours. Since elk are not hunted in the park, this bull elk never paid any attention to her at all. Eventually, it wandered into a dense swamp where she could no longer see it. Nikon D3, Nikon 200-400mm f/4.0 lens, f/8 at 1/320 second, ISO 500, and Shutter-priority with a +1/3-stop exposure compensation.

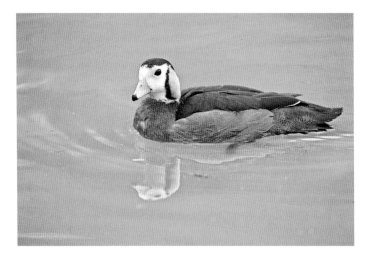

The African pygmy-goose is a captive resident of the Sylvan Heights Waterfowl Park in North Carolina. This superb facility hosts the largest collection of ducks in the world that is open to the public. It is a splendid place to capture many fine images and perfect your photo skills. Canon EOS 5D Mark II, Canon 500mm f/4.0L lens, f/5.6 at 1/800 second, ISO 640, and manual metering.

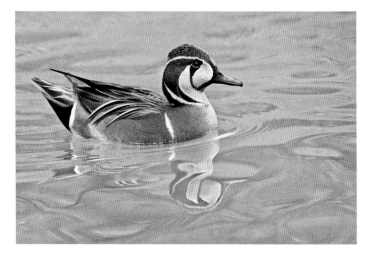

This Baikal teal is a gorgeous member of the teal family that is on display at the Sylvan Heights Waterfowl Park. Canon 5D Mark II, Canon 500mm f/4.0L lens, f/6.3 at 1/500 second, ISO 800, and manual metering.

difficult to learn how to quickly focus, expose, and compose wildlife images unless you photograph a lot. Therefore, it's worthwhile to take advantage of the captive wildlife that you find at zoological parks. In the past, most zoo enclosures were not especially favorable for good photography due to fences and obvious man-made habitats with cement floors. Now many zoos display their animals in more natural-looking settings. Digital cameras handle the light at the typical zoo quite well. Zoos have plenty of buildings, tall trees, and bushes to landscape the facility and provide shade for the animals and human visitors. These obstacles block early morning and late evening sun, making it difficult to photograph the animals in golden sunshine. Once the sun rises high in the sky, the shadows created by bright sun and obstacles make it almost impossible for a single digital image to adequately record detail in both the sunlit highlights and the darkest shadows. This contrast is difficult to effectively conquer, though fill-flash (if permitted) can help. On cloudy days, the contrast problem largely disappears. However, water droplets in the clouds easily scatter much of the blue portion of the available light, producing a blue color-cast in images. If an abundance of green leaves are near the subject, an unwanted green color-

cast from the foliage adds to the mix. This dreadful blue-green colorcast is undesirable, but easily controlled by using Auto WB, a Custom WB, or shooting RAW images and adjusting the colors later in the RAW converter. Although clouds, bushes, trees, and buildings diminish the amount of available light, being able to use higher ISOs allows the use of faster shutter speeds for sharp images. Bright overcast days at the zoo are superb for digital capture and it is easy to shoot fine images of many captive animals.

SMALL ANIMALS

We haven't photographed at zoological parks very often in the past, but plan to do more after our incredible experience at the Sylvan Heights Waterfowl Park (www.shwpark.com) in North Carolina during April of 2011. This exquisite park showcases the largest public waterfowl collection in the world. They offer several display ponds with high nets over the top to keep the birds from flying away. Special gates allow you to go inside the display pond enclosures. Therefore, there are no wire fences between you and the waterfowl to shoot through. There are separate display ponds for North

America, Eurasia, Africa, South America, and Australia. The corresponding pond for each continent displays a huge variety of waterfowl from that continent. Imagine having almost all species of North American ducks swimming closely in front of you during a short period of time. The same is true for each of the other display ponds for the other continents.

Having a keen interest in the waterfowl, it's exciting to see and photograph living individuals of species we had only seen in field guides before. We already have tons of photo experience, but we did improve our camera skills by shooting 25,000 images during four full days at the park. Our digital cameras offer us some new controls over focusing and much better image quality at ISO 800 than previous models. We used manual metering, back-button focusing, and continuous autofocus. The multi-controller button on the back of my Canon camera worked perfectly to rapidly select a single AF point that coincided with the face of the swimming ducks. The Wimberley Sidekicks mounted on our Kirk BH-1 ball heads let us easily pan with the ducks as they paddled by. Our percentage of sharp images (precise focus on the face of the bird and crisp feather detail) is quite high—at least 50 percent—which is quite good, considering the ducks are constantly moving.

Anyone who intensely photographs the waterfowl at the park over a few days and shoots thousands of images there will certainly improve their camera handling techniques as well as capturing many fine images. You will get far more opportunities to photograph the waterfowl at this park in a few days than you will with wild waterfowl over many years. The skills you perfect photographing captive animals can now and forever be used to successfully photograph wild animals. However, if your images of captive animals are published, always tell the publisher they are captive. Images of captive animals are published all of the time, but it is highly unethical to pass off a captive animal as one done in the wild. Always disclose the animal is captive!

APPROACHING WILDLIFE

FIND HABITUATED WILDLIFE

Wildlife accustomed to humans being close to them are often referred to as "habituated wildlife." They are commonly found where people tend to spend their time. Plenty of city and state parks host easily photographed squirrels, deer, Canada geese, robins, and other creatures. For example, during late winter, Santee Lakes near San Diego, CA, is known as a superb place to photograph wild ring-necked and wood ducks. Conveniently, the park even sells food to feed the birds. The ducks readily fly over to you and almost eat out of your hand. These are wild ducks that use the park as a wintering site. Over time, they learn people have food and will feed them. They readily approach photographers who feed them.

Many countries have national parks that have protected wildlife for decades. As a result, the wildlife in these parks are unafraid of people. Yellowstone National Park, where we live, is especially productive for wildlife photographers. Bison, mule deer, coyote, elk, bighorn sheep, yellow-bellied marmots, ground squirrels, pronghorn, and other animals are easy to photograph if you look for them in the proper habitat during

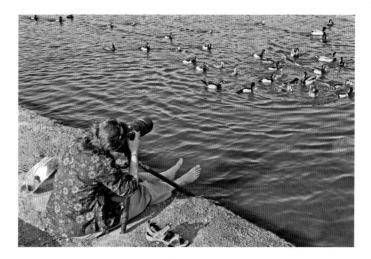

Santee Lakes is east of San Diego, CA, and it is a well-known spot to easily photograph some wintering waterfowl. Barbara is using bread to keep the birds close. Most of the ducks are ring-necked, but a few mallards and wood ducks have joined them. Canon EOS-5D Mark II, Canon 17-40mm lens at 40mm, f/13 at 1/200 second, ISO 400, and manual metering.

Many wild wood duck are habituated to people who feed them at Santee Lakes. This makes them easy to photograph well. We did not try to photograph this dandy drake wood duck until it was lit with golden late evening sunshine. The calm water improved the reflection details. Canon 5D Mark II, Canon 500mm f/4.0L lens, f/9 at 1/500 second, ISO 400, and manual metering.

the seasons when they are active. Marmots and ground squirrels hibernate during winter, for example. If you are lucky, it is possible to photograph black bears, grizzly bears, and wolves. In Yellowstone, though, it is illegal to approach any wildlife closer than 25 yards, and you must stay 100 yards away from bears and wolves for your protection and theirs.

Beaches are natural magnets for both people and wildlife. Many shorebirds, herons, egrets, gulls, terns, and other birds are attracted to beaches for resting or gathering food. Since people frequently stroll along the beach, beach-loving birds become accustomed to them. Often, they become ridiculously easy to approach without alarming them. Even boat launching sites and fish cleaning stations attract wildlife that quickly become habituated to us.

STALKING

Many animals are easily photographed if you carefully stalk them. Start by locating the subject from a distance and carefully plan your route for approaching the subject. Normally, it's best to approach the subject from the direction where the light illuminates the subject best. This eliminates the need to

Columbian ground squirrels are both attractive and cooperative. This one along the Icefield Parkway on the way to Jasper National Park loved to pick wildflowers and then return to this spot to eat its prize. Canon EOS-5D Mark II, Canon 500mm f/4.0L lens, f/7.1 at 1/250 second, ISO 500, and manual exposure.

make movements to improve the light when you are in position to photograph the subject, reducing the risk of scaring it away. This isn't always possible, though, as trees, fences, rocks, and water might block your route. Do the best you can.

Once you decide on your stalking route, start slowly and stay low to the ground. Bending over, or even crawling for the physically able and more motivated of us, makes you less scary to the subject. Since you appear to be smaller, the subject is less likely to flee. Never talk and keep other noises, such as breaking sticks while walking, to a minimum. Predators rush in quickly to capture prey, so always move slowly. Never move your hands, arms, or turn your head quickly. If the subject begins to react to your approach, freeze, and let it settle down. If the subject begins to leave, let it go. If you quickly follow after it, the animal will probably think you are after it—you are—and will rapidly disappear.

Whenever possible, give yourself plenty of time to approach the subject. If it will photograph best during the last hour of the evening sun, start the approach an hour earlier. This strategy allows plenty of time to slowly approach the subject closely to photograph it successfully. If all goes as planned, the subject will be accustomed to you when the light is the

most photogenic. Although mud, water, and plants might make it difficult, crawling slowly up to the subject is often the most effective way to stalk it. I stalk by crawling when the situation makes it possible because it works best and the low photography viewpoint creates compelling images as the foreground and background are rendered far out of focus.

Male sage grouse gather together in April on historic leks to display their dancing skills to hens who wander about the dancing ground deciding who will be the best suitor. They begin dancing at least one hour before sunrise, so it is important to be well hidden in a blind and remain quiet when they converge on the lek in front of you. Nikon D3, Nikon 200-400 f/4.0, f/8 at 1/250 second, ISO 400, and manual exposure.

Even better, if you can shoot up at the subject ever so slightly, that is an even more unusual and appealing viewpoint of a ground-dwelling animal.

Many photographers wear camouflage clothing for wildlife photography. Although I have camouflage clothing, I prefer to wear neutral brown, green, or gray colored clothes, especially when other people are present. Photographers who dress up in camouflage tend to draw undesirable attention to themselves. There is little reward in successfully stalking a great-blue heron, begin shooting images, and have it frightened away by another person running up to you to ask, "Are you a professional photographer?" Animals are quick to notice

anything unusual in their environment. Their life depends on it. Don't assume camouflage clothing will make you invisible to them. Some wildlife photographers buy camouflage covers for their equipment. It does seem reasonable to cover a white Canon telephoto lens with a camouflage cover to make it less noticeable and less alarming to the subject. Even if covering the lens doesn't alarm the subject less, at least the lens is protected better. These covers can be found at www.lenscoat.com.

BLINDS

We have designed and used many blinds (hides) over the decades. A camouflage blind hides you from wildlife quite effectively. Animals know the blind is there, but if they don't see or hear you inside the blind, often they will approach closely enough to permit you to capture excellent images. If possible, it is always best to put the blind in place a day or two ahead of time to let the animals get used to it. For example, when photographing birds in our back yard, I erect the blind near the seed feeder or water lure and don't try to do any photography from it for at least a day. In a day or two, most birds and backyard mammals accept the blind as a natural object and largely ignore it. Wind is an ever-present problem for blinds. Stake the blind down solidly to prevent it from being blown over.

The blind covering must be thick enough to make it impossible for the subject to see you move inside it. Animals are quick to react to unexpected motion and noise. Both must be avoided at all times. Of course, thick material can make it hot inside the blind. Wear clothes that make sense for the weather. We know some photographers who use blinds in hot desert temperatures who wear only shorts and use a bucket of water and sponge to stay cool.

Barbara and I especially enjoy using blinds in our wildlife photography. It's fascinating to watch the behavior of wildlife that are unaware of us. It's particularly fun when normally shy subjects, such as prairie chickens, approach the blind and dance while completely unaware that we are 10 feet away. However, photographing from blinds isn't for everyone. If you prefer to continually move on, and not be anchored to one spot, immobile blinds are not for you.

When using a blind, always carefully consider where you put it. What will be the background? Is the background a nicely out-of-focus forest 40 yards behind the subject or a twiggy bush 2 feet behind it? The twiggy bush makes a horrible background as the branches create many distracting lines. Selecting a more diffuse background that is farther away from the subject is a better choice. Consider the light! Normally bright sun behind the subject or off to one side doesn't work nearly as well as more frontal sunlight because the contrast is too severe. On the other hand, if the sun is diffused by clouds, then any direction can work well. Indeed, we often use the soft backlighting on an overcast day for wildlife photography. The backlight rims the subject slightly, yet the low contrast light nicely illuminates the side of the subject facing the camera.

TYPES OF BLINDS

BAG BLINDS

Barbara makes these simple blinds from a large piece of camouflage material that can completely cover one person, the tripod, and lens when they are standing up. The blind has no frame. Instead, your head holds it up and the material drapes down over you and your camera gear in an irregular fashion. Often we use a small chair to sit on while inside this blind. At the appropriate spot, Barbara sews a nurse's sleeve into the blind with a drawstring on the end. This lets the lens protrude from the blind and the draw string securely fastens the nurse's sleeve to the lens hood. This hides most of the lens and prevents the material from accidently covering the front of the lens. A viewing window (6 × 8 inches in size) a few inches above the nurse's sleeve is cut into the blind and covered with a thin mesh material. Now it is easy to see what is in front of us, yet the mesh covering prevents the animal from seeing us. Don't make the mistake of thinking you can use your lens to see what is in front of you. It is far too difficult, especially with telephoto lenses, due to their narrow field of view.

The bag blind is lightweight, quick to use, easy to carry, and effectively blends in with the environment because it has no regular shape as it drapes down over the photographer. We use it when we are short of time or can't set up a permanent blind because it might attract unwanted attention from other people. We typically use bag blinds when photographing dancing sage grouse, sharp-tailed grouse, and prairie chickens.

MANUFACTURED BLINDS

Many companies build blinds for hunters that work tremendously well for photography, too. These are effective any time you can safely set it up and leave it unattended for a while to allow animals to become accustomed to it. Most of our backyard animal photography is done with a blind that has a thick camouflage cover that attaches to a stiff wire frame to hold its shape. The blind is solidly staked down to the ground to keep the wind from blowing it over or sending it aloft.

The large stores that cater to hunters like Cabela's, Bass Pro Shop, Sportsman's Warehouse, and Gander Mountain sell

This is the blind we used at Bill Forbes', "The Pond," property south of Tucson, Arizona. Similar blinds can be purchased at any large store that caters to hunters. Canon EOS-5D Mark II, Canon 17-40/4 lens, f/20 at 1/160 second, ISO 320, and manual metering.

blinds that work perfectly for wildlife photography. I bought a Trekker T600B hunting blind from Cabela's in Boise, ID, for a little more than $100. The blind sets up in seconds, offers a few zippered windows for your lens to poke through, and provides mesh windows for you to easily view the scene before you. Many loops are attached to the base of the blind to make it easy to stake it to the ground. Otherwise, the first 10 mph breeze turns it into a kite.

The zippered viewing windows are especially useful. Most photographers poke the lens out the window when photographing and zip up the window somewhat loosely around the lens. This means animals may see the lens move as you change from one composition to another. It's best to move the lens s-l-o-w-l-y to avoid scaring the subject. The birds I was photographing last spring were especially flighty if the lens moved, so I tried another strategy for the first time that worked surprisingly well. The Trekker T600B hunting blind has large zippered windows and plenty of room inside it for a single photographer and their equipment. To avoid the lens movement problem, I unzipped the window entirely, moved the tripod away from the window until the lens no longer protruded from it, and photographed very effectively without scaring any birds. Since I had a large open window to shoot through, I could change my shooting angle without having the blind block the view. Although the window is wide open, the birds failed to see me inside the dark blind. Since the lens is entirely inside the blind, I could quickly move the lens up, down, left, or right without alarming the nervous birds. As long as I kept my movement to a minimum inside the blind and didn't make any noise, the birds were completely unaware of me. Not all animals are afraid of a moving lens, though. In times past, I have had sharp-tailed grouse, spotted sandpipers, black-capped chickadees, and pine siskens perch on the lens hood. They remained on the lens even when I panned the lens.

This type of blind is easy and quick to set up, but not as quickly as the bag blind. It is most effective when it is possible to leave the blind in place for a day or two to let the subjects become accustomed to it. Unfortunately, any blind that is left

unattended and discovered by other humans may be stolen. I have lost a few over the years to theft, so I only use blinds that will sometimes be unattended in my yard and in the nearby national forest where I know people seldom venture.

SCAFFOLDING

Both bag blinds and portable manufactured blinds work well on top of construction scaffolding. We own two sections of scaffolding and use it for photographing the nesting woodpeckers on our property and sometimes for birds that are attracted to our seed feeders. We recently used scaffolding to photograph both common flickers and Lewis's woodpeckers with great success. Why do we sometimes use the scaffolding at seed feeders? We have a group of three spruce trees that are about 12 feet tall. If we put the seed feeder 3 feet above the ground and 4 feet in front of the trees, the birds will descend to eat the seeds. However, we aren't interested in photographing the birds perched on the seed feeder. We want them perched on the spruce branches. While the birds will briefly perch on the branches right behind the feeder, they are quick to move to the seed feeder. Birds that perch near the top of the tree stay in one spot much longer than near the feeder. By using the scaffolding, we can photograph higher up and successfully photograph those birds that are calmly perched near the tops of the trees.

Each section of scaffolding raises you about 5 feet above the ground. Two sections used together, of course, get you 10 feet up. Plus, when sitting in a chair on top of the scaffolding platform, you gain another 3 feet of elevation. Therefore, two sections of scaffolding will get you to eye-level with a subject that is 13 feet above the ground. If you decide to use scaffolding, make sure you get four leveling feet for the scaffolding. These feet allow you to level the scaffolding on the typical sloping ground you find in wildlife photography. Two sections of scaffolding is the highest we go. Three or more sections become top-heavy and unstable. Wires are necessary to secure it if you use more than two sections. This is more work than we want and neither of us is especially fond of heights.

PERMANENT BLINDS

This can be a simple or elaborate structure that is built at a good photography spot and not meant to be moved. The first permanent blind I ever built was early in my nature photography career when I lived in a tiny cabin in the forest of northern Michigan. The back door of the cabin faced north and the background was a mixture of beech, maple, and conifer trees about 40 yards away. At the time, in the early 1980s, I was shooting film, so it was best to shoot north to allow the sunlight to light the front of the subject. Now that higher ISOs on digital cameras can be successfully used, the direction you photograph doesn't matter as much, especially when using wonderful bright overcast light.

I built a small porch out of 2 × 4s and plywood. The blind was built flush with the cabin wall, had one door to give me access to the backyard, and a single window to let me photograph due north. Of course, I didn't actually install a window. Instead, I covered the opening with a mesh camouflage material that let me easily view the entire backyard, but made it impossible for the birds to see me inside the dark porch. A small opening cut in the mesh fabric allowed the lens to poke through it. This blind worked fabulously well. I easily photographed evening grosbeaks, common redpolls, blue jays, hairy woodpeckers, downy woodpeckers, and pine grosbeaks that were attracted to the sunflower seeds and suet (beef fat) I provided. Birds typically visit in large masses at once. Most of the time few birds were present. At times, though, the feeders were crowded with birds of several species. By attaching the permanent blind to the back door of the cabin, I could remain inside the cabin typing my next photo article or editing images. However, I checked the bird activity in my backyard quite often. When the birds arrived, I quietly opened the back door to the cabin to enter the blind without scaring the birds. Since the lens was already mounted in the blind, I could immediately begin photographing the birds. When they moved on, I returned to my office work. Being able to enter your blind at any time without scaring the subjects is an incredibly effective way to photograph!

A word of warning. Some photographers use their home as a blind and photograph through the windows. I tried this a few

Here's the view from the pit blind we used in South Texas at the Marten Refuge. When in the blind, we are able to shoot while sitting in a comfortable chair with a viewpoint only a few inches above the ground. The opposite side of the pond is carefully lined with rocks to offer mirror reflections of the birds that visit it. Seeds, meal worms, and fruit are hidden behind the logs to attract wildlife. Notice the green jay and chachalaca perched on the log. Canon EOS-1Ds, 24-70mm lens at 30mm, f/11 at 1/30 second, ISO 250, and manual metering.

Green jays are common in Mexico, but barely make it across the US border near Brownsville, Texas. We especially enjoyed photographing it because it is colorful and a new species to us. Canon EOS-1Ds Mark II, Canon 500mm f/4.0L, f/5.6 at 1/250 second, ISO 320, and manual metering.

times and the results were horrific. I ended up selecting all of the images and then hit delete. None of the images were as sharp as they should be. Window glass isn't quality optical glass. For my professional needs, the images are too unsharp to be useful. If the sharpness is okay to you, then go ahead and shoot through windows. But, you lose a lot of quality. It's always best to shoot through open windows. Naturally, take the screens out of the window ahead of time.

At our Idaho mountain home, we have one sliding window that we never put a screen in. We keep a salt block in the natural grasses and wildflowers about 20 yards from the window. When white-tailed deer, mule deer, or moose come to lick the salt block, we quietly slide the window open and use our long zoom lenses to photograph the animal and it is completely unaware of our presence. Since we never know when a subject will visit the salt block, keeping the screen out of the window makes it possible to be ready when a handsome

Bill Forbes' small man-made pond in southern Arizona is a magnet for at least two dozen species of birds and mammals. The water and the seeds he provides keep this spot busy. Notice the cactus props are in wheelbarrows to make them easy to move around. The flashes fastened to sticks in the pond are used to photograph drinking bats at night. Unfortunately, when we visited, few bats were around and we had little success as it was too early in the spring season. To rent time at this spot, go to www.phototrap.com. Canon EOS-5D Mark II, Canon 17-40mm lens at 40mm, f/20 at 1/60 second, ISO 320, and manual metering.

creature shows up. We keep the curtain closed in this window all of the time to prevent the subject from noticing us through the window. We simply move the curtain a tiny bit to let the lens poke through the open window to photograph.

The most elaborate permanent blinds we have used are in South Texas. A number of ranches dig pit blinds that make it possible to photograph wildlife at eye level, since the lens is only a few inches above the ground. These elaborate blinds are well-made, comfortable, and highly effective. Usually, a small pond is built in front of the blind and feeders are stocked each day to keep the wildlife coming in regularly. These blinds are rented to wildlife photographers by the half-day, day, or longer. The ponds are set up to entice the animal to face the camera. The far edge of the pond is lined with natural-looking rocks, sand, or branches. This is a good way to capture mirror reflections of the subjects. These rentable blinds are quite popular in South Texas because there are many unique birds such as green jays that barely extend their range across the US border from Mexico. Try visiting www.martinrefuge.com to discover one South Texas ranch where we enjoyed excellent wildlife photography.

Another superb set-up that you can rent is in the Sonoran Desert south of Green Valley, AZ. It is called "The Pond." Bill Forbes is the mastermind behind this fine set-up. Water is in short supply in the desert, so the pond acts as a magnet to many desert birds and mammals. Desert cottontail rabbits, antelope ground squirrels, Gambel's quail, white-wing doves, mourning doves, northern cardinals, greater roadrunners, and other desert birds are attracted to the water and seeds Bill provides for them. Contact Bill at www.phototrap.com.

WATER BLINDS

Approaching wildlife from the water is incredibly effective. Many wildlife photographers construct a floating blind that resembles a muskrat house. Thanks to my dentist, Alan Charnley, who is a master at building these types of blinds, we have one, too. Our fourth-generation "Charnley Blind" is made out of a large sheet of Styrofoam and encased in thin boards to keep it all together. A camouflage blind is attached

to the floating platform. The photographer wears chest waders and slips through a hole in the middle of the floating blind. A gimbal tripod head (a Kirk Cobra in our case) is attached to the front of the blind at a comfortable distance from the hole the photographer occupies. Then a long lens in the 500mm to 800mm range is attached to the gimbal head. With great care, the photographer slips into the blind through the hole that is just large enough for their waist and crawls to deeper water. The blind easily supports and floats the photographer and all of the gear inside the blind. It is incredibly stable and not tippy as the center of gravity is low. The floating blind works best in shallow water from 2–4 feet because you can use your feet to walk along the bottom of the marsh. It is possible to awkwardly swim slowly in the blind, though we try to avoid that.

We use our floating blind extensively during the spring and summer. Some birds do notice it and swim away, while others accept its slow approach and allow us to photograph them from very close distances. Using this blind we have enjoyed wonderful times with red-necked grebes, ring-necked ducks, Forster's terns, and especially ruddy ducks. During one calm morning that offered perfect mirror-reflections, I had six male ruddy ducks dancing within 15 feet for the attention of a single lady ruddy duck.

This Forster's tern attacked me vigorously when I unknowingly wandered into its nesting territory while paddling my kayak along the edge of a nearby lake. I paddled fast to make a hasty retreat. The floating "Charnley" blind we use proved to be completely acceptable to them and they did not react to it at all. Canon EOS-7D, 500mm f/4.0L, f/5.6 at 1/800 second, ISO 640, and manual metering.

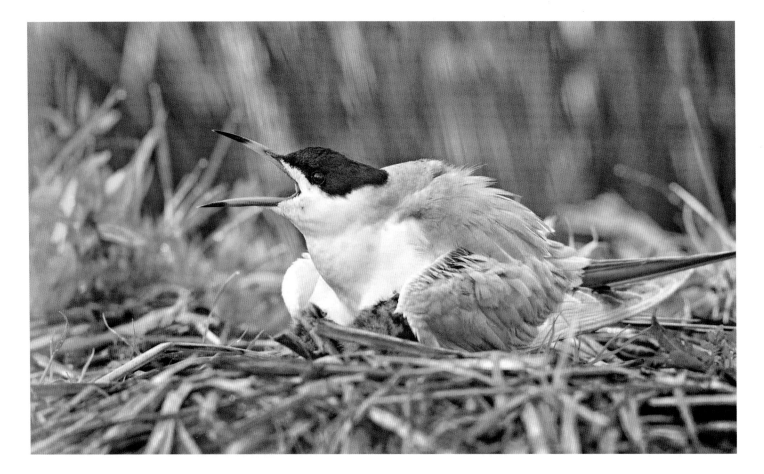

Photographing Forster's terns was an unexpected bonus. I was unaware of a pair nesting on the lake near our home. While kayaking one afternoon along a marshy shoreline, a Forster's tern suddenly plummeted out of the sky and began hitting the bow of my kayak. Its loud cries and determined attacks told me it must be nesting somewhere in the marshy bay. I immediately turned away and left the tern in peace. Terns of all species are well known for attacking and physically hitting intruders near their nest. I didn't want to be hit by the tern and didn't wish to disturb it either. Still, I wondered where the tern was nesting. I knew I would be aggressively attacked if I walked anywhere near that marshy bay. Being curious, I climbed a hill that let me look down on the bay from 300 yards away and used a powerful spotting scope to scan the marsh. It didn't take long to spot the tern brooding its young on top of a muskrat house.

How would the terns react to the approach of my floating blind? A couple of afternoons later, I finally got the calm and clear weather conditions I was looking for. I launched the floating blind from a spot where nothing in the bay could see me and carefully got inside. I slowly pushed my way along the shoreline where the water was about 3 feet deep. As I rounded a point to enter the bay where the terns nested, I wondered if the terns would protest now that I was completely concealed from view. Eventually, I could see one tern on the muskrat house from 200 yards away. Its mate was flying down the shoreline looking for small fish. This was the point where I was aggressively attacked in my kayak two days earlier. Would they protest the approach of a floating blind or not? If they did protest, I would abandon my photo plans, leave immediately, and avoid the area for the duration of the nesting period. If they accepted the floating blind, then perhaps I could get some nice photographs. As it turned out, the terns completely ignored the floating blind. They never reacted to it in any way and behaved normally, including feeding their young, when I was around. I felt like I was invisible!

The floating blind isn't for everyone. You must be completely comfortable working in and around water. If your feet aren't touching the bottom, a sudden high wind might blow you into even deeper water. If it is a small pond, then that shouldn't be too much of a problem. But, if it is a larger lake, you could be blown a long way and the waves gradually become more dangerous as you drift along. Also, safely walking in chest waders does take practice. Beginners often try to walk in chest waders like they are walking on a city street. When wearing chest waders, always make sure you don't step into deep water. Chest waders can quickly fill with water and pull you under. Many fishermen drown every year for this reason. As you wade in chest waders, always move carefully. If you lean forward too much and the trailing foot sticks in the mud, you have a good chance of falling face first in the water. Obviously, water hides logs, slippery rocks, dropoffs, and other hazards that can trip you unexpectedly. In no way do I wish to dissuade you from working around and in the water. We absolutely love it! It isn't that difficult, but there are some hazards that you must be aware of and you must keep safety the top priority at all times. Finally, remember that the floating blind makes you invisible to others using the water. Don't use it in places where motor boats are active. Being run over

My former dentist and good friend, Alan Charnley, helped us (he did most of the work) build this floating blind. This is the fourth-generation version of it, so we feel lucky to have it. All of the plans for building the blind remain in Alan's head and his lovely wife, Lynn, sewed the covers together for us. It always helps to have smart friends who are willing to help! Stalking wetland birds and mammals in this blind is my favorite kind of wildlife photography. You get to photograph plenty of wonderful subjects that can not be easily done in any other way.

by a high-speed jet boat will be a terrible outcome for you. Fortunately, the best wetlands for photography are often unappealing to other recreational users because they are shallow, choked with stumps and logs, and weedy.

CAR BLINDS

Your car doubles nicely as a wonderful moving blind that lets you easily photograph wildlife along roads. Animals that dwell near the road see vehicles speeding by and most eventually become rather unafraid of them. Car blinds work best on seldom-used dirt roads that offer fence posts or trees for birds to perch on. At many wildlife refuges, it's possible to drive some of the access roads at slow speed and photograph birds swimming in the adjacent ponds. A long lens in the 500mm and up range works best for photographing from the vehicle because you need the magnifying power of the telephoto lens. Use a big bean bag in the window or a window mount to support the large lens and camera. We use a Kirk window mount with a Kirk BH-1 ball head attached to it. It helps to hang a bit of see-through cloth material over the window you are shooting out of to conceal your movements from the wildlife. Of course, turn the car off when photographing to avoid the deleterious effects of engine vibration.

While effective wildlife photography from the car was once limited to those who owned super telephoto lenses—now with the digital crop factors—it is quite feasible for anyone to do it today. After all, a modest 300mm telephoto lens with a 1.5× crop factor and a 1.4× teleconverter behind the lens gives the lens the field of view of a 630mm (300mm × 1.4 × 1.5 = 630mm) super-telephoto lens.

USE FEEDERS TO ATTRACT SUBJECTS

Providing food is an effective way to photograph many species of birds and mammals. Depending on the species you wish to attract, use the food they prefer to eat. Many birds and small mammals, such as squirrels and chipmunks, are easily attracted to cracked corn, thistle seeds, millet, and especially black oil sunflower seeds. Most of the birds we feed prefer the black oil sunflower seeds. Thistle seeds are a delicacy for many small finches, but very expensive. Many woodpeckers, nuthatches, chickadees, starlings, and other birds are attracted to suet which is raw animal fat that you can get at the meat counter if you ask the folks who prepare the meat. The most spectacular images are captured if you hide or disguise the food to keep it from appearing in the image. There are plenty of creative ways to achieve this goal. For example, you can drill a 1-inch diameter hole in an attractive log and stuff it with suet. Select a camera viewpoint to barely hide the hole behind the wood or bark of the log. When the bird lands on the log, you want to see as much of the bird as possible without seeing the hole or any suet protruding from it. This works quite well for those birds that enjoy suet. Unfortunately, suet is a bit sticky. Small bits of it tend to stick to the bill, making it noticeable in the image. The best defense is to shoot as soon as the birds arrive before it can grab any suet. For photographers who are skilled with image-editing software, it's possible to remove the suet using digital darkroom techniques.

Even seeds stick to beaks at times, but the problem isn't as bad as suet. Sunflower seeds are very popular with many seed-eating species, but birds break the outer shell to get at the nutritious heart of the seed. Now the outer shells of the sunflower seeds are left lying around the set-up and may appear in the image. To counteract this, we sometimes use sunflower seeds where the outer shell has already been removed. These cost more per pound, but they are worth the price to avoid the discarded shell problem. Birds and mammals are appealing when they are perched on natural branches that are especially photogenic. Avoid using just any old dead stick you find. Take your time and find truly photogenic props. We often use a 1-foot live branch from a conifer in our yard that has a couple nice pine cones attached to it. We hide a small metal cap of food behind the pine cones or branch if it is big enough. Conifer branches work well because the needles help to hide the food. Obviously, the food must be on the side facing away from the camera to hide it. The bird may face away from you most of the time. However, birds are generally nervous, so they look around a lot. Many will look back over their shoulder in your direction. This is a

Bird seeds attract this handsome pyrrhuloxia to the pond at Bill Forbes' desert backyard photography station. Nikon D300, Nikon 200-400mm lens, f/9 at 1/800 second, ISO 400, and manual metering.

pleasing composition that shows the back and the face of the bird nicely at the same time.

SUGAR WATER FEEDERS

If you live in an area that is appealing to hummingbirds, they are fun to attract to your home and easy to photograph. Start attracting them by obtaining four hummingbird feeders that are mainly red, as this color attracts them. Mix sugar water in a 4:1 or 3:1 ratio. We use the sweeter 3:1 ratio. This means we put one cup of real granulated white sugar (no artificial sugar) into a pot and then add three cups of water. We boil the mixture for two minutes to keep it fresher longer and stir the solution until all the sugar dissolves. Once it cools, we fill the hummingbird feeders. If you don't know how many hummingbirds you have, fill the feeders only part way. You must replace the sugar water after four to seven days anyway to keep it fresh and safe for the birds. There is no point in wasting the sugar water by filling up the feeders if you don't need to. Hummingbirds often guard "their" feeder. You'll attract more hummers if you put up a feeder

on every side of your home so they are out of sight of each other.

Perky Pet and Nature's Best brands of hummingbird feeders work nicely for our needs. They come in different sizes. Use small feeders to avoid wasting sugar water if you only have a few hummingbirds. Get the larger sizes if you are blessed with a huge number of hummingbirds. Some locations literally get hundreds of hummingbirds, such as the Bull River Guest Ranch in British Columbia, where we conduct our workshops. Platform feeders are readily accepted by hummingbirds and they provide convenient perches for the birds to use. However, hummingbirds don't photograph well when perched on plastic. When we photograph the birds, we substitute the plastic with a stick or use feeders that have a single feeding tube that drops down. We carefully hide the end of the feeding tube with a well-placed flower.

In some places, nectar-eating bats are attracted to sugar water feeders, too. This seems to be more common in the deserts. Unfortunately, we have not had the opportunity to photograph bats yet, but we enjoy the many images produced by those who do.

Gambel's quail are readily attracted to water. When the wind is calm, photographing this adorable bird with a mirror reflection adds a positive element to the image. Nikon D300, Nikon 200-400mm lens, f/10 at 1/800 second, ISO 400, and manual metering.

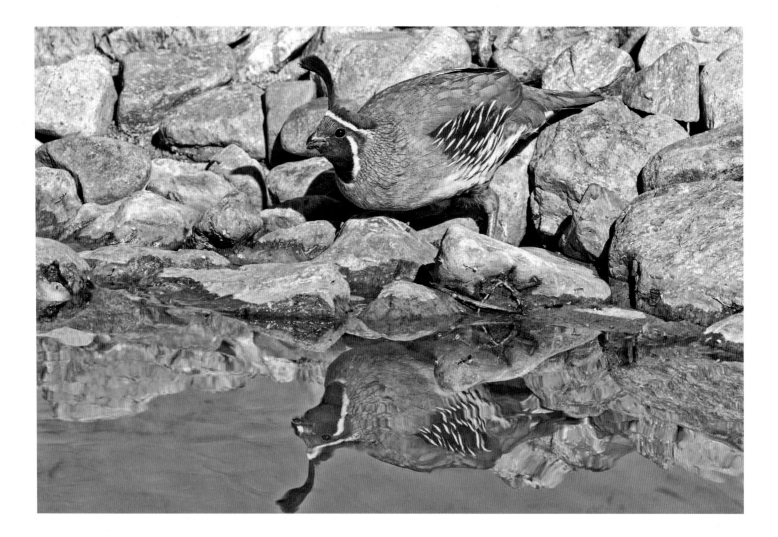

USE WATER TO ATTRACT SUBJECTS

Many birds are insect eaters and are not attracted to suet and seed baits. However, nearly all mammals and birds must drink water. Often water is a super lure, especially in dry environments, that readily draw animal species that cannot be attracted with food. Water can be used in many ways. You can build a small pond, about 6 feet in diameter, and place photogenic rocks on the far side. When birds perch on the rocks, you'll get a mirror reflection in the pond. Keep the pond shallow to let birds bathe in it.

Recently, we have been using a water drip with great success. This is a small diameter (1/8 inch or less) plastic hose about 25 feet long. The hose is attached to a regular outdoor faucet and it has a device that lets you control how much water drips from it. This small tube is easy to hide behind a moss-covered stick or lichen-covered rock. Birds readily land on the stick or rock to sip water from the drip and you don't have to worry about seeds appearing in the image. We'll be using the water drip that we bought at Wild Birds Unlimited a lot more from now on. It's incredibly effective for making the subject perch exactly where you want it to. Even if you are using a small pond to attract wildlife, use a drip to keep the pond full and the water fresh. The sound of dripping water is enormously attractive to wildlife.

BE SAFE WITH FOOD AND WATER

There are times and places where it may be unwise, unsafe, and even illegal to feed wildlife. Check your local laws. Generally, it is illegal to feed big game animals, but legal to feed the birds and small mammals that frequent your yard. Both grizzly and black bears inhabit the forests near our remote mountain home. Therefore, we always keep garbage and other possible foods, such as bird seed, locked away from them in the garage. Of course, you have to put sunflower seeds out to attract birds. We only do this when we are home and only in small quantities. We must refill our feeders every day or two. So far, we have never had a bear find our feeders. Should a bear find one of our feeders, we would discontinue feeding until they hibernate in late November. The last thing

you want to do is give food rewards to potentially dangerous animals like bears, wolves, and coyotes. Bears that learn to target human food sources quickly develop dangerous habits that all too often lead to the death of the bear. The bottom line, always be cautious when using food to attract wildlife.

It is widely believed that once you start feeding birds, you must keep it up or they will starve to death if you let your feeders go empty. This common advice is sheer nonsense. Birds exploit food sources as they find them, but continually look for more. If one food source disappears, they move on to others. Equally ridiculous is the idea that you must take your hummingbird feeders down in the fall or the hummers will refuse to migrate and freeze to death. Hummingbirds readily migrate when it is time without any regard to how much food is available where they are at. Otherwise, how do you explain the fact that most male hummingbirds begin migrating south a month or two ahead of females and young even though plenty of nectar-rich wildflowers are still blooming?

Some people believe that animals should never be photographed at their den or nest. They fear such activities may cause the parents to abandon the young or eggs, distress the adults unduly, and simply be hazardous to the subject. We agree that photographing wildlife can be hazardous to the subject, but it is possible to do it safely at certain places, or with specific species or individuals. We led a photo tour to the Galapagos Islands in 2011. Anyone who visits the Galapagos will agree the wildlife is almost completely unafraid of humans. We easily photographed nesting magnificent frigate birds with young without any distress to them. The hardest problem we encountered with the Galapagos wildlife is they are so acclimatized to humans that they often won't open their eyes when you photograph them. The alligator farm in St. Augustine, Florida, is a well-known hotspot for nesting egrets and herons. You'll be able to photograph some individuals with young from only a few yards away. These birds see people all of the time and don't react to photographers.

We don't do much wildlife photography at dens, but have easily photographed prairie dogs at Devil's Postpile National

Any book Barbara and I do isn't complete (according to Barbara) unless it has at least one of her pets in it. We have two Pomeranians, one wire-haired pointing griffon, and three Tennessee walking horses. This is Boo who is her 1.5-year-old pom. We carefully inserted him into the dense clump of Texas bluebonnets on a bright overcast day and managed to keep his attention for at least a few seconds before he bounded away. Boo is the boss in our home and believes we are his "captives." Nikon D3, Nikon 200mm f/4.0, f/8 at 1/320 second, ISO 400, and manual metering.

Monument in northeast Wyoming, Unita ground squirrels at our Idaho home, and golden-mantled ground squirrels at Canada's fabulous Jasper National Park. We doubt that photo activities at these dens are harmful to the animals. If they don't like you, they disappear down the burrow and that is the end of it. You'll soon tire of peering at an empty burrow and move on to something else. Indeed, always remember that some individuals are more trusting than others. If you find one that lets you photograph it easily, take advantage of it, and shoot plenty of excellent images.

Photographing birds that nest on the ground or in bushes is hazardous to them. In the old days, most birds were photographed at nests because the slow speed film that was used in that era made it necessary to use flash. You had to know precisely where the subject would be. Now that we have more flexibility with higher ISOs and projected flash, it is much more feasible to photograph wildlife away from the nest while

engaging in natural behavior. As a result, photographing birds at the nest isn't necessary today and should be avoided most of the time.

Still, photographing nesting birds is fascinating and can be safely done with some individuals. We photograph two or three nesting birds around our home each year. These are individuals that are already used to seeing us and don't become alarmed when we move a blind into place. Often, they are so used to us that they continue to feed their young while we erect the blind. We especially like woodpeckers and photograph a couple of pairs each year. Nearly all cavity nesters such as chickadees, nuthatches, and woodpeckers are easy to photograph well with scaffolding because the nest cavities are always out in the open on the trunk of an aspen tree. With our 500mm lenses, it is a simple matter of erecting our blind on top of the scaffolding and filling the image with the adult woodpeckers. We use natural light whenever possible, but sometimes use projected flash as a key or main light source. During 2011, a wonderful family of common flickers provided plenty of memorable moments at their nest cavity that was adjacent to our home for the second consecutive year. Unexpectedly, we discovered a pair of nesting Lewis woodpeckers nearby, which are seldom seen in our area. Although we had to go to Michigan to teach landscape and macro workshops before the young were poking out of the nest hole, we still captured some pleasing images of the handsome adult birds.

Although it's possible to photograph some nesting birds safely and easily, we agree that most nest photography should not be attempted. Adult birds that vigorously protest your presence should be left alone immediately. Never cut or move concealing branches from a nest. Never attempt to photograph colonial birds such as pelicans, gulls, terns, and others. Most bird colonies tend to erupt in alarm, exposing eggs and young to predation and the hot sun. It's best to photograph most colonial birds away from their nesting colonies. The welfare of the subject is always far more important than your images.

Index